RICHARD CATON WOODVILLE

American Painter,
Artful Dodger

7/12/04

For Ted,

◆

Justin Wolff

Faithfully,
Justin

RICHARD

CATON

WOODVILLE

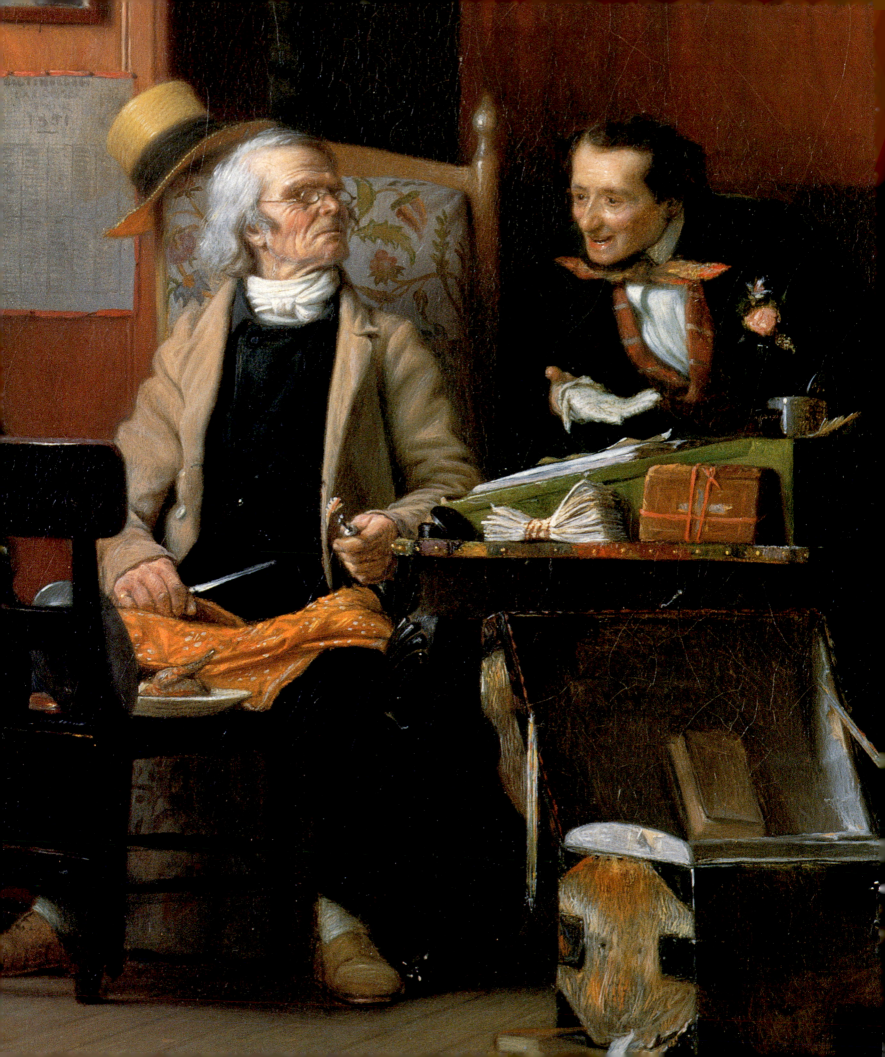

RICHARD CATON WOODVILLE

American Painter,
Artful Dodger

◈

Justin Wolff

◈

PRINCETON UNIVERSITY PRESS
PRINCETON AND OXFORD

For Megan

Front cover: *Waiting for the Stage,* 1851 (detail of fig. 70)
Back cover: *War News from Mexico,* 1848 (fig. 53)
Frontispiece: *The Sailor's Wedding,* 1853 (detail of fig. 75)

Published by Princeton University Press, 41 William Street, Princeton, New Jersey 08540
In the United Kingdom: Princeton University Press, 3 Market Place, Woodstock, Oxfordshire OX20 1SY
www.pupress.princeton.edu

Publication of this book has been made possible in part by a grant from the Publications Committee, Department of Art and Archaeology, Princeton University.

Designed and composed by Sam Potts
Printed by South China Printing
Manufactured in China
10 9 8 7 6 5 4 3 2 1

Library of Congress Cataloging-in-Publication Data
Wolff, Justin P.
 Richard Caton Woodville : American painter, artful dodger / Justin Wolff.
 p. cm.
 Includes bibliographical references and index.
 ISBN 0-691-07083-0 (cloth : alk. paper)
 1. Woodville, Richard Caton, 1825–1855. 2. Genre painters—United States—Biography.
 I. Woodville, Richard Caton, 1825–1855. II. Title

ND 237.W82 W65 2002
759.13—DC21
[B] 2002022724

CONTENTS

✧

✧

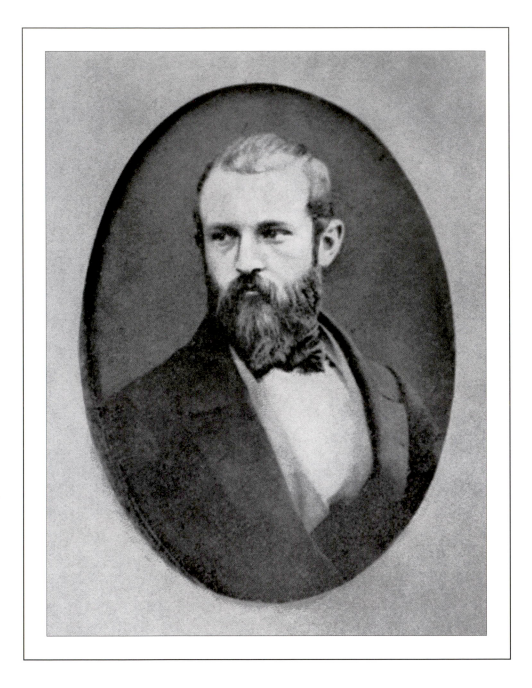

INTRODUCTION

✧

Woodville's Resemblances

"RESEMBLANCES" BECAUSE Woodville left so little behind—just over a dozen finished paintings all told. He died when he was thirty, and during his brief life he remained obstinately taciturn and seems not to have written a single letter. Like the crewmen on the *Pequod*, he was an isolato—a withdrawn transient, but one of many faces. Perhaps it is imprudent to admit up front that we cannot look at Woodville's biography as a source for much information about his attitudes. What we know about him we know from a few accounts in one journal, the *Bulletin of the American Art-Union*, and from whimsical posthumous sketches in several newspapers. The late Francis Grubar, Woodville's first and only biographer, managed to piece together some bare facts about the painter's youth, schooling, and tumultuous marriages—facts that I depend and expand on in this book—but in the end all we have is the semblance of a life.[1]

I cannot deny that while researching this book I would have loved to come across pithy letters and journal entries by Woodville, full of agile and quick-witted observations on the rambunctious Americans he described in paint. But I suspect that there is a reason—besides archival contingencies—why Woodville left us no expositions on his paintings: like some of his literary contemporaries, Herman Melville in particular, he was a skillful dissembler and ironist. What we learn after looking at Woodville's few paintings for some time

Opposite] Laura Lasinsky, *Richard Caton Woodville*, 1850–55. Photograph. Location unknown

7

is that he did not intend them to be literal descriptions of American public and domestic life. His figures, like the painter himself, resemble characters we think we know. Woodville seems to have been the obedient genre painter, supplying the public with facile, humorous stereotypes that approximated antebellum citizenry. We know that William Sidney Mount, Woodville's peer, described some of the characters in his own paintings in letters to patrons. While such a practice was certainly normal, and patrons sometimes demanded explanations of the works they purchased, in some instances it was unfortunate, if not disingenuous. If nothing else, such descriptions can take the fun out of looking at the works.

Many genre paintings, and Richard Caton Woodville's in particular, portrayed the antebellum period's most enigmatic and shifty citizens. He painted young, confident (too confident), urban men; traveling cardsharps; zealous dilettante politicians; war veterans (both young and old); and women craftily using what small amount of social influence they had managed to accumulate. Such characters appeared frequently enough in genre paintings, prints, the penny press, and novels that we have come to call them types. But Woodville, like Melville (who understood this better than any of his peers), knew that the characters in his paintings could never be fixed; they were fluid, illusory, sometimes fugitive personalities. We may call Woodville modern because he defied expectations, which was a common gambit of both the urban citizen and the ambitious artist. Neither Woodville nor his paintings delivered to those who looked what they had anticipated.

Nevertheless, the American Art-Union, that purveyor of popular taste in the arts, ranked Woodville the third greatest genre painter of his day, behind Mount and George Caleb Bingham. Since genre painting was very popular, this was not trifling praise. Not coincidentally, Woodville owed his success to the Art-Union, which produced and distributed engraved copies of his paintings. In 1879, almost twenty-five years after his death, he still enjoyed a good reputation: "His paintings show very decided traces of German influence," a *Harper's* author noted in 1879, "but behind it all was a strong individuality that seemed destined to assert itself, and to place him among our foremost painters."[2] Today, however, Woodville's work is relatively unknown: besides several scholarly essays, only one book-length study—Grubar's 1966 dissertation—examines his career in any depth.

Woodville's paintings are important because they grant glimpses of the anxieties of antebellum society and belie the myth that genre painting installs those anxieties into efficient narratives. Woodville's life and art suggest something else, something more unruly, a result both of his rebelliousness, or his "strong individuality," and of the economic disruption and social distress accompanying the maturation of capitalism. Many of genre painting's formal and narrative complexities correlate with certain economic and political dilemmas of the antebellum period. And Woodville's pictures especially demonstrate that antebellum social diversity should encourage diverse interpretive and methodological strategies. Woodville's career cannot stand for all of antebellum genre painting, but some of the menacing motifs that appear in his work (such as cheating) do appear in works by other genre artists. His art

resisted comprehensibility and was capable even of subverting popular ideologies, especially those that pitched expansion and the new economy to American citizens. In part because of the shifty urban environment he lived in and showed in his paintings, unpleasant themes, including alienation, racism, crime, and war, lurk beneath the surfaces of what so many have called Woodville's "pleasant paintings." Put more simply, Woodville's paintings are not always literal because the society that they supposedly describe often required its artists to see things metaphorically. Antebellum America was messy—optimistic and guided by a go-ahead spirit on the surface, but fragile and rickety underneath.

Two cultural historians in particular have remarked on Woodville's peculiar place within the crowd of American genre painters. In two separate essays, Bryan Jay Wolf, the nimble-minded Americanist, emphasizes Woodville's status as "a broker of knowledge" and his penchant for an "imagery of dislocation," "deconstructive gambits," and "dissemblance." Elizabeth Johns, in her comprehensive book on American genre painting, also sets Woodville apart from some of his contemporaries, demonstrating that his "scheming, nattily dressed types" were different from the characters that appeared in most genre paintings. Johns describes his settings as "confining, dark, and cluttered" and affirms that his motifs were America's "crooked moral atmosphere" and "economic disorder and deceit."[3]

These are provocative summaries of Woodville's eccentricities, and the observations of both Wolf and Johns prompted me to study his paintings and eventually to write a book about him and his cultural moment. I soon discovered that this would be a book more about the moment than the man; as A. S. Byatt recently demonstrated in her novel *The Biographer's Tale*, even after much searching, a biographer often faces mere scraps, the flotsam of a life.[4] We may insist that an identity inhabits those bits and try to fashion a likeness from them, or we may play around with the pieces themselves—both the archival documents and the coincidental social and cultural attitudes and episodes—to invoke the world that our subject moved around in, read about, and talked about. When the archival trail is scanty, a biographer can at best measure the particular angles from which the subject viewed his or her milieu. With Woodville, we must gauge and measure constantly. For one, he painted most of his scenes of American life from abroad—from Düsseldorf, where he studied at the academy. He also lived and painted briefly in Paris before dying in London from an accidental overdose of morphine. (No one knows for sure why he took the drug, though Grubar said it was for medicinal purposes.) Moreover, Woodville set his paintings in remarkably cramped spaces that often look more like mazes than rooms. Rarely did he set his figures within the ordinary confines of four corners; he was a geometrician, rather, who compulsively repeated and layered simple, hard-edged shapes into complicated, slanted amalgams of social meaning. In the four chapters of this book I look into this habit of Woodville's and chart how the four cities where he lived or where his work was on view—Baltimore, New York, Düsseldorf, and Paris—informed his paintings.

So besides some biography and cultural history, there is some "social history" in this book, though I see my practice here less as a particular kind of history, and even less as art

history, than as a kind of wide-eyed, omnivorous inquisitiveness. The antebellum city was a huge cabinet of curiosities—stairs led down to subterranean oyster cellars and taverns, windows exhibited phrenological heads and electromagnetic remedies for physical ailments—and just as the antebellum ambler observed this and that, so too may the contemporary writer saunter through the time's eclectic chambers. Like scholars before me, I enjoy what might be called bricolage, that enterprise of assemblage described so remarkably by Claude Lévi-Strauss in *The Savage Mind*. Bricolage may be a profound metaphor for all scholarship, but it is a particularly relevant one for the unrelieved materiality of the antebellum period and for the gamesmanship that is useful for writing about it. "In our time," Lévi-Strauss observed, "the 'bricoleur' is still someone who works with his hands and uses devious means compared to those of a craftsman."[5] However we describe it, the purpose should remain utterly apparent: to revitalize what has passed. Though he was referring to literary critics, Harold Bloom's summing up of the purpose of scholarship enchants me: "The critics who are my masters practice their art in order to make what is implicit in a book finely explicit."[6]

This might seem a justification for diffuseness except that among the few things we know for sure about Woodville is that he voraciously observed both the hard facts and the ephemera of his era. In writing about Woodville, we must take time to meditate on the penny press and newspapers for the simple reason that Woodville reflected on these subjects. The same goes for the Mexican War, gambling, confidence games, and the new economy, the capitalist revolution that Sean Wilentz says had already begun in 1825 and "had transformed the very meaning of labor and independence in the city's largest trades" by 1850.[7] Marjorie Garber demonstrates in her recent book *Academic Instincts* that we should obsess less about seeming like dilettantes or amateurs in our scholarly pursuits.[8] Taking that lesson to heart, I look at the political and economical discourses that influenced either Woodville's paintings or those people who saw them. Frequently, again because of Woodville's reticence, I must speculate about the painter's intentions, but that does not mean I apply context arbitrarily to my thinking about Woodville.[9]

It would be not only reckless but wrong to imply that social behavior and politics stand still as cooperative, static backdrops to personal history or to culture. Nor, of course, does culture obediently serve anything or anyone. So the cultural historian must not use social history as a mere convenience or suggest that it mirrors the themes of artistic or literary works. During the early modern period, which this book examines, culture and society entered a period of estrangement; one did not always mimic the ambitions and anxieties of the other. In America, while the body politic drew lines and barnstormed, writers and painters grew increasingly reticent and abstruse. The end of the nineteenth century would see artists guarding their private lives with a near maniacal zeal. Henry James, for instance, turning his "hot sympathy" for "subversion" into action, would burn many of his personal letters in a bonfire.[10] But culture and society sometimes shared problems and accomplishments, and Woodville's brand of genre painting, Johns has demonstrated, collaborated with many of the

nationalistic agendas and schemes of his time. Also, as I have said, Woodville's paintings tell us that he studied current political, economic, and social events and that, on the surface at least, he was a literalist; that is, he clearly referenced popular subjects and characters. But the association between Woodville's paintings and current events did not operate fluidly; irony was his particular gift. Writing about Woodville's contemporary Walt Whitman, Bloom put it succinctly: "His work can *look* easy, but is delicate and evasive." Whitman said so himself in a passage from "Song of Myself" that resonates nicely with Woodville's special view of his subjects and with his unusual dislocation from the market for which he painted:

> Apart from the pulling and hauling stands what I am,
> Stands amused, complacent, compassionating, idle, unitary,
> Looks down, is erect, or bends an arm on an impalpable certain rest,
> Looking with side-curved head curious what will come next,
> Both in and out of the game and watching and wondering at it.[11]

◈

When the Vermont sculptor Hiram Powers expressed misgivings about rendering President Andrew Jackson's toothless mouth, Jackson commanded, "Make me as I am, Mr. Powers, and be true to nature always."[12] This small anecdote is part of a much larger story about the political voices that espoused literalism as the most noble attribute of American culture. Art was a favored topic of the nationalistic Young Americans, a group of youthful journalists, including John O'Sullivan, Evert Duyckinck, and David Dudley Field, who promoted democratic principles and American cultural achievement. To varying degrees, the Young America movement adopted Melville, Nathaniel Hawthorne, Whitman, and the genre painters working for the Art-Union as emblems of their philosophies.[13] In 1845 Cornelius Mathews, an intellectual associated with the group, delivered a speech titled "Americanism." "And in art," he said, "shall we not have schools of our own? Partaking of the climate, the rocks, the woodlands, the rivers and the human faces of our own country? Chosen from whatever region of the world the subjects may be, will there not be something in the form and spirit, in the skill and kind of execution, to inform us that their origin is in the American heart and the American genius?"[14]

In part because no aristocracy or state church existed in this country to foster either an intellectual or a spiritual art, cultural nationalists celebrated the utilitarian and matter-of-fact aspects of America's art. At the same time, critics and politicians praised art that was clear and coherent, an art that did not dupe the citizens. Gulian Verplanck, a New York writer, politician, and distributor of federal patronage during his stint in Congress, demanded in

1824, "Taste must become popular. It must not be regarded as the peculiar possession of painters, connoisseurs, or diletanti [*sic*]. The arts must be considered as liberal, in the ancient and truest sense . . . as being worthy of the countenance and knowledge of every freeman."[15] In response to such demands, narrative art became popular, and artists, viewers, and critics alike preferred to read American art as legible even when it was not.

Genre painting ascended as a popular mode alongside Jackson's political power and invocations like those by Mathews and Verplanck. When a viewer considered Emerson's insistence that a painting must address the "new and necessary facts" of America—"the field and road-side . . . the shop and mill"—while viewing a work by Mount or Woodville, then that work obliged.[16] The obvious surfaces of genre painting—the stoves, the weathered faces, the barn doors, the earthy tonality—signified comprehensibility to most viewers. Genre did what was asked of it: it celebrated the everyday. Or so the theory goes. Emerson also remarked, "How many furtive inclinations avowed by the eye, though dissembled by the lips!"[17]

Emerson's ideal art was modern in that it reveled in the contemporary, but it was bound by function as well; it was immediately appropriated to serve political ends. Young Americans repeatedly praised the nation's genre painters and saw in Mount, for example, a "stamp of freshness that foreign works are sadly deficient in."[18] In an article in the *Democratic Review*, a Young American journal, William A. Jones claimed that Mount and other genre artists were "honestly national" because of their attention to "the camp meeting, the negro music, the auctioneers and orators, and fashionable clergy, life on the Mississippi and the Lakes, the history of every man's life, his shifts and expedients, and change of pursuits, newspaper controversies, fashions in dress, military trainings, public lectures, newspaper advertisements, placards, signs, names of children, man worship, razor-strop men." He concluded, "So far from being a dull people, we are eminently cheerful."[19]

Without the institutional support offered by the Young Americans and organizations such as the American Art-Union genre painting never would have flourished. The Art-Union supported genre painting because it too had been sired by cultural nationalism: its tastes, its annual lottery, and its support of artists who could not find patronage elsewhere said as much. From 1844 until 1852 the Art-Union was the primary channel through which the public viewed and read about works by Woodville, Mount, and Bingham, among others. The Art-Union treated genre painting almost as favorably as it did landscape: it supported many genre artists, including Woodville; engraved numerous genre works for its lotteries; and expounded on the mode at length in its bulletin. Beyond encouraging a "rudimentary appreciation of art in circles and places where such a thing was unprecedented," the Art-Union employed a number of craftsmen—engravers, printers, and die casters—to publish its annual bulletin and produce gift prints.[20] As an Art-Union speech from 1845 spelled out, the stewards of the organization believed craftsmanship was the foundation of American art: it was necessary to cultivate the boy who yesterday had been "a poor apprentice to a cutter of tombstones, a carver of dials, or a painter of signs and who now feels the divinity of genius stirring within him."[21]

Along with various Young Americans, the Art-Union contributed to the notion that American art must be guileless, even naive. One author encouraged young artists to "work more immediately from nature, and less through other pictures" so "their canvas smacks of fresh air, rather than of dingy galleries."[22] Genre painting soon became a cultural dynamo, a self-energizing, self-promoting mode that satisfied the petitions submitted by Emerson and the Young Americans. The folks who flocked to the Art-Union's galleries loved the realistic narrative scenes they saw there, and in 1848 the *Literary World* observed that the visitors favored Francis Edmonds's *Strolling Musician* over Asher B. Durand's "misty noon-tide of landscape."[23]

To a degree, Durand might have understood this preference. In the penultimate of his nine "Letters on Landscape Painting," published in 1855 in the *Crayon*, he briefly championed genre painting, being careful, however, to stress its quainter qualities. He said that genre painting was fit for younger artists because its "domestic virtues" were "not only estimable for their intrinsic loveliness, but also for their total lack of ostentation—and being appreciable by all, will be more certain of just and ample reward." "Realism," Durand concluded, "signifies little else than a disciplinary stage of Idealism."[24] For Durand, as for many others whose business it was, genre painting was not just youthful but innocent, even juvenile.

Some artists, such as Mount, played to the press, claiming that however the public and critics viewed their works was exactly how they intended for them to be viewed. Mount wrote, "Painting of familiar objects has the advantage over writing by addressing itself to those who cannot read or write of any nation whatsoever. It is not necessary for one to be gifted in language to understand a painting if the story is well-told—it speaks all the languages—is understood by the illiterate and enjoyed still more by the learned."[25] Mount meant what he wrote—he was a Jacksonian and socialized with Young Americans and other New York Democrats—but scrutiny of genre paintings by him and other artists reveals that their narratives are not as unambiguous as Mount pretended. And in terms of politics, it is worth noting here that though the Art-Union reflected a cultural nationalism similar to that of the Young Americans, most officers of the Art-Union were conservative Whigs. They promoted American art as an act of stewardship and a form of cultural authority, whereas the Young Americans applauded American art as an extension of a vibrant, vigorous, and egalitarian democracy.[26]

The Young America movement and the American Art-Union elevated and disseminated the arts in this country to an unprecedented degree, and they did so in accordance with the auspicious growth of populism. But both genre painting and the language used to discuss it developed causally: that is, artists responded to a demand by Jacksonians and Young Americans for a fact-based, populist art, and once these imploring authorities saw a bulbous nose or a hayseed, they proclaimed that the need had been met. Whether interpreted as pleasant pieces depicting scenes of everyday life, as gambits that typed antebellum citizenry, or as symbols that contributed to a nationalistic nostalgia for Jeffersonian idealism and the "way it

was," for years genre painting was viewed as lucid and ingenuous. Recent scholarship has shown otherwise.

Now we may at least ask whether the urgent demand for transparent narratives and delineated objects in American art interfered with the reception of genre painting. Did a semblance of the everyday in some genre paintings obscure their subversive themes? Were some of genre painting's tensions and quirks—its preoccupation, for example, with the deceitful aspects of capitalist enterprise—simply overlooked in favor of its obviously domestic qualities? Were some genre painters unsure about their own politics; that is, were they neither Democrats nor Whigs, but scavengers who foraged among the principles of each party?

In 1846 Wendell Phillips, a Boston Brahmin and abolitionist, demonstrated that his time was fickle and inconstant. "I am a teetotaler and against capital punishment," he said. "I believe in animal magnetism and phrenology. I advocate letting women vote and hold office. My main business is the abolition of slavery. I hold that the world is wrong side up and maintain the propriety of turning it upside down."[27] Nothing so tidy as universal experience existed during these decades, and the belief that genre painting reflected an authentic everyday life was, and still is, a flimsy ideology. Capitalism certainly worked against individuality and commodified specific "normal" behaviors that became common, but I do not wish for my use of the expression *everyday life* here to be mistaken for the idiom commonly used in Marxist social theory.[28] To my mind, in reference to genre painting the expression's connotations degrade the complexity of human experience during the 1840s and 1850s: people who belonged to specific groups in antebellum America—middle-class merchants, for example— did not necessarily share common political allegiances, reformist tendencies, or attitudes regarding Manifest Destiny.

A very real dislocation exists in Woodville's work as well. Though generations of critics have stamped Woodville's paintings with a domestic label, he spent most of his career abroad, in Germany, France, and England, literally alienated from the American characters and subjects he painted with supposedly unflinching realism. Ultimately, Woodville's genre is realistic not because he painted wooden planks and barrooms in a manner everyone could easily understand but because the tensions, hesitations, and ambiguities of his works developed alongside, and did not merely reflect the tensions, hesitations, and ambiguities of antebellum society. Both as a man and as an artist he reacted uncertainly to an uncertain time.

A typical reading of Woodville's paintings is that their obsession with the material world, physiognomy, and the anecdote are what make them factual, and therefore archetypally American. If we examine the facts surrounding the production of Woodville's paintings, engage some of the objects that sit on their peripheries, and concentrate on the fictional nature of the stories being told, what emerges is a body of work that, though still American, is not so literal. Woodville's paintings of domestic and public interiors circumscribe certain ideologies but do not present them in tidy packages. Like Melville (again), Woodville obscured his subjects with material excess and overwrought stylings. Most viewers of Woodville's paintings

have read his objects as signifiers of the everyday, as little facts that ground his work in some safe and recognizable reality. But a closer look at some of his paintings reveals something different. We see swinging pendulums that are always off-center, fragile glassware in rough barrooms, broken ceramics scattered on floors, and foreign textiles in domestic interiors. These objects are not always comfortably at home; frequently they are interlopers, each tweaking a scene's familiarity just a little bit.

What it all means is that we cannot pin Woodville down. Since his death he has assumed various personalities. He was a dashing, quixotic cavalier, an occasionally mischievous scion of a privileged Baltimore family; he was a scrupulous chronicler of his era; he was an instrument in the project to reify American stereotypes and to make what was a difficult period "look easy"; and he was a shifty dissembler. In considering Woodville we would be wise to keep in mind the remark from Goethe's *Elective Affinities* (1809) that Byatt uses as the epigraph for her own: "These similitudes are charming and entertaining, and who does not enjoy playing with analogies?"

CHAPTER ONE

❖

"Those Scorned Facts"

After a shiftless year in medical school spent doodling portraits of his class-mates and professors, Richard Caton Woodville reached a milestone that any artist would call momentous: in 1845 he exhibited a painting in New York City and sold it to a respected art collector.

It was time to tell his father that he wished to make his living as a painter.

William Woodville V was a competent financier fortunate to have been born into a prominent and influential Baltimore family. He disapproved of his son's artistic endeavors and, later, of his marriage to a woman with little wealth. When the young man announced his plans, his father likely vented a tempest of displeasure. For even though the young Woodville enjoyed the friendship of esteemed Baltimore artists and entrée into the homes of the city's distinguished patrons, he left for Europe immediately following his debut in New York. The twenty-year-old was bound for Düsseldorf, Germany, to study at the city's art academy. At this point Woodville's father was likely content to see his "hot headed" son go.[1]

As it turned out, school disagreed with Woodville abroad as much as it did at home; he lasted just one year at the Düsseldorf Academy. But he stayed in Europe, returning to the United States only twice before dying in London in 1855 at the age of thirty from an acciden-tal overdose of medicinal morphine.

Opposite] Detail of fig. 1

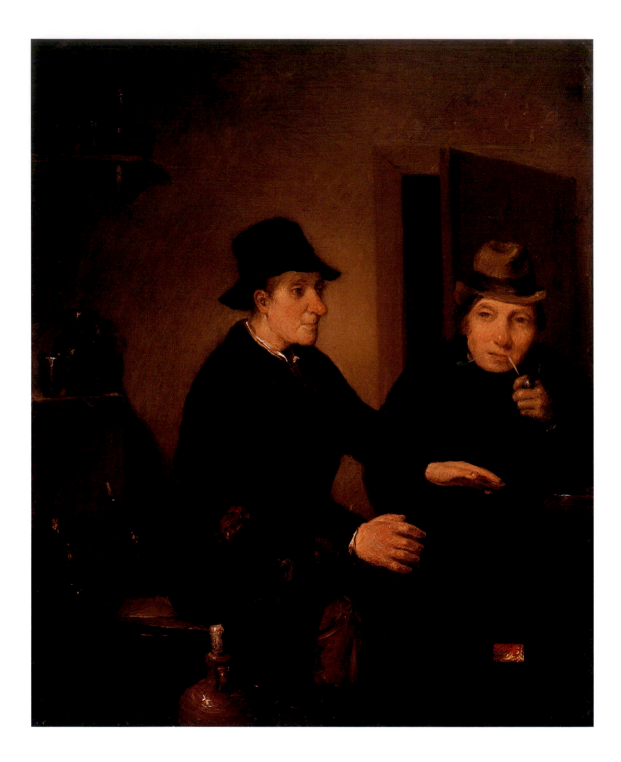

The painting that Woodville exhibited in New York was *Two Figures at a Stove*, known then simply as *Scene in a Bar-room* (fig. 1). At first glance it seems a humble painting of a humble subject—two drunkards warming themselves in front of a glowing fire. The venue, however, was not so average; it was the prestigious National Academy of Design. Just being included in its annual exhibition secured Woodville some standing. Lesser artists in the show benefited from the fine reputations of gentleman artists like Thomas Cole and Asher B. Durand, both of whom also exhibited in 1845. Though it had its detractors, mainly members of the older American Academy of Fine Arts, the National Academy wanted to be the country's arbiter of cultural taste and to instruct its students to make a moral, high-minded art. Speaking in 1831, William Dunlap, an academy founder and the first historian of American art, encouraged his students to address their works to "the enlightened men who can appreciate their value." He told them to forget about "patronage" and "pecuniary" reward and to work instead for the good of man and democratic ideals.[2]

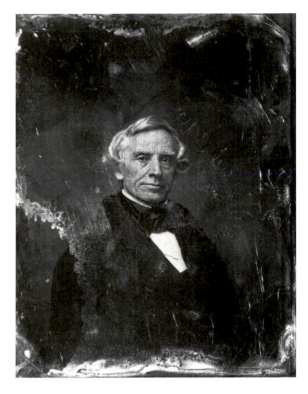

The National Academy of Design had sprung from the mind of Samuel F. B. Morse, the artist, educator, and inventor who began thinking about forming an association "for the Promotion of the Arts, and the Assistance of Students" in 1824 (fig. 2).[3] Morse intended for the National Academy to emulate England's Royal Academy: it would train artists and cultivate a public capable of understanding, admiring, and ultimately patronizing their art. If successful, Morse would assume the "pedagogical and cultural mantle" of Sir Joshua Reynolds.[4] In order to meet his goals, Morse had to do more than found an academy and school; he had to overcome what he perceived as an "almost total want of taste for the fine arts in our country."[5] In contrast to the founders of the American Academy of Fine Arts, an exclusive club with little regard for professional artists, Morse denied that taste was something to be borrowed from the Old World. A nationalist, he reveled in the here and now. In a speech defending the National Academy he said, "The encouragement of national genius is more directly promoted by giving *practice* to our own artists in the highest department of painting, than by any efforts to place before them the best *models*."[6]

The egalitarianism that Morse supposed to be the cornerstone of American democracy ought to characterize the nation's art academies as well. He wanted to wrest American culture from the patricians so that self-made artists might guide the nation, more democratically, toward cultural respectability. To achieve these ends, Morse worked with flare and made sure that his formation of the academy was a dramatic act. In 1826 he announced a rupture with the privately managed American Academy of Fine Arts and the formation of the National Academy, a public institution.

This fissure in the arts mirrored coincidental political and ideological crises, mainly

Fig. 2]
Mathew Brady
(AMERICAN, 1823–1896),
Samuel F. B. Morse, 1845.
Half-plate daguerreotype.
Library of Congress, Prints
and Photographs Division,
Washington, D.C.

the replacement of a paternalistic federalism with a vocal, teeming populism—the same shift that resulted in Andrew Jackson's election in 1828. However, though both were based on a new order, Jacksonian democracy and Morse's vision for the arts were at odds: Jackson saw artists as craftsmen with useful skills, whereas Morse saw them as moral guides. During his tenure as president of the academy, from 1826 to 1845 and again from 1861 to 1862, Morse realized that he was no populist. Although he believed that government served the people, according to one writer, he "abhorred mass rule . . . disdained mass culture, and thought 'the people' suffered from . . . an absence of religious principle and a prevalence of ignorance."[7] Morse was also a fervent nativist and led a vitriolic anti-Catholic campaign. He called himself a Democrat because that was the only viable party in New York at the time; ideologically he was extremely conservative. Believing that the society he hoped for was irreconcilable with American reality, Morse stopped painting in 1837 and resigned from the presidency of the National Academy in 1845, the same year Woodville exhibited *Two Figures at a Stove*.

Though exhibiting at the National Academy was an achievement for any artist, juries and hanging committees were not very strict until about twenty years after Woodville exhibited there; the only proviso in 1845 was that a picture could not be exhibited at the academy more than once.[8] What, then, did Morse think of Woodville's picture? Did he admire this unassuming painting of a tavern interior? Or did he cringe at the sight of these two loafers slouching at a bar stove?

The two figures in the painting sit at a square stove in a cramped and seemingly subterranean barroom; the only suggestion of the outside world is a half-open door in the background.[9] A corked jug sits at their feet, and bottles, glasses, and a pitcher stand on the bar and shelf behind them. Otherwise the room is empty. Though one of them smokes a pipe, the men neither talk nor drink. The broken chair and the absence of advertising broadsides and posters indicate that they are in a public bar housed in a private home rather than a commercial space. At the time, small businesses and households commonly operated as barrooms; on downtown streets a man could drink whiskey while he shopped for sundries or candy or while waiting in line to get a haircut. "At night," one historian writes, "he could join crowds at the theater, spending time before and after the show in the noisy and crowded barroom that occupied the basement."[10]

Wherever the figures in this painting have gone to drink, they appear to be regulars: each has a red, bulbous nose and a hunched, weary demeanor. How Woodville describes both the scenery and the characters of this scene distinguishes it from the rest of his work before 1845, just as it predicts his future pictures. These two idlers share nothing in common with the students and teachers whom Woodville was used to drawing, and they were certainly strangers to his proper family. It may be ironic that *Two Figures at a Stove*, a frank painting in which the handling of anatomy is amateurish and almost grotesque, earned Woodville his first recognition, but he would never abandon this candid style. From the beginning, Woodville played with but never imitated the sentimental and humorous mode of genre

painting made so fashionable by William Sidney Mount and Francis William Edmonds. Though the subject and setting of Woodville's painting appear to have been patterned on Mount's painting *The Long Story* (fig. 62), purchased by the Baltimore collector Robert Gilmor Jr. in 1837, the two pictures are very different in tone.

In 1867 an art critic for the *New-York Daily Tribune* described the circumstances of Woodville's first success, adding some fanciful flourishes to the story:

> Woodville's father did not wish him to become a painter, and we believe it was without his knowledge that he sent his first picture to the Academy Exhibition. A friend of our townsman, Mr. Abraham Cozzens, known far and wide as a generous and discriminating lover of art, told him that this little picture had been sent, and asked him to buy it for the sake of encouraging the artist. Mr. Cozzens accordingly bought it without seeing it, trusting in his friend's recommendation, and when the exhibition opened, the picture was marked in the catalogue "sold," a word which an artist need not be mercenary to see with real pleasure, for it means not merely "cash" but "appreciation," "recognition," and he is a dull soul to whom these are not dear. Mr. Cozzens' prompt generosity brought forth speedy fruit. The father of Young Woodville, convinced by the ready sale of his son's picture that he must have talent, no longer opposed his pursuing the artist life.[11]

In truth, Woodville's father was not pleased by his decision to be a painter. Perhaps his father would not have minded if Woodville had become a landscape painter or a portrait painter, anything other than a chronicler of the downtrodden. No reviews of the painting survive from its exhibition year, but later criticism demonstrates that it tapped into a distasteful aspect of antebellum social life. The same critic for the *New-York Daily Tribune* said the subject "was neither very elevated nor very interesting, being nothing more than two barroom loafers sitting over a stove. Although, the loafers are evidently Americans."[12] Henry Tuckerman wrote in his *Book of the Artists* that the painting was "a little picture of humble pretensions, as regards subject, but bearing indications of decided executive ability. It was the interior of a bar-room with two vulgar 'habitués' seated therein."[13] If the painting annoyed visitors to the National Academy of Design, it was because it invoked loaferism and alcoholism, improper conduct for a gentleman in 1845.

During the first three decades of the nineteenth century drinking was a normal social activity for men. "Merchants who would become temperance spokesmen stocked huge supplies of whiskey," one historian tells us, "and rich men joined freely in groups where bottles were passed from hand to hand."[14] Masters and workers maintained an easy sociability in part by sharing drinks in the workplace both during and after the workday. But by 1830 the household economy and the social order it sustained had given way to the new economy. Drinking on or after the job did not agree with new standards of discipline, and as masters and workers

retreated further into their circumscribed worlds drinking emerged as a troublesome habit. From the regimented privacy of their homes some members of the middle class issued proclamations against intemperance. "Sullen and disrespectful employees, runaway husbands, paupers, Sabbath breakers, brawlers, theatergoers," Paul E. Johnson explains, "middle-class minds joined them in the image of a drink-crazed proletariat."[15]

Indeed, heavy drinking was part of working-class social life, and violence did erupt at urban taverns, but leaders of the temperance movement did not draw a correlation between the harsh realities of the new economy and working-class frustration.[16] In addition, reformers directed their appeals toward businessmen and the middle class, thus neglecting poor alcoholics and doing little to ameliorate mistrust between the classes. When Lyman Beecher, the New England minister who led the temperance crusade, wrote about drink and class in 1826 he sounded much like the conservative ideologues of the 1980s on welfare reform: "Add the loss sustained by the subtraction of labor, and the shortened date of life, to the expense of sustaining the poor, created by intemperance; and the nation is now taxed annually more than the expense which would be requisite for the maintenance of government, and for the support of all our schools and colleges, and all the religious instruction of the nation. Already a portion of the entire capital of the nation is mortgaged for the support of drunkards."[17]

Growing up in Baltimore, Woodville would have seen alcoholics and heard the cries of reformers. Many of the inmates at the Baltimore City and County Almshouse, where Woodville made some early portrait drawings, had been incarcerated for excessive drinking, and the Washingtonians, a nationally prominent temperance group, organized themselves in a Baltimore barroom in 1840. The Washingtonians banded together when six men drinking in a Baltimore bar sent some of their party to a nearby temperance meeting for kicks. These men converted, or so the legend goes, and became the core of a group that grew rapidly, appealing to the masses by acting out in skits the pathetic lives of drunkards and founding temperance saloons, hotels, theaters, and festivals—envisioning "an alcohol-free version of working-class life." Whitman too was attracted to the "colorful festivals" and pageantry of the Washingtonians.[18]

In *Two Figures at a Stove*, Woodville tells a "tough story." Though he borrowed Mount's basic genre formula of placing two or more figures in a confined room in order to generate rapport and narrative momentum, Woodville deviated from the tone of Mount's *The Long Story*. *Two Figures at a Stove* is not a benign picture; its story is not free and easy, and its figures are not entertaining. Whether Woodville empathized with these cold, huddling figures we cannot say, but the painting does more than borrow from American genre formulas or from the Dutch realism he saw in Gilmor's collection. If Woodville studied anything before 1845, it was the impoverished, mentally ill inmates of the almshouse. More generally, he observed the social customs of his home city, which was distinguished by a ribald citizenry.

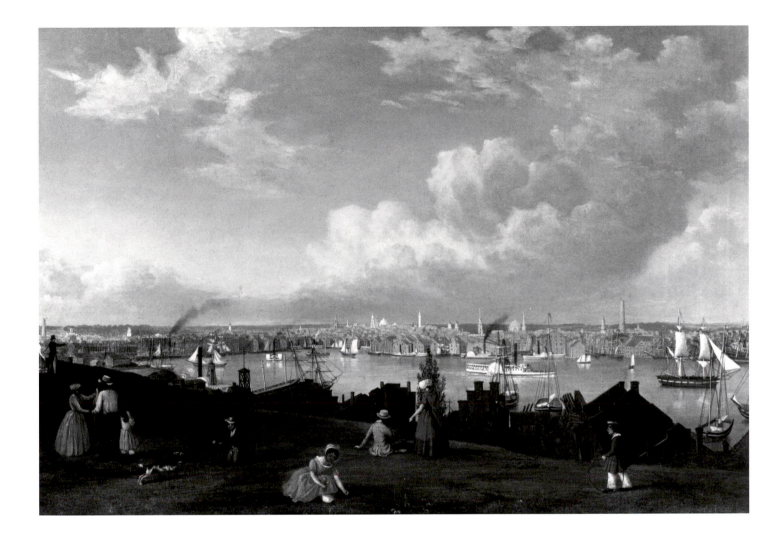

Woodville was born on 30 April 1825 in Baltimore, a port city of confined alleys and subterranean oyster bars as well as social clubs and elegant houses (fig. 3). As a youth he spent most of his time in classrooms, learning side by side with the children of Baltimore's aristocracy; his parents, meanwhile, socialized with an intimate group of bankers, merchants, and their wives in carpeted rooms bounded by heavy wooden doors and cluttered with framed pictures, portrait busts, clocks, textiles, and footstools. As an adolescent Woodville began to step out of this world, to distance himself from the domesticity that had determined his early life. One paradox that marks Woodville's career is that while he painted interior scenes almost exclusively, he remained exterior to, even alienated from, what he painted. He could paint a small room, but he was obviously restless and not the type who could stay in a small room for very long.

Fig. 3]
Fitz Hugh Lane
(AMERICAN, 1804–1865),
View of Baltimore from Federal Hill, 1846.
Oil on canvas,
19 ¼ x 28 ½ in. (48.9 x 72.4 cm).
Shelburne Museum,
Shelburne, Vermont

Fig. 4] Charles Volkmar Sr. (AMERICAN, 1809–1892), *Richard Caton*, 1846.
Oil on wood panel, 11 x 8 ½ in. (27.9 x 21.6 cm). The Maryland Historical Society, Baltimore

About 1850 Baltimore too was on edge: it lay somewhere between the North and the South, was a slave state (with many free blacks) that eventually joined the Union, and was diverse and bustling yet plagued by violence. Baltimore's citizens—its wealthy merchants and exploited laborers, its barroom drunks and ambitious artists—worked and socialized in the glow of the city's promise and the shadows of its misfortune.

Woodville's father, William Woodville V, was born in Liverpool, England, in 1792 to William Woodville IV and Dorothy Caton, the sister of the prominent Baltimore merchant Richard Caton (fig. 4). Sometime between 1810 and 1815 William V moved to Baltimore, the "Liverpool of America," where he became a banker and merchant. In 1822 he married Elizabeth Ogle.[19] The Catons had enjoyed a distinguished reputation in Baltimore for generations. Richard Caton, the painter's great-uncle, was the son-in-law of Charles Carroll of Carrollton, a Marylander and the longest-surviving signer of the Declaration of Independence. Philip Hone recorded the details of his 1832 visit to the Caton home. "Mr. and Mrs. Caton having called this morning to invite us, we passed an hour or two delightfully at their house this evening," he noted in his diary. "The family were all present. Mr. Carroll was cheerful and talkative, and enjoyed himself very much until nine o'clock, when, according to his uniform practice, he took the arm of Mrs. McTavish, and quietly left the room. I feel while in the presence of this venerable man as if I were permitted to converse with one of the patriarchs, re-visiting the land which, in days long gone, he had enriched with his patriotic counsels. . . . Would to God we had such a race of men in high places at this eventful period of our country's affairs!"[20]

The easy intimacy and polite cheer of the Caton residence contrasted sharply with the incivility on the streets and danger in the alleys that Hone disapproved of periodically in his diary. On Thanksgiving Day in 1839, for example, he wrote, "There are troubles enough, certainly; but they are the work of man's hands, and show how wayward and weak he is when left to his own inventions." In the several entries that follow, Hone reacts to separate incidents of rowdyism, making Whig indictments of "the man on the street." He describes New York as a city "infested by gangs of hardened wretches, born in the haunts of infamy" and regrets "a most outrageous revolt" of tenants near Albany, "of a piece with the vile disorganizing spirit which overspreads the land like a cloud."[21] At the time of these entries, Hone, who believed that America required the stewardship of a moral and principled elite, must have longed for the "patriotic counsel" of Charles Carroll, who died in 1832, the year of Hone's visit to the Caton house.

Although there were many incidents of rowdyism and rioting in Baltimore during the antebellum years, none of the turmoil seemed to interfere with the life of "elegant materialism" enjoyed by the Catons and their relatives.[22] Like Hone's diary entry, most descriptions of life among the Catons tend to emphasize the material pleasures of domestic leisure in Maryland. A nephew of Caton's named Richard Jackson wrote a letter relishing the foodstuffs and amenities enjoyed at the family's country residence, Brooklandwood, a name that

reads like an itemization of the family's assets. Jackson counted twenty servants and was amused on the morning after his arrival to find several "darkies" in his room, putting water in the tub, stirring up the fire, brushing his clothes, and "kicking up a devil of a row." "We have four waiters at dinner," he wrote, "which is always sumptuous: Terrapin, soup, fish, turkey, Galena fowls, omelette, ducks, corned beef, oysters stewed, carrots, turnips, potatoes, cabbage, parsnips, etc., puddings, whips, sweetmeats, and thick cream after dinner, American apples, etc. Uncle Caton's roof is certainly the roof of hospitality. . . . Aunt Caton and Mrs. McTavish have a sleigh of their own and drive four horses."[23]

Despite Caton's comfortable circumstances, he was frequently in debt and not a favorite of Carroll's. The elder statesmen only permitted Caton to marry his daughter so long as he secured employment "sufficient to maintain himself and his family," which he did by going to work for his frustrated father-in-law.[24] With his daughter's interest in mind, Carroll bought Caton the commodious Baltimore house that Hone visited, as well as the country estate Brooklandwood in Green Spring Valley, near the city. But Caton's four exceptional daughters, three of whom dazzled society in Baltimore and London by marrying titled Englishmen, compensated somewhat for his "speculative instincts."[25]

Though he enjoyed his relatives' standing and land, Woodville's father too was prone to speculation. The Woodville name appears only very rarely in documents pertaining to antebellum Baltimore, usually in the context of legal disputes involving William.[26] Nevertheless, young Woodville spent his first twenty years surrounded by the luxuries and appetites of Baltimore's upper classes. As a painter, though, he would exhibit less interest in indulgence than in taking inventory of the objects and merchandise most prevalent in domestic life. As varied in tone and subject as Woodville's paintings are, most are marked by a stout, ponderous materialism. Woodville's *Old '76 and Young '48* (fig. 63), for instance, captures the same culinary abundance catalogued in Richard Jackson's letter.

Woodville was the second of five children and the eldest son, and even though he went away to school when he was eleven, he had ample opportunity to enjoy the comfortable world into which he was born. The Woodvilles were not Catholic, but they sent Richard to Saint Mary's College, where he studied from 1836 until 1841. There had been a large Catholic population in Maryland, in Baltimore especially, from the moment the colony was settled in 1634. Saint Mary's College, located on the grounds of Saint Mary's Seminary in Baltimore, was the first Catholic institution of collegiate rank in Maryland. The college was founded in 1799 to educate three Spanish-speaking youths from Havana, and at first the city permitted the school to admit only students from the West Indies. In 1803 Bishop Carroll lifted this restriction, and it remained an esteemed institution until its closing in 1852.[27] The curriculum at Saint Mary's College emphasized the classics: Greek and Latin were required, and French, Spanish, and English were stressed. The remainder of the liberal-arts curriculum included courses in natural philosophy, physical science, mathematics, geography, history, and penmanship, with dance, fencing, music, drawing, and design offered as electives.[28] None of the

three Woodville boys who attended the school earned its terminal degree, which was not unusual. Many elite boys attended school without graduating; attending classes was more important than getting a diploma.

One year after leaving Saint Mary's, Woodville registered as a medical student at the University of Maryland in Baltimore, but he dropped out of the program after one year. It is difficult to imagine why the eighteen-year-old Woodville chose to continue his education and receive medical instruction; he had not performed well at Saint Mary's and was not passionate about medicine. Most likely, he felt obligated to attend medical school against his wishes. A letter written by Woodville's father in 1845 indicates that his family disapproved of his decision to become an artist, and during the antebellum period medical school was a common alternative for young men without precise ambitions.[29]

Because tuition was expensive, most of the students at the College of Medicine came from wealthy families, and a third were from Baltimore. But a career in medicine did not promise glamour, prestige, or fortune; the banker and lawyer fathers of many of the students associated medical practice with filth, pain, and quackery. One physician regretted that families sent their more intelligent children into law or the ministry because they believed that a medical education was for young men "the strength of whose intellectual powers they . . . doubt."[30] One man recalled his father's response to his intention to attend Jefferson Medical College in Philadelphia: "He said to me: 'My son, I confess I am disappointed in you. . . . I suppose that I can not control you; but it is a profession for which I have the utmost contempt. There is no honor to be achieved in it; no reputation to be made, and to think that *my* son should be going around from house to house in this country with a box of pills in one hand and a squirt in the other . . . is a thought I never supposed I should have to contemplate.'"[31]

Although the College of Medicine expected its incoming students to have some preliminary education or apprenticeship experience, it did not have any admission requirements. In 1850 the school's catalogues admitted frankly that the university "does not dictate the quantity or quality, of preliminary education."[32] A student could earn a medical degree in two years, graduating with what amounted roughly to the modern bachelor of science. As proprietors of the school, the faculty encouraged enrollment by guaranteeing that virtually any student could earn a degree. By 1846 almost any man with an elementary education could take a course of lectures for one or two winters, pass an examination, and practice medicine under the sanction of state law. By 1850 the degree was so cheapened that some medical leaders wanted to abandon it altogether. In fact, a third of those who graduated from the College of Medicine never practiced medicine at all, becoming planters, merchants, politicians, writers, or clergymen instead.[33] For Woodville, as for many young men, attending the College of Medicine was a temporary solution, a way to buy some time before deciding on a career.

Baltimore has been a medical center since the middle of the eighteenth century, when Charles F. Wiesenthal, one-time physician to Frederick the Great, settled in the area in 1755. In 1769 Wiesenthal built a two-story brick laboratory behind his house and charged

twenty students ten dollars each for instruction in medicine.[34] The school flourished until 1788, when a mob of Baltimoreans, terrified by the school's practice of studying anatomy on corpses, stormed a laboratory, destroyed its furnishings, and dragged a cadaver through the streets. Rather than hindering medical education in Baltimore, such incidents compelled the city's physicians to join together in an effort to suppress quackery and develop a formal, state-sanctioned curriculum.

In 1807 several prominent Baltimore physicians established a major medical school in the city. Throughout the fall of that year a series of announcements appeared in Baltimore newspapers advertising the school and stating that "the course in Anatomy will be rendered more full and complete, by a series of prelections, on the functions of some of the most important organs of the body."[35] The school opened on 2 November 1807, and just over a month later, on 18 December, the state assembly approved a charter incorporating the College of Medicine of Maryland as a private institution, owned and managed by its faculty.[36] The college was the sixth medical school in the country and the first south of Pennsylvania. Over the next three decades the College of Medicine at the University of Maryland flourished. Under the control of a renowned faculty it enjoyed a national reputation for its progressive courses. During its first three decades only the University of Pennsylvania School of Medicine graduated larger classes.

Once settled at the university, students attended at least one hour of lecture per day five or six days a week, under one of seven professors. The core courses were "theory and practice," or the application of medicine for healing; chemistry; *materia medica*, or pharmacology; obstetrics; and surgery. The College of Medicine taught anatomy, but well into the 1830s professors emphasized the "Maryland theory" of medicine, which derived from Benjamin Rush's notion that illness results from an imbalance of natural elements in the body and that therapy should, therefore, aim to restore equilibrium.[37] Students learned about various purging and bleeding techniques, in addition to methods for promoting equipoise, such as diet, exercise, and chemical stimulation. All the same, no one pretended that medicine was a perfect science. Professor William Aikin, an instructor of Woodville's, said in 1837 that medicine "is emphatically an experimental science, all its deductions are based on experiment."[38]

Medicine may have grown out of the spirit of enlightenment and optimism that characterized American science after the Revolution, the same mood that led Benjamin Franklin to prophesy that men and women could be made to live forever, but during the antebellum period medicine's positivism could not hide its foibles.[39] During the Jacksonian era, attacks on elitism and standards, fear of concentrated power, and immigration of people with diverse medical customs and remedies threatened the illusion of unanimity and infallibility that medical practice depended on. One newspaper, for instance, denounced a perceived epidemic of "poisoning and surgical butchery" at the hands of physicians; even a medical journal warned that medicine might become a "stupendous humbug."[40] In 1857 the editor of the *Cincinnati Medical Observer* lamented that "it has become fashionable to speak of the Medical

Profession as a body of jealous, quarrelsome men, whose chief delight is in the annoyance and ridicule of each other."[41]

This bickering also contaminated medical schools, which often stood at the center of the quarrels. During the year that Woodville was enrolled in courses a power struggle between young, ambitious faculty and older, headstrong professors intensified the contentious atmosphere at the school. Impeachment hearings, slanderings, and even physical intimidation were commonplace. Woodville's advisor Dr. Nathan Ryno Smith, for example, who was known as "the Emperor," reputedly carried a teaching stick that he "snapped against his legs like a field marshal's baton," causing students and colleagues to recoil.[42] In one incident, Smith entered into a physical dispute with Richard Wilmot Hall, an older professor. After Hall confronted Smith with his customized cane, the younger man grabbed it and drew forth the sword it contained, challenging his elder to a fight.[43]

As profit-making institutions, medical schools participated in the vulgar competition and politicking built into the country's overall medical system. Medical colleges were conglomerates of ambitious physicians who functioned as both faculty members and proprietors. Professors, who launched many schools on "waves of puffery, or florid promotional literature, which contemporary observers criticized as being more in keeping with business hucksterism than with scientific activity," lived comfortably off tuition fees.[44] Many Baltimoreans thought medical professors were "godless grave robbers" who monopolized medical education and raised licensing fees in order to bankrupt unlicensed but cheap miracle healers.[45] Such suspicions were not unfounded. The College of Medicine was proud of its reputation as an illicit hub for the profitable trade in corpses used for anatomical study; in its catalogues, the school advertised Baltimore as "the Paris of America . . . where the abundance of subjects is greater than any other city in the United States."[46] One College of Medicine instructor nonchalantly described in a letter to a Bowdoin College professor how he planned to send him several bodies: "It will give me pleasure to render you any assistance in regard to subjects. I think you may rely upon having them. I shall immediately invoke Frank, our body-snatcher (a better man never lifted a spade), and confer with him on the matter. I would not tell the world that any but ourselves should know that I have winked at their being sent out of the state. I will cause about three to be put up in barrels of whiskey."[47]

When Woodville was a student, medicine was no more a refuge for the high-minded from the indecencies of the modern economy than, say, the lightning-rod business. Images of bespectacled scientists pursuing miracles in medical laboratories and classrooms were the stuff of myth. More accurately, medical schools represented the most aggressive aspects of the "go-ahead" spirit. In fact, in addition to courses in anatomy and *materia medica*, the schools offered students lessons in business acumen and banking.

Besides being exposed to the posturing and profiteering of his teachers, Woodville would have seen a part of the city his family probably never visited. The school was located in southwestern Baltimore, a neglected section of the city occupied by boardinghouses,

livery stables, factories, and railroad-repair shops. The nuns who worked at the hospital feared walking alone in this run-down part of town, which was more industrial and working-class than academic. The university, which had no dormitories, could only give students a short list of approved boardinghouses, all of which charged exorbitant rates. One student who was strapped for cash claimed to live "very cheaply on roast potatoes, pudding and milk."[48] Students rarely ventured out, preferring instead to stay in their rooms and smoke tobacco and play whist.

Woodville did not immerse himself in the study of medicine; he remained, as he would throughout his career, on the perimeter of institutional life. A number of drawings and sketches he made while attending lectures attest to his priorities. Rather than scribbling copious notes during a chemistry lecture, Woodville doodled in the margins of his texts and notebooks, a nice metaphor for his later emphasis on the edges of society and for his ability to make fundamental what appeared peripheral. In addition to various doodlings, Woodville produced a number of finished sketches of his classmates and professors that demonstrate a precocious talent.

In 1836, when just eleven and a student at Saint Mary's College, Woodville exhibited an extraordinary aptitude in the execution of a watercolor drawing that depicts a mounted general dying in the arms of a companion.[49] The subject of the watercolor had been in vogue among American artists during the late eighteenth century, and Woodville likely lifted the subject from a print at the school, but the image is striking because it predicts many aspects of his mature style.[50] As in all of Woodville's works, in this little watercolor he revels in childlike enthusiasm for stuff, in this case the stuff of war—horses, bridles, uniforms, and bayonets. Woodville's style was never dainty, and in this early picture we can already make out the heft that he would give to all his figures. The histrionic narrative—a general gasps his final breath—testifies to a youthful imagination and anticipates the hyperbole Woodville would foster in his life and art. As we shall see, he had become something of a cavalier dreamer by

early adulthood. Dashing and restless, he fashioned an unruly temperament that kept him on the fringes of both his community and his profession.

Two years later, in 1838, Woodville made several sketches of his teachers (figs. 5–7). These pencil and watercolor wash drawings depict three French clerics of the Sulpician order who were members of Saint Mary's faculty. The drawings waver between matter-of-fact character studies and caricatures, an early sign of a feature of Woodville's later paintings. Even in this miniature format Woodville scrupulously reproduced each quirky trait (unshaven stubble, side-glancing eyes) that he observed in his teachers' appearances. At the same time, the drawings are jeering; Woodville exaggerates the men's nervousness, and their cowled heads appear either remarkably fat or remarkably lean. Many of the boys at Saint Mary's, including Woodville, were not Catholic, and they likely mocked the clerical faculty behind their backs. Even though these sketches are more than schoolboy scrawls, it is hard to imagine that Woodville shared them with his teachers.

These three drawings are preserved in the most significant source of Woodville's work before 1845, the Dr. Stedman R. Tilghman Scrapbook.[51] Stedman Tilghman, who belonged to a distinguished family from Maryland's Eastern Shore, also attended Saint Mary's College and the College of Medicine, where he received his M.D. in 1843. Immediately after graduating, Tilghman joined, as its physician, the last of several hunting expeditions that Sir William Drummond Stewart, of Scotland, led to the Rocky Mountains.[52] After returning, Tilghman served for two years as a resident physician in the Baltimore City and County Almshouse, where Woodville made sketches of doctors and inmates. At the outbreak of the Mexican War, in 1846, Tilghman enlisted as a surgeon in the District of Columbia and Maryland Regiment of Volunteers. Broken down from the strain of the war, Tilghman died in New Orleans in 1848, at the age of twenty-six.[53]

The Tilghman Scrapbook contains a varied assortment of personal souvenirs, including newspaper clippings, autographs, a theater notice, a beaver tail, engravings, and twenty-three drawings—nineteen by Woodville—either pasted in or made directly on its blank sheets. Woodville and Tilghman were close friends at Saint Mary's, the University of Maryland, and the Baltimore City and County Almshouse, so Woodville most likely gave his friend the drawings as gifts. All of them are small and rapidly made on cheap paper. Nevertheless, they testify to what Woodville made of his education, to how he observed his immediate environment, and most important, to what his instincts were as an artist. One can find the roots of Woodville's later oil paintings in the expressions, clothes, and gestures depicted in these drawings.

When Woodville arrived at the University of Maryland, he continued his practice of drawing in class, preferring to doodle rather than listen to professors drone about leeches and dysentery. The usual distraction, of course, was romance. One student scribbled about his love's "tender sweetness," and another about his own "impassioned rapture"; when Professor Potter lectured on the maladies of lovesickness, the students took copious notes.[54] Woodville,

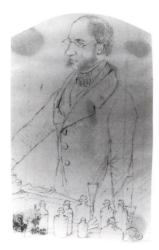

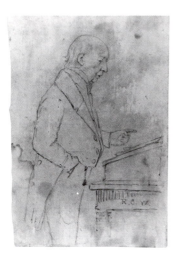

however, focused on the appearance of his professors, not on what they said. A portrait of Dr. William E. A. Aikin typifies the handling of these sketches (fig. 8). Professor Aikin stands at a lectern covered with papers; a dozen glass jars and containers—aids, presumably, for his chemistry lectures—sit on a desk adjacent to the lectern. Woodville portrays Aikin as a tall, slender, middle-aged man with muttonchop whiskers, a balding head, and a meditative manner. The bespectacled, finely dressed professor—he wears a neckpiece and a long, wide-collared coat—stares off into the distance. His demeanor signals that he is a professor, thoughtfully going about the business of teaching aspiring physicians. Or perhaps what appears as concentration here is really reverie. Either way, this little drawing speaks as much to Woodville's purpose which was to divert himself from the tedious task of memorizing chemical equations, as it does to the professor's.

The finest element of the drawing is its description of the glass containers. Woodville sketched them quickly, suggesting their liquid contents with the lightest spiraling strokes, their rims and stoppers with nimble, elliptical loops. Yet they are substantial, weighty objects in a rational, geometric space. For Woodville, the vessels on the desk are not the materials of a medical education but emblems of his early forays into the activity of perception, the tools of his self-guided education in picture making. Dr. Aikin was a respected figure at the College of Medicine, serving as its dean twice, from 1840 to 1841 and from 1844 to 1845.[55] He had actually stopped practicing medicine in 1830 in order to pursue his real passions—teaching, chemistry, and natural science. Throughout his career as an educator Aikin pursued a number of other interests, ranging from law to gas illumination, and Woodville likely identified Aikin as a kindred spirit, someone else who saw medicine as a catalyst for dreamier pursuits. In 1844, just a couple of years after Woodville made this sketch, Ralph Waldo Emerson delivered his lecture "Education." In describing the transformation that some people go through in school, from apathetic pupil to inspired student, Emerson by chance articulated Woodville's experience. At first, he said, "the time we seek to kill: the attention it is elegant to divert from things around us." But then "the aroused intellect finds gold and gems in one of those scorned facts—then finds that the day of facts is a rock of diamonds."[56] Woodville may not have cared much for medicine, but his time in medical school transformed him, from a mediocre student into a discerning artist.

Woodville also sketched a portrait of Dr. Nathaniel Potter (fig. 9), probably in 1842, just months before the professor's death. Professor Potter, who had studied under Dr. Benjamin Rush at the University of Pennsylvania, distinguished himself as a Baltimore physician and founder of the College of Medicine, which he served faithfully as a professor of the theory and practice of medicine. Potter delivered animated lectures for almost forty years; toward the end of his life he read from crumbling, yellow notes and continued to insist that "miasmic fevers, dysentery, gout, dropsy, and nymphomania" all shared the same cause.[57] A lifelong bachelor, he took a particular interest in lovesickness, which he believed caused fevers, hysteria, and mania. This type of malady, he maintained, afflicted women and "men

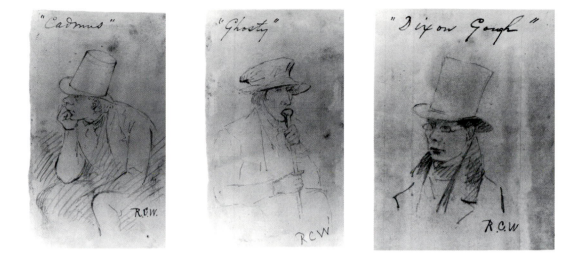

of delicate minds," although it was common among "New England men" and could be brought on as well by "indolence." As a cure Potter prescribed a diet of bread and water, cold baths, a hard bed, and massive doses of the purgative calomel, admitting meanwhile that the only permanent remedy was "matrimony."[58] Students admired Potter's wit and intensity, and one described him as a man of "medium height, of full figure and ruddy complexion. He was fond of playing cards and given to swearing. He varied the tedium of his lectures by anecdotes which often brought down the house. Some of these taxed even the credulity of the students, who would express their skepticism by ahems, ohos, by whistling and in other ways. To these he would reply by saying, 'I'm damned, gentlemen, if it ain't so.'"[59] Woodville's portrait of Potter shows the smartly dressed professor striking what must have been a familiar pose: standing at a lectern, reading from a pile of notes, and gesturing emphatically with his index finger. His other hand is stuffed in his pocket, probably rubbing his watch (we see the fob hanging outside the pocket). Woodville kills time while Potter keeps it.

In addition to the pencil drawings of Professor Aikin and Professor Potter, Tilghman collected in his scrapbook portraits of Professor Charles Bell Gibson and three fellow students, "Cadmus," "Ghosty," and Dixon Gough (figs. 10–12). Woodville never generalized physical attributes such as weight or expression, and even in quick sketches such as these he was sure to describe dress, demeanor, physiognomy, and attitude. "Cadmus," for instance, strikes an especially easy pose despite attending a lecture by the imperious Professor Smith.[60]

According to a description by a classmate, Woodville maintained the same natural confidence that he saw in his peers. Woodville, this man remembered, was "of aristocratic lineage, courtly manners and very handsome, he was essentially the artist. Possessed of remarkable perceptive faculties, both mental and physical, he was a keen observer of character, and such was his acuteness of sight that the minutest details were visible to him at some distance. His sense of humor was refined, and he expressed dramatic situations with rare power of composition."[61]

Richard Caton Woodville
Above, left to right]

Fig. 10]
"Cadmus," c. 1842.
Pencil on paper,
5 x 2 ¾ in. (12.7 x 7 cm).
The Maryland Historical Society,
Baltimore

Fig. 11]
"Ghosty," c. 1842.
Pencil on paper,
5 x 2 ⅞ in. (12.7 x 7.4 cm).
The Maryland Historical Society,
Baltimore

Fig. 12]
Dixon Gough, c. 1842.
Pencil on paper,
5 x 2 ¾ in. (12.7 x 7 cm).
The Maryland Historical Society,
Baltimore

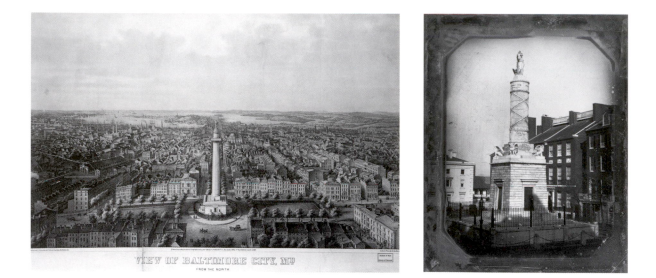

As early as 1841 Woodville portrayed himself in a small pencil sketch as a blasé dandy, or Baltimore's version of one, a cavalier southern gentleman.[62] (He did so again in a painted self-portrait from about 1853 [fig. 74].) The 1841 drawing shows the young Woodville seated with his legs crossed, his right arm resting on the top of a chair, looking away—that sly maneuver of the self-possessed. Endowed with grace, he wears a loosely knit bow tie, a long, unbuttoned coat with wide lapels, and a buttoned vest with a watch fob. This portrait alone does not illustrate Woodville's particular dandyism, but the emphasis placed on his style and aplomb, combined with his later behavior, suggests that Woodville was sensitive to his appearance and position within (or without) whatever establishment he found himself.

These dandiacal mannerisms were not of the subversive Baudelarian sort. Woodville did not attempt to assert cultural authority in resistance to the more powerful reign of the marketplace and bourgeois propriety, though some of the characters in his paintings would do so.[63] Woodville's dandyism was really just youthful exhibitionism, more in keeping with the kind identified by Thomas Carlyle in his chapter on the "dandiacal body" in *Sartor Resartus* (1840). Dandyism, according to Carlyle, was merely theater. "The Dandy," he writes, "is a Clothes-wearing Man, a Poet of Cloth," and "like a generous, creative enthusiast . . . fearlessly makes his Idea an Action." But Carlyle also believed the dandy was a coward for disengaging from his community when in fact he was "abjectly dependent on the recognition of the audience he professes to disdain." What is it, Carlyle asks, "that the Dandy asks in return? Solely, we may say, that you would recognise his existence; would admit him to be a living object; or even failing this, a visual object, or thing that will reflect rays of light." And as if describing the impact of the visual carnival that was Woodville's Baltimore, Carlyle explains how the dandy, despite what he pretends, searches for his place in the modern city. "May we not well cry shame on an ungrateful world," Carlyle asks, "which refuses even this poor

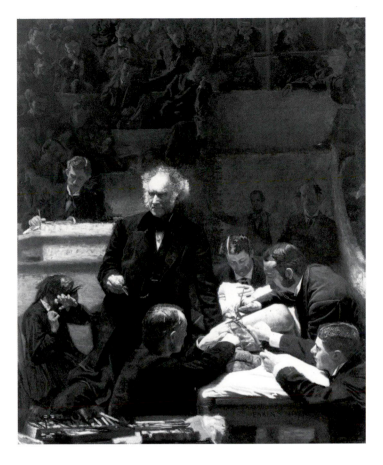

boon; which will waste its optic faculty on dried Crocodiles, and Siamese Twins; and over the domestic wonderful wonder of wonders, a live Dandy, glance with hasty indifference, and a scarcely concealed contempt."[64]

Woodville grew up in a melodramatic city. During his youth the city was known by two sobriquets: the Monumental City, owing to its fondness for public statuary (figs. 13 and 14), and Mobtown, on account of its disorderly citizens. Baltimore's vital energy surely aroused some of Woodville's own theatrics, but the stagelike classrooms where his medical school lectures took place also kindled what the *Baltimore Sun* called his "courtliness."[65] As at most medical schools at the time, lectures at the College of Medicine were staged in large amphitheaters, with the professor positioned in the pit below and the students seated above on tiered seats. In one drawing from this period, of a team of doctors performing surgery at the Baltimore Infirmary, Woodville portrayed just such a performance (fig. 15). The drawing shows ten figures grouped around a reclining patient suffering from "necrosis of radius."[66] Woodville identified seven of the ten figures with a number key: a number of doctors from the University of Maryland, including Tilghman, observe as the infamous Dr. Nathan Ryno Smith hammers a chisel into the patient's right forearm. Smith earned his reputation as a great surgeon by expertly performing this operation again and again. Dr. Samuel Gross, whom we see performing a similar procedure in Thomas Eakins's *The Gross Clinic* (fig. 16), learned it from Professor Smith. In the days before anesthesia, doctors impressed audiences by working rapidly, thus causing their patients less suffering. With "calculated gestures" they won applause and cheers from their colleagues and students.[67]

If Woodville chose not to absorb his professors' medical lessons, he did take their posturings and penchant for spectacle to heart. He may not have held formal education in

Fig. 15 *above, left*]
Richard Caton Woodville,
An Operation at the Baltimore Infirmary, 1842–43.
Pencil and ink on paper,
4 ½ x 3 ⅞ in. (11.4 x 10 cm).
The Maryland Historical Society, Baltimore

Fig. 16 *above, right*]
Thomas Eakins
(AMERICAN, 1844–1916),
The Gross Clinic, 1875.
Oil on canvas, 96 x 78 in.
(243.8 x 198.1 cm).
Jefferson Medical College of Thomas Jefferson University, Philadelphia

high regard, but he did engage himself socially by sketching portraits, which struck the classmate who remembered him in the *Sun* as eccentric or "aristocratic" and "courtly." What is more, perhaps to further differentiate himself from his peers, he was interested in fringe medicine. Woodville took an interest in mental illness, that aspect of medicine that received the least notice in medical schools during the antebellum period. In 1845 he made a series of drawings at the Baltimore City and County Almshouse, where his friend Stedman Tilghman worked from 1843 to 1845.[68]

The prevailing belief among government officials and physicians at the time was that psychiatric disorders resulted from "intemperance and idleness" and that immigrants were particularly prone to both.[69] A fear of social breakdown like that expressed by Philip Hone and Samuel Morse prompted the country to acknowledge that its most unfortunate citizens needed the government's help. Accordingly, state legislatures set up committees to investigate the customs, illnesses, and hardships of the poor.

Baltimore's almshouse was built in the late eighteenth century, and in 1822 a legislative act created a board of trustees to oversee the "poor of Baltimore City and County" and to manage the almshouse, which it did until 1854.[70] During the antebellum period, almshouses were horrifying, often merciless institutions. Almshouse administrators, in fact, opposed the building of new mental hospitals because they would siphon off the inmates the almshouses used as cheap labor. Crumbling facilities, poorly trained staff, lack of land and devices for the amusement of patients, and obscene overcrowding prevented any attempts to "practice moral management" in antebellum almshouses.[71] The institutions treated occupants more like inmates than desperate patients, and according to an 1845 report on "pauper insanity" commissioned by the city council, the Baltimore almshouse was no exception. It too made patients perform hard labor as payment for their residence.[72]

The Baltimore Almshouse employed physicians, but their primary purpose was to minimize obvious suffering and instruct visiting medical students. "Before the Civil War," Norman Dain explains, "American psychiatrists, although generally pragmatic in outlook, did not altogether succeed in fulfilling Rush's command that physicians "assert their prerogative, and . . . rescue mental science from the usurpations of schoolmen and divines.""[73] Doctors and trustees made no attempt to diagnose disorders and deemed treatment futile; they believed that most inmates were drunks, and drinking, according to the era's wisdom, was a disease of will.[74] In 1855 a physician at the Baltimore Almshouse said that the institutions were "humanity's commons, where the useless and incurable are turned out to die."[75]

As grim as the Baltimore Almshouse may have been, it was also an ambitious and lively institution that provided shelter for about four hundred inmates and offered medical students at the University of Maryland the opportunity to observe a variety of ailments. Situated on a three hundred-acre farm about two miles from the center of Baltimore, it had six separate units, each accommodating a specific type of outcast: these included, according to one report, an "infirmary for the indigent sick; a lying-in hospital; a work house for the

employment of vagrants; an asylum for destitute children; a lunatic hospital; and a medical and chirurgical school."[76] The same account reported that intemperance had reduced three-fourths of the inmates to pauperism and that immigrants made up one-third of the total number of patients. One-quarter of the inmates were sick, another quarter were homeless children, and the rest were aged and infirm.[77]

Since he was no longer a student at the College of Medicine, Woodville likely gained access to the almshouse through Tilghman. We can assume that Woodville did not visit the almshouse because of his love of medicine, but that does not mean, as has been suggested, that he visited only to secure free models, even if he was attracted to strange personalities and physiognomies.[78] Of the six drawings Woodville made at the almshouse, two are of physicians employed there, Dr. Charles Frick and Dr. J. H. Pottenger; three are of anonymous inmates; and one is of L. C. Pignatelli, a particularly sad case (figs. 17–19).

Pignatelli was an Italian artist who had painted miniature portraits for the "ladies and gentlemen" of Baltimore as late as 1828. When his business failed, he attempted to teach miniature painting, also without success.[79] Pignatelli ended up as a periodic inmate at the almshouse from 1836 to 1845. Three letters he sent to friends while living in the almshouse are among the artifacts in the Tilghman Scrapbook. They testify to his bouts with depression and delusions. In one letter, written in 1844 to the Reverend W. E. Wyatt, Pignatelli lists the incidents that had landed him in the almshouse: he had been maimed in a bar brawl with Irish workers, he had been unjustly accused of an impropriety against a Dr. Alexander, and all of his possessions had been stolen by another Italian. Pignatelli tells Wyatt that marriage might change his luck, and he names four ladies of Baltimore as suitable partners: "Miss E. Johnson, Miss A. E. Swan, Miss E. Hoffman, or Miss D'Arcy." He ends the letter by urging his friend to hurry and make the arrangements for his marriage, as "I am reduced . . . like a piano forte with out strings."[80]

In an 1845 letter to Dr. Tilghman, Pignatelli describes the brutal conditions in the almshouse. "I am extremely obliged to you," he begins, then proceeds, dejectedly, in a pidgin English, "as one of your letter to assuring me of your friendship, at this my critical situation I am reduced in the cellar whit out any fault, Yesterday about 5 o clock afternoon Jeorg Corman Capn has strike me 2 blows one in my head, and my breast I am persecuted from this man whit out reason. I most earnestly to request to you to be sensible of my unpleasente situation, to raccomand me to the . . . Dr. Robinson if it is possible to remove me from the cellar. do me this favour Dr. S. Tilghman and you lay a particolar obligation on all my life."[81]

In Woodville's miniature pencil drawing Pignatelli looks right at the viewer with a feeble expression and tired eyes, outward manifestations of inner surrender. This rapid

Richard Caton Woodville
Above, clockwise from top left]

Fig. 17]
Inmate of the Baltimore Almshouse, c. 1845.
Pencil on paper,
4 ⅜ x 3 in. (11.2 x 7.6 cm).
The Maryland Historical Society, Baltimore

Fig. 18]
Dutch Woman at the Almshouse,
c. 1845. Pencil on paper,
4 ⅛ x 5 in. (10.4 x 12.7 cm).
The Maryland Historical Society, Baltimore

Fig. 19]
L. C. Pignatelli, c. 1845.
Pencil on paper,
3 ⅝ x 2 ¼ in. (9.1 x 5.7 cm).
The Maryland Historical Society, Baltimore

sketch, like several others in the Tilghman Scrapbook, demonstrates Woodville's intuitive talent for capturing the unique dispositions of his subjects. With a few pencil strokes and heavy lines for the eyes and mouth, Woodville summons Pignatelli's sorrow. Grubar suggests that Pignatelli instructed Woodville while the two were acquainted at the almshouse.[82] Given Pignatelli's state, this seems unlikely. His letters indicate that he was in no condition to provide the aspiring artist with practical training, though Woodville may have chosen the miniature format for this portrait, which is much smaller than the other drawings made at the almshouse, as a tribute to the infirm artist. More likely, the two had informal conversations about art.

The destitute were new subjects for Woodville. Whether or not he felt sympathy for them, these studies corroborate other indications that he rejected the formalities of medical school and the privileges of his world—there are no watch fobs or swallow-tailed coats in these portraits. We know that Woodville's father disapproved of his career, but he must have preferred his son's portraits of distinguished doctors to those of nameless drunks. With these small sketches Woodville's stage shifted from the confined lecture halls of the College of Medicine to the world at large.

◇

Though Woodville did not study art formally, he took advantage of the Monumental City's cultural opportunities and of his friendships with artists who did train. An 1881 article in the *Baltimore Sun* claims that the young artist studied with Alfred Jacob Miller, a Baltimore native who was teaching art as early as 1842, but there is no evidence to support this claim.[83] However, a close friend of Woodville's, Franklin Blackwell Mayer, did study with Miller. Moreover, Stedman Tilghman, Woodville's friend who traveled to the Rockies with Sir William Drummond Stewart in 1843, certainly knew Miller, who had accompanied Stewart on an earlier trip to the western mountains in 1837.[84] At the very least, Woodville knew Miller and his work, and because Miller was Baltimore's most prominent artist, the acquaintance was undoubtedly an important one for Woodville.

Miller too displayed a precocious talent for art by doodling during class, a talent that he was not encouraged to pursue; his stern master would tear up his drawings.[85] Like Woodville's, Miller's earliest drawings were mocking portraits of his schoolmasters, followed, when he was fifteen, by sketches of Baltimore drunks and market loafers. In addition to training with the portrait painter Thomas Sully, Miller studied the works in the Peale Museum in Baltimore. By the time Miller was visiting the museum, Rubens Peale had already assumed control of the struggling institution and boosted revenues with spectacular attractions like Mr. Tilly, the glassblower, and Signor Hellene, the "celebrated Italian musician"

who played six instruments at once.[86] Regardless, the museum managed to fulfill some of Rembrandt Peale's intentions for it, one of which was to build a "Picture Gallery with paintings to 'elucidate History, Biography, Geography, the beautiful, characteristic and sublime scenes in nature.'"[87]

After traveling to the Wyoming Rockies with Stewart in 1837, Miller began to produce and exhibit his drawings, watercolors, and oils of Native American life. He settled in Baltimore long enough to show off his new work and arrange an exhibition in 1839 at the Apollo Gallery (later to become the American Art-Union). Eventually Stewart hired Miller to accompany him back to Scotland to document life at Murthly Castle. When Miller returned to Baltimore for good in 1842, Woodville was just finishing his year at the College of Medicine.

Although Miller continues to be known for his scenes of the West, he was a versatile artist who worked in oil, watercolor, and pencil with equal proficiency and who shifted with ease between different modes, including landscape, portraiture, and genre. Throughout his life, Miller kept scrapbooks that he filled with sketches of life in Baltimore, scenes from popular literature, and drawings from his private farm and residence, Lorraine. For the most part, these sketches are whimsical and amusing caricatures; Miller included in the scrapbooks, for example, drawings of cigar-smoking drunkards, streetcar passengers, newspaper boys, and unsophisticated youths carousing during a performance at the Holliday Street Theatre. The cluttered interior and mussy domesticity of one of Miller's literary-genre scenes, which depicts the startled, broom-wielding marchioness from Dickens's *The Old Curiosity Shop* (fig. 20), confirms a typical antebellum genre sensibility. As a teacher, Miller had plenty to offer his students: he worked in several mediums and regarded Baltimore's follies and the West's drama with equal attention.

Mayer, who enjoyed a successful career as a painter of genre and history scenes and a professional arts organizer, was Miller's student and Woodville's friend, and so the most likely link between the two. During the time that both men lived in Baltimore, Woodville maintained a close working relationship with Mayer. Of the several genre studies that Woodville made before leaving Baltimore, two are related drawings titled *Bringing in the Boar's Head* (figs. 21 and 22). One, a pencil sketch of a figure carrying a boar's head on a platter and participating in a pageant with other figures dressed in sixteenth-century costume, appears to be a preliminary study for the other, a pen drawing of a single figure, also carrying a boar's head on a platter. Although these drawings are the earliest examples of the romantic period pieces that Woodville would continue to produce throughout his career, they may very well have been records of incidents he observed in a Baltimore market or at Brooklandwood. It appears that Woodville produced the final pen drawing in collaboration with Mayer; for on the verso of the sheet an inscription reads: "Dear Frank—Don't expect me to I won't be able. R.C.W." A later painting by Mayer (fig. 23) almost duplicates Woodville's design in this drawing, suggesting that this inscription was addressed to Mayer.

Fig. 20]
Alfred Jacob Miller
(AMERICAN, 1810–1874),
The Marchioness from Dickens's "The Old Curiosity Shop."
Watercolor wash on paper,
8 ⅛ x 5 ⅛ in. (21 x 14 cm).
The Walters Art Museum,
Baltimore

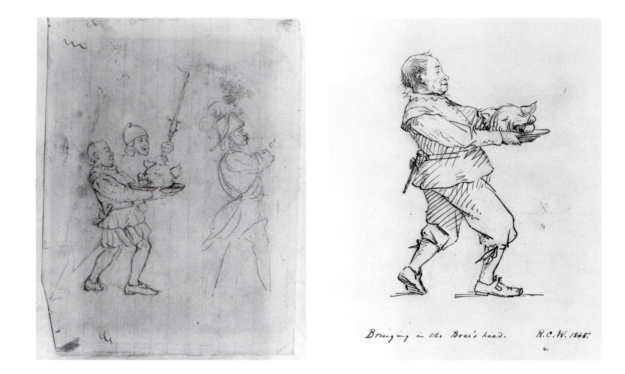

Woodville's association with Mayer was surely part of his artistic education. Mayer's father and uncle, Charles and Brantz Mayer, were cultural leaders in Baltimore, respectable Whigs with a passion for "scholarship" and the "advancement of the city."[88] Charles, it is said, met his wife, Eliza Caldwell, an amateur artist, at that "elegant rendezvous of taste, curiosity, and leisure," the Peale Museum.[89] Among their friends were the critic John Neal; the scientist and first director of the Smithsonian Museum, Joseph Henry; the Baltimore patron John H. B. Latrobe; and the painter Thomas Sully. The Mayers participated with these and other Baltimore luminaries in the establishment in 1844 of the Maryland Historical Society, where Frank would serve for several years as an assistant librarian in the gallery of fine arts.

Not only did Woodville benefit intellectually from his friendship with such a learned family but he seems to have taken some of his social cues from the Mayers as well. Brantz has been described as "flamboyant," "something of a dandy," and influenced by the "expansive and socially effective style" of his brother's law partner, Joseph Pendleton Kennedy.[90] Frank also had a lively sense of humor, which in his unpublished autobiography, "Bygones and Rigamaroles," he claims to have inherited from his mother's "sense of the ridiculous." He continues, rather bitterly, "The world is an e-nor-mous jack-ass! . . . more foolish than wicked. Mankind moves on, a tumultuous crowd swayed by the jangle of the fool's bauble and bells, mingling the sadness of the wise, the mirth of the thoughtless and the stupidity of the selfish. With the eyes of the genial jester to look on the passing show and to regard life as

Fig. 21 above, left]
Richard Caton Woodville,
Bringing in the Boar's Head,
c. 1845. Pencil on paper,
6 ½ x 4 ¹³⁄₁₆ in. (17 x 12.2 cm).
The Walters Art Museum,
Baltimore

Fig. 22 above, right]
Richard Caton Woodville,
Bringing in the Boar's Head,
c. 1845. Pen and ink on paper,
7 ⅛ x 5 ⅞ in. (19 x 15 cm).
The Walters Art Museum,
Baltimore

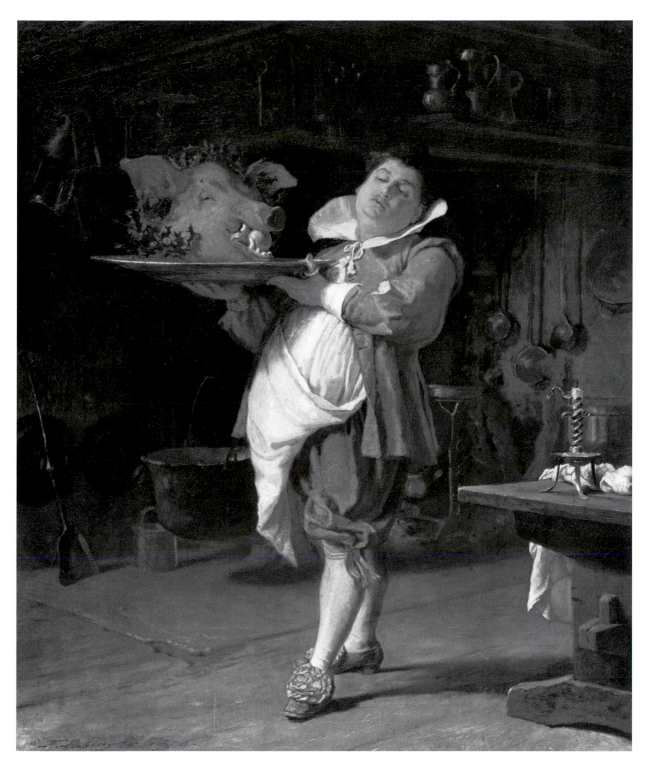

Fig. 23] Franklin Blackwell Mayer (AMERICAN, 1827–1899), *Boar's Head, Christmas*.
Oil on canvas, 18 ½ x 15 ¼ in. (47 x 38.7 cm). The New Britain Museum of American Art,
New Britain, Connecticut. John Butler Talcott Fund

comedy seems to us commendable wisdom."[91] The Conscience Whiggery (a Whiggery less prone to Victorian moralizing and more forthright in its abolitionism) and sociability of the Mayers must have seemed refreshing to Woodville, especially compared with his father's stern admonishments about career choices and personal decisions.

Two other Baltimore notables with connections to Miller also played important roles in Woodville's early career: Dr. Thomas Edmondson (fig. 24) and Robert Gilmor Jr. (fig. 25).[92] Edmondson, another graduate of Saint Mary's and the College of Medicine, was the scion of one of Baltimore's wealthiest families. He owned a distinguished library and art collection and had a reputation as a cavalier gentleman about town who prided himself on patronizing young artists.[93] In 1844 or 1845 Woodville painted a small portrait of the collector. Since Edmondson could have afforded to hire any artist in the country to paint his likeness (as Alfred Jacob Miller did in 1842), he likely patronized Woodville as a favor. The portrait is bland and unoriginal, a typical Dutch-style picture that depicts Edmondson dressed in black and white and positioned against a black background. Edmondson, however, did not seem to mind: on the reverse side of the panel he wrote an inscription that proudly reads, "Caton Woodville's first kick into the world!" Indeed, this was most likely the first work for which Woodville received money; and as the inscription implies, and Woodville would later learn, it was a rough profession indeed.

During the early 1840s Woodville visited Gilmor's collection, which was one of the most impressive private collections in the nation. Gilmor's gallery of paintings and prints functioned as a "school for artists" and was an important tool for aspiring painters who could not make the trip to Europe. The collector also fancied himself an instructor of the arts. He had specific ideas about what American art should look like—he favored absolute literalism, or a painting "without manner," as he put it—and believed his collection gave him the authority to instruct young American artists. Gilmor vexed Thomas Cole, for instance, with unsolicited advice on matters of style and technique.[94]

Gilmor did not offer Woodville the kind of avuncular advice he gave Cole, but he certainly welcomed him to his outstanding collection.[95] Next to landscape painting, genre painting was the strongest component of Gilmor's gallery; Dutch, Flemish, and English genre scenes attested to the collector's taste for the literal. Included in his collection at one time or another were about 150 works by artists such as Jan Brueghel, Meindert Hobbema, David Teniers, and Gerard Terborch, as well as several paintings from the English school by artists such as Sir David Wilkie.[96]

Neil Harris groups Gilmor with other patrons who emerged during the 1820s, men like Philip Hone and Luman Reed in New York City, Nicholas Longworth in Cincinnati, and Edward Carey in Philadelphia. These men, according to Harris, were merchants who had retired at an early age with a great deal of money but less education than those men who had founded the nation's athenaeums and academies.[97] But in truth, Gilmor, who was more of an aristocratic and paternal patron, was at odds with these upstarts. In one instance he was

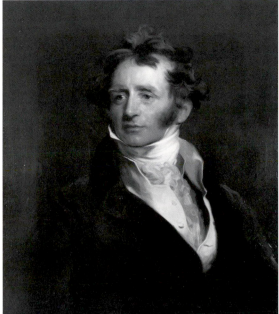

forced to defend his honor after a public attack on his reputation as a collector. On 27 March 1844, just months before Woodville's departure for Europe, the *New York Herald* published a droll account of an evening two weeks earlier at the home of the Baltimore merchant Benjamin Coleman Ward. The article, written by one "Ariel," opens as follows:

> Baltimore, the city of monuments—the centre of hospitality, with its gaiety, beauty, frivolity, and fashion, its rosy cheeks and cheap mutton, continues to echo with mirth and gaiety. . . . Mr W., as a patron of the arts, occupies the same position in Baltimore that Thomas H. Perkins did in Boston, the late Luman Reed did in New York,

and that Henry Carey does at the present time in Philadelphia. His house is always open to artists of merit, and he takes delight in showing his pictures, which, differing from Mr. R****t G****r, (who, by the way, has six original oil paintings by Michael Angelo,) he has obtained by paying a fair price, and not by haggling with the artist, or by attempt to exchange some worthless daub.[98]

The outraged Gilmor responded in a letter to his friend and business associate Jonathan Meredith that he was "a gentleman of good & correct feeling" and that the attack was an unfair "reward for patronising when no one else in their native city would do it." In addition, Gilmor took a swipe at Luman Reed, a man, he writes, "who without any knowledge of the art, had accompilated [*sic*] wealth & paid extravagant prices for the pictures of New York artists."[99]

Regardless of Gilmor's reputation in New York as a stingy and exasperating patron, his purchases played a big role in Woodville's early development. After Woodville quit medical school and became an artist, he schooled himself by maintaining friendships with Baltimore artists and collectors like Mayer and Edmondson. It was from Gilmor's collection, however, that Woodville learned what type of art he wanted to make. Though the Dutch and English genre painters caught his attention and appealed to his own awareness of character and anecdote, Mount's *The Long Story*, which was in Gilmor's collection by 1837, clearly struck a chord in the young artist. Woodville recognized something in this painting, something more than just its figures and setting. In medical classrooms, soirées at the Mayers' homes, and visits to Dr. Edmondson's collection he had heard all kinds of stories. Now he would tell his own.

It is difficult to determine why Woodville chose genre as his preferred mode. His earliest drawings in the Tilghman Scrapbook show that when he began to doodle and sketch, he usually made portraits. However, he tended even then to place his subjects in a larger narrative context. In his early drawings professors gesture, inmates knit, anonymous characters parade in pageants, and all kinds of objects, each with its own narrative capabilities, frame their actions. Woodville taught himself to draw by sketching people he knew, but latent dramas lurk in his early portraits and characterizations. From the beginning Woodville was capable of more than just describing physiognomy: his lone figures—the Italian painter and vagrant L. C. Pignatelli, for example—cry out for context, for a long story.

Woodville made his first genre picture, *Soldier's Experience*, in 1844 (fig. 61). The watercolor drawing, discussed in a later chapter, employs familiar genre formulas, but it taps into Woodville's personal feelings about family. The picture exhibits what would become Woodville's usual attention to what divided Americans rather than what brought them together. This, more than anything, distinguished Woodville from his peers. Rather than helping to "order the body politic," which Johns demonstrates was the implicit project of most genre painters, Woodville summoned fringe characters and directed them in dramas

that speak more to his era's disorder. Whether veterans, gamblers, or confidence men, Woodville's characters are representatives of an emerging underworld, speakers of many tongues, followers of rules not encoded in bourgeois values. Rather than demonstrating the typical behavior of certain citizens, Woodville's paintings revealed social eccentrics to a society not quite ready for them. It is this aspect of Woodville's small oeuvre that makes him a closer comrade of antebellum writers, Melville especially, than of antebellum painters.

This is not to say that Woodville was the first painter of his time to steal furtive glances at social ills. Francis William Edmonds, a New York banker and genre painter, exhibited two paintings at the National Academy of Design in 1845. One, titled *Facing the Enemy* (1844; private collection) shows a man in his workshop mesmerized by a bottle of hard liquor sitting on the windowsill. The struggle is undeniably sad, and surely the painting was meant as a temperance proclamation. The work became popular enough for the American Art-Union to issue a mezzotint copy, which it advertised in a temperance handbill reinforcing the moralizing message.[100] Christian Mayr was a German-born artist who arrived in the United States in 1834 and exhibited portraits and genre paintings at the National Academy of Design and the American Art-Union until his death in 1850.[101] His *Reading the News* (fig. 26) depicts the great divide that was growing between the working and middle classes, which was in evidence on city streets every day. While three prosperous men rest leisurely on the doorstep and consider the day's news, two shoemakers in the shop behind them sit dutifully at their worktable. This contrast is not lost on the younger shoemaker, who gestures mockingly at the men. When Woodville treated the same subjects as Edmonds and Mayr, he did it with a keener appreciation for context and with less sentimentality. He did not have the same taste for sarcasm and was rarely coercive or heavy-handed with his audience—avoiding what Whitman called genre's awkward "straining after effect."[102] Mayr, by contrast, reduced class tension to a crude "us versus them" synopsis. Though Woodville was more privileged than most Baltimoreans, he viewed the city and its quirks from a less contrived perspective.

Karl Marx described the duplicities the American metropolis forced on its inhabitants. "Where the political state has achieved its full development," he wrote, "man leads a double life, a heavenly and an earthly life, not only in thought or consciousness but in *actuality*. . . . In the *political* community he regards himself as a *communal being*; but in *civil society* he is active as a *private individual*, treats other men as means, reduces himself to a means, and becomes the plaything of alien powers."[103] In antebellum cities, the disorienting tensions between the supportive networks of republican citizenship and the isolating realities of self-interest inherent to capitalism often boiled over into the streets. From 1830 to 1850 New York witnessed what Sean Wilentz describes as "atavistic" and "cruel" explosions of mob violence.[104] Baltimore was no different; even when celebrating, Baltimoreans were prone to losing control. When Fanny Elssler, Europe's leading dramatic ballerina, toured the United States in 1840, her pretty face and sex appeal prompted eruptions of Elsslermania in New York, Philadelphia, Richmond, Boston, and New Orleans. During her visit to Baltimore the

Fig. 26]
Christian Mayr
(AMERICAN, born
in Germany, 1805–1851),
Reading the News, 1844.
Oil on canvas,
21 x 36 ½ in. (53.3 x 92.7 cm).
National Academy of Design,
New York

city's citizens lived up to their reputation as rowdies. After her final performance at the Holliday Street Theatre carousing fans commandeered her carriage, and "a pack of strong young men then picked up the traces and drew her slowly through the streets." When they reached Barnum's Hotel, the crowd picked up the pace. Elssler scrambled inside, but when she appeared at the window and threw some bouquets to the throngs, "there was a desperate scramble for the souvenirs." The merriment "continued in the hotel until nearly daybreak,

and even distant residents were kept awake by the rounds of cheers that floated on the night air."[105] That same year a lithograph (fig. 27) published in New York lampooned the enthusiastic Baltimoreans by portraying them as braying donkeys towing Elssler's carriage.

But crowds in Baltimore, which was home to many immigrants, more often gathered to express their nativism or to perpetrate acts of ethnic violence. On 17 March 1819, for example, the Irish celebrated Saint Patrick's Day in the saloons and dance halls of Fells Point, a tough working-class neighborhood. In high spirits, they sang and danced from bar to bar, which offended non-Irish residents of the city. In retaliation, some boys stuffed old clothes with straw, labeled the effigy "Paddy," and ran it to the top of the mast of a Baltimore clipper ship. An Irish mob quickly gathered on the wharf and tried to set the effigy free. When it became fouled in the boat's rigging, they felled the mast with axes, prompting rioting, assaults, and arrests.[106] Later, during the 1850s, the Know-Nothings committed some of their most outrageous acts in Baltimore. Members of the Know-Nothings were essentially anti-Catholic and antiforeign; they had earned their name by their secretive tactics and anonymous membership. The group operated mainly by pressuring politicians and candidates to adhere to nativist principals, but it also practiced intimidation, much as the Ku Klux Klan would do during the first half of the twentieth century. In Baltimore, the Know-Nothings formed small gangs with names like The Rough Skins, The Gladiators, The Ranters, The Blood Tubs, and The Plug Uglies.[107]

Social unrest that had its roots in labor practices and racial tension had been fermenting in Baltimore since the beginning of the nineteenth century.[108] Rioting had become a common way to voice grievances by 1831, when a mob revolted at a B&O Railroad construction site. A contractor had absconded with his workers' pay, so "the laborers took the law into their own hands and commenced to destroy the property of the company, because their employer had wronged them! They were between 200 and 300 strong, and with pick-axes, hammers and sledges, made a furious attack on the rails, sills and whatever they could destroy. The sheriff of the county and his *posse* were resisted by these ignorant or wicked men."[109]

The Bank of Maryland Affair was another infamous event that occurred during the Jacksonian era and Woodville's youth. In March 1834 the Bank of Maryland failed, and the middle and working classes suffered great losses. Neither group, however, went down without a fight. The failure resulted from the fraudulent management of the bank, which did not

FANNY ELSSLER AND THE BALTIMOREANS

Fig. 27]
Fanny Elssler and the Baltimoreans, 1840. Lithograph published by John Childs, image 12 ⅜ x 17 ⅜ in. (31.4 x 44.3 cm). Library of Congress, Prints and Photographs Division, Washington, D.C.

A "BOWERY BOY" SKETCHED FROM LIFE.

possess adequate reserves to cover its expansion. In order to cover the costs of growth, it introduced a novel scheme, to pay interest on deposits. This plan attracted deposits from Baltimoreans of modest means, citizens who did not possess enough capital to invest in larger ventures. So when the bank failed, those least equipped to absorb a loss were hit the hardest. Because of the middle-class affiliation of the Bank of Maryland, the affair had a wider social significance than similar crises.[110] An employee of Alex Brown and Sons, the most prominent mercantile firm in Baltimore, described the situation to a peer in New Orleans: "Here there has been a great deal of distress by the failure of the Bank of Maryland," the agent understated, "say to the amount of about three million dollars, a great part of which falls on the middling & lower classes of the people who were induced for the sake of saving a little interest to place their little all in these institutions which has been loaned out to designing men on little or no security & now those who are able can pay their debts to them at 50 cents in the dollar—we had no confidence in any of these institutions & are not invested for one dollar."[111]

Those who lost their savings grew impatient after months of waiting for creditors to act. Meanwhile, those who profited from the fraud exchanged accusatory pamphlets and dodged culpability at every turn. On 7 August the mayor, at the public's insistence, staged a meeting in Monument Square to discuss the progress of the case against the bank's managers. The assembly quickly disintegrated into several angry mobs that burned, looted, and vandalized the homes and businesses of those suspected of playing a role in the affair. The rowdyism persisted throughout the weekend. By the time peace was restored, a total of fifty-five people, many from the city's middle classes, had been placed in jail for crimes committed during the rioting.[112] The Bank of Maryland Affair caused Baltimore's citizens to lose trust in those who managed the city's capital, as well as in the city's ability to police itself. The *Washington Native American* denounced another assault, the 1839 Baltimore Nunnery Riot, as a disgraceful illustration of "Mobocracy."[113] Local papers and citizens also expressed outrage at the city's reputation as Mobtown; one author, a Mr. Niles, of the *Baltimore Register*, was apoplectic: "*Society seems everywhere unhinged*, and the demon of blood and slaughter has been let loose upon us! We have the *slave* question in many different forms, including the proceedings of *kidnappers* and *man-stealers*, and others belonging to the *free negroes*; the proscription and prosecution of gamblers; with mobs growing out of *local matters*—and a great collection of acts of violence of a *private* or *personal* nature, ending in death. . . . We have *executions* and murders and riots . . . and thousands interpret the law in their own way . . . guided apparently only by their own will!"[114]

Violence, of course, was peculiar neither to the antebellum period nor to Baltimore. Similar crimes and perpetrators could be found in Boston, Philadelphia, Richmond, and New Orleans.[115] But it was in New York City, where Woodville exhibited his paintings, that authors and the press fashioned the lawless urban type into an American original. Whitman, as both a newspaper man and a poet, was enamored of the b'hoys of the Bowery (fig. 28), whose rugged lives appealed to his love of individuality and physicality:

Fig. 28]
A "Bowery Boy," 1857.
Wood engraving, in *Frank Leslie's Illustrated Newspaper,* 18 July 1857, 109. American Antiquarian Society, Worcester, Massachusetts

The boy I love, the same becomes a man not through derived power,
 but in his own right,
Wicked, rather than virtuous out of conformity or fear,
Fond of his sweetheart, relishing well his steak,
Unrequited love or a slight cutting him worse than sharp steel cuts,
First-rate to ride, to fight, to hit the bull's eye, to sail a skiff, to sing
 a song or play the banjo,
Preferring scars and the beard and faces pitted with smallpox over
 all latherers,
And those well-tann'd to those that keep out of the sun.[116]

As David S. Reynolds points out, Whitman (fig. 29) modeled his own persona in *Leaves of Grass* on b'hoy culture: "[W]icked rather than conventionally virtuous, free, smart, prone to slang and vigorous outbursts."[117] Other groups Whitman observed were variously called roughs, rowdies, and loafers: gang members and street loungers, they roved Manhattan instigating riots and causing trouble. But he chose not to lionize these street toughs as he did the Bowery b'hoys; rather, he presented an improved version of them, ignoring the vulgarity and criminality that he disapproved of.[118] In an 1845 article Whitman asked, "How much of your leisure time do you give to *loafing*? what vulgar habits of smoking cigars, chewing tobacco, or making frequent use of blasphemous or obscene language?"[119] In later articles the poet bemoaned the triumph of ruffianism in America's urban centers: "[T]he revolver rules, the revolver is triumphant," he wrote, and "mobs and murderers appear to rule the hour."[120] This emerging urban type intimidated even America's most potent poet.

 Whitman distinguished between those urban characters who rambled, gambled, and flaunted their freedom from conformity at every turn and those who were simply criminals, thugs who roamed the streets practicing intimidation and committing violent crimes. This distinction is crucial, for the activities of the former group were essentially leisurely, whereas those of the latter were unlawful. During the antebellum period, however, the public in cities like Baltimore did not perceive clear distinctions between harmless loafers and dangerous rowdies. Lounging, in the minds of the largely conservative middle and upper classes, led to crime, and to some the mere sight of tobacco-chewing cardplayers in a tavern meant that more insidious activities were within spitting distance.

 Despite New York City's prominence in the country and its central role in the country's news making, Baltimore came to typify the national trend toward both premeditated and wanton violence. Just as Whitman's voiced ambivalent opinions about rowdies and loafers in New York, the citizens and press in Mobtown simultaneously expressed shame and pride in Baltimore's reputation. Danger, or the illusion of danger at least, was an aspect of modern urban experience, and in the 1830s and 1840s Baltimore was indeed a modern city—self-aware, watchful, unpredictable, segregated, and unsafe.

Fig. 29]
Samuel Hollyer,
Walt Whitman, 1855.
Engraving after daguerreotype
by Gabriel Harrison, in
Leaves of Grass (1855),
2 1/8 x 2 in. (5.4 x 5.1 cm).
Columbia University, New York,
Rare Book and Manuscript Library,
Solton and Julia Engel Collection

The men in *Two Figures at a Stove* (fig. 1) are part loafer, part rowdy, and part poor L. C. Pignatelli—all Baltimore natives in Woodville's eyes. Gauging Woodville's attitude toward these men is no easy task; he was not, as I have mentioned, a letter writer or a journal keeper. The only clues to his politics are his paintings. To be sure, he inherited a Whiggish superiority from his family, but he clearly preferred the compassionate and socially liberal kind of Whiggery to the priggish, reform-minded kind. In terms of prisons and mental hospitals, for instance, Whig efforts were frequently altruistic, whereas Democratic policies tended to be "callous" and concerned with "economy, efficiency, and deterrence."[121] At the same time, Whig reformers could be arrogant, and their self-importance likely exasperated the young Woodville. Ralph Waldo Emerson cast Whig didacticism in medical terms, calling the archetypal Whig an overprotective physician whose "social frame is a hospital." He dresses everyone in "slippers & flannels, with bib & pap-spoon," Emerson protests, and prescribes "pills & herb tea, whig preaching, whig poetry, whig philosophy, whig marriages."[122] Just as Woodville stepped away from the hospital, so he stepped away from predictable Whig politics; what he saw in Baltimore may have made him mindful of, and even nostalgic for, his family's noble past, but it did not turn him into a whimpering Philip Hone or a paranoid Samuel Morse. In the end, Baltimore was a very different place for Woodville than it was for his family. What he observed of Baltimore's underclasses intrigued him, which must have made his decision to leave the city for Europe even more difficult.

A letter written by Woodville's father hints that he asked his son to leave the country because he disapproved of his marriage:

> I must mention to yourself and my sister that to our amazement Caton has been secretly married to a young girl here, a Miss Mary L Buckler [*sic*], for some time past. She is the young lady of whom I spoke to my sister when I was at Buckam Hill—She is a daughter of Dr Buckler of Baltimore—who is at the head of his profession here—It was an affair of three or four years old—and we have done every thing in our power to break off the engagement, but without success. The Bucklers, or rather Mrs. B. has managed the affair indiscreetly—in the first instance permitting him to visit there constantly, and after she discovered the engagement, taking injurious steps to break up all intercourse—
>
> Dr B has seven children and some fortune, not I presume however a considerable estate—I shall send Caton next week . . . on his way to Florence, to study the profession he is bent upon adopting—if Dr B chooses to send his daughter, he will do so—Caton is not yet 20, she is 17—possibly 18—.[123]

Although the letter indicates that Woodville may not have wanted to leave Baltimore, once abroad, the artist wasted no time enrolling in Düsseldorf's esteemed art academy and starting work on his next painting, a genre scene set in Baltimore. The irony is that just when

Woodville decided that the interior life of his home city would be his primary subject, he distanced himself from that environment. But rather than impeding his production of genre scenes, Woodville's new city, with its lively culture, encouraged his fledgling art.

In some ways Woodville's dislocation from his subject after 1845 makes perfect sense. While in medical school, Woodville had appropriated some of the airs of the modern dandy; he wanted to appear outside, or above, whatever world he inhabited. And his duplicity, his increasing scrutiny of the environment he stepped away from, was not an uncommon gambit of modernism. In many ways art became the palatable surrogate for city life, the legible re-creation of urban chaos. At the same time, Woodville's expatriatism and the physical distance separating his working environment and audience mirror aspects of the antebellum cultural marketplace. What role could Woodville possibly play in determining perceptions of his art if he was not even the one peddling it? The increasing alienation between artists and their audiences, which resulted in part from the growth of the publishing and exhibition industries, also conditioned some of the major literary works of the moment: Thoreau retreated, for instance, and so did Melville's Bartleby.

Both Woodville the artist and Woodville the dandy were constructs of his home town: many young southern gentlemen assumed such airs, but to do so was a way of coping with the disorienting aspects of a modern city like Baltimore. His cavalier attitude was, of course, a pose, a way of pretending to be resistant to what Walter Benjamin called the "shocks" of the city.[124] And as Melville wrote in *The Confidence-Man* (1857), the artist was free to peruse the city and its people like a shopper browsing for new fashions: "Where does any novelist pick up any character? For the most part, in town, to be sure. Every great town is a kind of man-show, where the novelist goes for his stock, just as the agriculturist goes to the cattle-show for his."[125] This was Woodville's stratagem; in Baltimore he observed the sharps and shills that were becoming an increasingly common feature of the American social landscape. As it is for the narrator of Edgar Allan Poe's story "The Man of the Crowd," unriddling the city, turning the gas lamp's "fitful and garish lustre" on its corners, could be a vocation. The dandy, Albert Camus later said, "can only be sure of his own existence by finding it in the expression of others' faces."[126]

The literary scholar R. H. Byer believes that "what might be described as [a] wish to 'naturalize' the city guided the imaginative strategies of writers in their encounters with its perplexing and threatening, if fascinating, spectacle."[127] True for some, no doubt, but Woodville, though an invested observer, was not terribly interested in cleaning up the mess. His pictures of the urban scene do not impose harmony on the city where it did not exist. His paintings, rather, remain faithful to the perplexities and subterfuges of his American city.

CHAPTER TWO

◇

Homing Devices

WHEN WOODVILLE LEFT for Europe, just after his debut at the National Academy of Design, his family believed he was heading for Italy to tour with other American aristocratic artists. Instead, in a typically capricious move, Woodville redirected himself to Düsseldorf, a destination that, though surprising to his family, was an important one to American artists. From Düsseldorf, he sent to the American Art-Union those pictures that secured his reputation as one of this country's most astute genre painters. Though he learned from German masters and tuned into European fashions, Woodville's subjects remained the interior dramas and social rituals of America's lower and middle classes. Like so many other artists, Woodville gained a better perspective on his country from abroad. In Düsseldorf he sharpened both his technique and his sense of what was and was not peculiar to America. Even more ironic, at the moment that Woodville absented himself from the American art scene, it lauded him as a faithful parochialist. Out of sight, in his case, did not mean out of mind.

Almost twenty years after Woodville moved to Europe, Charles Baudelaire described this fracturing of the self as a condition intrinsic to the new order and especially typical among his peers. "To be away from home," Baudelaire mused, "and yet to feel oneself everywhere at home; to see the world, to be at the centre of the world, and yet to remain hidden from the world."[1]

So it went for the painter of modern life.

Opposite] Detail of fig. 47

Fig. 30]

Andreas Achenbach
(GERMAN, 1815–1910),
The Old Academy in Düsseldorf,
1831. Oil on canvas,
25 ¼ x 32 in. (64 x 81 cm).
Museum Kunst Palast, Düsseldorf

Three years after Woodville arrived in Düsseldorf the social revolutions of 1848 swept through Europe, resulting in a brief victory for liberalism. Even before the barricade engagements the conflict between Prussian conservatives and radicals had been building in the region's cultural institutions, including the famed Düsseldorf Academy (fig. 30).[2] Regarding the curriculum, however, everything still appeared in order. During the first half

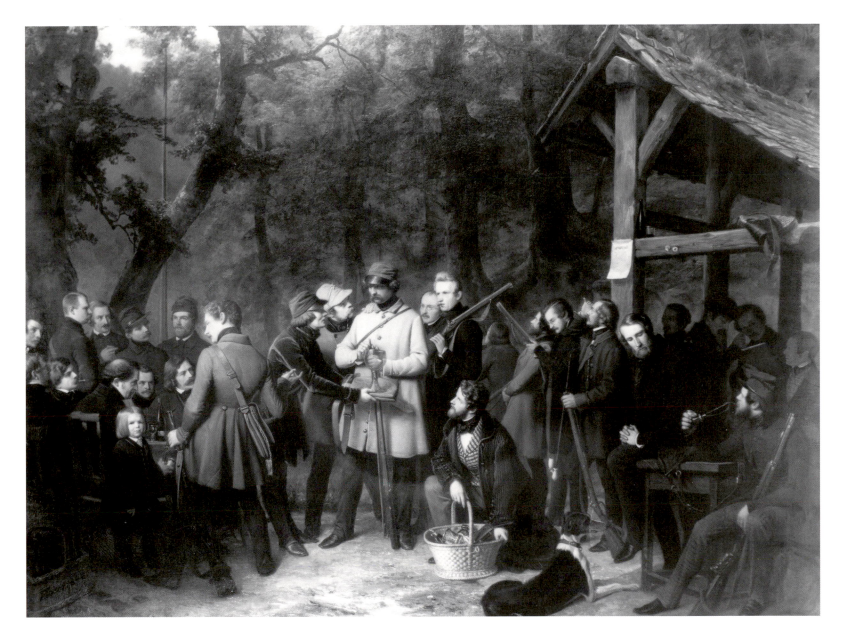

Fig. 31]
Carl Friedrich Lessing
(GERMAN, 1808–1880)
and Friedrich Boser
(GERMAN, 1809–1881),
Group of Düsseldorf Artists, 1844.
Oil on canvas, 31 ⅞ x 41 ¼ in.
(81 x 104.8 cm).
The New-York Historical
Society, S-92

of the nineteenth century the Düsseldorf Academy was the most prestigious art school in Germany; artists respected the curriculum, critics admired the artists, and the church, the nobility, and the middle class all responded by patronizing academy members, who were a diverse, international group of painters (fig. 31).[3]

Though Woodville enrolled at the academy for only one year, he lived and studied in Düsseldorf for six years, from 1845 until 1851. The *Literary World* published a description of Düsseldorf in 1852 that paints a pretty picture of a quiet city of thirty thousand inhabitants, a place that must have seemed worlds away from the frantic Mobtown:

The streets are clean and moderately wide; the houses elegant . . . a character of newness, of recent construction, an absence of effort directed toward the attainment of durability, are perceptible, and indicate a bias towards a cheerful and somewhat frivolous mode of life. The city, open at all points . . . loses itself almost insensibly in its delightful and gracefully laid out promenades. On the right side of the Rhine, somewhat more than half a mile from the city, rise the Grafenbergen with their shady woods; a favorite resort of the Düsseldorf artists for the purpose of exercise or study. . . . The Düsseldorf artists are not backward in appropriating the treasures spread before their view. Particularly in the Autumn, little caravans of them cover the roads along the Rhine. While the genre painter delights in the gay and lively pursuits of the day, the landscape painter turns . . . away from the cultivated and modernized highway.[4]

The reputation of the Düsseldorf Academy reached its apex between 1826 and 1860. The "fervent and austere" Peter von Cornelius became director of the academy in 1819 and implemented the curriculum that Woodville found in place upon his arrival.[5] Cornelius was a Nazarene, one of a group of German and Austrian Catholics who had come together in Vienna in 1810 and turned to the Bible, Germany's Middle Ages, and the Italian Quattrocento for inspiration. The Nazarenes rejected the rigid studio practices prevalent in European academies, favoring instead a more communal association between master and pupil. At the same time, they endorsed rigorous training and preferred meticulous techniques. Cornelius said that there was to be no "choking and intimidation of the spirit": all students would keep their "natural, unaffected, freely developed peculiarity and independence." But William Morris Hunt, who briefly attended the academy before going to Paris to study with Thomas Couture, chose not to stay because he opposed "the principle that the education of art genius, of a mechanic and of a student of science were one and the same thing—a grinding, methodical process for the accumulating of a required skill."[6]

By the time Friedrich Wilhelm von Schadow took over the academy in 1826 a tripartite curriculum was in place. Students took courses in elementary drawing, geometry, and perspective before proceeding to drawing from antique models. Finally, they advanced to painting under the close tutelage of a master. Schadow was a stern and expert administrator of the curriculum. Whereas Cornelius had preferred older mediums, such as fresco painting, Schadow favored easel painting, a medium more in line with his belief that "the ideal subject should be imbued with palpable life, and that its representation would remain an incomplete work of art without the basis of natural reality."[7] In 1850 the *Bulletin of the American Art-Union* ran the following account of the academy's program:

The chief characteristic of the Düsseldorf school . . . is the strict attention paid to the elementary principles of painting, and more particularly drawing. . . . After having

acquired a certain degree of familiarity with the crayon, the student prepares several drawings of plaster casts, carefully finished and modelled, which are presented for the inspection of a committee. . . . The ordeal here is a very severe one, and but few candidates are admitted on the first application [to the Antique School]. . . . Accuracy of outline, and perfect acquaintance with the modelling of the object, are all-important—and the judges to whose criticism these drawings are submitted, are those who have passed through the same trials themselves. . . . To a person unaccustomed to such scrupulous care, this apparently exaggerated caution becomes almost ridiculous; but it is only by such assiduous attention to the "finesses" of drawing that one is enabled to arrive at a just appreciation of the whole.[8]

Pedagogically and ideologically, Schadow sympathized with the ideals of "aristocratic and autocratic" Prussia.[9] He contributed to the academy an emphasis on religious and allegorical painting and established the *Meisterklasse*, a course in which gifted students worked directly with the school's master artist, Schadow himself. The singular Düsseldorf style—characterized by expert draftsmanship, precise linearity, and, in the case of painting, a high degree of polish and finish—emerged from his strict curriculum. In 1847 Henry Tuckerman reinforced the reputation of the Düsseldorf Academy as a conservative school best known for its emphasis on rote learning. "For the beginner in the arts," he wrote, "Düsseldorf is probably one of the best schools in existence and has educated an uncommon number of distinguished men."[10]

Interior View of the Dusseldorf Gallery.

Consequently, a number of important American artists attended the academy, and it became the primary destination for ambitious painters from America. Arriving in Düsseldorf in 1841, Emanuel Leutze was one of the first American painters to study there. His success, which came even before the American debut of *Washington Crossing the Delaware* in 1851, attracted other American painters to the school, including Worthington Whittredge and Eastman Johnson, both of whom arrived in 1849. Once there, Whittredge, for one, found "the professors of the Academy in Düsseldorf among the most liberal-minded artists . . . ever met, extolling English, French, Belgian, Norwegian and Russian art."[11]

In 1849 the Prussian consul to the United States, John G. Boker, opened the Düsseldorf Gallery in New York to show works by academy members (fig. 32). Audiences lauded the gallery and saw it as a showcase for the great new tradition in American art. Because the American Art-Union also exhibited so many works by American artists working in Düsseldorf, it profited from the gallery's success as well. "It is one of the most gratifying and instructive collections that has ever been seen in the United States," a reviewer wrote in the

Fig. 32]
Interior View of the Düsseldorf Gallery.
Wood engraving by Nathaniel Orr, in *Cosmopolitan Art Journal* 2 (Dec. 1857): 57. The Metropolitan Museum of Art, New York, The Thomas J. Watson Library

Art-Union's *Bulletin*. "It is full of the evidence of that indefatigable and minute study of Form which characterizes the German schools. . . . Results such as these show the advantage of this severe discipline . . . the decision in handling the freedom of outline, the firmness and accuracy of touch . . . give a completeness and unity to the expression of thought on canvas."[12] This author, like many others, overlooked the political circumstances that led to the gallery's establishment: part of Boker's intention was to protect the paintings from revolutionaries.[13]

The technical proficiency of the Düsseldorf works dazzled Art-Union officers and the American public. The German school, epitomized by the Düsseldorf Academy, complemented the preference in the United States for literal and anecdotal pictures. The promise of advanced training in technique, which artists and critics agreed was missing at home, attracted American artists to the academy. At the same time, the city of Düsseldorf offered all the "middle-class, middle-sized sobriety of an American small town."[14]

Woodville and the Düsseldorf Academy should have been a perfect match. Before his arrival, Woodville had been working on his draftsmanship and favored the meticulous observational style that the academy stressed. But in typical fashion, Woodville quit the authoritarian academy after one year, though he maintained a close association with its members and became a private pupil of one of its teachers, Carl Ferdinand Sohn. One author says that Woodville "was one of [Sohn's] best students, especially for his color and handling."[15] When the American artist Benjamin Champney toured the Rhine area in 1847, he noticed a "young American painter, named Woodville, studying there . . . who showed much ability. He was slow and patient, but his little paintings were full of exquisite color, and he always painted some subject characteristic of American life, which young art students are not apt to do."[16]

Sohn, who had studied at the Berlin Academy with Schadow in 1823, moved with him to Düsseldorf in 1826. Once settled at the academy, Sohn painted portraits of local citizens and, along with the academy members Carl Friedrich Lessing and Ferdinand Theodor Hildebrandt, fabulous scenes inspired by Renaissance literature. This tendency surely appealed to Woodville's own romantic leanings, evidenced in the two versions of his period piece *Bringing in the Boar's Head* (figs. 21 and 22). The academy taught four popular modes of painting: history painting, landscape painting, "romantic-poetic" painting, and genre painting. However, Schadow, a Prussian conservative, held genre in low regard; he saw it as a profane mode linked to revolutionary ideals.[17]

Nevertheless, a number of artists associated with the academy painted genre scenes. For the most part, these Rhinelanders made paintings that were more topical than those favored by Schadow's group. Professors like Johann Peter Hasenclever and Adolf Schrödter, both of whom painted peasant and drinking scenes in the Dutch tradition, certainly influenced Woodville. Their pictures reveled in regional customs and a free-spirited social carousing that caricatured Prussian priggishness. Hasenclever's *Scene in the Atelier* (fig. 33) was a direct challenge to the rigid pedagogy at the academy. This satire shows Hasenclever with a group of fellow students flouting academic practices: one of the figures poses as a classical statue even as he

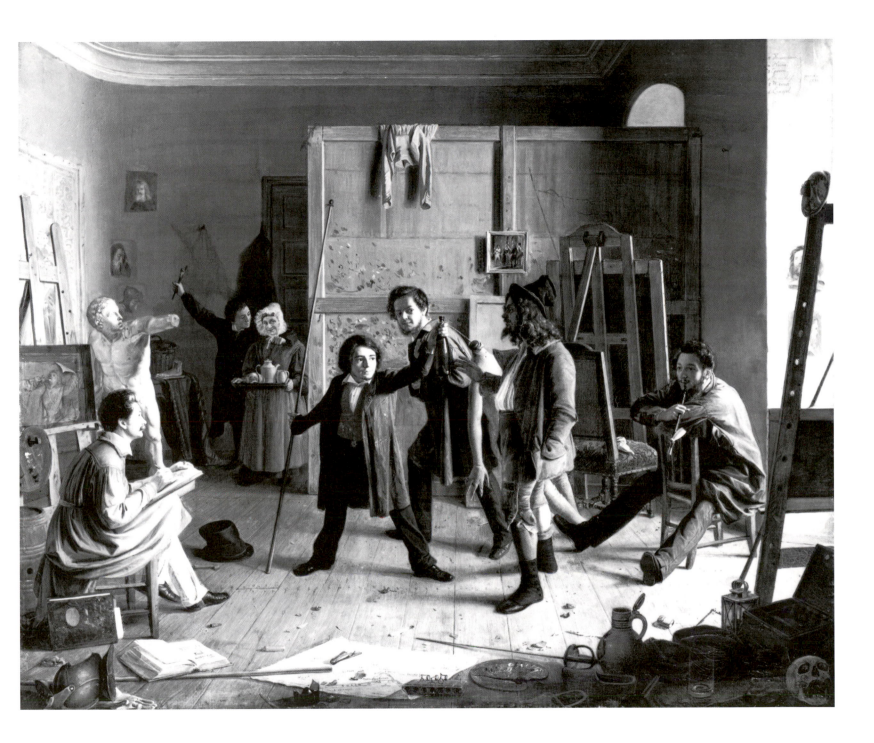

Fig. 33] Johann Peter Hasenclever (GERMAN, 1810–1853), *Scene in the Atelier*, 1836.
Oil on canvas, 28 ⅓ x 43 ⅔ in. (72 x 88 cm). Museum Kunst Palast, Düsseldorf

offers a bottle of liquor to a dissolute comrade. Though a tongue-in-cheek theatricality and irreverent humor characterized the Düsseldorf genre style, it could be pointed and radical. Hasenclever, for instance, was a "militant" member of the "radical left" who sympathized with German workers and who knew Karl Marx.[18] In 1853 Marx wrote a letter to the editor of the *New-York Daily Tribune* praising Hasenclever's painting *Workers Confronting the Magistrature* (1850; Museum Kunst Palast, Düsseldorf), which depicts events from the October uprising in Düsseldorf and was on view at New York's Crystal Palace Exhibition.[19] Other Düsseldorf painters, such as Karl Wilhelm Hübner, supported the proletariats and protested against inequities perpetuated under the imperialistic Prussian regime, which upset both Schadow and Prussian authorities. In addition to making individual statements, these artists, many of them genre painters, banded together to form protest clubs and associations. One, the Malkasten (Paint Box), was a progressive organization that included academy students and became the "final expression of liberal anti-Prussian currents."[20] The Malkasten "accepted artists of every stamp analogous to the 'peaceful coexistence' of all the colours" in a box of paints, thus inaugurating the concept of the 'Rainbow Coalition.'"[21] Hasenclever, Lessing, Leutze, Schrödter, and many others belonged to the group, which met in a local tavern.

It is difficult to gauge precisely how American artists responded to the political discourses in Düsseldorf. The revolution in Germany, though repressed by Frederick William IV in October 1848, was felt in the United States. Americans knew that the bourgeoisie participated in the struggle in Germany and that it was part of a larger, pan-European affair not unrelated to their own independence movement.[22] Americans also witnessed the arrival on their shores of exiled "Forty-eighters," liberal German intellectuals who had actually started coming to the United States several years before the revolution that began in March 1848.[23]

Leutze, a radical political creature, certainly had some influence over his comrades. In 1843 he joined the Malkasten and withdrew from the Düsseldorf Academy to protest a program that he believed was allied with aristocratic rule, a "dissociation" that "was interpreted as part of the rising democratic struggle." Leutze, a "brash and confident product of the New Order"—a Democrat through and through—was a "harbinger of change." In 1845, two years after he left the academy, Leutze was elected president of the Union of Düsseldorf Artists, a liberal organization that offered artists in the city an alternative to the strict academy. Though he enjoyed great popularity in the United States, Leutze remained in his native country, most likely in order to participate in the revolutionary fervor and democratic reforms that reached their zenith in 1848. He wanted to see Germany "follow a democratic course to nationhood," an agenda he vigorously promoted in his paintings of American history, some of which he exhibited in Düsseldorf for years before sending them to the United States.[24] Furthermore, when Leutze returned to New York in 1851, he organized celebrations and fundraisers for Louis Kossuth, the hero of the 1848 revolution in Hungary.

Above all, however, the Düsseldorf Academy was a professional school. American artists, Whigs and Democrats alike, attended the school to become better painters, to absorb

the "procedures and precepts" of a strict academy; not to engage in radicalism.[25] "The lives of the students in Düsseldorf," one historian writes, "were predicated upon their 'American-ness,' as it were, not upon the divided loyalties that preoccupied Leutze. As transients they were isolated from the community and its problem. . . . Nor were the Americans concerned about the political circumstances of greater Germany."[26] Some American artists, Leutze most prominent among them, were political, but we cannot assume that Woodville was an unequiv-ocal supporter of the revolution. As far as the historical record is concerned, Woodville, unfortunately, did not make a single political statement—besides his paintings, of course. Albert Boime, writing about Hasenclever, makes an eloquent case for genre as a mode appro-priate for political activism. It could be a "dynamic social category, . . . as much a social and political statement as a cultural artifact"; it could move beyond the "static expression of bour-geois condescension towards the rural and labouring classes, or, in its more liberal manifesta-tion, as self-parody."[27] Though Woodville's paintings exhibit a sympathy for liberalism and observe moments of social subversion, we cannot call them radical in a political sense. While abroad, Woodville found a community that gave him professional support and a good dose of radical excitement, but his expatriatism was not, or not explicitly at least, a political stratagem.

◇

Shortly after his arrival in Düsseldorf, Woodville made a drawing of six figures playing cards (fig. 34). The nostalgic aspects of the drawing—the men, dressed in seventeenth-century costume, are arranged in a northern European interior with latticed windows—confirms his affinity for the kind of romantic historicizing typical of the academy's conservative members. Yet this amusing image of carousing laymen displays a mischievousness more in keeping with the academy's Rhinelanders. Woodville would return to the quixotic past to treat heroism and romance, but not before conjuring current kinds of low ceremony like card playing.

The first painting Woodville made in Düsseldorf, and the painting that set the tone for the rest of his career, was *The Card Players*, completed in 1846 but not exhibited in the United States until the following year (fig. 35). The outward plot, anyway, does not leave much to chance. Two men seated at a table in a railroad or stagecoach waiting room square off in a game of cards. The man standing over them smokes a pipe and referees the game, though his impartiality is in question. The younger cardplayer, a dandified but sinister loafer likely in cahoots with the referee, has tucked a card under his left thigh. Meanwhile, he plays it cool, calmly and hypnotically stirring his hot toddy. The older player falls prey to his adversary. Perhaps he suspects something, but even if he does, his suspicion comes off as naiveté. His hesitancy, we suppose, comes a little late. In fairness to the old man, though, he may be the sharp here, making cunning use of the mirror behind the shoulder of his young opponent.

Fig. 34]
Richard Caton Woodville,
Group with Men Playing Cards,
c. 1845. Pencil on paper,
8 ⅛ x 7 ⅝ in. (20.6 x 19.3 cm).
Collection of Stiles T. Colwill,
Maryland

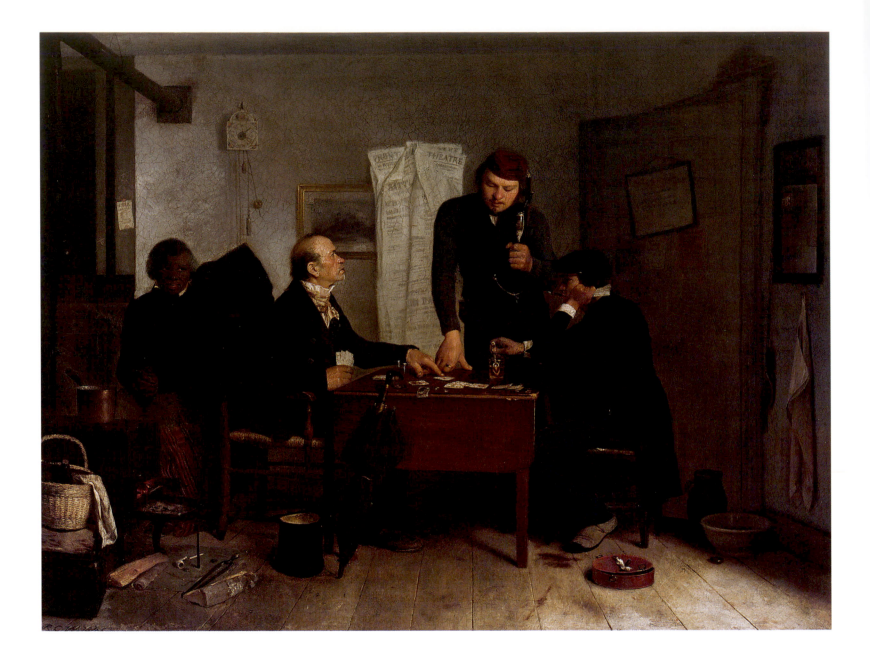

Fig. 35] Richard Caton Woodville, *The Card Players*, 1846.
Oil on canvas, 18 ½ x 25 in. (47 x 63.5 cm).
The Detroit Institute of Arts. Gift of Dexter M. Ferry Jr.

The bent decor and dirty surfaces of this cramped room contribute as much to its polluted atmosphere as does the illicit activity of its occupants. Though the interaction between the figures generates much of the drama, Woodville writes an equally compelling narrative on the wall behind them, where placards, posters, and advertisements weave together a text that speaks to the commercial culture in which they live. A preparatory drawing (c. 1846; Walters Art Museum, Baltimore) for *The Card Players* portrays an even more cluttered interior. In the drawing, Woodville clearly describes a squat barrel, the word *rye* written across its belly, and all kinds of printed matter pinned to the walls—leaflets; small portraits; an advertisement for the Baltimore-to-Washington coach; a reward poster; a banner announcing fifty-cent box seats at Baltimore's famous Front Street Theatre; and a pennant promoting the Canton Course, the east Baltimore racetrack where on 4 May 1840 Whigs terminated a boisterous parade celebrating their national convention. Woodville reduced both the amount and the legibility of the printed ephemera in the painting, but there are enough diversions—a piping-hot stove, dirt and debris on the floor, a swinging pendulum—to distract the players. In fact, despite Woodville's literal style, it requires some crafty skill on our part to concentrate on the painting's main tableau in this smoky, suffocating room. Woodville managed to infuse this painting with a fogginess that surprises us, given his fine technique and deliberate reporting. Besides some expertise as a draftsman, it seems that Woodville learned the art of dissemblance during his first year in Düsseldorf.

William Woodville, the artist's father, must have had a change of heart regarding his son's profession, because it was with his help that *The Card Players* became such a success at home. In 1847 Woodville sent the painting to his father in Baltimore, where it was exhibited briefly before being forwarded to Philadelphia for another exhibition.[28] On 22 July 1847 William, encouraged by the reception of the painting, assumed the role of agent for his son and contacted the Boston Athenaeum. "At the suggestion of my friend, Mr. H. G. Rice of Baltimore, and of Mr. Greenough," he wrote, "I have taken the liberty of forwarding to you a picture [by] my son, for exhibition at the Athenaeum at Boston. . . . He has adopted painting as a profession, it is important to him that he be brought before the public as much as possible. I expect another picture from him very shortly, and I should be glad to have a similar facility of placing it in the Athenaeum." The Athenaeum's reply is lost, but William wrote again on 3 October. "I had the pleasure of receiving your favor of 31 July," he responded, "and was exceedingly gratified at the favorable opinion you express of my son's picture. I have been under an expectation that the Baltimore Athenaeum would purchase this painting, but I find that the Association are so cramped for funds . . . that I shall not make an offer to them—on its arrival here, there was an indirect offer made to me through Genl I. S. Smith, their secretary, of $200 . . . but wishing to make my son professionally known, by exhibiting his picture, I declined it. That object now accomplished, I should be glad to sell it for him."[29]

Though William objected to his son's career, in the end he represented him with a cunning comparable to that of the cardplayers themselves. He pushed for a sale and skillfully

managed the painting's travel and exhibition schedule. William's refusal to sell the picture right away, presumably to keep it from an obscure and dingy parlor, and his publicizing of "indirect offers" eventually paid off.

On 26 October he sent the painting to the American Art-Union along with some correspondence. "I have the pleasure to send you the enclosed introduction from Mr. Waters," William wrote. "As you will perceive, it refers to a picture by my son, who is a student at the Academy of Design in Düsseldorf, Germany. As he pursues the art as a profession, I am anxious to make him known as an artist—and I should be exceedingly obliged by your giving this picture a favorable place at your exhibition. The painting is for sale, and I ask $200 for it, and you would oblige me, if an offer should be made, by informing me of it." The Art-Union purchased the painting immediately, and William responded to express his gratitude and to relay some missing information: "His name," he reported, "is Richard Caton Woodville."[30]

Fig. 36]
Charles Kennedy Burt (AMERICAN, 1823–1892), after Richard Caton Woodville, *The Card Players*, 1850. Etching and engraving printed by J. Dalton, published by the American Art-Union, New York, sheet 14 ½ x 18 ½ in. (36.7 x 47 cm). Davison Art Center, Wesleyan University, Middletown, Connecticut. Friends of the Davison Art Center funds donated by John E. Andrus III (B.A. Wesleyan 1933), 1994

With the help of the Art-Union, *The Card Players* was an unqualified success for Woodville. The organization exhibited the painting and published an engraving (fig. 36) of it to distribute to members; moreover, the *Bulletin of the American Art-Union* made close to a dozen references to the painting from 1847 to 1852. In one lengthy editorial on Woodville's work that appeared in May 1849, the *Bulletin* described *The Card Players* as one of the artist's most "pleasing" works. One year later, in an article on the Düsseldorf Academy, another *Bulletin* author wrote, "The systematic cultivation of [Woodville's] talent, which has been before under less careful discipline, has proved of the most essential service to him, and there is no doubt that with moderate application and perseverance, he is destined to occupy a very high place in the list of American painters."[31] We can deduce some idea of the painting's popularity from a brief note that appeared in the *Literary World* in 1850. *The Card Players*, the author wrote, "numbers its admirers by thousands. All frequenters of the gallery have been familiar with it."[32]

When Woodville left the United States, he had only a modest reputation, but he managed to secure some renown within the country's most powerful art organization in a very short time. His dislocation from his subjects and his venues did not impede his career. Thanks to his father's acumen, the reputation of the Düsseldorf Academy, and the Art-Union's advocacy of genre painting, Woodville became known, for a brief moment at least, as one of the country's most talented genre painters.

Woodville also benefited from the American public's paradoxical belief that the best training was available in Germany, while the most delightful subjects were native ones. Such

convictions coexisted because of the peculiarities of the new economy's cultural marketplace. Antebellum capitalism distanced cultural producers from cultural consumers, just as it forced a wedge between the hard facts of material manufacture and the fluid mechanisms of the retail industry. The 1840s, Sean Wilentz has demonstrated, were not years when the notion of "labor" was easily consumed by the "Christian morality of discipline, industriousness, and charity." On the contrary, beneath the period's "broader terms of social conflict, of 'producer' versus 'nonproducer,'" lay unfeigned radicalism and protest.[33] The divisions of the marketplace were evident to a great many people, workers and intellectuals alike. Woodville, for one, could only guess at how New Yorkers would interpret and market his paintings and at the meanings the paintings would assume and those it would cast off. *The Card Players* is sure-handed, made with precision and confidence. Yet the Art-Union, not Woodville, assumed responsibility for contriving a meaning for it.

William's deft correspondence on his son's behalf and the fact that the painting traveled so fast and so far—admirers sent it with apparent ease between Germany, Baltimore, Philadelphia, Boston, and New York—testify to its life within an aggressive marketplace. This market made painting, like literature, an article of commerce and nudged it along, with improvements in manufacture, distribution, and promotion. Like other commodities, paintings and novels drifted from their makers into the torrent of the marketplace.[34] Of interest to cultural historians is not just this particular aspect of capitalism but that antebellum painters and writers were aware of it and treated it explicitly as well as implicitly in their work.[35] Melville, for instance, "suggests that the prohibition against freely speaking the truth requires the artist to withdraw or efface himself from what he writes."[36] In "Hawthorne and His Mosses," Melville wrote, "All excellent books were foundlings, without father and mother, that so it might be, we could glorify them, without including their ostensible author. . . . For in this world of lies truth is forced to fly like a scared white doe in the woodlands; and only by cunning glimpses will she reveal herself."[37]

Melville commented on the cultural marketplace perhaps more than any other figure of the period. *Moby-Dick*, we have been told, mirrors the complex relations between production, commercial infrastructure, and consumption. The book is "an exuberant paean to labor," Paul Royster writes, "an elaborate celebration of the human energy and industry of nineteenth-century America." Yet it "converts to metaphor" this "particular set of economic relations."[38] The obtuseness of literary language, Melville figured, was perfectly suited to exposing the business of his time. Though many authors and painters engaged certain features of the market for which they labored, they did not always condemn it. Though *Walden* and "Bartleby, the Scrivener" protest some of the insidious effects of the Great Transformation, Thoreau and Melville were ambitious authors who wanted their works to sell as many copies as possible. As usual, Thoreau got right to the meat of the matter. "The whole duty of life," he wrote in his journal in 1841, "is contained in the question how to respire and aspire both at once."[39] In other words, how might one observe society from the outside and then

have those observations circulate within society? It remains a conundrum, and Woodville, just like the more illustrious authors of the time, equivocated over his answer.

Marketwise, *The Card Players* was a success: it made money for Woodville and attracted new members to the Art-Union. Later, Thomas Foster, of Utica, New York, won it at the organization's annual lottery; he then sold it to William J. Hoppin, an Art-Union officer. Everyone profited, and the shipping of the painting from one admirer to another became yet another instance of the Art-Union's living up to its promise to rescue art from the dingy galleries. Even though the Art-Union professed that "president-making and money getting stir up all that is bitter, sectional or personal in us," that the country needs "some interests that are larger than purse or party, on which men cannot take sides," and that "such an interest is Art," it participated wholeheartedly in the new commercial culture.[40] Neil Harris locates the organization within a "popularizing-phase" of urban culture and links it to enterprises such as P. T. Barnum's American Museum and new urban libraries, hotels, and theaters. Though they did not profit directly from the buying and selling of art, Art-Union officers did trade in cultural authority as if it were a currency and profited from their roles as arbiters of taste.[41]

Oddly, even though it was thrust in the middle of this economic carnival and viewed by "thousands," not a single review of *The Card Players* addressed what the painting meant or tried to determine why its subject resonated with audiences. The theme was common enough, to be sure; audiences recognized these sharps from any number of pictures by the prominent genre painters of the day. But even if admirers had lively discussions about the painting, no one analyzed what was happening in it, at least not in print.

Gambling had been a popular and even honorable pursuit during the first third of the nineteenth century. In southern cities especially—Norfolk, Richmond, and Baltimore, for instance—men and women of all classes enjoyed horse racing, cockfights, cards, and other games of chance. Wagering was popular enough by 1804 for a Baltimore critic to attribute lackluster support for a city benefit to the "gaming and dissipation . . . so prominent among the fashionable class of our citizens." And a committee appointed to study gaming in Richmond in 1833 noted that at any gambling house you could find "legislators—even it has been said, the administrators of justice—the fashionable, the honorable, the educated: and they talk over the next day, their various fortunes at the faro table, with a businesslike sobriety, or a fashionable nonchalance."[42] City taverns along the Eastern Seaboard designated certain rooms for various games, and there respectable citizens and riffraff came together to gamble.

Around midcentury, however, wealthier citizens of cities like Baltimore grew wary of public displays of gambling and withdrew to their private parlors. During the 1830s and 1840s rougher crowds infiltrated gaming events and scared away the upper classes. Professional gamblers, confidence men, and career criminals arrived in the rooms, set up their own tables, and on occasion assaulted or murdered one another. This once genteel pastime soon

became another symbol of the depravity and social disintegration that stained the reputation of cities during the two decades before the Civil War.

"Members of the elite withdrew when they could no longer maintain . . . control," Patricia Click explains, and once they retreated, gambling lost the shield of legitimacy that they had lent it. At this moment the sharp emerged as a popular type of urban degenerate.[43] Papers like the *Baltimore Sun* and the *New York Mirror*, the same papers that reviewed or advertised Woodville's paintings, were alarmed by gaming and published sensationalized stories about gambling crimes. New York reporters, according to Ann Fabian, identified "skinning houses" and "a whole new set of urban figures known as 'ropers' and 'steerers' who earned their keep by charming foolish young men and luring them into gambling halls. . . . The gambling dens were described in rather formulaic fashion as 'small, dimly lit and meanly furnished' resorts of smalltime thieves and randomly idle men and women, black and white."[44]

In her book on genre painting, Elizabeth Johns also identifies several of the character types that emerged during the period. Genre painters, she maintains, were chiefly concerned with reifying these types, which included, among others, the Yankee, the yeoman, the country bumpkin, the free African American, and the sharp. The adversarial and combative political system that emerged in the United States during the antebellum years, the argument goes, induced citizens to a compulsive kind of labeling. Categorizing others has always been one way of getting a clearer sense of one's place in the body politic. In this large project, Johns astutely points out, Woodville's particular talent was for describing "city dandies," "traveling card sharps," and criminal types. His "scheming, nattily dressed types . . . were vastly different from Mount's and Edmonds's farmer-yeomen, and they showed none of the healthy openness and wilderness skills of [Charles] Deas's, [William] Ranney's, and Bingham's westward-roving trappers, rivermen, and sovereigns." Indeed, Woodville's settings and characters are exceptional. His spaces, more than those of his peers, are "confining, dark, and cluttered" and "registered the transitions both literal and psychological of a changing populace." The interior of *The Card Players*, Johns writes, is a "room in which tilted schedules and notices suggest a crooked moral atmosphere. . . . The issues in this citizenry are economic disorder and deceit."

Though New York audiences understood Woodville's picture as an "indictment of urban citizens," perhaps he meant to reproach another group entirely.[45] Woodville, one presumes, would not have been content with painting a typical portrait of typical gamblers. He surely noticed that gambling had become a convenient symbol of the new economy. Perhaps, from a safe distance, he meant to make a picture that addressed those attributes of the economy that promoted fraud, deceit, and financial instability rather than one that merely caricatured urban types. Because of Woodville's reluctance to comment on his own pictures, we cannot say for sure that this was his intention, but other figures of the period drew easy connections between gamblers and capitalists. The mercenary motives and tactics of Woodville's

cardplayers were certainly linked to a common distaste for what Henry Brevoort, an early patron of Mount's, called "the morals of businessmen and lawyers, and the manners . . . of commercial families, [which are] degenerate and corrupt to the very core."[46]

In 1845 George Lippard, a working-class advocate, reiterated this summation of capitalist enterprise in his novel *The Quaker City*, which describes urban centers as full of "deceits and confidences" and "Pretenders" peddling "moonshine."[47] Melville, of course, took aim more specifically at Wall Street. It was the place that caused Bartleby's death, and in the ironic words of one passenger aboard the steamship in *The Confidence-Man*, it was full of "growling" men who promised a "New Jerusalem" over yonder and who practiced the "wicked art of manufacturing depressions" and "black panics."[48]

We must determine here, it seems to me, whether the figures in *The Card Players* are transient gamblers or regular habitués of the waiting room. According to the lore of the period, the migratory practices of the confidence man and the sharp magnified their danger. The criminal on the move posed more of a threat than the stationary felon. In victimizing unwary citizens of northern cities, the sharp often employed the charms of a southern gentleman. One notorious gambler, for instance, the Virginian Robert Bailey, succeeded by playing "with the trappings of authority still holding sway among the slaveholders of the south."[49] And the "master charlatan" in *The Quaker City*, Algernon Fitz-Cowles, is an "eternally shape-shifting 'prince of swindlers' who variously appears as a businessman selling stock in a phony mining company, as a Southern plantation owner, and in countless other disguises." The trickster, not coincidentally, haunted riverboats and waiting rooms, places where he could ply his trade and then move on.[50]

The two young sharps in *The Card Players*, however, stay put; they appear to be regular denizens of the waiting room who would set traps for cash-laden travelers. Though we have to leave the comings and goings of the four figures in the painting to some conjecture, the most likely scenario is that the older man, who has hung his coat on the chair and set aside his umbrella and top hat, is in transit. The African American figure, who is his servant or slave, sits obediently in the background, observing the game and tending to the man's carpetbag, which rests at his feet. On the wall above the travelers hangs the clock that will tell them when it is time to leave. In the preparatory drawing for the painting (Walters Art Museum), a poster on the door clearly advertises the Baltimore-to-Washington stage, probably the Safety Coach Phoenix Line, on which a one-way trip cost three dollars and took five hours.[51]

Woodville reverses the common formula for the swindle. Rather than depicting his sharps as itinerants—as cousins of the roaming Yankee peddler and door-to-door lightning-rod man—he shows them as office-bound merchants, nothing more, really, than incorporated purveyors of capital. These figures, Johns writes, set "out to dupe the other; they band together temporarily, remaining cohorts only so long as it helps their own interest."[52] Seen in this light, Woodville's painting addresses not so much a growing social pathology, what George G. Foster called the "ghostly farce" of fraud, as the routine mechanisms of enterprise

central to the new economy.[53] These gamblers differ little from most entrepreneurs in the antebellum marketplace; they behave, above all, like capitalists, the more aggressive of whom were frequently satirized by writers and the press. Poe had a special skill for lampooning Wall Street practices, which he often compared to gambling, and in his story "The Business Man" (1845) the main character pursues all kinds of absurd enterprises, including the "Assault and Battery business," "Mud Dabbling," and "Cat-Growing."[54] Though unwelcome in bank offices or judicial chambers, Woodville's characters, like all businessmen, hastily forge the deals and alliances needed to earn money.

Moreover, the cardplayers' game proves to be as exclusive as the marketplace, closed, we see, to women and blacks. The presence of the African American figure is a foil to the greed of the three main figures, his neutral expression and obedient posture in the recesses of the room signifying his inability to participate in the period's economy. But these clubhouse schemes are indistinguishable from most get-rich designs of the day. Nevertheless, the painting's viewers and critics, mostly middle- and upper-class members of the American Art-Union, never commented on the painting's implied satire of the sly and exclusive nature of capitalist economy. They saw the painting as an insouciant caricature of the antebellum go-aheader, something akin, for example, to Mount's painting *Raffling for the Goose*, in which a group of men compete playfully for the prize (fig. 37).

❖

After a brief detour to the more respectable and sentimental world of family unity in his painting *The Cavalier's Return* (fig. 47), Woodville looked once again at the posturing intrinsic to public life in the antebellum city. His *Politics in an Oyster House* shows two men—one young, bearded, and top-hatted; the other old, ruddy-cheeked, and balding—in a curtained booth at an oyster house (fig. 38). These subterranean dens, where all sorts of aficionados quaffed oysters and swilled spirits, appealed to all classes of people in New York and Baltimore. Oyster houses also popped up in the political dialogues of the day. One author, angry that the United States Senate had refused to let Senator Sumner of Massachusetts speak about repealing the Fugitive Slave Law, wrote, "If there is a man in Massachusetts who will uphold the negro drivers, and their meaner instruments who voted nay on the question, he ought to be condemned to be a waiter in a negro oyster cellar for the rest of his life."[55]

Fig. 37]
William Sidney Mount
(AMERICAN, 1807–1868),
Raffling for the Goose, 1837.
Oil on canvas,
17 x 23 ⅛ in. (43.2 x 58.8 cm).
The Metropolitan Museum
of Art, New York. Gift of
John D. Crimmins, 1897. (97.36)

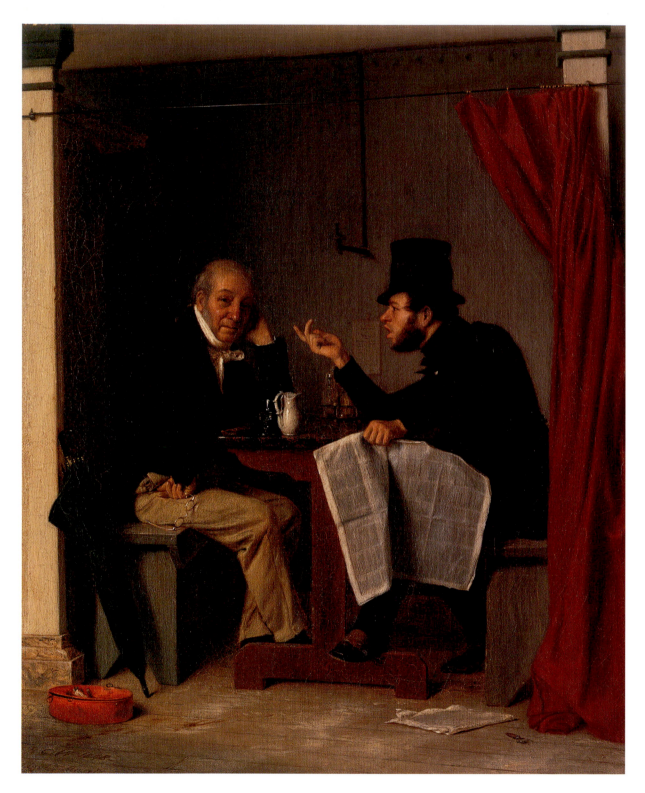

Fig. 38] Richard Caton Woodville, *Politics in an Oyster House*, 1848.
Oil on canvas, 16 x 13 in. (40.6 x 33 cm). The Walters Art Museum, Baltimore

According to Charles Dickens, who observed these parlors on his trip to the United States in 1842, oyster-house spectacles were not out of the ordinary: "Of all eaters of fish, or flesh, or fowl, in these latitudes, the swallowers of oysters are not gregarious; but subduing themselves, as it were, to the nature of what they work in, and copying the coyness of the thing they eat, do sit apart in curtained boxes, and consort by twos, not by two hundreds."[56]

Francis J. Grund, a German tourist who visited the United States in the 1830s, remembered his adventure in a New York oyster cellar:

> New traces of life appeared, until at last the brilliant facade of the theater, surrounded by a host of liquor-shops, eating-houses, and oyster-cellars, presented itself through the dark-green foliage with the magic light of an enchanted castle. . . . We entered, by descending six or seven steps into a capacious bar-room, furnished in very good style, and lit with gas as brilliantly as any saloon in London. This was a sort of reception hall, intended for those who "drank without stopping"; the real supper-rooms, with something like eighteen or twenty boxes to preserve the incognito of the visitors, being lodged in another part of the building. . . . The New York oyster-cellars remain open until three or four in the morning.[57]

The recessed booth was also a compositional device typically used by Düsseldorf artists. Many of the academicians participated in theatrical productions and employed similar stage boxes in their paintings. "The super-realism of the Düsseldorf style cannot be understood," one academy historian explains, "without study of contemporary stage properties. . . . The shallow foreground of the paintings where the action takes place is directly related to the uncluttered front of the stage where the theatrical *tableau vivant* was placed, a technique suggested by Tieck and realized by Immermann in Düsseldorf. This close connection with the stage produced a theatrical quality in Düsseldorf painting which clearly distinguished it from the style of Munich or Berlin and which did not prove to be to its advantage."[58]

In this case, however, Woodville was likely more concerned with describing an oyster house with some verisimilitude than with the customs of the academy. He knew what his audience wanted. Though Woodville sold *Politics in an Oyster House* to a private patron in Baltimore rather than to the American Art-Union, the painting made a brief appearance in the Art-Union galleries before arriving at the purchaser's home on 29 May 1848. Based on that exhibition and on a color lithograph made after the painting in 1851, the Art-Union's *Bulletin* said the picture possessed "much truth and character."[59] Several months later, a description and review of the painting appeared in the *Literary World*, and the lavish narrative of this supposed synopsis reveals to what degree audiences relished the storytelling aspects of genre painting:

Most of our readers are probably familiar with the . . . benevolent looking old gentlemen . . . depicted in [*The Card Players*], and will be glad to learn that we shrewdly suspect they may see him again under equally comfortable circumstances. His countenance shows him to be fond of good living, and it is not surprising that . . . he should partake himself to one of those subterranean temples devoted to the immolation of bivalves, served by Abyssinian priests in white robes . . . and vulgarly known as oyster cellars. Like a prudent man he has brought that old hooked-handled umbrella with him . . . [but] our old friend is not as choice as he might be in his company. You remember that hard looking youth he was playing cards with in the country, and here in the city he has fallen in with one of the same kidney. . . . They have evidently despatched earlier a dozen roast with exuberant trimmings, and the shells have been cleared away long ago, as you may infer from the old gentlemen's beer jug nearly empty and the segar stump which his contemporary has just discarded. . . . This companion looks as if he was fresh from Tammany Hall of the park in the heat of a presidential canvass . . . he clutches a newspaper in one hand, and with the other, the elbow resting on the table, is enforcing his arguments with impressive forefinger on the old gentleman, who, a little hard of hearing, and still harder of conviction, has his hand to his ear and listens with an incredulous smile. The orator is capital and thoroughly American, as is the entire scene, an oyster cellar being one of the most "sui generis" places which we possess, and which we are surprised has not been more frequently drawn by our humorous artists.[60]

The author liked this painting because he recognized its story and characters, which permitted him to expand on its narrative with bits and pieces from his own experiences in oyster cellars. What attracted the American Art-Union and other patrons to Woodville's paintings was how they seemed to reify their presumptions about the body politic, how they "embodied . . . the characteristics they blamed for commercial decay."[61]

When *Politics in an Oyster House* arrived in Baltimore in 1848, Woodville's father once again assumed the role of emissary and arranged for its delivery to John H. B. Latrobe, one of the city's most distinguished citizens. Latrobe, the son of the architect Benjamin Latrobe and a law student of the prominent colonizationist Robert Goodloe Harper, was, according to one historian, "without a doubt the most versatile Baltimorean of his day, and probably of all time." Latrobe was educated at West Point and became a leader in the local bar under Harper's tutelage; he also "displayed exceptional gifts as a poet, painter, writer, philanthropist, and inventor."[62] In 1832 he offered legal advice to Morse regarding a patent for the telegraph, and the following year he was one of three judges for the *Baltimore Saturday Visitor* who awarded a prize to Poe for his short story "A MS. Found in a Bottle." Latrobe also knew some of Woodville's acquaintances. With the Mayers, Latrobe helped establish the Maryland Historical Society in 1844.

In a letter dated 29 May 1848 Woodville's father humbled himself and his son before the benefactor. "The bearer of this note will deliver to you the picture Caton has painted for you," he wrote. "Caton desires me to say to you, that if you do not like it, you must not hesitate about returning it to me, and he will, with the greatest pleasure, paint another for you."[63] Latrobe exhibited the painting at the first annual exhibition of the Maryland Historical Society, in 1848, where it appeared beside two earlier Woodville paintings that are now lost.[64] In 1850 the French print firm Goupil, Vibert and Company (later Goupil and Company) produced a color lithograph of *Politics in an Oyster House*. The firm, which opened a gallery in New York in 1848 (fig. 39), competed aggressively with the Art-Union for a piece of the retail market in reproductions of popular paintings. It was Goupil and Company, for instance, that changed the name of Mount's famous painting from *The Force of Music* to *The Power of Music*, thus linking it to Wordsworth's poem of the same name. The firm also pushed Woodville's painting: just before Christmas in 1850 a full-page advertisement appeared in the *Literary World* promoting several lithographs after paintings by Mount and "*Politics in an Oyster-House*! A most exquisite representation of American politicians."[65] Though Woodville alternated between cynicism, sarcasm, and amusement in his painted descriptions of commercialism, he could not deny that his livelihood depended on it.

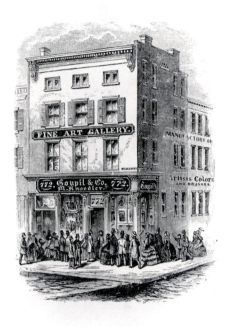

Two mysteries surround *Politics in an Oyster House*, whose resolution might reveal something of Woodville's attitude toward the business he was in. He was, to be sure, an enterprising artist who wished for a successful career. But how did he feel about the art market in New York, an industry plagued by quarrels and fiscal crises? Long after he completed his formal studies in Düsseldorf, Woodville stayed in Europe, even though moving to New York would have benefited his career. At home, Woodville might have forged professional relationships with individual patrons, many of whom would have paid more handsomely than the Art-Union. But Woodville stayed away, refusing to deal with the Art-Union directly; instead, he put faith in their goodwill and trusted his father to act as his agent.

Woodville stayed abroad, in part for personal reasons. For one, he clearly enjoyed Europe; during his ten years there he lived in Düsseldorf, Paris, and London. Also, after leaving his first wife, Mary Buckler, Woodville married a young art student from Düsseldorf named Antoinette Marie Schnitzler and had two children with her—Alice and Richard Caton Woodville Jr. Perhaps she refused to move to the United States, or maybe Woodville was too ashamed to return to Baltimore after his failed marriage.

Another possibility is that Woodville simply preferred not to participate in the marketing of his paintings. Although he owed his reputation to the tireless efforts of the American Art-Union on his behalf, the organization came under frequent attack by disgruntled artists who claimed that it did not treat them fairly. Almost from the moment the Art-Union opened, the penny press portrayed the Art-Union's managers as "privileged manipulators of the marketplace whose corrupt activities debased art and artists." Critics described Art-Union

Fig. 39]
Exterior of Goupil & Co.,
Fine Art Gallery, 772 Broadway,
c. 1860. Wood engraving by
Augustus Fay.
American Antiquarian Society,
Worcester, Massachusetts

officials as patricians who used their cultural influence as a means to corner a market, often at the expense of artists.[66]

By the late 1840s a group of New York artists led by John Kendrick Fisher, a painter of historical scenes, portraits, and copies of European masters, attempted to set up their own system of patronage and exhibition. According to Fisher, the Art-Union peddled in popular art—genre painting, for instance—for mercenary reasons alone. "Some artists," he wrote, "do not enjoy that vulgar popularity which is got by oyster fed criticism, Academy and Art-Union influence and patronage, and other means that true artists regard with aversion."[67] Fisher disapproved of the fact that moneyed businessmen pandered to Whitman's shoemakers, paving men, and canal boys. Whitman, meanwhile, admired the Art-Union and the aspiring connoisseurs who mingled in its galleries with "half-shut eyes bent sideways."[68] In the pages of the *New York Herald* other artists—such as Thomas Doughty, whose landscape paintings were falling out of favor by the late 1840s—denounced the Art-Union and urged painters to fight for independence from the controlling organization.[69]

Such quarreling was either distasteful or uninteresting to the reticent Woodville, who chose to send his paintings to New York and reap the rewards of their popularity from abroad. Nevertheless, he painted two variants of *Politics in an Oyster House* (one is lost; the other is in the collection of the Indianapolis Museum of Art), which implies that he could shrewdly manage his career and capitalize on prevailing tastes when he had the opportunity. In 1852 the Royal Academy in London exhibited a version of the painting with the variant title *A New York Communist Advancing an Argument*. That painting, now lost, was reproduced in the *Illustrated London News* accompanied by the following critique: "Amongst the foreign contributors we find Mr. R . C. Woodville, of Baltimore (U.S.), with a very spirited little piece. . . . The details of the picture are all appropriate and carefully finished. Altogether this is a pretty little piece of more than ordinary merit."[70]

Grubar was surprised by the new title and unsure how Woodville's "little piece" had assumed such a provocative message.[71] He apparently forgot that Woodville had returned to the United States late in the summer of 1851. We know nothing about Woodville's movements during the trip, but we can assume that he traveled home to Baltimore. There he would have had the opportunity to make a copy, or maybe even several, of *Politics in an Oyster House*. The painting was in Latrobe's possession at the time, and perhaps Woodville made a copy to send to the Royal Academy exhibition. Either Woodville or the curators could have chosen the alternate title, which linked the painting to political topics familiar to most Londoners. Just a few years before the exhibition, Karl Marx had published *The Communist Manifesto*; when the exhibition opened, Marx was living in London and working in the British Museum's famed reading room.

Regardless of Woodville's strategies for cashing in on his popularity, he would have been unable to influence how audiences responded to *Politics in an Oyster House*. Also, because the painting remained in a private collection, it received less exposure in the press

than his previous works. The painting, therefore, was left to speak for itself. Nevertheless, we can imagine how viewers reacted to the two politicians by examining typical attitudes about their conduct. It seems unlikely that audiences saw them as conscientious adversaries engaged in healthy democratic debate. According to popular opinion, their behavior and appearance indicated, rather, that they were undignified loafers or menacing political upstarts killing time with idle chatter.

Dickens's and Grund's descriptions of New York oyster cellars stress their role as low-life social clubs; Grund described them as late-night lodges for those who "drank without stopping." In *New York by Gas-Light*, George G. Foster's sketch of New York's underworld, the author describes those private rooms in oyster houses where "men and women enter promiscuously, eat, drink, and make merry and disturb the whole neighborhood with their obscene and disgusting revels, prolonged far beyond midnight" (fig. 40).[72] Writing in the *Colored American*, the Reverend Robert Turnbull, of Boston, issued another warning against the excesses of the oyster cellar. In an essay meant to guide "ardent, susceptible, and inexperienced" country bumpkins, Turnbull describes the "destructive labyrinths" of "the taverns, the oyster house, and houses of pleasure" that had supposedly ruined an acquaintance of his.[73] That the older man in Woodville's painting looks like a drunk would not have surprised these writers. A half-empty drink sits on the table in front of him, and he has a red, bulbous nose, flushed cheeks, and a dazed smile.

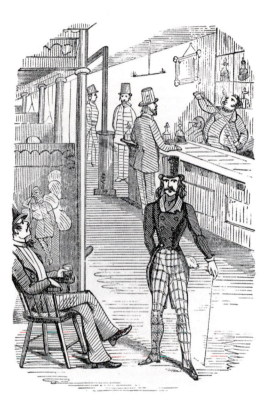

Reformers understood insobriety as a working-class affliction and a disease of the will. While the upper classes drank in the cozy privacy of their homes and respectable social clubs, activists blamed drunken laborers for social disintegration. "By focusing on the drinking question," Sean Wilentz writes, "masters found an alternative explanation for the journeymen's economic problems."[74] One temperance pamphleteer contended, for instance, that no one could "ascribe social evils to a bloody tyrant [or] an excess of population"; nor were explanations "to be fished out of the maze of political economy" or found "in the systems and complexities of commerce."[75] According to such arguments, intemperance and rowdiness resulted from personal decisions. Opinions like these were common during the years when Woodville painted. The Washingtonians, for instance, the temperance group that coalesced in such dramatic fashion in Baltimore in 1840, had half a million members by 1843. In *Franklin Evans*, his 1842 temperance novel, Whitman wrote, "A great revolution has come to pass. . . . The dominion of the Liquor Fiend has been assaulted and battered."[76] These reformist philosophies were taken seriously, and in 1855 temperance leaders passed a record number of prohibition laws.[77]

Fig. 40]
Oyster Cellar, 1849.
Wood engraving, in
George G. Foster,
New York in Slices
(New York: W. F. Burgess, 1849), 94.
Princeton University Library,
Princeton, New Jersey

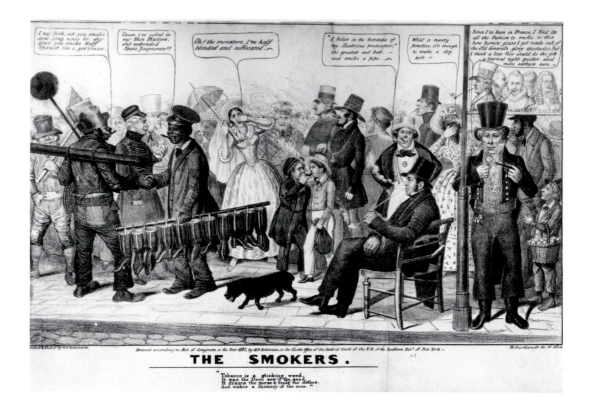

THE SMOKERS.

Fig. 41]
E. W. Clay,
The Smokers, 1837.
Lithograph printed and
published by H. R. Robinson.
The Library Company of
Philadelphia

Reformers also targeted tobacco use, which they saw as another decadent habit (fig. 41). To most, the red cuspidor and stamped-out cigar in *Politics in an Oyster House* signaled a benign untidiness, but social reactionaries believed tobacco use was a vice particular to rogues and even criminals. After his visit to the United States, Dickens remarked, "In courts of law, the judge has his spittoon, the crier his, and the prisoner his; while the jurymen and spectators are provided for. . . . In some parts, the custom is inseparably mixed up with every meal and morning call, and with all the transactions of social life."[78] Another English visitor to the United States noted that the three items most in demand were "spirits, tobacco, and oysters."[79]

The American press also expressed disappointment in the rampant abuse of tobacco during the antebellum years. The *New York Evening Mirror* considered smoking in the streets "the height of bad taste," and the *New York Herald* maintained that "this abominable nuisance was first introduced by gamblers and blacklegs, and is still followed by that class. . . . We are sorry to say that a few of more respectable standing have permitted themselves to be degraded to a level with the fashionably dressed sharpers who parade the streets and lounge about the hotels, where they lay in wait to entrap their victims."[80] Woodville's cuspidors, pipes, and cigar butts represent more than his desire to capture a slice of life; to his audience such details said a great deal about one's character.

Corporeal appearance and health also attested to one's status. According to many writers and painters, the shape of the head and body—and whatever else numerous books

about so-called physical- and self-culture told them to keep an eye on—offered clues about the individual. Dr. William Alcott published *The House I Live In; or, the Human Body* in 1836, and the book was reprinted regularly throughout the antebellum period. Alcott, a country schoolmaster and the author of the famous *Young Man's Guide*, was so appalled by ignorance about the body that he lectured and wrote about it constantly. Physiology, Alcott instructed, like architecture, could be taught and had strict rules. He divided his book into chapters with titles like "Frame-Work of the House" (for the skeleton), "The Cupola" (for the cranium and all it contains), and "Apartments and Furniture" (for the internal organs). "To keep the mind and heart right," Alcott wrote, "we should know how to keep the body right. . . . Man . . . has a body as well as a mind. A system of education which overlooks either is essentially defective."[81]

Melville also pondered physiology. In *Melville's Anatomies*, Samuel Otter reflects on that literary genre identified by Northrop Frye in which "linguistic features" become dense, and "diction, syntax, [and] metaphor" become the lifeblood of the inquiry at hand.[82] Otter studies Melville's obsession with the human body and puts it in the context of anthropology, phrenology, and self-culture. Melville's novels, Otter shows us, gorged on anatomy—on craniology and tattoos, on missing legs and shrunken heads. And poor Bartleby, though a metaphysical creature, could not escape his flesh, his "pallid," "motionless," and "lethargic" body.[83] Poe and Hawthorne are other handy examples: Poe's narrators become "deranged" because of "bodily fixations," and Hawthorne, saw in birthmarks and other aberrations of the skin a metaphor for the Puritanical drive to fix "grace."[84]

The epigraph to the Fowler brothers' popular *Illustrated Self-Instructor in Phrenology and Physiology* (1840)—"Self knowledge is the essence of all knowledge"—testifies to the currency of Emersonian philosophy.[85] Emerson, for his part, worshipped ghosts, or the corpses of the vanished agrarians: "The civilized man has built a coach, but has lost the use of his feet. He is supported on crutches, but lacks so much support of muscle," he wrote in "Self-Reliance." "The sinew and heart of man seem to be drawn out, and we are become timorous, desponding, whimperers. . . . We shun the rugged battle of fate, where strength is born. . . . A sturdy lad from New Hampshire or Vermont, who in turn tries all the professions, who *teams it, farms it, peddles*, keeps a school, preaches, edits a newspaper, goes to Congress, buys a township, and so forth, in successive years, and always like a cat falls on his feet, is worth a hundred of these city dolls." The final sentence of the essay's penultimate paragraph resolves it: "A man who stands on his feet," Emerson concluded, "is stronger than a man who stands on his head."[86] He merely intellectualized the popular sentiment that the city wastes the healthy body and with it the hope for virtuous, republican citizenship.

The promoters of self-culture, such as Emerson's mentor William Ellery Channing, would have cringed at Woodville's young oyster-house politician, whose brutish face and gestures he grossly exaggerated.[87] Critics certainly recoiled from some of Woodville's figures. Henry Tuckerman, remember, called the drunks in *Two Figures at a Stove* "vulgar"

customers, and the author who described *Politics in an Oyster House* for the *Literary World* said the young man was "of the same kidney" as "that hard looking youth" in *The Card Players*.[88]

But Woodville's modernistic gambit was to stop short of giving his figures sturdy identities no matter how palpably he painted them. Similarly, the minutiae that float around his paintings like overstated clues often insinuate into them what turn out to be contradictory traits. While everything about *Politics in an Oyster House*—its shady venue, the alcohol, the tobacco, the crude anatomies—appears to say one thing about its protagonists, we cannot deny the meaningfulness of their debate. The oyster house, it turns out, was not just a place where aimless drunks went to find companions for smoking, drinking, and trivial banter. In the antebellum press the oyster cellar emerged as the metaphorical habitat of the oyster-house critic, identified as an engaged though dangerous journalist. In 1852 the *New York Evening Mirror* described the "oyster-house critic" as an aggressive "puff writer" or "penny-a-liner" with dubious opinions who conned strangers.[89] George G. Foster called their kind "fishers of men."[90] The oyster-house critic evolved from an earlier city character, the puff critic, who was roasted in the urban humor periodical *Yankee Doodle*:

> The snobbery of the Puff Critic is infinite. Yankee hardly knows how to regard him, whether jocosely or seriously. It is a pleasant spectacle, certainly, to witness the Puff Critic entering a concert room resplendent with the free-will offerings of hatters and tailors, shining in the silk of Beebe and Costar, nattily pantalooned by Brundage, gloved by Leary, musked by Tiffany and caned by Woodworth. He is an amazingly fine phenomenon and quite puts to the blush "the base slaves who pay," the honest citizens who degrade themselves by occasionally cashing a bill. But if this base creature were looked into a little closely, he would appear scarcely as respectable a character as his brother of the side-walk who lets himself out to be sandwiched in show boards. . . . The Puff Critic in fine is a poor creature who might have passed all his days as a lying drummer in a jobber's store, or a false clerk over the counter . . . but he . . . blundered into a business where honesty and independence are the standards.[91]

What really upset Yankee, it seems, was that the democratic penny press gave respectable jobs to these dilettantes. Literate men from any background found work as reporters, critics, and editors, thus gaining an unseemly respectability. This particular satirist rejected these interlopers in his "fine" world because they reported with authority on what he believed they knew nothing about. Though ironic, the amusing syntax and vocabulary of class contempt in this passage—(and the author calls the puff critic a snob!)—strikes a chord. *Yankee Doodle* humorists, even if less than serious, usually hit their mark: genuine social apprehension.

Though Edgar Allan Poe said that he regretted doing popular beat journalism, he depended on that kind of work for money.[92] Between 18 May and 6 July 1844 Poe wrote "Doings of Gotham," letters that appeared in the *Columbia Spy*, a small-town Pennsylvania

paper that emulated the format of the large urban dailies. Poe's correspondences, which appeared in the paper in November 1844, examined gritty life in New York and included accounts of Irish squatters, oyster cellars, and sensational murder cases. Poe wrote with a cruel wit about "the prevalent shanties of the Irish squatters," which looked like "tabernacles"; the typical immigrant dwelling was "nine feet by six, with a pigsty applied externally, by way of both portico and support. The whole fabric (which is of mud) has been erected in somewhat too obvious an imitation of the Tower of Pisa."[93] Though Poe seemed to relish writing about the city in a popular style, he rebuked the puff writers and oyster-house critics, who he believed compromised the quality of American literature. In "Puffing" and "Puffing—No. 2," both published in the *Spy* in the fall of 1844, Poe regretted "the extensive and extravagant manner in which many of the country newspapers lavish their praise upon any and every work emanating from the Presses of our large cities." Later he wrote, "Puffing has become a science and 'celebrated men' and 'distinguished writers' are manufactured in the shortest time imaginable."[94]

The puff critic mutated into the oyster-house critic around the mid-1840s and remained a popular figure until the late 1850s. On 27 May 1852 the *New York Herald* felt compelled to justify an article it ran by an "oyster-house critic": "We have to trust sometimes to the outside oyster house critics of the day, who write with such a tremendous vengeance on these interesting topics that one would almost suppose they would burst their boilers before they got through the next paragraph." Dilettante politicians like those in Woodville's painting evidently read these oyster-house critics. In September 1854, for instance, the *Herald* wrote, "We publish today several extracts from the Sunday papers *par excellence*, on city politics, and the various movements on foot, and the various candidates in the field. . . . The oyster house politicians are evidently in for a full share of the spoils." In 1855 a flurry of articles appeared regarding a particular oyster-house critic's reviews of theater performances in New York City. The *Herald* was not sure where it stood on the matter. On 22 March it described oyster-house criticism as "blood-thirsty, ferocious and merciless" and associated it with the "horrible mysteries of pugilism, of menageries and necromancy." A little over a week later it added this passage to the disputation: "Now in a great many of the strictures of these oyster-house critics, we entirely concur. They are written, it is true, in a coarse, slashing, knock-him-down, Stanwix Hall style, but it cannot be denied that there is a good deal of justice in them. . . . We say, therefore, to these oyster house critics, 'Go on and prosper in your vocation; exercise your right to cut, carve and slash in the most approved Grub street fashion, and don't be afraid of laying it on too heavy or too thick.'"

Finally, just twelve days later, when the theater critic took a job at the rival *Tribune*, the *Herald* reversed itself again. "From the very fact," the paper wrote, "that he has gone into the political college of the *Tribune* office to complete his democratic studies, and from the occasional confessions of his criticisms, it is evident that this gentleman is an abolitionist, a socialist, and a visionary cockney republican." Despite the *Herald*'s flippancy regarding the

oyster-house critic, this comment locates his voice within the political arena. Whether he was a puff or not, the *Herald*, a Democratic paper, admired the oyster-house critic's brash manners and regretted his defection to the more skeptical and Whiggish *Tribune*.

Eventually the preoccupation with oyster-house criticism faded. "Recently," the *Herald* reported on 4 May 1855, "we observed that a law had been passed declaring oysters to be unhealthy during the spring and summer months. Has this anything to do with the silence of the oyster house critics? It looks ominous." Two years later the *Herald* announced the demise of the oyster-house critic: "Years ago the oyster house critic was a more important personage, at least in his own estimation, and in that of deluded artists. . . . That day is past. To all intent and purposes his occupation is gone. No more will he enjoy his midnight treat of oysters and champagne in subterranean cellars. His spell has lost its influence, and henceforth, if he would avoid starvation, he must betake himself to some honester calling."[95]

Evidently, the younger figure in Woodville's painting has been impressed by a report in the newspaper he holds. We cannot tell, naturally, whether he is reacting to the stimulating rantings of an oyster-house critic; regardless, he exhibits the oyster-house attitude and appears sympathetic to the Democratic line. Moreover, he makes his point in the preferred manner of the party—expansively and pugnaciously. And as with the new breed of puff critics, beneath his gentlemanly costume lies a quick, urban temperament. In this hypothetical drama the older man plays the part of the skeptical patrician editor to his partner's James Gordon Bennett, the brassy editor of the *Herald* who feuded with just about everyone in the Moral War.[96] And what we smile at, like the old man, is that this earnest partisan is still young enough to believe everything he reads.

But Woodville did not paint for punch lines alone. It may very well be that to speak politically in this country is to speak absurdly, but Americans have always had more faith in the ideas and methods of party politics than in its rhetoric. Thoreau, for one, despised the oratory of reformers and party men—"There is no odor so bad," he wrote in *Walden*, "as that which rises from goodness tainted"—but he loved as much as anyone his freedom to say so.[97] So the irony of Woodville's painting is that its figures both idle time away and engage in democracy's fundamental exercise. Loafers who sit in a cellar, drinking and smoking, these two are also constituents, citizens whose exuberant opinions have some consequence.

The public perceived loafers, "mainly working-class men and women who had been impelled by hard times to reject normal capitalist pursuits and find other means of gratification," as disenfranchised, when in fact they played an active role in antebellum politics.[98] One observer noted in 1838 that a Democratic meeting "looked like a convention of loafers from all quarters of the world" and that while Whigs attracted respectable citizens, Democrats tended "to take in all the loaferism of the nation."[99] However, the very act of dropping out, of hiding out in smoky cellars, became (as it would again in the 1960s) a political statement. Whitman understood this and celebrated the loafer in his prose and poetry: "I loafe and invite my soul, I lean and loafe at my ease observing a spear of summer grass," he wrote in

"Song of Myself." And earlier, in 1840: "[G]ive us the facilities of loafing, and you are welcome to all the benefits of your tariff system, your manufacturing privileges, and your cotton trade. For my part, I had serious thoughts of getting up a regular ticket for President and Congress and Governor and so on, for the loafer community in general."[100]

One way to gauge the politics on display in this painting is to consider its patron, the estimable John Latrobe. It is not surprising that Latrobe, a vivacious promoter of Baltimore and its citizens, supported Woodville by purchasing his painting. Perhaps Latrobe bought *Politics in an Oyster House* as an act of charity or because of the Woodvilles' connections to Robert Goodloe Harper, who was, like Richard Caton, a son-in-law of Charles Carroll of Carrollton. But more likely he bought it because he liked Woodville's pictures. As a friend and law student of Harper's, Latrobe deliberated on slavery; he and Harper promoted colonization as a solution to the racial problems in the United States during the first quarter of the century. In fact, Harper decided on the name Liberia for the colony, and Latrobe proprosed the name Monrovia for the capital.

Perhaps Latrobe, a Jacksonian, appreciated Woodville's amusing depiction of the type of political intercourse that Latrobe witnessed as a prominent lawyer in Baltimore. Latrobe was self-made: his father left him and his brother, the engineer Benjamin Latrobe, few assets. Besides practicing law, John Latrobe worked as an inventor, and he earned some money from the heater he designed called the Latrobe Stove. As a patron of the arts, an inventor, and a member of the B&O board, Latrobe acted like a good Democrat, placing a premium on innovative entrepreneurism. Even if he saw Woodville's painting as a caricature of fumbling political loafers, he surely perceived a certain nobility in their dynamic conversation. Latrobe described himself as a "stump speaker" and "a hot Jacksonian" who "harangued multitudes." And "on more than one occasion," he said, "I tried my hand at politics, but had no natural turn that way and my efforts never amounted to anything. The trade was, so far as I was concerned, a profitless one."[101]

Though Woodville gravitated toward the controversial social issues of his day, he too abstained from partisanship for the most part; one notable exception being his 1849 painting *Old '76 and Young '48* (fig. 63), which probes the divisive ideologies surrounding the Mexican War. In many ways Woodville's paintings resemble Melville's novels. Both treated the same themes—slavery, an acrobatic economy, and confidence games—and both tended to obscure their private architecture with intricate scaffoldings. But Melville, as Alan Heimert so gracefully points out, was a partisan politician, a writer who borrowed freely from the political rhetoric of his time and who constructed elaborate metaphors for issues debated by Whigs and Democrats in Congress during the 1840s and 1850s. Melville referred to Longfellow's "The Building of the Ship," which appeared in 1850, and alluded more generally to the ship of state, which bobbed along on the currents of political dialogue. Heimert explains, "In the *Pequod* Melville created a ship strikingly similar to vessels which rode the oratorical seas of 1850. It sails under a red flag, and its crew—in all its 'democratic dignity'—

comprises a 'deputation from all the isles of the earth.' But the *Pequod* is clearly reminiscent of Longfellow's *Union*; it is put together of all 'contrasting things' from the three sections of the United States: 'oak and maple, and pine wood; iron, and pitch, and hemp.' And the *Pequod* is manned (as we are reminded at each crucial moment in its career) by *thirty* isolatoes—all, Melville remarks, 'federated along one keel.'"[102]

The fiery debates between Whigs and Democrats impressed Melville, who was an associate of those partisan writers the Young Americans. Yet, as Heimert demonstrates, Melville's favorite political metaphors from the late 1840s and early 1850s came straight from the rhetoric of his party. He took the position of most Whigs when he worried again and again about Manifest Destiny and the swift course of the American empire. "The pro-expansionists whom Melville satirized," Heimert writes, "found no single image adequate to the whole of their imperial aspirations. . . . Whatever Melville's judgments on the 'fiery' Barnburners portrayed in *Mardi*, he obviously continued to question the imperialist ambitions of American Democracy." Melville, Heimert reminds us, wrote of "all the revolving panoramas of empire on the earth" and gave Ahab as an omen "not Tarquin's imperial eagle, revived in the symbol of American liberty, but the other bloody bird, the conquering hawk."[103]

Two other American genre painters who exhibited at the Art-Union, George Caleb Bingham and William Sidney Mount, were as openly political as Melville. Mount was a New York Democrat with considerable influence, and Bingham was a Whig politician from Missouri.[104] Though he most likely inherited Whig principles, and though he painted at a time when the ballyhoo of Whigs versus Democrats reached a fevered pitch, Woodville rarely mimicked the rhetoric of either party in as direct a manner. Even when many of his colleagues at the Düsseldorf Academy made "tendentiously political genre paintings which advanced the causes of nationalism, democracy, and to some extent, socialism," Woodville did not reveal his true sympathies.[105] His paintings appealed equally to the officers of the American Art-Union, mostly Whigs, and to the Democrats who saw his work—Latrobe, for instance, and those Art-Union officers and their friends who were Democrats. Woodville chose not to stump for either party with heavy-handed political statements; instead, he made more general statements about urban life, an issue that may have entered into political debates but appeared, for the most part, in discourses about American social customs.

Regardless of Woodville's private politics, those who saw *Politics in an Oyster House* must have politicized it, either siding with or scoffing at its untamed Democrat. That the painting earned the variant title *A New York Communist Advancing His Argument* when exhibited at the Royal Academy testifies not only to the political climate in London at the time but also to the picture's relevance to American partisan politics. Woodville separated himself from other genre painters by inventing characters that both engaged and disengaged from society. Like Woodville himself, who viewed the American scene from a safe remove, his characters seem both listless inhabitants of the fringes of society and active participants in the economy and politics of that society. And Woodville implicates viewers of the painting in

this equivocation. The cycle of opinion that courses through the picture begins with the newspaper, runs from the mouth of the young critic, and pauses on the bemused expression of the older man. He, then, turns to us, asking quite frankly, "What do you make of this?"

Historians regularly cite Woodville's *The Card Players* and *Politics in an Oyster House* when discussing genre's role in nurturing antebellum stereotypes. The natty costumes and clever schemes of their gamblers and barroom loungers made the two paintings popular; they appealed to the antebellum taste for humorous depictions of native characters and reinforced assumptions about urban decay shared by the antebellum middle and upper classes, who were busy laying claim to moral superiority. But we should not assume that Woodville's paintings were intended to fit neatly into debates about class tensions in the city; his characters speak in many voices. In *Politics in an Oyster House* Woodville places the newspaper more or less at the center of the painting. Not only does the paper allude to oyster-house criticism but its words generate the action—the thinking and talking—of the picture. Even though we cannot make out the words on its pages, Woodville invites us to look a little closer, to scrutinize the paper's texts and subtexts. Johns is right to say that unlike Mount's characters, these men do not "jostle for concrete, material advantage, [but] merely talk and . . . talk."[106] As anyone trying to write about Woodville's paintings has surely discovered, this talk proves contagious, and more to the point, it ends up being more incisive than the lampoons by other painters of the same subject. James Goodwyn Clonney, for instance, painted *Politicians in a Country Bar* (fig. 42) four years before Woodville painted his version of the story. Clonney's painting feels much lighter and, frankly, less human because it is overwrought and exhibits that "straining after effect" that Whitman disliked in genre painting.[107] All those laughing figures fill the room with one mood. In both paintings the younger figure counts off his arguments on his fingers, but in Woodville's picture the gesture comes off as something more than a comical rhetorical device. Woodville's restraint, if we can call it that, adds what one author has called a "piquancy to otherwise nonpartisan scenes."[108]

Woodville breathed more life into his protagonists than did his fellow genre painters. They look less like convenient symbols than like people with many ideas in mind at once. Woodville's figures are political in a positive and humane sense; they work things out. Once again, Melville got to the heart of the matter: "In literature," he wrote, "as in zoology . . . all life is from one egg."[109]

◇

Like many of his peers, Woodville invites comparison with a long line of European genre painters. Though celebrated at home for their native themes, his paintings belong to a tradition that gestated in northern Europe during the seventeenth century and hatched

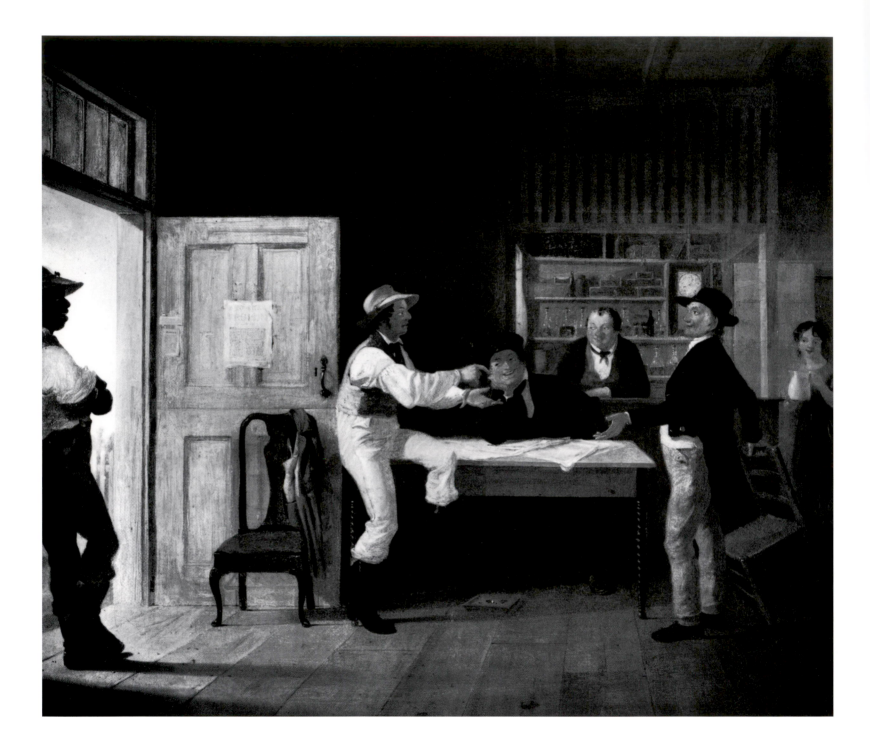

Fig. 42] James Goodwyn Clonney (AMERICAN, 1812–1867), *Politicians in a Country Bar*, 1844.
Oil on canvas, 17 ¼ x 21 ⅛ in. (43.8 x 53.6 cm). New York State Historical Association, Cooperstown

again in Victorian England. Woodville's cardplayers inhabit American interiors and personify the American economy and political scene; they are the progeny of boisterous Dutch and Flemish gamblers and graceful French sharps. Seventeenth-century Dutch genre painters like Cornelis de Man and Jan Steen conjured merry and quarrelsome cardplayers and placed them in rowdy taverns. These scenes cautioned against idleness and leaving things to chance.[110] The French painter Georges de La Tour assembled a different cast; his cardplayers were elegant tricksters, many of them women, who engaged in promiscuous amusements (fig. 43). Their sleights of hand and conniving glances, though cheating to be sure, symbolize an elaborate, gestural kind of courtship. In the hands of La Tour, sex looks like a perilous game of give and take, but his paintings appeal to us because they are so deftly executed. His fastidious descriptions of stitched embroidery and precious jewelry and his careful concealment of crucial details speak persuasively about a modern subject, painting as a craft with its own duplicities and false gestures. This, more than any other, is the lesson Woodville learned from his predecessors. With the exception of his period pictures, Woodville's pictures fall into the "low-life" category of genre painting, the category of those familiar pictures of carousing peasants by Adriaen Brouwer (fig. 44), Adriaen van Ostade, and Jan Steen (fig. 45). Woodville's characters belong to various classes and can be enterprising and urbane, but his paintings share with low-life scenes a thematic preoccupation with deception and an aesthetic appreciation for disarray—broken pipes, worn wood, rickety furniture. Sir David Wilkie, a Scottish-born painter who painted in this mode and enjoyed considerable fame in England during the early Victorian period, had a more immediate influence on Woodville. Wilkie's heavy-set, ruddy-cheeked peasants inhabit ramshackle cottages in muddy villages; they warm themselves at hearths, dance tirelessly to fiddle music at tavern weddings, and argue over political editorials in the local papers. He perfected the pressure-cooked interior, where bodies and passions reached dangerous temperatures. Wilkie's friend Humphrey Repton explained what the painter was after. "Since the exact resemblance of the face gives little pleasure, unless the mind is in a manner poutrayed [*sic*]," he wrote, "it is not the *features*, but the *passions*, which the higher art is ambitious of transfusing."[111] American audiences and painters, especially Mount, admired reproductions of Wilkie's works (fig. 46) and held them up as models for aspiring genre painters.[112]

Occasionally, Woodville took a break from the spirited masses, preferring instead the cozy sanctuary of romantic history. In *The Cavalier's Return* (fig. 47), which he painted in 1847, after *The Card Players* and before *Politics in an Oyster House*, Woodville deviated from the low-life tradition.[113] Gone are the public quarrels; in their place we find quiet domestic simplicity. Set in another tight interior space, the scene depicts the reacquaintance of a Cavalier—just back from serving Charles I—with his wife and child.

Fig. 43 *above, top*]
Georges de La Tour
(FRENCH, 1593–1652),
The Fortune Teller, c. 1635.
Oil on canvas, 40 ⅛ x 48 ⅝ in.
(101.9 x 123.5 cm).
The Metropolitan Museum of Art,
New York. Rogers Fund, 1960. (60.30)

Fig. 44 *above, bottom*]
Adriaen Brouwer
(FLEMISH, 1605–1638),
The Smokers, c. 1636.
Oil on wood, 18 ¼ x 14 ½ in.
(46.4 x 36.8 cm). The Metropolitan
Museum of Art, New York. The
Friedsam Collection, Bequest of
Michael Friedsam, 1931. (32.100.21)

Fig. 45 *above, left*]
Jan Steen (DUTCH, 1625–1679),
Rhetoricians at the Window,
1662–66. Oil on canvas,
29 ⅞ x 23 ⅟₁₆ in. (76 x 58.7 cm).
John G. Johnson Collection,
Philadelphia Museum of Art

Fig. 46 *above, right*]
John Burnet, after David Wilkie,
The Blind Fiddler, 1811.
Engraving, image 16 x 21 ⅛ in.
(40.6 x 54.9 cm).
Print Collection, Miriam and Ira D.
Wallach Division of Art, Prints and
Photographs, The New York Public
Library, Astor, Lenox and Tilden
Foundations

The three figures form a tight circle in the middle of the composition, and the inwardness of the scene recalls the tranquil intimacy that was a favorite motif of the Delft school. Woodville weaves together a textural array—satin embroidery, softly lit kitchenware, lattice windows, tile floors and walls, an intricate tablecloth—reminiscent of the expert arrangements of Johannes Vermeer, Gerard Terborch, and Pieter de Hooch.[114] Many artists at the Düsseldorf Academy showed more interest in the trappings of history than in modern social life. Carl Lessing, for example, painted many images of both literary and historical military heroes (fig. 48) whose chivalry excited the emotions of daydreamers and Forty-eighters. Friedrich Wilhelm von Schadow, the Prussian conservative at the head of the academy, also nurtured the romantic mode, and he brought from Berlin a number of artists who painted quixotic pictures. With Schadow, one historian notes, "[m]edieval castles, warrior monks, legend, and history" entered Düsseldorf.[115] This preoccupation with gallantry and history caused Karl Immermann, the novelist and Düsseldorf theater director, to remark, "The forces at the school have unmistakably produced a national mood through color and form, a mood from which the school is only beginning to disassociate itself in a conscious way. And if this frame of mind is specifically of the sentimental-romantic variety, and if the soft, the distant, the musical and the contemplative predominates rather than the palpable, the forceful, the real, the active, why then must you change the painting when you praise poetry to which you all owe some of your background."[116]

The Cavalier's Return marked a departure from the materiality of Woodville's earlier

Fig. 47] Richard Caton Woodville, *The Cavalier's Return*, 1847.
Oil on canvas, 28 ½ x 30 ¼ in. (72.4 x 76.8 cm). The New-York Historical Society, 1914.2

Fig. 48]
Carl Friedrich Lessing,
*The Crusaders Find a Spring
in the Desert*, 1849.
Pencil, pen, and gray ink, gray wash
on beige paper, 20 ¼ x 26 ⅛ in.
(51.5 x 67 cm). Cincinnati Art
Museum. Gift of Joseph Longworth,
1882.58

works, but critics praised the painting nonetheless. Even though Art-Union members favored
landscapes and scenes of American life, the cloying sentiments expressed in *The Cavalier's
Return* resonated with them. The cavalier was not an unfamiliar figure in America, especially
in the South; he compared to images of plantation gentlemen—surveying their land on
horseback, for example—described in southern literature.[117] Though the press never com-
mented directly on this connection, the *Bulletin of the American Art-Union* tracked the where-
abouts of the painting in dozens of brief reports and remarked, "Woodville's *Cavalier's
Return* . . . [has] been admired here by thousands."[118]

And family, of course, was the most precious topic among American reformers of
the period. In his sermons, the revival preacher Charles Grandison Finney, who denounced
the selfish, the irreligious, and the novels of less extreme reformers, thundered against the
disintegration of the American family. In the minds of reformers, behaving decently in pri-
vate life could not be dissociated from acting responsibly in public. Reformers promoted
family as the solution to such ills as alcoholism and even went so far as to model their associ-
ations on the family unit. Since "the old mechanisms of the patriarchal household order were
no longer available to regulate and supervise the . . . habits of the young," one historian

notes, "the metaphor of maternal embrace, like that of fraternity, affirmed affection as the primary bond between members of both associations and families."[119]

In addition to the numerous publications promoting family togetherness, such as Catharine Beecher's *Treatise on Domestic Economy* and *Godey's Lady's Book*, an array of prints and paintings with titles like *Happy Family* and *Married* presented the home as the last pious and loving place, the link between an individual's morality and his or her responsible citizenship. One painter in particular, Lily Martin Spencer, built a successful career upon this taste for sentimental images of the American family. Married, the mother of thirteen children, and the overseer of a busy household (though her husband, Benjamin, helped her with chores in the house and studio), Spencer, according to David Lubin, earned her position as an authority on family. From a "modernist or formalist point of view," Lubin writes, "Spencer's work is simply and self-evidently bad." To "contemporary eyes, her art appears reactionary, both in terms of its family values content, with idealized children, Madonna-like mothers, happy housewives, and lovably inept husbands, and its sentimental rhetoric deifying motherly nurture, the beauty of domesticity, and the homey humor of family life."[120] Regardless, one reviewer remembered the attention Spencer's painting *Domestic Happiness* (fig. 49) received, noting that it "exceeded that given to any other single production that has appeared on the walls of the Gallery since it was first opened."[121]

Though painted in 1847, *The Cavalier's Return* debuted at the American Art-Union in May 1848, and the *Bulletin* was writing about it as late as December 1849, the year Spencer painted *Domestic Happiness*, her first critical success. The painting depicts a glowing mother and father standing over their two sleeping babies; they radiate so much pride that it seems about to disturb their children (the painting's original title was *Hush! Don't Wake Them*). The dutiful adulation of the parents announces Spencer's ultraconservatism, but as Lubin explains, her position was just one of dozens on the subject of domesticity. "Orthodox Protestants clinging to Calvinist tradition decried the new liberalization of the family, in which the status of mother and children was elevated at the expense of the patriarch," he writes. "Feminists argued that the sentimental family was unduly binding of women. Socialists urged that household labor, including childcare and kitchen work, be reapportioned through public cooperatives. The followers of communitarian John Humphrey Noyes advocated free love, Mormons practiced polygamy, and many who believed that the millennial day of judgment was at hand forswore sexuality altogether."[122]

Seen through the scattering lens of domesticity, *The Cavalier's Return* assumes new shades of meaning. On the one hand, Woodville presents a reactionary picture of family life.

Fig. 49]
Lily Martin Spencer
(AMERICAN, 1822–1902),
Domestic Happiness, 1849.
Oil on canvas, 55 ⅓ x 45 ¼ in.
(140.3 x 116.2 cm).
The Detroit Institute of Arts.
Bequest of Dr. and Mrs. James
Cleland Jr.

The mother, having just fed her husband lunch, indicated by the carefully painted array of dishes on the table, takes it upon herself to oversee the unity of her family. The ancestral portraits hanging on the wall chaperone the reunion and remind the couple of their obligations. But the fact that the mother needs to supervise the meeting of father and son at all leaves us a little uneasy. The Cavalier's military duties have kept him away from home long enough that his son either has never met him or does not remember him. Furthermore, we sense that this probationary alliance will be brief, that sooner rather than later the Cavalier will leave his family again. Though he never commented on them publicly, Woodville's own family troubles—his cool relations with his father and his unhappy first marriage—haunt this imaginary reunion.

However, in keeping with Woodville's uncanny aptitude for remaining noncommittal, this painting alludes to issues far broader than domestic predicaments. Antebellum history painters "in search of less hackneyed subjects than Pilgrim Thanksgivings" turned to the Continent, and to England especially, for stories and inspiration. "Between the early 1840s and the Civil War," Wendy Greenhouse has calculated, "some fifty American artists executed more than 130 scenes from British history of the Tudor and Stuart eras."[123] The American Art-Union supported this obsession by exhibiting and distributing about half of the British-history paintings produced by American artists. While he was in Düsseldorf, Emanuel Leutze executed paintings with British themes, such as *The Courtship of Anne Boleyn* (or *The Court of Henry VIII)* (1846; Smithsonian American Art Museum, Washington, D.C.) and *Oliver Cromwell and His Daughter* (fig. 50). The latter painting, according to an author from the *Literary World*, was "the most popular picture we have ever had among us."[124] Perhaps encouraged by Leutze's impressive example, Woodville turned to another British protagonist, the Cavalier, who rode gallantly in the service of Charles I against Cromwell and the Puritans. Such gentlemen soldiers loomed large in the imaginations of literate Americans. England's Civil War, Greenhouse explains, offered American history painters "a rich fund of incidents in which their own national trauma could be represented affectingly by the conflict between genders and generations. For two decades before the outbreak of the Civil War, Americans drew parallels between the national character types of the hard-nosed northern Yankee and the aristocratic southern gentleman, and their supposed ancestors: the stern English Puritan and the chivalric Cavalier."[125]

Even though he was from Maryland, Woodville indicated no interest in the geopolitical implications of the Cavalier. The citizens of Maryland, a slave state that eventually joined the Union, were torn by the Civil War and probably saw little in the contest between the Puritans and the Cavaliers that related to their situation. The equivocation of his friends and family during the decade leading up to the war may account in part for Woodville's own reticence on political matters. But his reserve gives rise to the intriguing questions about this painting's

Fig. 50]
Emanuel Leutze
(AMERICAN, 1816–1868),
Oliver Cromwell and His Daughter, 1843.
Oil on canvas, 29 ⅛ x 24 ½ in.
(74 x 62.2 cm).
Philadelphia Museum of Art.
The W. P. Wilstach Collection,
bequest of Anna H. Wilstach

family. Leutze also treated the subject of the Cavalier in *After the Battle* (or *The Puritan and the Wounded Cavalier*) (1850; Montclair Art Museum, Montclair, New Jersey), in which a daughter appeals to her stern Puritan father to help a wounded soldier. In Woodville's hands the drama is more subtle, and more foreboding. The Cavalier's sword and spurs, resting in the foreground of the painting, testify, according to Greenhouse, "to an absence on business both grim and prolonged." The Cavalier, she writes, "is now not so much a father as an intruder in the quiet refuge of his own home, into which he brings the conflict convulsing the larger world outside. By evoking the English Civil War in costume, setting, and title, Woodville thus imposed somber overtones on what would otherwise read as a cozy affirmation of home and family, transforming a trivial domestic incident into a subtle warning against the disruptive force of manly affairs."[126] *The Cavalier's Return* is another example of Woodville's tendency to transform traditional modes and themes into something unruly. Even while abroad and working in a European historical style, he addressed a salient crisis of private life in the modern world.

After *Politics in an Oyster House*, Woodville painted another period picture, *The Game of Chess* (private collection), which played with some of the motifs set forth in both his genre pieces and his romantic pieces. Painted in Düsseldorf in 1850, it depicts five figures in seventeenth-century costume in a stately parlor. *Harper's* reprinted a description of the painting from the *Bulletin of the American Art-Union*, that praised the painting as one of "great merit": "It represents the interior of the sitting-room of a noble mansion in the days of the Tudors," the anonymous critic noted. "The cavalier is lifting a piece with his hand and looking toward the father as if for approbation of his move. . . . This is a tranquil, pleasant picture, in which the characters of the personages are very nicely indicated. It places the spectator in the very midst of the domestic life it portrays. It is, however, in the distribution of light and shadow, and the wonderful fidelity of its imitations, that the work is most remarkable. The effect of the light upon carved marble is done with wonderful skill, and the representation of velvet, fur, satin, and metals worthy of Mieris or Metsu."[127]

One month later the *Bulletin* used a Charles Burt print after the painting as its featured reproduction (fig. 51). In December the *Bulletin* called the painting "one of the most exquisite cabinet pieces ever produced by an American painter" and offered the print, along with others after Woodville's *War News from Mexico* (1848), and *Old '76 and Young '48* (1849), to each Art-Union member. The Art-Union had planned on giving the painting to a lucky winner at its Christmas party, but New York attorneys citing antilottery laws forced the organization to close before the lottery could be held. Instead, the Art-Union sold the painting at auction in December 1852 to a legal client of John Van Buren, whose father had been president when Woodville was just starting to sketch. The client then gave Van Buren the painting as a Christmas gift.[128]

Chess, of course, was a common metaphor for the game of life. During the two decades before Woodville made his painting, Poe deconstructed chess in "The Murders

in the Rue Morgue" (1841)—"the pieces . . . have *bizarre* motions"; and a popular engraving by the nineteenth-century German artist Moritz Retszch, titled *The Game of Life; or, the Chess-Players*, which shows Satan facing off against an ordinary man, was commonly reproduced in prints and gift books.[129] In *The Game of Chess* Woodville refrains from such morbid symbolism; he describes a unified and responsible family in which the parents guard the best interests of their daughter. The cavalier responds in kind by turning to the father for approbation. Still, courtship here is an analytical game with proper and improper moves. For Woodville, social interaction was never effortless.

Nevertheless, during the early part of his brief career Woodville comported himself with the acumen of a cardsharp or chess master. The best competitors at poker and chess succeed by keeping to themselves, by maintaining a quiet, cerebral detachment from the other players in the game. They thus avoid distraction and watch for opportunities; it is akin to being cool, or in the parlance of Woodville's day, sharp. From his comfortable refuge in Düsseldorf, Woodville (with an assist from the Art-Union) surveyed the tastes of his audience and produced a series of clever commentaries on social life. Oddly, what press responses to his paintings reveal is that few people recognized Woodville's predilection for irony and satire or his ability to cast common characters in unpredictable narratives. But, emboldened by his success, Woodville sharpened his perspicacity to an even finer point and then found the perfect target for it in the Mexican War.

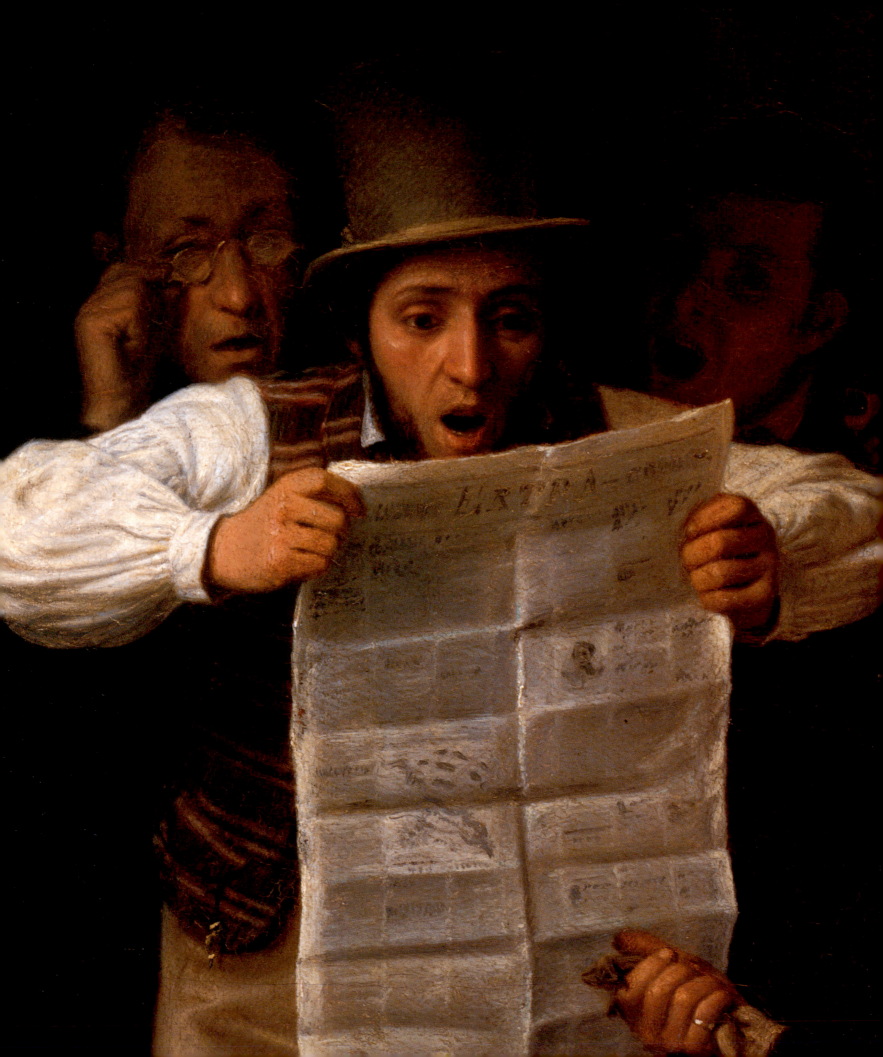

CHAPTER THREE

◇

Here and There:
The Mexican War

THE DEBATES SURROUNDING the Mexican War (1846–48) and American expansion
assumed many political voices. Put simply, President Polk and his Democrats favored
expansion and pushed for the war with Mexico, while the Whig Party, which tried to legislate
more conservative national policies, opposed it. The Whigs urged the nation to constrain its
expansion, warning that unchecked growth would make responsible governance of the
republic impossible. But even the Whig coalition was flimsy, especially when confronted
with the question of slavery, the future of which was tied to expansion. Small, bipartisan fac-
tions—northern Democrats and Conscience Whigs, for example—formed, disintegrated,
and reformed with alarming speed and unpredictability. And once war broke out, the Whigs
were unable to agree on a single opposition strategy, being "consistent only in their constant
denunciations of the president. Damning the war itself, the Whigs nevertheless gloried in
each military victory and attempted to outdo their opponents in eulogizing American sol-
diers and their Whig commanders." On the other side, Democratic writers associated with
the editor John L. O'Sullivan, who coined the concept of Manifest Destiny, first supported
the war—Whitman wrote, "Yes: Mexico must be chastised!"—but then asserted their Free
Soil principles soon after war began.[1]

The popular press welcomed the copy the war generated. War stories sold papers, *Opposite*] Detail of fig. 53

and publishers could not afford to alienate readers by taking a stance against it. Because the government never explicitly stated the exact goals of the war, many papers justified it in racist terms. The *New York Mirror*, for instance, downplayed the imminence of war in 1845, explaining that though hot-blooded, the Mexicans were cowards and would surrender instantly. Papers spoke of the "fiery impetuosity of Spanish character; the heat of Mexican blood—the explosive nature of Mexican pride," and assured their readers that "an American fleet lying off Mexican harbors is not likely to be overlooked."[2]

Letters home emerged as another form of war news. Many officers wrote directly to penny papers, or letters to their families were submitted to the papers for publication. These firsthand accounts of war were popular because they carried an assumed accuracy and emotional weight that secondhand accounts did not; reporters could only guess at the true nature of battle. The soldiers' accounts played off the American public's love of patriotism and dramatic narrative during the antebellum years. Nevertheless, *Yankee Doodle*, the weekly humor magazine, parodied this genre of war narrative. On 12 December 1846 the magazine published a mock letter home from a soldier. "Dear Father," it reads:

> What could have possessed you to send me way off here? Your notions of military glory are altogether too exalted. Yet it was natural for you, that had fought in the Revolutionary and Late Wars, to entertain a big opinion of battle. . . . It's all well enough to talk about; but a most dreadful thing to practice. . . . But for the stirring music of fine dresses, it would pass for just the same as other butchery. There is no fun in cutting throats. I've tried it. The other day, I dissected several of my fellow creatures in the most approved military style; but do you think it was pleasant to see their bowels gush out, and hear their cries of agony? If I were "to do to the Mexicans as I would have them do to me," I should let them alone. . . . Blowing out the brains of such jubilating, good-hearted simpletons, is no joke; but I am called out.[3]

The facts of death intruded rudely into American parlors and offended many people's sense of justice, not to mention decency. To capitalize on the prevailing taste for the sensational among their readers, the penny papers reprinted many accounts of violence, brutality, and dismemberment, but they also appealed to a widespread sentimentalism. The *Herald* included descriptions such as one of a "General Hospital" that was "filled with the wounded and the sick, many of whom are dying daily," and the *Daily National Intelligencer*, of Washington, D.C., included an account of the death of Lieutenant Colonel Clay, "the eldest son of the honored Statesman who left this city [Buena Vista] but a few days since with gloomy forebodings and an evident presentiment of evil."[4]

Back home, particularly in the Northeast, these accounts prompted sharp criticism. The strongest opposition to the Mexican War came from religious men and women, some of whom were pacifists and most of whom feared the incorporation of the conquered territories

into the union as slave states. In his popular book *A Review of the Causes and Consequences of the Mexican War*, published in 1849, William Jay declared that slavery was the true motive for the war and that "the peace [Polk] desired was not a just, and therefore an honorable one, but a bold, rapacious spoliation." Jay also regretted the war's breach of the home front. "This constant familiarity with human suffering," he wrote, "instead of awakening sympathy, has roused into action the vilest passions of our nature."[5] Some authors were even more vehement in their attacks on the government. In a sermon delivered at Easthampton, New York, William Bement stated, "England sends desolation among inoffensive tribes of India and China, France ravages the coasts of Algiers and Tahiti, and the United States invade the cities of feeble and distracted Mexico."[6]

Abiel Abbot Livermore wrote, "We are stating a solemn and incontrovertible truth, when we say that we discern in slavery the main-spring to the war with Mexico. Had the idea of extending the 'peculiar' institutions of the south . . . been entirely excluded from the question, not a shot would ever have been fired." And in a chapter titled "War and the Fireside," Livermore maintained that "war has brought horrors . . . to pass . . . and it sends back to the lovely places of domestic happiness the heart-rending intelligence of its dear bought victories, or bloody defeats. . . . We have invaded the homes of another nation [and] destitution now is at our own firesides."[7]

Not every critic of the Mexican War worried openly about the spread of slavery. Many spoke against the war in more general terms and feared that government-condoned violence set a poor example for the nation's citizens. One author spoke of a "causeless vindictiveness toward a weak and distracted nation" and admonished that "the evil impulses of our nature constitute a law of selfishness, which prompts man to seek his own interest or gratification, regardless of the . . . rights of others." Hostilities, he continued, have "introduced crime and vice among us," and "a camp is the notorious home of unbridled passions." War, in sum, "has excited and encouraged among our people the spirit of conquest. Desire . . . invents a thousand plausible excuses for its gratification."[8]

◇

The story of the telegraph brings some of the debates surrounding the Mexican War to life and provides a perspective from which to look at Woodville's paintings about the war. Having fixed a network of wires between Baltimore and Washington, D.C., Samuel F. B. Morse stunned the United States Congress on 24 May 1844 with a demonstration of his invention. The Old Testament phrase that Morse transmitted—"What hath God wrought!?"—announced what he believed to be the telegraph's divine origins and sublime implications.

For several years after Morse's dramatic presentation the telegraph was a favorite

topic of the same newspapers that benefited from its technology. The papers ran daily reports on reactions to the magic instrument and the legal quibbles surrounding its patent. So popular was the telegraph as a media topic that in October 1846 the inaugural issue of *Yankee Doodle* satirized both the invention and the inventor. In response to a petition submitted to Congress demanding that it reward Morse for his invention with a commission to fill the vacant panel in the Capitol Rotunda, a *Yankee Doodle* author quipped, "Considering the service he rendered, it would be better to make him President of the Board of Brokers, whose shaving operations he has assisted so much by the hopeless confusion into which Wall-Street is thrown by the

irregularity of the Telegraphic dispatches, and their bewildering incomprehensibility when they arrive,—or Generalissimo of the Army, whose movements he announced in such a Pythonic manner that no one could tell whether we had beaten the Mexicans or they us, until the Mail arrived to assist in construing the Magnetic Oracle."[9] Beneath the text the magazine reproduced a mock sketch, with the caption "Mr. Morse's Great Historical Picture," of his painting for the panel (fig. 52). It is merely a procession of tall telegraph poles stretching in a giant semicircle.

Yankee Doodle lampooned Morse's tremendous ego, as well as the public's infatuation with the telegraph; before its invention most Americans had thought of electricity as a "mysterious agency," an illusory, cabalistic energy summoned by quacks under cover of night.[10] Scholars have made much of the awe with which the American public received the news of the telegraph. Whereas "the steamship and the locomotive were real objects that produced odors, made noise, and, above all, moved at a speed that could be appreciably sensed . . . the telegraph moved information over great distances almost instantaneously, without any visible movement."[11] Electricity, the Reverend Ezra S. Gannett told his Boston congregation, was both the "swift messenger of destruction" and the "vital energy of mental creation. The invisible, imponderable substance, force, whatever it be . . . [that] is brought under our control, to do errands, nay, like a very slave."[12]

As these responses to the telegraph and its mechanisms demonstrate, Americans first spoke about the device as something magical and sublime. Soon, however, they understood that it occupied a more mundane realm. The telegraph, even with its awesome capabilities, could not avoid the pervasive, radiating impulses of antebellum politics: *Yankee Doodle*'s parody of Morse, humorous as it was, placed the telegraph in the context of the Mexican War—"no one could tell whether we had beaten the Mexicans or they us"; Reverend Gannett, meanwhile, preferred ruling over electricity "like a very slave." Morse himself recognized that the telegraph was an "instrument of immense power, to be wielded for good or evil," by which he meant that it could be used by those loyal or opposed to the policies of the U.S. government. Morse feared that the telegraph might fall into the wrong hands—those of

Fig. 52]
Mr. Morse's Great Historical Picture, 1846.
Engraving, in *Yankee Doodle* 1 (Oct. 1846). Princeton University Library, Princeton, New Jersey

a unionizing working class, or worse, Catholics or spies sympathetic to Mexico. Morse's code, it turns out, was a hawkish and reactionary paranoia.[13] The telegraph promised to be another example of American progress, positivism, and pragmatism—and, of course, of the country's expansion. Instead, it operated in the midst of the country's divisive debates during the two decades before the Civil War. Was American technology, many citizens wondered, being employed to advance an unjust war against Mexico? And, they asked more frankly, what impact would the war have on slavery?

The story of the telegraph provides some apt metaphors for examining antebellum society and politics. It speaks to that odd coincidence, especially evident about 1845, of America's territorial consolidation and social fragmentation: the new lands both broadened the identity of American citizenry and became fertile ground for political divisions already evident in eastern cities like New York and Baltimore. The story of the telegraph also helps us understand two of Woodville's most popular paintings, *War News from Mexico* (fig. 53) and *Old '76 and Young '48* (fig. 63), both of which address the Mexican War, though from almost opposite points of view. The former views it from the public perspective of the body politic, while the latter views it from within the private domain of the family. Just as the telegraph defied certain expectations, so did Woodville, especially in the second painting. The instrument defied linear reasoning and confused transitive logic. Now one could be in Baltimore, while one's thoughts circulated in Washington. As for Woodville, he may have favored a linear style and anecdotal narratives, but he resisted clarity and obviousness and never wrapped meaning in tidy packages, even if that is what his audience had come to expect from genre painting. Woodville, in fact, behaved much like the telegraph, posting his "reports" from a distance. His dispatches tell stories about antebellum citizenry, but they do not tell them efficiently and do not pretend that class, family, geography, or party allegiance necessarily determined the politics of that citizenry—especially when it came to the Mexican War.

The coincidence of the telegraph's invention with the Mexican War determined the success of the new medium. In 1846 the *Home Journal*, a popular New York periodical aimed at "all classes of readers," extolled the virtues of the telegraph: "The wonderful results which this invention [the telegraph] is finally to produce, have been partially shadowed forth during the past week by the transmission of the war news from Washington here. The advices from the scene of the most interesting events which have transpired for half a century, were received simultaneously in Washington and New-York, and had it been necessary, we could have raised an army of twenty thousand men, and met the news at Baltimore. . . . Future times will wonder how we ever got along without the telegraph."[14]

The Mexican War, which began in late April 1846, had been a long time coming. The battles that took place during the Texas Revolution were vicious and well publicized; by 1844 the press had already sensationalized the siege of the Alamo, the massacre at Goliad, and Texas's final victory at San Jacinto. Popular lithographs added to the public's knowledge of these events.[15] The United States and Mexico quarreled over Texas from the moment it won

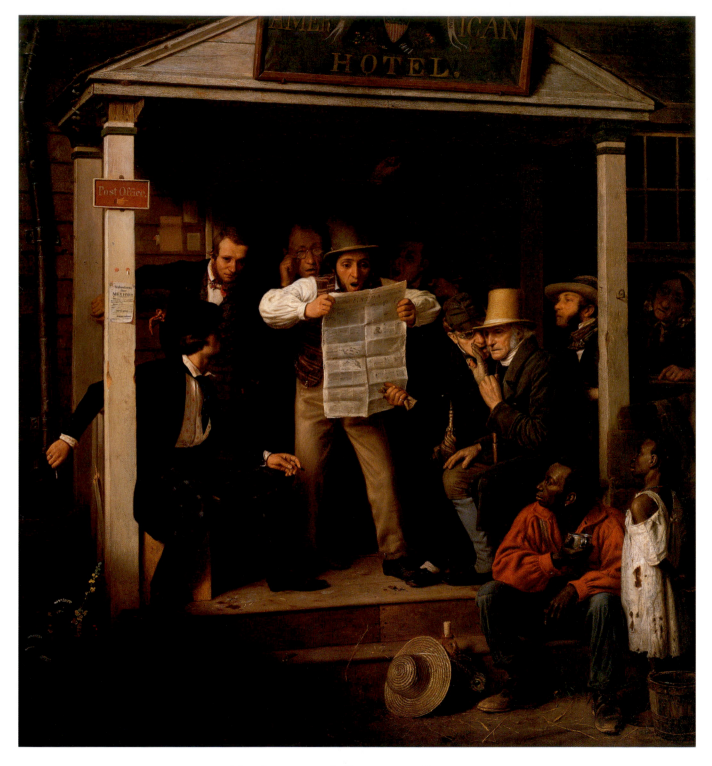

Fig. 53] Richard Caton Woodville, *War News from Mexico*, 1848.
Oil on canvas, 27 x 24 ⅛ in. (68.6 x 62.9 cm). The Manoogian Foundation,
on loan to the National Gallery of Art, Washington, D.C.

BATTERIES AT VERA CRUZ.

independence a decade before the war. President Polk (fig. 54), an expansionist, did not hesitate to fight when given the chance: after the Mexican government refused to receive his envoy and then inflicted a few casualties on U.S. troops blockading a Mexican town, Polk declared war. Though some Americans fretted over his justifications for the war, once it was under way many succumbed to its audacious rhetoric.

With telegraph stations in place and reporters in the field, the penny press was prepared to relate the war news. Fearful that General Zachary Taylor's small army stood in great danger, the country greeted tidings of his victories with "giddy relief."[16] Philip Hone declared that "the news from the seat of war on the Rio Grande and the army of occupation is the absorbing topic. 'General Taylor and the Army' is the toast which swells the ordinary allowance of wine in the glass to the generous overflowing of the bumper." The penny press, Hone reported, participated enthusiastically in this party: "The squeaking voices of newspaper boys are modulated to the monotonous tune 'Great News from Mexico,' and you cannot pass the pave in front of the Exchange unprepared with an answer to the only question asked, 'What news from Mexico?'"[17] On 1 September 1846 a front-page story in the *Herald* reported, "Our relations with Mexico now absorb all other questions; it is the only question of the day." Papers like the *Herald* and Washington's *Daily National Intelligencer* capitalized on both the message and the messenger with headlines such as: "Latest Intelligence: Telegraphic" or "Mexican News—Direct." Despite opposition to the war, the conflict bred a certain playfulness on the home front. The war gave the public a chance to savor the telegraph, feats of American engineering, and national military might (figs. 55 and 56).

Woodville's *War News from Mexico* appeared at the American Art-Union in 1849, after the war had ended but before its dizzying promotion had ebbed, so its topicality resonated with the gallery's visitors.[18] Grubar maintains that the painting's shallow, compacted space forces its overstated formalism on the viewer. "The pyramidal or triangular organization of the central group," he argues, "is repeated with little variation in the depressive porch pediment, the space between the reader's legs, and in the numerous bent arms and legs of the characters. . . . On the left, the right arm of each figure is repeated with monotonous

Fig. 54 *above, left*]
Untitled Cartoon ("President Polk prepares to take his slice of Mexico's territorial pie"), 1847. Blue ink on paper. Special Collections Division, The University of Texas at Arlington Libraries

Fig. 55 *above, center*]
Batteries at Vera Cruz, 1848. Woodcut from *The Military Heroes of the War with Mexico* (Philadelphia: W. A. Leary, 1848). Special Collections Division, The University of Texas at Arlington Libraries

Fig. 56 *above, right*]
Richard Caton Woodville, *The Storming of Chapultepec*, 1848. Wallpaper. Special Collections Division, The University of Texas at Arlington Libraries

exactitude."[19] But the labored composition of the painting did not overshadow its forceful drama or its immediate success.

The *Morning Courier and New-York Enquirer* remarked, "The picture [is] full of life and truth. The attitudes are excellent; easy but intent. The deaf expression of the old man is very truthful, the negro figures are ridiculously good, and all the accessories and accidents of the picture in fine keeping, and finished to a degree worthy of the best Dutch school."[20] The *Bulletin of the American Art-Union* called the painting a "highly meritorious work" and compared Woodville to England's most famous genre painter, Sir David Wilkie. The Art-Union also commissioned Alfred Jones to produce two steel line engravings (fig. 57) after the painting, the larger of which it distributed as a gift to its members. In advertisements for this engraving, the Art-Union described its subject as being "strictly AMERICAN."[21]

Reaction from overseas, however, was far less kind. In England, the *Art Journal* changed the title to *American News* and advised rather condescendingly, "We must warn our friends on the other side of the Atlantic, that it is not by the circulation of such works as this, a feeling for true Art will be generated among their countrymen. The subject is commonplace, without a shadow of refinement to elevate its character; it is, we dare say, national, and may, therefore, be popular; but they to whom is entrusted the direction of a vast machine like the American Art-Union, should take especial care that all its operations should tend to refine the taste and advance the intelligence of the community."[22]

But the painting remained a favorite at home. Writing in 1870, almost twenty-five years after it was painted, a critic in *Putnam's Monthly Magazine* pronounced that *War News from Mexico* was even better than Winslow Homer's Civil War painting *Prisoners from the Front* (1866; Metropolitan Museum of Art, New York). Woodville's painting, the author claimed, "is expressive of an epoch; it is a bit of local history of vast significance, painted with adequate knowledge and the right purpose. It is more elaborate art than Homer's picture; the direct and simple talent of the painter is less, his study and experience greater, than Homer's. . . . Character, expression, action, grouping, are alike good—I will say more, remarkable—in this thoughtful and well-designed picture, which has more good sense, more brains, in it, than any Meissonier we have ever seen."[23]

These authors, even the avuncular British critic, recognized that the painting was popular because it was what one might call patriotic. It reminded viewers not only of the country's decisive victory in the Mexican War but also of the power of the press to bring Americans together. Audiences saw *War News from Mexico* as a celebratory picture, a revel in American ingenuity. These figures, with their limbs akimbo and mouths agape, dance on stage under the portico of the safe American Hotel; theatrical and not very subtle, their actions remind us of the partying and frolicking in Dutch merriment paintings. The figures appear, in fact, to be performing a victory dance. This is what appeared to the *Bulletin of the American Art-Union* as "meritorious" and to the English *Art Journal* as unrefined.

Despite Woodville's overstatement in the painting, he appended to it several oblique

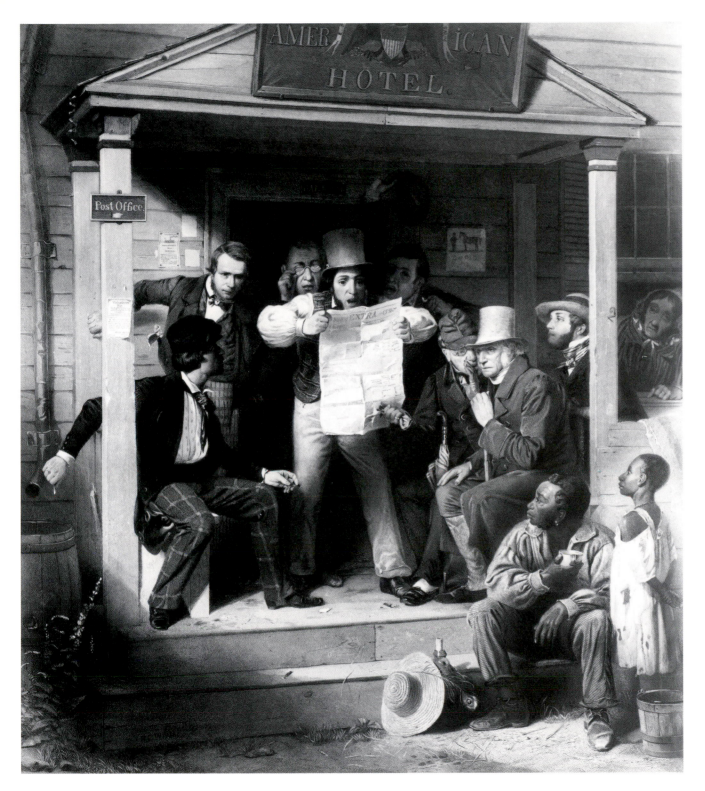

Fig. 57] Alfred Jones (AMERICAN, 1819–1900), after Richard Caton Woodville, *Mexican News*, c. 1853.
Engraving. Library of Congress, Prints and Photographs Division, Washington, D.C.

riddles. Just as the Mexican War meant more than one thing to America, so too does the painting. *War News from Mexico* is Woodville's most iconic painting, if its frequent reproduction in art and history books is any indication. Historians use the painting to advance arguments about any number of aspects of antebellum society: the goals, consequences, and processes of expansion; the diversity of American citizenry; and the position of certain members of the population—specifically women, blacks, and the elderly—within the nation's pantheon, in this case the American Hotel.

The painting shows eleven figures grouped on the porch of a public building, identified on the pediment above as the "American Hotel." A young man stands at the center of the painting reading aloud from a newspaper with the word "EXTRA" printed across the top. The remaining figures respond in different ways to the latest news about the Mexican War. Because the work was so popular, reproduced in numerous engravings and lithographs, it operated on its audience in much the same way as the penny press did: it possessed the power to convey to an eager crowd yet another opinion regarding the controversy. At the same time, by illustrating the ubiquity of the penny press and by making little attempt to conceal his metaphors, Woodville emphasized how newspapers (and images) determined public opinion. Americans these figures may be, but at every step Woodville calls their autonomy into question.

In an ambitious and provocative essay, Bryan Jay Wolf considers Asher B. Durand's *Kindred Spirits* (1849; New York Public Library), Woodville's *War News from Mexico*, and other paintings in the context of what he calls "epiphanic," or romantic, and "informational," or journalistic, modes of knowledge, which became entangled during the antebellum period. Whereas Durand's picture resisted the informational mode by escaping into transcendental tropes and the realm of metaphor, Woodville's picture, Wolf argues, mimicked the new, market-driven way of understanding the world and was reportorial in that it appeared to reach for the truth.[24]

Just as Grubar obsessed over the repeated triangles in Woodville's painting, Wolf gets caught up in the picture's recurring rectangles. "The rectangle of the newspaper," he writes, "is repeated in the frame of the doorway behind it, the enclosure of the porch that surrounds it, the numerous rectangular forms of the signs, clapboards, and pillars of the 'American Hotel' before us, and, ultimately, the picture frame itself" (332). Regardless of Woodville's intentions, this fastidious formalism is surely meaningful. For one, it emphasizes how newspapers work on a reader's understanding of the world. Moreover, the intervening figure who whispers in the old man's ear personifies the very act of consuming information. As Wolf puts it, the signifier here "*structures* as well as signifies" (332). But by having the picture frame be the ultimate rectangle in his telescoping geometry, Woodville implicates painting itself, his own vehicle, in this process. Woodville is masterful here, managing within the four corners of his canvas to bring to life the influence his painting had on its viewers. After all, the figures *look* at the paper as much as they read it. It is a clever painting, and this is what

Wolf means when he says that Woodville "renders himself, like the newspaper he depicts, a broker of knowledge" (333).

Woodville's presence in *War News from Mexico*, Wolf believes, is that of a mythographer in the Barthesian sense. In other words, he naturalizes what is in fact socially and economically determined. By linking the new, press-driven system of knowledge with older forms of information transmission, mainly the storytelling between the whispering man and the older representative of republican times, Woodville "ignores the paper's structure as an economic commodity . . . [and] renders the news part of a personalized network of human relations" (332), which, of course, it is not. A compelling argument, to be sure, but we can still detect at least some distant strains of humanism in the painting if we extricate it from the precise discourse of semiotic theory and bathe it in a more diffuse, less incriminating light. Rather than to elide the incompatibility of the two modes of communication—the personal and the commercial—Woodville may have meant to emphasize it. After all, the reading and the whispering, in the form of the old man, are tinged with sadness. If Woodville was playing a trick here, we might describe it as irony before reification.

Though the publishers and editors of the country's popular newspapers acknowledged the entertainment value of their publications, they took their jobs seriously. Newspapermen talked about their work as a calling and described the business as a service to bourgeois readers, as a way to keep them "wide-awake" and engaged in society (figs. 58 and 59). James Gordon Bennett's *New York Herald*, for instance, appealed to a diverse audience and charmed average readers by championing "entrepreneurial equal rights." As one literary critic puts it, "The half of the population that was artisans and mechanics would have enjoyed its exposés of the elites."[25] Aristocrats like Philip Hone read the paper only so they could defend themselves against its populism. Hone called Bennett's paper a "vile sheet,"[26] and the editor retorted by calling Hone a "loafer." "What is to prevent a daily newspaper from being the greatest organ of social life?" Bennett wondered aloud in the *Herald*. "Books have had their day—the theaters have had their day—the temple of religion has had its day. A newspaper can be made to take the lead of all these in the greatest movements of human thought, and of human civilization. A newspaper can send more souls to Heaven, and save more from Hell, than all the churches or chapels in New York—besides making money at the same time. Let it be tried."[27]

Both Bennett and Horace Greeley, editor of the rival *New York Tribune*, believed that informing their readers about urban depravity was a way to prevent their being swallowed up by the city and to empower them against the schemes and crimes of the elite. "Always implicit in the *Tribune*'s success was Greeley's own," Hans Bergmann explains. "The paper was a beacon of a fierce confidence in the educated individual's ability to encounter the city and comprehend . . . it."[28] Greeley believed that people could in fact "beat the world."[29] The *Tribune* was more reformist—that is, more antislavery, antiwar, antitobacco, antigambling, and antibrothel—than the *Herald*, but it supported its activism by

Fig. 58 *above, top*]
John Plumbe Jr.,
*Portrait of a Man Reading
a Newspaper*, c. 1842.
Quarter-plate daguerreotype.
The J. Paul Getty Museum,
Los Angeles

Fig. 59 *above, bottom*]
Gabriel Harrison
(AMERICAN, 1818–1902),
California News, c. 1850.
Half-plate daguerreotype.
Gilman Paper Company
Collection, New York

covering sensational topics, which Greeley reluctantly admitted sold papers. In order for these papers to succeed, however, they had to be timely; the intense competition between them demanded that their news be immediately relevant to the lives of readers who walked the city streets to and from work, shops, theaters, and oyster houses.

Editors obsessed over timeliness so much that they let it dictate content. Yesterday's murder upstate was of little interest to an audience accustomed to "extra" editions reporting on that morning's ferry accident at the Battery. In general, proprietors of the penny papers did not belong to the social elite of New York. Working at a distance from the city's main corridors of power, they could not count on well-positioned friends to provide precious political and economic information; instead, they gathered news from the outside. "In practical terms this meant they had to hustle around town to find filler for their news columns, and the easiest information to come across was local news. . . . [R]eports of crimes and sermons, of fires or parties . . . of a sudden death . . . could be collected instantly by merely walking around town."[30] Newsboys and the extra were two ways that penny papers increased the speed of the news. Newsboys walked the streets bringing the news directly to passersby. As soon as a big story broke, editors wasted no time releasing it as an extra edition. "The whole process and atmosphere of the competition," one historian writes, "contributed to public awareness of, and interest in, news; hence, all participants in the race for news were winners."[31]

Though the telegraph promised to advance the populist attitudes of these papers, it did very little to democratize the content of the news. Even after the invention of the telegraph, news remained susceptible to monopolization. The telegraph was "both the road and the vehicle," and "control of telegraph lines implied control of the message traffic flowing through them."[32] Also, the telegraph transmitted information sequentially; each message had to be sent separately and in turn. Furthermore, cities like New York literally made the news: it happened and was reported there before it spread to outlying areas. For the most part, events that occurred in rural areas were not considered newsworthy. Though its implications were huge, the telegraph, practically speaking, never challenged the grip that large cities like New York and Baltimore had on information. (Nor did the telegraph help Melville with his correspondences. On 29 May 1846 he wrote to his brother, Gansevoort Melville, in London, a letter full of war fever: "People here are all in a state of delirium about the Mexican War. A military order pervades all ranks—Militia Colonels wax red in their coat facings—and 'prenticeboys are running off to the wars by scores.— Nothing is talked of but the 'Halls of Montezumas.' . . . But seriously, something great is impending. The Mexican War [tho' our troops have behaved right well] is nothing of itself—but a 'little spark kindleth a great fire' as the well known author of the Proverbs very justly remarks—and who knows what all this may lead to?" But Melville was too late. Gansevoort had died of a brain disease on 12 May, just one day before President Polk declared war on Mexico.)[33]

The telegraph's proponents nonetheless predicted that it would satisfy a growing appetite for connectedness. As early as 1838 Morse anticipated the modern notion of the

global village. It would not be long, Morse wrote, "ere the whole surface of this country would be channeled for those *nerves* which are to diffuse with the speed of thought, a knowledge of all that is occurring throughout the land; making in fact one *neighborhood* of the whole country."[34] Morse's rhetoric of the electrical sublime reflects the middle-class positivist ideology typical of the era: that "communication, exchange, motion brings humanity, enlightenment, progress and that isolation and disconnection are . . . obstacles to be overcome."[35]

Though Morse's global "neighborhood" never came together, one of the telegraph's tricks was to strip the "local, regional and colloquial" from journalistic language.[36] To keep from alienating readers from different parts of the country, papers standardized the rhetoric of the reporter, a development that would later irritate Ernest Hemingway. He admitted that his experience as a journalist influenced the literal language of his fiction; he said that he had to "quit being a correspondent" because he was getting "too fascinated by the lingo of the cable."[37] In addition, to keep costs under control, newspapers restrained their reports: bare facts replaced editorializing and analysis in news stories. In the end, the telegraph reduced the news to a commodity, "something that could be transported, measured, reduced, and timed."[38] This trend exasperated Thoreau, who wrote, "I do not know why news should be so trivial—considering what one's dreams and expectations are, why the developments should be so paltry. The news we hear, for the most part, is not news to our genius. It is the stalest repetition."[39]

In *War News from Mexico* Woodville embodied the telegraph's implications in a diverse cast of characters. On the surface, the news appears equally available to all the citizens—blacks, whites, men, women, and children. In fact, the information radiates out from the central figure, who holds and therefore controls the newspaper, to the individuals around him. This particular young American monopolizes the news because he is the one who reads it; he can choose what portions to paraphrase or omit and whether to alter the tone and pitch of his voice as he reads. The two older men who sit to his left—one whispers in the ear of the other, whom we presume is hard of hearing—further demonstrate this point. The news that the old man hears is filtered yet again, this time through the speech of his interpreter.

Woodville's painting is most commonly understood as a testament to the unifying power of the news industry, but in fact it speaks just as well to the struggle of individuals to conform to the new voice of journalism. Woodville, we must never forget, was a talented dissembler. Beneath the cooperation in this scene runs an undercurrent of apprehension. Almost everyone here, except the young man who reads the paper, strains to hear the news. The woman leaning out the window, the young man standing just beneath her, and the older man in the hat must all exert themselves physically just to hear the reader. And the spectacled older man in the rear tries to lean over the shoulder of the reader to see for himself what the paper says. The information here does not flow freely.

Because their clothes are torn and dirty, it is easy to overlook the fact that the black man and his daughter at the foot of the stairs wear a combination of red, white, and blue. The

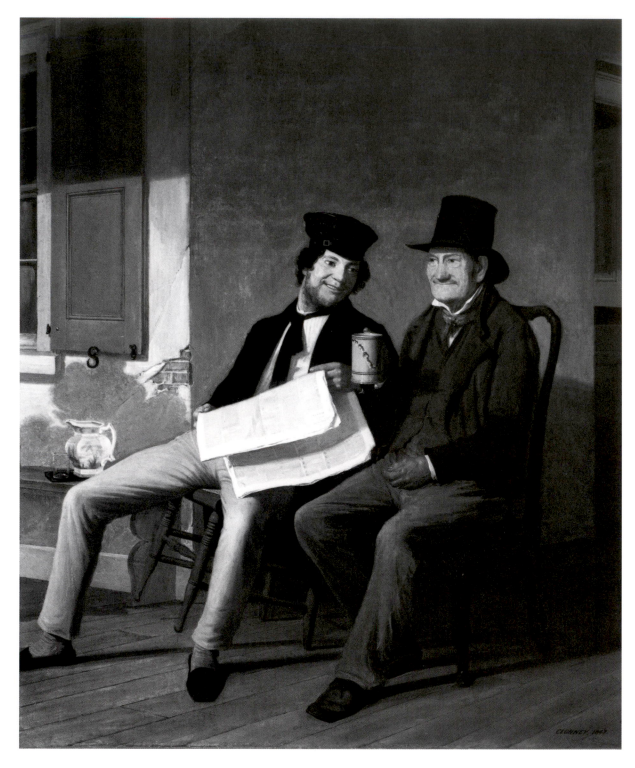

Fig. 60] James Goodwyn Clonney, *Mexican News*, 1847.
Oil on canvas, 26 ⅛ x 21 ¾ in. (67.6 x 55.2 cm). Munson-Williams-Proctor Arts Institute,
Museum of Art, Utica, New York, 66.73

irony is too glaring to be accidental. As blacks, these folks are not welcome in the "American Hotel," so they watch the action passively, from below the porch and outside the portico. At the time, the outcome of the Mexican War promised to have a larger immediate impact on the lives of blacks than on the lives of whites. What so many people wondered, or what so many blacks wondered at least, was whether slavery would spread to the new territories. Johns explains very well the contrast between these two calm figures and the bumbling cohort on the porch. "Given a psychological interiority denied other figures," she writes, "this humble and ragged pair share a destiny."[40] In a painting ostensibly about American ingenuity, Woodville made sure that his viewers would consider the ugly fact of slavery if only for a moment. At least one observer took notice. A writer in the Art-Union's *Bulletin* remarked on the "painful . . . truth with which the squalor and rags of the poor negro girl are rendered."[41]

Besides this couple, the only characters in the painting who react to the news without a modicum of enthusiasm are the woman and the old man. While the blacks sit away from the group, the woman, who presumably takes a break from her domestic chores to lean out the window, stays inside while she listens to the news. She looks sad, and Woodville likely intended for her to stand for those values that caused many women to disapprove of the war. That American families mourned the loss of fathers, husbands, and sons threatened the domestic ideal peddled in so many novels, journals, and artworks. In addition, though the old man's pensive expression may be a symptom of his poor hearing, in the context of opposition to the war it more likely testifies to his anxiety about American aggression (Woodville would flesh out this personification more convincingly in *Old '76 and Young '48* [fig. 63]). By contrast, the American Revolution, to which the man's age and costume link him, still echoed with virtuous principles. Seen in this light, his thoughtfulness takes on graver meaning. Perhaps he disapproves of the mood and comportment of his companions, who stick their elbows in his face and crowd him out. Instead of standing for inclusiveness, the old man suffers the consequences of the new, fast-paced information culture. His presence speaks for the many Americans who believed that the morally dubious Mexican War, and all the gloating that accompanied it, was destroying what the Revolution had made. Rather than striving for a transcendent idealism, this next generation was content to buy its opinions for a penny.

Though the painting did not reveal Woodville's politics, at least it broadcast his sympathies. The mood in his painting, for instance, deviates sharply from the one in James Goodwyn Clonney's relaxed *Mexican News* (fig. 60). While *War News from Mexico* celebrates many aspects of American society in 1848, it also issues an admonishment. Later on, in *Old '76 and Young '48*, Woodville returned to the themes and characters of *War News from Mexico* with more emphasis on difference and individual psychology, but he offers one final clue to his intent here. What are we to make of the figure to the far left in the painting, who prepares to drop a match into the barrel under the storm drain? Good sense tells us that the barrel is filled with water that has spilled off the roof, but surely Woodville wanted us to think for a second that it might be a powder keg. If so, the man's seemingly casual gesture

Fig. 61] Richard Caton Woodville, *Soldier's Experience*, 1844.
Watercolor and pencil on paper, 10 ¾ x 11 ¾ in. (27.3 x 30 cm).
The Walters Art Museum, Baltimore

contains a potentially explosive energy that threatens to fracture the trim, geometric unity of this scene. Thoreau, who detested spectacles, comes to mind yet again; he would not have been impressed by Woodville's ironic detail. "We should wash ourselves clean of such news" he wrote in "Life without Principle." "Of what consequence, though our planet explode, if there is no character involved in the explosion? In health we have not the least curiosity about such events. We do not live for idle amusement. I would not run around a corner to see the world blow up."[42] Thoreau, as usual, expressed the minority opinion.

◇

In May 1844, the same month that Morse presented his telegraph to Congress, and after Woodville had left the College of Medicine at the University of Maryland, he quit making his small sketches of friends and almshouse inmates and turned his attention to the small water-color *Soldier's Experience* (fig. 61). In terms of technique and narrative, Woodville had never before concentrated so much effort on the production of a single work. The picture marks a turning point in his career: although he continued to draw and make portraits, from this moment forward he was primarily a genre painter. Because Woodville borrowed several aspects of the drawing from other artists, it reveals to what extent he used Robert Gilmor's collection for inspiration. At the same time, the drawing testifies to Woodville's singular vision and imagination. Several of the picture's details and themes, in particular that of generational conflict, would distinguish Woodville's paintings throughout his career. Also, like so many of his other pictures, it looks cramped and parochial, though it refers to the outer world.

The drama unfolds in a living room crowded with people and the stuff of domestic life—a stove, a sideboard, a grandfather clock, chairs, and pictures, among other things. The drawing in fact is partly about the burdens of intimacy and the often suffocating universe of family, about which Woodville was acutely aware. In the picture, the young, wounded soldier addresses his mother, father, and grandfather; presumably he tells them war stories. The grandfather, whose musket, tricorn hat, and "1776" print hanging on the wall announce that he is a veteran of the American Revolution, listens to his grandson with a tinge of regret. The two men, both seated in chairs, square off at the center of the picture. The grandson may have come home with his arm in a sling, but he has not lost his fighting instinct; whatever point he drives home, he gestures emphatically with his right arm and rises out of his seat. Woodville turns that gesture into yet another stroke of irony, for we have to wonder what exactly he motions at. What, in other words, is his point?

Perhaps he raises his fist in frustration, but we suspect that he wants to direct his family's attention to something specific. But what could that be? His mother? The Revolutionary War print? The musket? Or the empty, black space behind the sideboard door? Whatever it

Fig. 62]
William Sidney Mount,
The Long Story, 1837.
Oil on panel,
17 x 22 in. (43.2 x 55.9 cm).
The Corcoran Gallery of Art,
Washington, D.C. Museum
Purchase, Gallery Fund, 74.69

is, his grandfather has had enough and seems to be shifting his weight in a move to leave the room. The mother and father do nothing to prevent this little skirmish; they appear torn between the grandfather's revolutionary principles and their son's hawkish spirit. Meanwhile, the dutiful family dog sleeps at the foot of the burning stove.

The themes of *Soldier's Experience* come from Woodville's own family life and from his interpretation of national events, but several of the picture's motifs derive from a single painting that he surely saw in Gilmor's collection. In 1835 or 1836 Gilmor had seen two of William Sidney Mount's paintings in Luman Reed's picture gallery and commissioned the artist to paint him a picture "of cabinet size."[43] New York audiences loved Mount's depictions of rural America, which reinforced their assumptions about country bumpkins. Mount came

from rural stock on Long Island, which to the minds of his middle-class admirers added authenticity to his paintings of country courtship, barn dances, and rustic living. The most popular and most successful genre painter of his day, Mount enjoyed the support of the American Art-Union and of some of the country's most elite patrons.[44]

Mount completed the commission during the fall of 1837 and sent *The Long Story* (fig. 62), along with a written explanation, to Gilmor. The healthy young man smoking a pipe is a "regular built Long Island tavern and store keeper . . . [who] has quite the air of a Citizen," Mount wrote. He added:

> The man standing wrapt in the cloak is a traveller as you supposed, and is in no way connected with the rest, only waiting the arrival of the Stage—he appears to be listening to what the old man is saying. I designed the picture as a conversation piece. The principle [*sic*] interests to be centered in the old invalid who certainly talks with much zeal. I have placed him in a particular chair which he is always supposed to claim by right of profession, being but seldom out of it from the rising to the going down of the sun. A kind of Bar room oracle, chief umpire during all seasons of warm debate whither [*sic*] religious, moral, or political, and first taster of every new barrel of cider rolled in the cellar, a glass of which he now holds in his hands while he is entertaining his young landlords with the longest story he is ever supposed to tell, having fairly tired out every other frequenter of the establishment.[45]

Though Mount does not say that the invalid storyteller is a veteran, Woodville clearly had this painting in mind when he began *Soldier's Experience*. Although Woodville places his figures in a domestic space, the room is similarly confined, and certain details—the wide floorboards, the stove and its box-shaped pedestal, the firewood on the floor, the old man's cane, the storyteller's emphatic gesturing—appear almost exactly as they do in Mount's painting. Most obviously, both paintings tell a story within a story and so share discourse as a subject. In treating the mechanics of storytelling the two painters understood that they were scrutinizing their own science. Accordingly, they ask pertinent questions about the subject: How are stories physically told? Who listens? Who cares? Does the truth matter? What does it mean to be literal?

Though Mount and Woodville share the visual equivalent of a phraseology, critical differences distinguish the two pictures and reveal some of what sets Woodville apart from his peers. For one, Woodville displays a *horror vacuii*, an almost agoraphobic sense of space, which physically and psychologically constricts his figures. In *Soldier's Experience*, as in most of his later paintings, the room is so cluttered that it barely holds its occupants. In only a few paintings does Woodville offer his figures a view out a window or through an open door. But his cramped, suffocating rooms are apt settings for his tense dramas, such as that between the grandfather and his loquacious grandson. Mount, by contrast, sets *The Long Story* in a

comfortable, proportional space, and his storyteller, the artist admitted, narrates an easy, humorous yarn.

Mount explained in his letter to Gilmor that the old man's truthfulness is in question; he has apparently "tired out" all previous listeners as well. But for his two temporary friends the truth does not matter. The value of the man's story depends entirely on the telling and whether it can kill the time until the stage arrives. The two listeners care little for authenticity; they want to be entertained. Mount, thankfully, was under no obligation to be solemn or especially didactic, but it was the innocuous quality of many of his paintings, the unstated but understood fact that no one would get hurt in his stories, that appealed to his admirers. It was in part for this reason that the press called Mount "the pride and boast . . . of the whole country" and asserted that paintings by "Bingham [and] Woodville," among others, could not "justly be compared . . . with the comic designs of Mount."[46] And it is for the same reason that Mount's paintings are called "benign" by one of today's prominent cultural historians.[47] Grubar saw something similar in Woodville's paintings, and in this picture in particular—a "warm human sentiment," he called it[48]—but Woodville was not a sentimental painter. The figures in *Soldier's Experience* interact passionately and vehemently; they have to, for unlike Mount's characters, who can pick up and move on, Woodville's are bound by the obligations of family.

Woodville offers few clues about what the two veterans in *Soldier's Experience* are so passionately disagreeing over. To understand the small family war being waged in this drawing, we must first determine where the young soldier was wounded and what cause he so zealously defends. When Woodville made this small genre piece, in 1844, the United States was not at war. The country was becoming embroiled in the conflict between Texas and Mexico, which would lead to the Mexican War in 1846, but at the time the urgent question for the United States was whether it would annex Texas—more a diplomatic than a military quandary. In 1845 the country did opt for annexation, causing war to break out. During and after the Mexican War, Americans entered into a rancorous debate about the integrity of the country's motives. People from the same neighborhoods with similar political allegiances, people from the same family even, would come to disagree on the matter.

But more current to the time when Woodville produced this watercolor was the Second Seminole War, a vicious and controversial conflict that had ended in 1842 but continued to resonate in the public's consciousness. Encouraged by the bellicose Major General Andrew Jackson and desiring control of Spanish territory, the United States had waged war on Florida's Seminole Indians since the early nineteenth century. Georgia commenced a systematic attempt to take Florida from Spain in 1811, and the Seminoles, who were often the victims of these border raids, fought back with the consent of the Spanish government.[49] Raids and counter-raids continued until early 1818, when Jackson, with the help of the Creek Indians, pushed into Florida, overwhelmed the Seminoles, and forced them onto land in the center of the state. The stage was set for a second full-scale war before Spain ceded Florida to the United States in 1821.

By 1830 Florida had a population of almost 40,000—18,000 whites, 15,000 slaves, 900 free blacks, and about 4,000 Native Americans. The United States quickly learned of Florida's naval and agricultural potential, and speculators eager to purchase cattle land and to capitalize on the production of sugar, cotton, rice, and rum wanted the Seminoles driven out of the territory. The Seminoles, a nation of wanderers (*Seminole* means "runaway") from other Southeastern tribes, including the Creeks and the Miccosukee, resisted. Believing they were protected by the 1823 Camp Moultrie Treaty, which guaranteed them at least twenty years of protection, food, and clothing in return for their confined settlement on a reservation, the Seminoles scoffed at the government's requests that they relocate. These events were recorded in 1836 in Woodburne Potter's book *The War in Florida* (published in Baltimore), which criticized American diplomacy in the region.[50]

After white settlers initiated a campaign of intimidation, which was largely ignored by Congress, the Seminoles responded by crossing their reservation's borders, robbing homes, and slaughtering cattle. Most horrifying of all, white settlers and Seminoles commonly abducted and murdered each other's black slaves in brutal acts of retaliation. The conflict yielded no shortage of terror, but the correspondence between Seminole chiefs and American officers before the outbreak of war makes it sound more like a schoolyard spat. In a letter to the commanding officer at Fort Hawkins, Chief John Walker wrote, "The white people killed our red people first—the Indians took satisfaction. There are three men that the red people have not taken satisfaction for yet. There is nothing said about what white people do—but all that the Indians do is brought up." The United States signed, then ignored, a second treaty, the Treaty of Payne's Landing, in 1832, and afterward terrorism reigned in central Florida. Negotiations failed to appease either party.[51]

When two Seminole factions turned against each other in 1835, the United States saw an opportunity to intervene and commit forces to the area, thus commencing the Second Seminole War. The war in Florida, which lasted seven years, was hard fought and costly. Combatants fought hand to hand, relying on ambushes and other guerrilla tactics. Much of the fighting took place in waist-deep, alligator-infested swamps.[52] The press wrote unconfirmed reports about Seminole warriors disemboweling and mutilating the bodies of American troops. Certainly, both sides suffered terrible casualties.[53] In *The War in Florida*, one of the first accounts of the causes and facts of the war, Potter provides grisly details of the most horrific battles. In one passage he describes the dead bodies of several officers: "That of General Thompson was perforated with fourteen bullets, and a deep knife wound in the right breast. Those of Lieutenant Smith and Mr. Kitzler had each received two bullets, and the head of the latter was so broken that the brains had come out."[54]

Whether Woodville was acquainted with Potter's book or perhaps knew a surgeon who had served in the war, the Seminole War seems the most likely source for *Soldier's Experience*.[55] As Potter makes clear, the conflict inspired plenty of storytelling, both fact and fiction. Most citizens knew about the famous Battle of Okeechobee, the 1837 clash that made Zachary

Taylor a war hero, but at the cost of many members of Missouri's volunteer corps. The soldiers who survived these battles came home with terrifying stories, which they told only in the company of family. We might presume that Woodville's wounded soldier describes the moment of his injury; in that case what, we wonder, provokes sadness in his grandfather, who is himself a veteran?

Potter's account of the war emphasizes to what extent both American officers and civilians opposed it. For many, American treatment of the Seminoles during the 1830s and 1840s was as egregious an example of dishonesty and avarice as the Mexican War would be. Opposition to the war stemmed not so much from sympathy for the Seminoles as from shame over the underhanded schemes of a country as principled as the United States. Potter, for instance, found the government's disregard for the Camp Moultrie Treaty contemptible. "Oh tempora, oh mores!" he writes, "how degraded must we be when we prove faithless to our obligations with weaker powers!"[56] Potter cites numerous instances when the U.S. government, specifically President Jackson and Secretary of War Lewis Cass, broke promises made to the Seminole nation. His book is a thinly veiled indictment of American policy in Florida. In several instances Potter insinuates that Secretary of War Cass refrained from sending more troops to Florida in the months before the war (as requested by his officers) in order to trick the Seminoles into believing they had an edge, which would keep them from surrendering. Whether a tactic or not, this permitted American troops to wipe out the Seminoles in battle, thus saving the country the expense of resettling the tribe.[57] Some officers disapproved of the country's handling of the Seminoles. Potter cites letters written to Cass and Jackson by several officers stationed in Florida expressing an abhorrence for their orders.

Writing just after the conclusion of the war, Jacob K. Neff, a military historian, also excoriated the government. "The Florida war consisted in the killing of Indians, because they refused to leave their native home," Neff writes. "Many a brave man lost his life and now sleeps beneath the sod of Florida. And yet neither these nor the heroes who exposed themselves there to so many dangers and sufferings, could acquire any military glory in such a war."[58] John T. Sprague recorded a number of eloquent Indian speeches he heard in Florida in 1841 and then published them in a book several years later. Coacoochee, known as "Wildcat," was a Miccosukee and a defiant leader during the war. In 1841 he was captured, put in chains, and forced under threat of hanging to make a speech urging his people to surrender. Sprague published the speech in his book, and it became one more testimonial to atrocities in the region.[59]

Public outrage against the war helps explain the grandfather's reaction to his grandson's pugnacious narrative. *Soldier's Experience* was the first act in Woodville's dramatization of the conflict between republican virtues and imperialist aggression. The grandson, the voice of expansion, cannot convince his grandfather, the old guard of the Revolutionary era, that the nation has lived up to its promise; the patriarch senses that the ship of the state he once served has veered off course. In the picture, Woodville mirrors a heated national debate; he stresses the urgency of the question by making it a family rather than a public

affair—more is at stake here than barroom friendships. Who does Woodville side with in this debate? Perhaps that is beside the point. What matters is the picture's topicality, its reworking of Mount's genre formula into an unsentimental and incisive drama. Nevertheless, it certainly appears that Woodville allies himself with the grandfather, the harried old veteran, who, despite his infirmity, is the only figure in the picture taking action. While the grandson prattles on and the mother and father just listen, the grandfather puts weight on his cane and gets ready to stand and walk out of the small room. Is anything resolved or reconciled in the picture? The answer to this question only became more muddled when Woodville returned to the subject five years later in *Old '76 and Young '48*, perhaps his most cryptic painting.

◇

In *The War with Mexico Reviewed*, published just two years after the war, Abiel Abbot Livermore wrote, "'War and the Fireside'! how contrasted, and yet how connected! One, the name of everything most awful in passion, pain, vice, outrage, and death; the other, the name of all the sweetest joys, hopes, possessions and associations out of heaven."[60] Woodville invoked similar sentiments in *Old '76 and Young '48*, painted in 1849 (fig. 63). The painting, like Livermore's lamentation, visualizes two realms separated by a great divide, and like the telegraph, it connects them with a current, only of a psychological rather than an electrical impulse. The picture's power comes from its unusual equivocation, which is another example of Woodville's skill as a penetrating interrogator. The story he tells here is not easily coopted by the "mythopoetic" accounts of the antebellum era, which sell parables about a period of compulsory expansion and triumphant soldier-explorers (see fig. 64).[61] But the New York press overlooked the painting's complexities. The *New York Herald* praised it as an "excellent composition," and none other than Whitman himself described it as a "pleasing piece, painted in a very subdued manner." The mother, he added, and the "Old '76er are beautifully done." *The Literary World* called it a "rare Woodville," and the Art-Union praised it as "one of the best works of this distinguished artist, and it abounds with feelings that will touch the hearts of all who see it."[62]

In June 1850 the *Bulletin of the American Art-Union* announced the Art-Union's reception of Woodville's latest accomplishment. The analysis, both a fanciful description and an appraisal, dulls the painting's sardonic edge:

> In point of form and character it fully sustains the reputation of this artist. In color, it is, perhaps, a little dry; but this may be less observable after the painting shall be varnished. It represents a young officer, just returned from Mexico, describing to his family some of the scenes of the war. One of the most attentive listeners is the old

Fig. 63] Richard Caton Woodville, *Old '76 and Young '48*, 1849.
Oil on canvas, 21 x 26 ½ in. (53.3 x 67.3 cm). The Walters Art Museum, Baltimore

grandfather, whose portrait, in a military dress, on the wall, as well as a bust of Washington over the book-case, announce him to be a Revolutionary veteran. The other characters are the father, mother, and sister, and several black servants, whose lively curiosity has gathered them in a group at the door. The young man is seated at a table upon which some refreshment has been prepared for him; but he turns away from this, and with the most animated air and earnest gestures, describes the perils he has encountered. The others listen with expressions of affectionate interest. The whole subject is presented in the most touching manner, while at the same time the details are painted with great precision and delicacy.[63]

At a time when several European cities, Düsseldorf among them, witnessed a radical liberalism, both European and American artists idealized the American Revolution. Meanwhile, supporters of the Mexican War, in order to deflect criticisms from peace activists, resuscitated the rhetoric of the founding fathers and reminded citizens of the nation's destiny. This veneration of the nation's elders was part of a broader nostalgia that manifested itself as a sentimental patriotism. In his 1842 story "The Last of the Sacred Army," for example, Whitman implored his readers, "The memory of the Warriors of Freedom—let us guard it with a holy care." Later, a philosopher counsels the story's dreaming narrator, "The model of one pure, upright character, living as a beacon in history, does more than the lumbering tomes of a thousand theorists."[64] Whitman's tale, one of his biographers points out, was as "jingoistic and lachrymose as anything by his fellow authors."[65] Many of the paintings being shipped from Düsseldorf to New York reflected these themes and, as one author recently put it, "served to reinforce in the public mind America's right to claim a special understanding of liberty and to qualify for the role of moral magnet"; the paintings functioned as "goads to national righteousness and beacons of future triumph."[66]

Emanuel Leutze's *Storming of the Teocalli by Cortez and His Troops* (fig. 65) is a sensational but scrupulous rendering of the ultimate battle in Cortez's conquest of the Aztec empire. In Leutze's words, the painting represents "the final struggle of the two races—the decisive death-grapple of the savage and the civilized man."[67] Leutze's reference to Cortez's sixteenth-century campaign in the same year that the United States won the Mexican War is a plain boast. But Leutze, who painted in Düsseldorf from 1841 until 1859, years during which the Mexican conflict began and ended, was removed from the diversity of American views on the war. As a result, his painting appeared over-excited in its chauvinism, and critics reprimanded its immodesty. The *Bulletin of the American Art-Union* praised the work's technical

Fig. 64]
The Soldier's Return: A Song for the People, 1848. Lithograph. Special Collections Division, The University of Texas at Arlington Libraries

Fig. 65] Emanuel Leutze, *The Storming of the Teocalli by Cortez and His Troops*, 1849.
Oil on canvas, 84 ¼ x 98 ¾ in. (215.3 x 250.8 cm). Wadsworth Atheneum, Hartford, Connecticut.
The Ella Gallup Sumner and Mary Catlin Sumner Collection Fund

merits but recoiled from its egotism. "In this work nothing mitigates the terrible ferocity of the action—not even the figure of the monk, whose misguided ideas about the true spirit of Christianity destroy our respect for his devotedness," the anonymous critic remarks. "On all sides are the glaring eyes and bloody hands of a mortal combat, and all the most ferocious passions that can agitate the human heart—the thirst for gold—the blind fanaticism—the relentless cruelty of the Spaniard, and the disgusting superstitions and horrid rites of the Aztecs, which obscure from our view the bravery of his defence, and take away all our pity for his fate."[68] Racist he may be, but the author is embarrassed by Leutze's unabashed worship of violence and conquest. Though the Art-Union was populist in spirit, a majority of its officers were Whigs, and these remarks may be symptomatic of a discomfort with the war and with the course of the empire in general. Leutze, a Democrat, had misjudged the currency of these concerns.

Just as the Mexican War prompted a boom in penny papers, it also spawned the publication of hundreds of pamphlets and books. Even before its end in 1848 organizations and individual authors weighed in on the causes, consequences, and motives of Polk's short war. A number of military memoirs and government-sponsored volumes justified the war and celebrated the nation's decisive victory, and an equal number challenged it on moral and political grounds (see fig. 66). So vehement and widespread were arguments against the war and the government's ambitions that the situation qualified as a national crisis: political parties divided, tensions between the North and the South heated up, and family members feuded in parlors across the country. In churches, newspapers, clubs, and associations the war forced Americans to reconsider the responsibilities of the republic. Since debates about the war were fueled with political rhetoric, any statement for or against it appeared to be a broad ideological proclamation. It was in this context that Woodville, by way of his painting *Old '76 and Young '48*, made the most blunt political gesture of his career.

Regardless of Whitman's observation that the painting was "subdued," the *Bulletin of the American Art-Union*'s regard for its "affectionate" and "touching" airs, and a later interpretation calling the painting "artificial," in *Old '76 and Young '48* Woodville exhibits a sensitivity to the arguments by the likes of William Jay and Livermore against the Mexican War.[69] However, partly because the painting was produced under circumstances so similar to those of Leutze's painting, it has assumed some problematic meanings. For years, historians of American art have overlooked its anomalies and quirks by reading the painting as sweetly patriotic or at most a domestic quarrel without public consequence.

A dependence on elemental hierarchies—old and young, male and female, black and white, aggression and impotence—and an unwillingness to reconcile them lies at the heart of the painting's tension. The two veterans, resurrected from their roles in *Soldier's Experience* (fig. 61), square off once again. The issue this time, no doubt, is the Mexican War. Old '76, a popular personification of revolutionary principles, frequently appeared as a defeated reactionary. In one illustration from *Harper's*, a blind Old '76er sits dejectedly in the background

Fig. 66]
Incidents and Sufferings in the Mexican War, 1848. Engraved pamphlet. Special Collections Division, The University of Texas at Arlington Libraries

of a bustling New World full of transitory spectacles that he can neither see nor comprehend (fig. 67). In Woodville's painting, Old '76, who sits still and silent in his chair, again looks defeated; he is no longer an agent acting on American politics but a passive witness to a new era. His grandson, by contrast, personifies the active voice of Young America; he stabs the air with his finger to make his point. Each remains obstinate: while Young '48 gestures and delivers his pronouncements, Old '76 ponders the family dog lying at his feet, who is far more accommodating than his grandson.[70] Joseph J. Ellis recently described the impulse of republican principles in terms that elucidate what Woodville's Old '76er might be thinking about: "The original 'spirit of '76,'" he explains, "was an instinctive aversion to coercive political power of any sort and a thoroughgoing dread of the inevitable corruptions that result when unseen rulers congregate in distant places."[71]

The Five Senses.—No. I. Seeing.

A veteran of the Revolution similar to Woodville's Old '76 appears in George Caleb Bingham's *The County Election* (fig. 68). Bingham also uses the character to question the legacy of the American Revolution during the antebellum period. Among the merry and drunken voters in the painting one figure stands apart. A hunched and faltering man descends the courthouse stairs, working his way against the upward flow of the crowd. The downward motion of this infirm revolutionary contrasts with the jubilant, rising tide of younger America. Bingham complicates the Revolution's legacy by placing Old '76 at the center of the scene. On the one hand, he functions as the axis around which the composition revolves; the democratic process, Bingham reminds us, would not be possible without his sacrifices. On the other hand, no other figure in the painting acknowledges his presence, let alone offers him a hand. "'Old '76,' souvenir of the United States' own successful overthrow of despotism, is a mark of national pride in Bingham's *The County Election*," Gail E. Husch writes. "He reminds modern viewers of their heritage, but, old and frail, he also warns them of their responsibility."[72]

In *House of the Seven Gables*, written the same year Bingham made his painting, Nathaniel Hawthorne comments, "As a mere object of sight, nothing is more deficient in picturesque features than a [political] procession." Regardless of what one scholar has called a widespread distaste for the messy facts of the political process at the time, most of the figures in Bingham's picture engage wholeheartedly in the voting process.[73] Moreover, they assume responsibility for the few ailing figures who do not, or cannot, vote, which seems to indicate that democratic ideals are alive and well in Bingham's United States. These voters may be self-absorbed and boorish, but they mean no disrespect to the painting's aging hero. "The tension suggested in Bingham's *The County Election*," Husch concludes, "is . . . more palpable

Fig. 67]
The Five Senses—No. 1, Seeing, 1854.
Wood engraving, in *Harper's New Monthly Magazine* 9 (Oct. 1854).
American Antiquarian Society, Worcester, Massachusetts

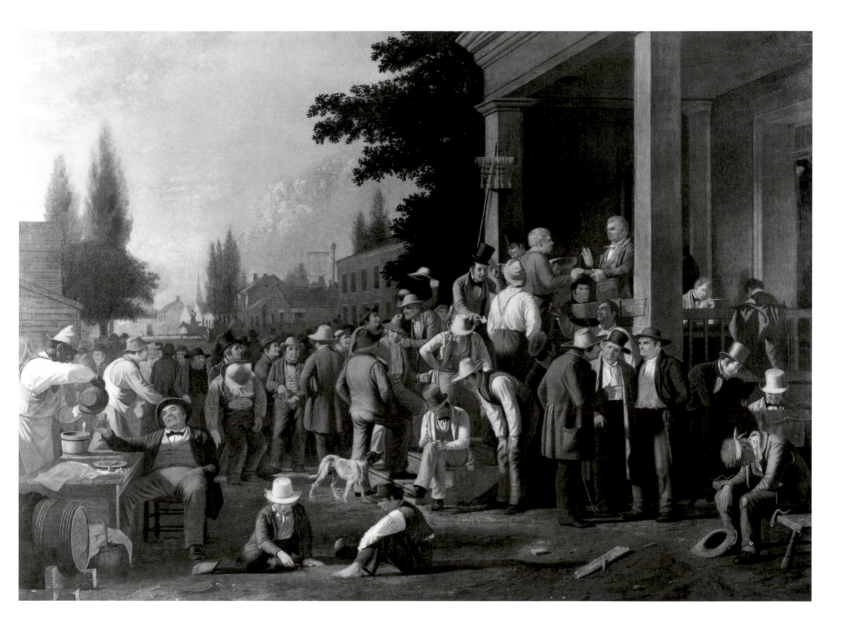

in Richard Caton Woodville's *Old '76 and Young '48*, which offers no reconciliation between the days of General Washington and General Taylor."[74]

 Old '76 and Young '48—the painting's antagonisms are spelled out clearly in the title. The old are wise—fidelity is the issue that matters—while the young are hasty and presumptuous. What Young '48 appears to say as he points to his grandfather's portrait (though we should ask again if that is really where he points) is that he and the war he defends issue directly from the founding fathers. Old '76 is not so sure. By personifying actual historical dates from different centuries, Woodville emphasizes the painting's theme of conflict, but then he refuses to provide a solution to this human equation. He withholds any visible sign of

Fig. 68]
George Caleb Bingham
(AMERICAN, 1811–1879),
The County Election, 1852.
Oil on canvas, 35 ⅞₆ x 48 ¼ in.
(90 x 123.8 cm).
The St. Louis Art Museum. Purchase

reconciliation. The painting, in other words, ignores the fundamental principle of deference to elders. Disrespecting his grandfather's averted gaze, Young '48 reverses customary family dynamics and rebukes his older relative. Rather than functioning as agents of reconciliation, the mother and father exacerbate the feud by doing nothing. Despite the father's position at the apex of the pyramid and as the titular head of the household, he stands as a neutral figure in this domestic skirmish. The mother also plays an ironic role in this house. Certainly she does not display any of the frank sadness seen on the face of the woman leaning out the window in *War News from Mexico*. In fact, she looks upon her son with a slight smile of devotion, a small gesture but a provocative one too because it does nothing to conciliate the anxiety of the moment.

In a long poem titled "The Veteran of Seventy-Six," which appeared in the *Knicker-bocker*, Richard Haywarde dramatized the kind of conciliation between veterans and their families that audiences expected. For the encouragement of a group of soldiers about to charge in the Battle of New Orleans, General Andrew Jackson's most decisive victory during the War of 1812, the '76er paints an inspiring picture:

> Homeward now, the wars are over; homeward, never more to rove;
> Ah, what memories cluster round me! Ah, what promised transports move!
> Fireside faces—homestead gossips—mother's blessing. . .
> On and ever onward bore me.[75]

In Woodville's painting, by contrast, old and young, past and present, male and female are released from their balancing functions in relationships. The divorce of these traditional pairs exposes the visual cohesion of Woodville's pyramidal unit as a decoy that masks the family's dysfunction. Every detail of the painting is a conspirator in this subversion of domestic politics. The art on the parlor wall speaks to the past, but the clock on the sturdy marble mantel tracks only the present moment; its pendulum, in motion and off center, emphasizes the present's power over the past and thus dismantles any hope for the reconciliation of the antithetical positions personified in the painting.

The painting subverts conventions of the antebellum family. Johns explains how female figures in genre paintings function mainly as aids to male narratives of identity. For men to conform to popular social expectations, they needed "sweet domestic influence in the parlor and female subservience to male authority." Genre paintings presented this gender relation as something arrived at naturally; in them, women often enjoy their chores, or their "privileges."[76] While men bargain for horses, discuss the day's news, and consider their political allegiances, women work to maintain clean homes and the respectability and morality of the family. The female moral reform movement, though by no means the most radical expression of feminist ideals during the antebellum period, did provide women with links to antiwar, abolitionist, and other progressive modes of thinking. Women brought a new authority home

from their societies, and whether radical or not, middle-class wives and mothers exerted a powerful influence on how their families thought and behaved. A. J. Graves was one female moral reformer of this middling sort. She rejected excessive expressions of feminism but believed that women alone possessed the strength to keep families together. She seemed to predict the exact composition of *Old '76 and Young '48* when she wrote in 1843, "We need not follow the American [man] to his place of business or to political meetings—we have only to listen to his fireside conversation. It might be supposed that the few waking hours he spends at home in the bosom of his family, he would delight . . . upon such subjects as would interest and improve his wife and children." But, Graves regretfully reported, such was not the case. "In place of this, what is the perpetual theme of his conversation? Business and politics, six percent, bank discounts." In a changing, chaotic society—thousands of American men had been lost to the recent war with Mexico and to migration to California—the fireside emerged as a refuge and, according to Graves, a place where women could do their moral work: "The great principles of liberty and equal rights . . . have penetrated even into the quiet havens of domestic life," she writes. "While men are fiercely contending for their prerogatives upon the world's arena, without seeming yet to have settled what should be their relative position in regard to each other, women have come forward to claim immunities which ancient usage has long denied them."[77]

Woodville did not philosophize on gender—his world, to be sure, was a male one—but *Old '76 and Young '48* glances off Graves's commentary and shows some of her notions in action. She wrote about the conflict between male and female work; a man's employment, in her analysis, must be balanced by a woman's work, which was to keep a home in order despite the mess a man might make of it. That work, Graves argued, was important and empowering even if it was not as manual as a man's. Woodville, we have seen, was not a reporter of the imagined facts of antebellum life; he was, rather, a tattletale bent on exposing the era's duplicities. However, the action pictured here most likely did play itself out in any number of antebellum parlors. So, we might ask, what work does the young soldier's mother do?

These men, we see, are stripped of their conventional masculinity. The grandfather needs physical supports, a high-backed chair and a walking stick, and the father's passivity and indecisiveness diminish his authority. Meanwhile, injury cuts short the son's youthful virility—his sword is cast aside on the floor. This impotent group frames the figure of the mother, who occupies the exact center of the painting. Poised to mediate the debate and maintain domestic order, she holds the group together visually and metaphorically assumes a position of power. So while Woodville emasculates his men, he appears, at first anyway, to portray a female character of the morally active kind, a woman situated to act for her family's sake. But like her husband, she does nothing, and her paralysis permits her son's harangue to continue and thus contributes to the home's disorder. This particular fireside is more like the kind described in 1849 by Lynn Pioneer, writing for Amelia Bloomer's feminist journal *The Lily*: "How many 'homes which are no homes!'" she exclaims. "It is enough to make one sick

to look at it. Not one home in ten is deserving of the name. And what wonder! Look at it . . . [a man] consoles himself with cigars, oysters, whiskey punch and politics; and looks at his 'home' as a very indifferent boarding house. . . . Young folks get their ideas of the holiest relation in life from the novel. Or when this is not the case, they, in most instances, have no idea at all of it, but are governed in their choice and conduct by their feelings, their passions, or their imagined interests. . . . The terrible retribution is seen in myriads of discordant and disordered households."[78] Woodville illustrates all the elements of Pioneer's "discordant household"—the indifferent father, irascible youth, material excess—but replaces the conventional female peacekeeper with a woman who does not work for her family or on her family in the manner that Woodville's audience might have expected.

Old '76 and Young '48 is composed around an X. In most cases, X marks the spot; in Woodville's ironic hands, however, the crossing elements become a mark of nullification. The compositional slopes of the painting converge on the mother's face. So, what sits here? Does she keep the family together? Ultimately her expression is as enigmatic as the painting; her almost imperceptible smile an act of support that does little to close the gap between the young man and his grandfather. Wolf maintains that "history in Woodville becomes *myth* only by forgetting its difference from the present."[79] The evidence in *Old '76 and Young '48*, however, testifies to the irreconcilable differences between America's past and present, a testimony that contradicts, or exposes as myth, those attitudes prevalent during the antebellum period that presupposed the past's blessing of its enterprises. The X in the painting does not mark coherence; instead, it locates the disintegration of this family. The son's gesture then becomes even more mysterious. His fingertip rests directly on a point on one of the diagonals dividing the painting, as if to say: "There. That is what I mean. Don't you see?" But no one does; no one looks at his hand. The gesture is ignored, treated not as signifying something but as a mannerism.

Comparing the family that Woodville depicts in *Old '76 and Young '48* with the one Mount describes in his 1852 painting *Great Grandfather's Tale of the Revolution (A Portrait of Reverend Zacariah Greene)* (fig. 69) blatantly reveals the differences between Woodville and his contemporaries. Mount's painting provides a sentimental antidote to Woodville's conflicted family: the grandfather relates his war stories from the American Revolution to a brood of reverential youths, who listen intently and respectfully. To be sure, Mount also made pictures that engaged difficult aspects of antebellum social, political, and economic life, but more often he gravitated toward the reconciliation of past and present. Woodville, on the other hand, almost always recognized social disintegration, and this, finally, is what distinguishes the two artists.

Pioneer's notion of a "disordered household" provides a context in which to consider Woodville's politics in *Old '76 and Young '48*. Few of Woodville's paintings, we have seen, are laden with the kind of political symbolism used by authors like Melville or by other genre painters, such as Mount or Bingham. *Old '76 and Young '48* is an exception to that rule: the

Fig. 69
William Sidney Mount,
Great Grandfather's Tale of the Revolution (A Portrait of Reverend Zacariah Greene), 1852.
The Metropolitan Museum of Art, New York. Purchase, Morris K. Jesup and Maria DeWitt Jesup Funds, Gift of George I. Seney and Bequest of Vera Ruth Miller, by exchange, and Gift of Anita Pohndorff Yates, in memory of her father, F. G. Pohndorff, 1984 (1984.192)

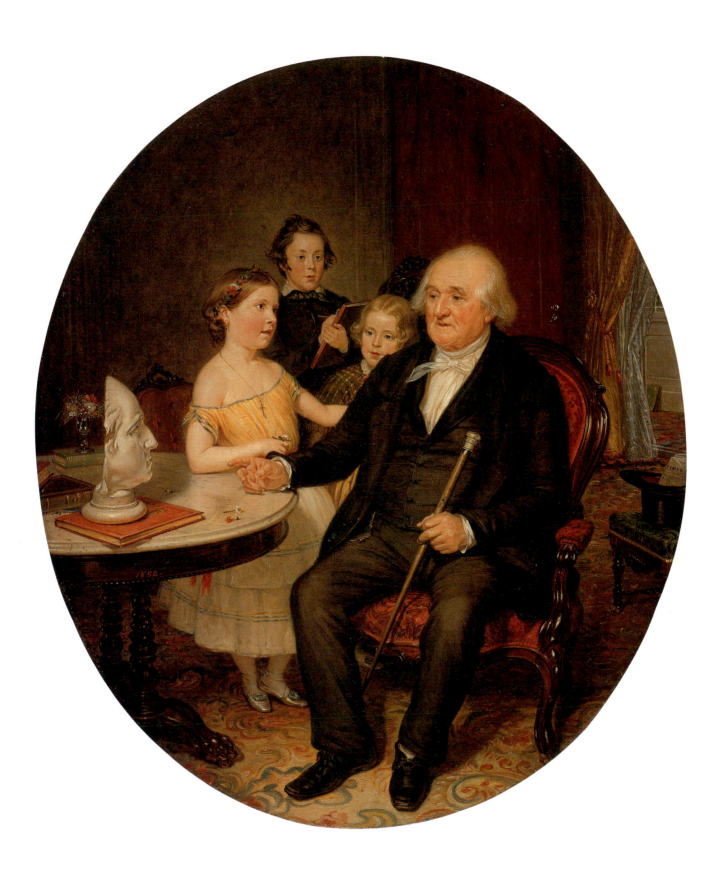

painting clearly illustrates the damage the Mexican War inflicted on America's republican principles. Not only did Woodville strike a Whig pose here but he illustrated his opposition by using a political rhetoric common to the period. Writing about partisan bickering over expansionism, the literary historian Alan Heimert declared, "Here precisely was the Whig indictment of the apostles of Manifest Destiny: they were causing America to forsake its household gods in a senseless quest for the sublime. . . . The Democracy was encouraging an 'itinerant desire' in American breasts, making people discontent with 'familiar objects of devotion,' and luring them from 'the domestic altar' into worship of 'strange idols' not unlike 'the Baalim' of an earlier age. The Democratic prospect of empire was grand and vast, but the Whigs cherished their less-troubled bookkeeper's vision of national prosperity."[80] Whigs saw the war as an attack on the American home. By intoxicating the nation's youth with grand visions of extraordinary new lands, Democrats lured them away from the country's traditional icons, which were not just grandparents and the home itself but the portraits and busts of George Washington and other Revolutionary War heroes that hung in those homes. Woodville's painting illustrates this type of defection: rather than absorbing the principles of his elders, Young '48 imposes on them the beliefs—the "strange new idols"—he picked up on the western battlefield. In Woodville's picture this desertion undermines the family's unity.[81]

Though Woodville appears to align himself with Whig principles in this painting, we cannot say that Woodville was a loyal member of the Whig Party. *War News from Mexico*, for example, makes a statement more in keeping with Democratic principles: it captures the excitement, the jubilation, and the masculine showmanship that accompanied each of the country's victories in western territories. Woodville, it seems, may have been capable of making political statements on the Mexican War, but he was not a political creature. In the end, Woodville, like so many other antebellum citizens, probably found it impossible to maintain political allegiance to the Democrats, the Whigs, or their various factions. At any rate, *Old '76 and Young '48* depicts the sad vandalism of "the domestic altar" and the erosion of household bonds, both of which Whigs publicly decried.

◈

In the painting, what the *Bulletin of the American Art-Union* called the family's "black servants" stand at the door behind the table. In her book on American genre painting, Johns includes a chapter on images of blacks titled "Standing outside the Door." It is worth pointing out that while the blacks in *Old '76 and Young '48* group themselves by a door, they actually stand in front of its frame. The group is simultaneously part of the family—they listen with interest to the drama—and completely alien to the family; they have no voice here, even

though the Mexican War will affect their families the most. Though likely not a conscious symbol, Woodville's placement of the blacks in *Old '76 and Young '48* on a threshold is an apt metaphor for his home city of Baltimore, where we might presume the painting is set. The citizens of Maryland, a slave state that eventually defected to the Union, divided over the question of slavery. In Woodville's hands the door does not stand simply for exclusion; it becomes another ironic detail. The black figures here are both dissociated from the debate and central to it; they are not perpetrators but key witnesses.

The Maryland colonizationist Robert Goodloe Harper, a son-in-law of the venerable Charles Carroll of Carrollton, was a distant cousin of Woodville's. In fact, Woodville's parents named him after Harper's brother-in-law. In addition, John H. B. Latrobe, who purchased *Politics in an Oyster House*, was a friend of Harper's and studied law with him.[82] These connections are important because they show that Woodville was probably familiar with some of the most heated and provocative debates in the country about slavery. One of Harper's main interests, for example, was black education and literacy. Harper believed that blacks and whites were equal races and that education alone separated the two groups: the "powers" and "advantages" of both races came not from "birth" but from "the endowments of the mind." As a young lawyer, Harper spoke and wrote frequently about race and slavery, something he despised but did little in the end to overthrow. He continued, for example, to draw up bills of sale for slave owners.[83] In 1794 he was elected to South Carolina's Fourth Congress, where he argued against slavery on ethical grounds, but his political aspirations prevented him from ever committing to emancipation. After retiring from politics in 1801, Harper moved to Baltimore—the "middle ground"—and became the city's preeminent lawyer. His marriage to Catherine Carroll assured him a lavish allowance, but Harper did not withdraw into his privilege; he was interested in social issues and continued to mull over the problem of slavery.

Harper opposed slavery, but he feared releasing blacks, who were poor and uneducated, on American society. He argued, for example, that the "horror" felt by whites at the "idea of an intimate union with the free blacks precludes the possibility of . . . a state of equality." After various activities, including serving the Washington Society of Maryland as president, fighting bravely at the Battle of North Point in 1814, and sitting briefly as Maryland's senator in Washington, Harper returned to Baltimore in 1817 and committed himself to the cause of African colonization. His most important tract on this matter was a widely circulated letter to the American Colonization Society, in which he wrote, "You may manumit the slave, but you cannot make him a white man," for which reason blacks were "condemned to a state of hopeless inferiority and degradation."[84] Harper then was able to cloak his racism in a democratic rhetoric, asserting that yes, blacks were inferior, but they were not born that way. Harper's middling position, which reflected that of the state of Maryland, did little to ameliorate the divisive controversies of slavery. At the time of his death in 1825 Harper's own twenty-seven slaves remained in bondage.

In the abovementioned letter by Woodville's cousin Richard Jackson describing life at Richard Caton's estate, Jackson mentions several "darkies" in his room putting water in the tub, stirring up the fire, brushing his clothes, and "kicking up a devil of a row." Whether through the presence of slaves and black servants in his own home or through his family's association with Harper, the young Woodville was exposed to Baltimore's blacks and to the debates in the city about slavery. Also crucial to the artist's sensibility was the large number of both slaves and free blacks who lived in Maryland during his youth. Baltimoreans lived side by side with blacks; they heard the songs of domestic slaves and the cries of the famous Baltimore street vendor "Old Moses," who sold ice cream and oysters on the city streets.[85] Woodville included black figures in a number of his paintings, and though his treatment of them fluctuated between sincere sympathy and typical prejudice, he understood that questions about slavery and race had profound social and political implications. This, for Woodville, was another of Baltimore's legacies.

In another provocative letter, from William Wirt, the U.S. attorney general during the 1820s, to his daughter, Wirt describes Harper's sudden death from a heart attack. "On Friday morning," he wrote, "[Harper] was again well, had eaten his breakfast as usual, and was standing up before the fire, reading a newspaper, when death struck him in the manner I have mentioned. No one was in the room but his son, a fine young man of nineteen, and a little negro boy."[86] The scene Wirt set here, with the parlor fireplace and the servant, prefigures Woodville's painting, and Harper's room was likely filled with furniture resembling that in the picture. Charles Carroll of Carrollton had begged Harper, his son-in-law, to moderate his lavish expenses and "cease ordering any more . . . furniture." "In all likelihood," Eric Robert Papenfuse notes, "the room where Harper died was adorned with imported fabrics, elegantly crafted chairs, and intricate plaster moldings. What would 'the little negro boy' have thought as his master stood before him 'uncommonly erect' amidst this opulent display of wealth and finery?"[87] It is wise to ask the question from the point of view of the black boy because even though the similarity between the scene in the letter and that in the painting speaks to little more than popular interior designs, all three men—Harper, Wirt, then Woodville—paused to consider the place of blacks in American society. Wirt and, in particular, Woodville emphasized race through that ironic act of stress wherein what is placed on the margins assumes (the most) significance. In Wirt's letter, as Papenfuse points out, the subtext must be gleaned from the point of view of the "little negro boy." In Woodville's painting the black figures obscured in shadow appear only peripheral to the narrative; they are, in fact, agents in the drama. As with Old '76 and Young '48, questions about age and genealogy are what invigorate the black characters in the painting, thus freeing them from stereotype.

The ex-slave Frederick Douglass became a controversial but authoritative abolitionist in the 1840s. He published his popular autobiography, *Narrative of the Life of Frederick Douglass, An American Slave, Written by Himself*, in 1845, only four years before Woodville

painted *Old '76 and Young '48*. The book details Douglass's twenty years as a slave in Maryland, as well as his experiences as an abolitionist after his escape in 1838. As Douglass's experience in Baltimore makes manifest, a particular hardship of slave life in Maryland was how masters would tease slaves with certain liberties, only to deny them total freedom. For example, the wife of Douglass's master taught him to read and write, but later, at the insistence of her husband, turned on him and snatched the newspaper from his hands.[88]

Douglass describes other practices that masters in Maryland commonly used to disorient their slaves.[89] He devotes the first two pages of his autobiography to presenting what he does not know about himself: his age and his family. Douglass's first master refused to tell him his date of birth and the identity of his father, and Douglass was permitted to visit his mother only four times before she died. If Douglass had seen Woodville's painting, he might have accused Young '48 of taking his self-knowledge for granted. Whereas Woodville strains for specificity in terms of both age and time—Old '76, Young '48, the frozen pendulum of the clock—Douglass writes, "I do not remember to have ever met a slave who could tell of his birthday. They seldom come nearer to it than planting-time, harvest-time, cherry-time, spring-time, or fall-time. A want of information concerning my own was a source of unhappiness for me." Young '48, by contrast, enjoys the dedicated attention of his mother and uses the positions of his relatives to fashion his own identity. "Never having enjoyed, to any considerable extent, her [his mother's] soothing presence, her tender and watchful care," Douglass writes, "I received the tidings of her death with much the same emotions I should have probably felt at the death of a stranger."[90]

Considered alongside what Douglass says was missing from his life, the tension between Old '76 and Young '48 seems especially troublesome. Woodville's placement of the black figures in shadow does more than signify the problematic issue of slavery in the years prior to the Civil War. To read these figures as mere "others" would be to distort the crucial role they play in the painting. The visual unity of the black group—shadows obscure these figures to the point that they blend into one cohesive unit or figure—plays against the psychological fracturing of the white family in the foreground. The male black servant in Woodville's painting knows something the white figures do not. He looks at Young '48's hand and sees that his gesture, his point, pertain to him—to the future of slavery. The servant looks at Young '48 with wide-open eyes. The blacks function in *Old '76 and Young '48* much as they did in the Mexican War; they hover on the periphery, almost out of sight, but remain a constant reminder of what each is really about. In the meantime, by virtue of their cohesiveness, they expose the deficit at the center of this family.

Finally, what should we make of this painting's accessories, of its ornaments and embellishments? There is a lot to look at in *Old '76 and Young '48*: carpets, a fireplace, a plaster bust, a print, a painting. These latter three are identifiable objects, things with their own histories and discourses.[91] Although they hover in an upper register, set in shadow, we can make out their subjects: above the mantel is a framed reproduction of John Trumbull's

painting *Declaration of Independence* (1787); to its right, a marble bust portrait of George Washington; and finally, on the wall behind the table, an oval military portrait of Old '76. These objects identify the family as one proud of its history. But what good is this pride if it cannot be reconciled with the present and cannot contribute to familial bonds? Past and present, as we have seen, are themes that hang both *around* this painting and, in the form of these art objects, literally *in* the painting. Yet we can draw no conclusion or truth from them. The objects hang there, but Woodville sets them back and above, so that he appears to question the very legibility of the visual arts in general and to interrogate the function of his own painting as a testament to a historical moment. Two lamps sit on the mantel, positioned presumably to light the reproduction of the *Declaration of Independence*; neither, however, is illuminated. Woodville gives them the paradoxical function of accentuating the room's darkness.

An early historian of American art, James Thomas Flexner, criticized Woodville's painting, partly for being so crowded with material distractions. Writing about *Old '76 and Young '48* in 1962, Flexner said that Woodville "did not produce his most emotional picture but his most artificial. He hid his feelings behind the whole pantheon of Düsseldorf crooked-fingerisms."[92] Flexner's colloquialism is a reference to the tendency of the Düsseldorf artists to look a little too closely sometimes or to overuse clever details and the scrutiny of physiognomy as gambits. The criticism is a fair one, to a degree. Woodville, we have seen, did not emote in his paintings; that is, he did not present *himself* as a feeling person in his pictures—not even in *Old '76 and Young '48*, which, legend has it, was intended to be a portrait of his family.[93] During the 1840s Düsseldorf, to be sure, was not home to the kind of cultural progressivism evident in Paris, and Woodville never learned there how to impose his reticent self on his subjects. But Flexner was wrong to dismiss the painting entirely, for its "crooked-fingerisms"—the young man's gesture, for example—circumscribe a range of tangled attitudes regarding an intensely controversial episode in American history.

The painting pulses between the public and the private and so leads us back to where we began, with the telegraph. Transmitted from and into this dark Baltimore parlor is a mysterious message, one that travels circuits connected at one end to the far reaches of the American empire and at the other to the nation's fireside, to its core. In 1850 the *Bulletin of the American Art-Union* described Old '76 as an "attentive listener," a notion most likely deduced from the identification of Young '48 as an "animated" and "earnest" speaker—his words had to be heard, after all, or what would the painting mean? But the grandfather does not really pay attention. This awkward family discussion, wherein everyone looks at the grandson except for the man to whom he speaks, his grandfather, illustrates what Morse feared about the telegraph: How do you know who is listening?

Perhaps uncomfortable with his expatriatism and his telegraphic relationship with the New York art market (that is, his having to send his work overseas, to an unfamiliar place,

and his audience's perception of him as a distant artist, disembodied from his images), Woodville attempted to locate himself by making a rare political statement and triangulating his position using three American wars. Both the American Revolution and the Mexican War are personified in *Old '76 and Young '48*. But the Civil War is there too, hidden, ready to ambush at any moment. Old '76 and Young '48, it turns out, are not impotent veterans but soldiers keeping cadence with a "mobile army of metaphors [and] metonymies."[94]

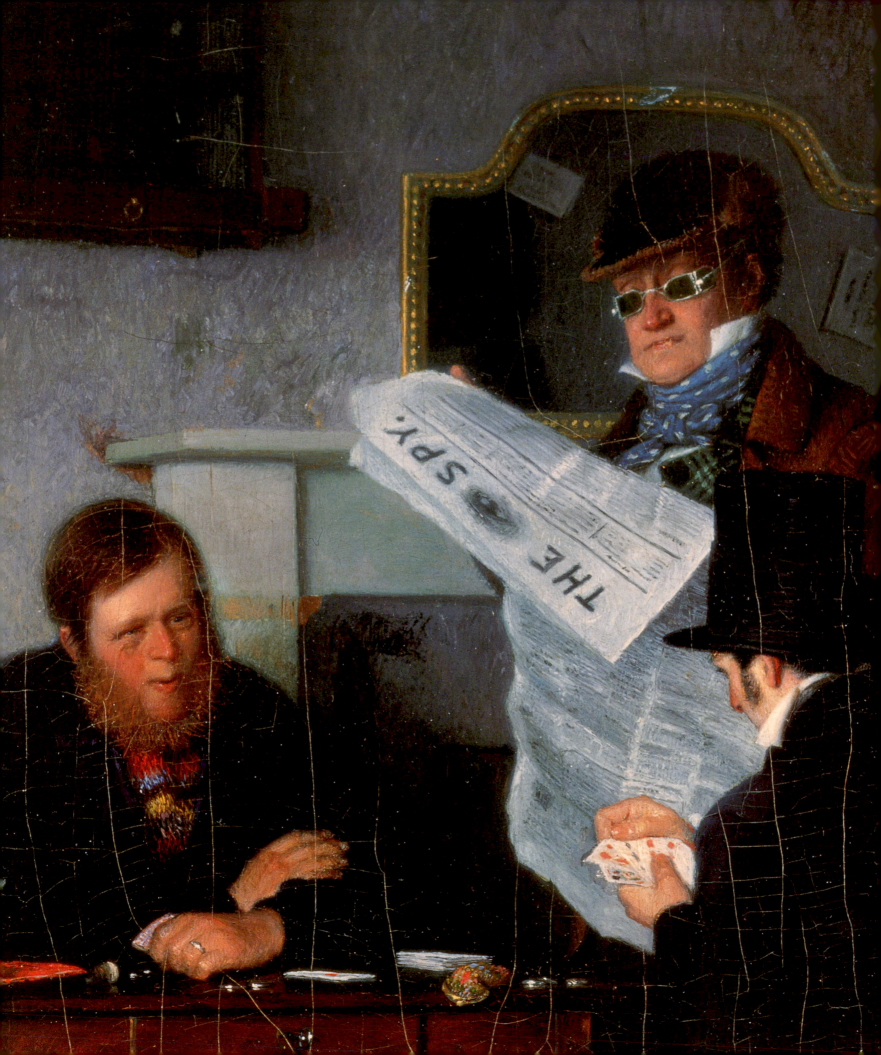

CHAPTER FOUR

◆

Cornered

Aᴛᴇʀ ᴛʜᴇ sᴜᴄᴄᴇssᴇs of *War News from Mexico* (fig. 53) and *Old '76 and Young '48* (fig. 63), Woodville moved to Paris, where he stayed for a year and a half, leaving for two brief visits to the United States and several trips to London. During that time the American Art-Union closed its galleries and stopped purchasing paintings. Both his departure from Düsseldorf and the demise of the Art-Union had an impact on Woodville's painting. Away from the academic atmosphere in Düsseldorf, and certainly missing the patronage and financial support of the Art-Union, Woodville was both autonomous and adrift. He adapted well to his itinerant life though. His flight from the scrutiny of the academicians in Düsseldorf may account for the less predictable and less formulaic nature of his final paintings, which are unbridled in some ways and downright odd in others but always assured in their visual and social observations. They also exhibit, stylistically and thematically, two pervasive, connected features of the antebellum period—subtlety and confidence.

An article in the *New-York Daily Tribune* on 22 January 1867 reports that 1850 was Woodville's final year in Düsseldorf. "In the Spring of 1851," it says, "he went to Paris, and after staying there a few weeks, he came home in July for a brief visit. He went back to Paris in September, and for the next eighteen months remained in that city." In fact, from September 1851 until 12 March 1853, when his daughter Alice was born, Woodville shuttled between

Opposite] Detail of fig. 70

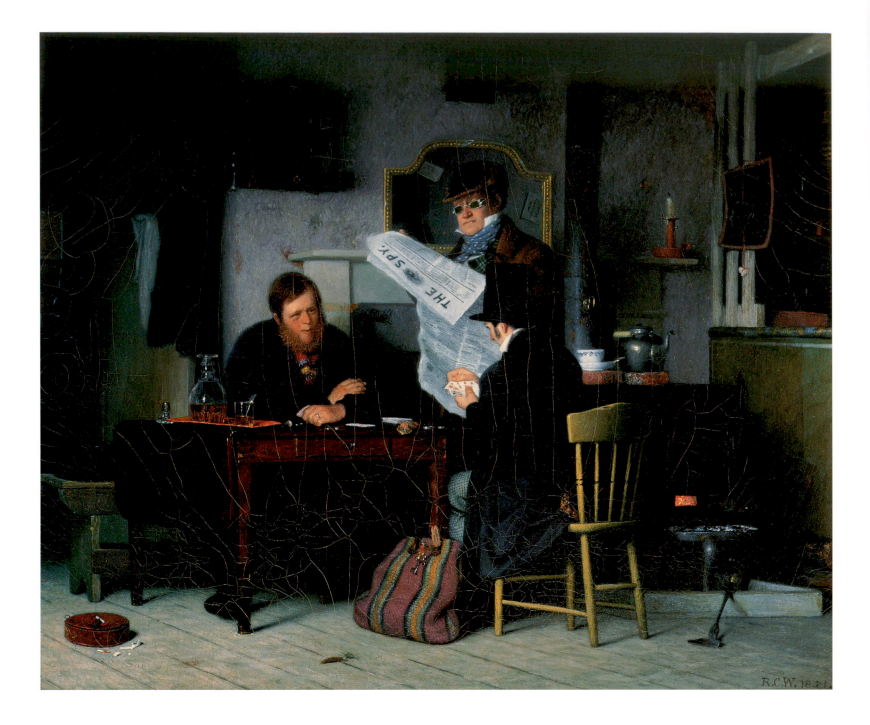

Fig. 70] Richard Caton Woodville, *Waiting for the Stage*, 1851.
Oil on canvas, 15 x 18 ½ in. (38.1 x 47 cm). The Corcoran Gallery of Art, Washington, D.C.
Museum Purchase, Gallery Fund, William A. Clark Fund, and through gifts of
Mr. and Mrs. Lansdell K. Christie and Orme Wilson, 60.33

Paris and London with some frequency.[1] Whatever his exact movements during these years, he spent enough time in Paris in 1851 to paint *Waiting for the Stage*, which he signed and dated "R.C.W. 1851. Paris" (fig. 70).

Grubar observed stylistic and atmospheric differences between this painting and *The Card Players* (fig. 35): "A basic change may be noticed in the perspective," he writes. The earlier painting "emphasizes a symmetrical balance in the grouping of the figures and the direction of the floor and walls," while in the later painting "the figures are shifted slightly, and there is a definite oblique, asymmetrical movement of the floor and side walls."[2] Though Grubar says nothing more about the painting, he touches on its most salient feature, its play with visual and narrative point of view.

As Woodville managed to do in all of his paintings, he tells the story in *Waiting for the Stage* as much with the things orbiting around its interior as with its figures. For Woodville, to paint was to take inventory; at the conservative Düsseldorf Academy he learned to distrust open space and even the slightest hint of abstraction. Accordingly, the cardplayers barely have enough room to lay down their hands. Coins, cards, a change purse, an empty candlestick, and a tray with a decanter and glass crowd their table. Woodville's trademark red cuspidor and stamped-out cigar litter the planked floor, and a birdcage and mirror hang from the flat wall behind the bearded player. On the stove to the right of the room sit two bricks on which rest a cup in a saucer and a kettle, in which water is warming for hot toddies. Woodville describes these details, including the apparel of the figures, with his usual fastidiousness. Everything, it seems, is accounted for.

However, as carefully observed as the painting may be, Woodville employs what Wolf calls a "deconstructive gambit" undermining at every turn precisely what he relies on so heavily, which is the very act of surveillance. "The painting is divided between imagery of reassurance, tied to familiar objects within the room like the stove, cuspidor, tea kettle, decanter, and desk, and a countervailing imagery of *dislocation*," he observes. "This latter imagery stems from the signs of transience in the painting; the card player's carpetbag, the random notes posted in the frame of the mirror, the burning candle, the blackboard with its dangling chalk and rudely limned head, the bird cage with its absent bird, and the standing man himself, dressed as a dandy and sharpster, a forerunner of Melville's confidence man."[3] The "imagery of dislocation" that Wolf identifies in the painting comes in part from the "oblique, asymmetrical movement" that Grubar observes. Every bit of clarity that Woodville serves up here—the circular rims of the glasses and the stopper in the decanter—he counters with obscure angles, hidden corners, and indirect lines of sight.

Only after absorbing the painting's surface material and story do we notice the two side rooms that lead off from the central waiting room. To the right of the stove is a cupboard, at one end of a longer bar. Behind three vertical lattices that shield the space from clear view we make out shelves holding a full decanter, several glasses, and two kegs. Woodville garnishes this visual feast with a seemingly frivolous accessory: a bowed slate

with a caricature portrait drawn in chalk hangs from the lattices. A door leads from the left of the waiting room to a half-seen chamber in the rear. A coat and towel hanging from the corner of the door suggest that at least one of the figures, most likely the bearded man, who seems most at home here, either resides in the building or spends a good deal of time nestled on his bench. Through the door we can make out a window with a bottle and bowl sitting on its sill, below which rests a coffeepot. That half-seen window provides the only exit from this overstuffed interior, which threatens to trap us in a maze of right angles and sharp corners. This space's cramped and menacing aspects are suited perfectly to its subject.

At the center of *Waiting for the Stage* dwell a trio of optical tropes: a newspaper, titled *The Spy*; the standing man's dark glasses; and, framing his head, a mirror. Woodville does not pretend that the standing reader is not a cheater. From his vantage point he can see both players' cards. The spy literally steals his glances; his dark glasses shield his roaming eyes and peripheral glimpses. And the mirror, like the one in *The Card Players*, turns corners that eyes cannot.

When it comes to plot, Woodville never went for understatement, but any viewer would know that the spy was cheating even if he were not wearing dark glasses. The glasses, then, are an unnecessary and puzzling accessory. Perhaps Woodville used them as part of his "deconstructive gambit," as part of a layered witticism about the tricks that antebellum gamblers employed in the service of deception. The spy, preposterous as it sounds, very well may be posing as a blind man. The type of metal-rimmed dark glasses that he wears are peculiar in that they have hinged side blinders for blocking light. A blind man pictured in an anonymous quarter-plate daguerreotype from the 1840s wears an almost identical pair of dark glasses, with the same rims and blinders. In the daguerreotype, titled *Blind Man and His Reader* (fig. 71), the man sits next to an adolescent boy who, coincidentally, holds a newspaper, a copy of the *New York Herald*.[4] Without the newspaper the daguerreotype makes little sense; it is the detail that vouches for the man's blindness. By contrast, the newspaper in Woodville's painting, if he meant for us to believe that the spy pretends to be blind, adds to the mystery of the painting, specifically to what Wolf calls the "issues of surveillance" raised by the work.[5] Whether he fakes his blindness or pretends to be reading, the spy's purpose is unchanged. He must feign absorption, either in an article or in a lightless world, in order to cheat effectively.

We know, of course, that he is not blind. He holds a newspaper, after all. But the paper might simply be Woodville's way of letting his viewers know that he is not blind. Perhaps it is a little too obvious—the painting's tropes might be more surreptitious if the man were not holding a paper—but Woodville was prone to diversion of this kind, to getting lost in his own jokes. This is where the gambits and dissemblance that others have observed in the

Fig. 71]
Anonymous artist,
Blind Man and His Reader, c. 1850.
Quarter-plate daguerreotype.
Gilman Paper Company Collection,
New York

painting originate.[6] We should see the objects in the painting, such as the dark glasses and the mirror, and the compositional elements of the painting, such as the indirect lines of sight and hidden corners, as quirks born of Woodville's subjects here, gambling and confidence games.

Melville also retreated into obscure and mannered stylization when he turned his attention to a similar subject several years later in *The Confidence-Man* (1857). The cosmopolitan's query from the book, "Awake in his sleep, sure enough ain't he?" refers to the duplicity of both subject and author.[7] When treating gambling and other forms of deceit Woodville and Melville act like shills. They pretend to be on our side, to draw us in with a promise to expose criminality, when in fact their art is as underhanded as any sharp's. Both remind us that one of the artist's purposes in the nineteenth century was to misbehave.

The Confidence-Man was not a successful novel. Melville wrote the book during a period of mental and physical breakdown, and it vexed his contemporaries. Elizabeth Foster, still the most articulate critic of the book, explains that "the outpouring of the giant energies that had gone into *Moby-Dick* and *Pierre; or, The Ambiguities* left [Melville] close to physical and nervous exhaustion. . . . The sea of metaphysical, religious, and ethical speculations into which his books had plunged him was sweeping him along into more and more fearful currents of agnosticism and pessimism."[8] Melville wrote to Hawthorne in 1851, "Dollars damn me, and the malicious Devil is forever grinning in upon me, holding the door ajar."[9] Bitter about poor reviews of *Pierre*, published in 1852, Melville seemingly set out to be stubborn and to alienate readers. American critics greeted *The Confidence-Man* with virtual silence, though some reviewers, "with blithe condescension, called him mad."[10] The English press, however, reviewed the novel promptly and articulated what American critics must have been thinking. The *Athenaeum*, for instance, spoke of the "opaqueness of the author's final meaning," while the *Literary Gazette* concluded that the book was rambling—"nonsensical people talking nonsense."[11] One American critic, an anonymous reviewer in *Mrs. Stephen's New Monthly*, was baffled by the book: "You might, without sensible inconvenience, read it backwards."[12]

In most of his books, but especially in *The Confidence-Man*, Melville displays an agoraphobia similar to Woodville's, and this contributes to the book's confusion. Packed onto the steamship *Fidèle*, to which Melville confines all of the book's action, are so many characters, plots, ploys, and costumes that the reader has barely enough time to work out a sensible meaning from the words. In place of Woodville's cluttered interior, shadowy corners, and obscure sight lines, Melville injects long-winded passages, rambling dialogue, and masked characters. Melville's overstated text, like Woodville's overdescribed painting, results in a choking redundancy that thwart many readers' attempts at even basic interpretation. The book, set fittingly on April Fool's Day, opens with paragraph-long sentences that speak coincidentally about the challenges facing the observer standing in a diverse crowd:

> As if it had been a theatre-bill, crowds were gathered about the announcement, and
> among them certain chevaliers, whose eyes, it was plain, were on the capitals, or, at

least, earnestly seeking sight of them from behind intervening coats; but as for their fingers, they were enveloped in some myth; though, during a chance interval, one of these chevaliers somewhat showed his hand in purchasing from another chevalier, ex-officio a peddler of money-belts, one of his popular safe-guards, while another peddler, who was still another versatile chevalier, hawked, in the thick of the throng, the lives of Measan, the bandit of Ohio, Murrel, the pirate of the Mississippi, and the brothers Harpe, the Thugs of the Green River country, in Kentucky—creatures, with others of the sort, one and all exterminated at the time, and for the most part, like the hunted generations of wolves in the same regions, leaving comparatively few successors; which would seem cause for unalloyed gratulation, and is such to all except those who think that in new countries, where the wolves are killed off, the foxes increase.[13]

Like the throngs crowded "about the announcement," we struggle to see from "behind intervening coats" just what Melville describes in this passage. He condenses no fewer than four characters and four geographies into this spinning, one-sentence paragraph. The first character we meet in *The Confidence-Man*, the "man in cream-colors," is deaf and dumb, completely incapable of making sense of a verbal world. One scholar notes that the "deaf-and-dumb act" was a popular one in the world of confidence games, an observation that lends some credence to the notion that Woodville intended for his viewers to believe that his spy feigns blindness.[14] (He could not suggest deafness or dumbness in paint, of course.) Melville, in fact, has a character—the "limping, gimlet-eyed, sour-faced person," a skeptical cripple with a wooden leg who argues with an Episcopal clergyman about trusting strangers—utter what might be the finest, most succinct analysis of Woodville's painting, even if today it reads as a cliché: "Looks are one thing," he says, "and facts another."[15]

Most twentieth-century scholarship on *The Confidence-Man* focuses on the novel's snarling language and plot. Reacting to the collage of deceit and distrust that Melville weaves into his novel—absurdly, only the confidence man ever gains anyone's trust in the book— Foster speaks of the "intellectual excitement and imaginative extension and enlargement" that lay in Melville's "laminated meanings, in [his] close-packed, multiple suggestion and ironic echo." Melville's comedy, she writes, "is one of subtle, pervasive, elusive irony, of suggestion . . . rather than exaggeration, of talk rather than action," an observation that brings to mind Johns's characterization of Woodville's work as being about "political palavering" or "merely talk and more talk."[16]

In the "radically egalitarian 'message' of his art and the complicated and inaccessible codes in which he feels obliged to express that message" Michael T. Gilmore identifies Melville's chief riddle. "It highlights the disparity between what might be called an artisanal and a working-class attitude toward the product of his labor. On the one side," he claims, "Melville views the writer as entering into an intimate fellowship with his audience, speaking to them and for them directly in his work. On the other, he regards the writer as a kind of

alienated worker, turning out texts from which his individuality has been erased—like a copyist, for example, or a girl tending a machine in a factory."[17] Foster also circumscribes Melville's messy novel within the antebellum economy. His language, she believes, bares his subject: "the invasion of all areas of life, even religion and philanthropy, by the 'Wall Street spirit.'"[18] Melville inherits from his time a lack of regulatory instinct, which he then imparts to his characters. He engages in what Foster terms "double-writing," which is something more than mere allegory, something closer, in fact, to a confidence game.

In the end, we cannot determine whether Melville was simply painting a realist portrait of the chaotic economic society in which he lived or whether he was up to something more, like an indictment of Christianity, which purports, arrogantly perhaps, to be above that chaos. The "man in cream-colors," we have been told, is a Jesus figure. Melville describes him as "lamb-like," as coming "from the East," and has him hold up placards warning against a "mysterious impostor" and preaching that "Charity thinketh no evil."[19] Yet it is this man's pleas for charity that soften up the *Fidèle*'s passengers for the confidence man's games. Is he in cahoots, then, with the confidence man, the rogue who changes appearances at will? We cannot try to pin Melville down on the subject, for he wears as many faces as the masquerading confidence man himself. His roaming novel emphasizes the transient nature of all the men aboard the boat, none of whom, by the way, states a destination.

An author "who had more than once embarked on a chartless voyage" is how another critic characterizes the writer of *The Confidence-Man* and *Moby-Dick*.[20] While sympathetic to readers who find the book "fragmented, truncated," Tom Quirk dismisses the notion that Melville intended for the book's confused narrative qualities to disguise a "sacrilegious intent"; they come, rather, "out of an authentic ambivalence." Melville "had been genuinely fascinated by what he would come to call in *Billy Budd* the 'moral emergency,' and what he had called in *Pierre* 'the ambiguities.'"[21]

As an author, Melville could no more impose order on an antebellum steamship than could any other man or woman, no matter how "lamb-like." This may not surprise the social historian, but it demands recitation, for it lies at the heart of Woodville's paintings. Simply put, Woodville, like Melville, did not create allegories or stereotypes for easy consumption. He crowded paintings with as many significances as objects, not because he was a wise-cracking modernist carefully laminating meanings one to the other but simply because antebellum soldiers and sharps had never meant just one thing. They, more than any other popular characters, stood for the transient, fickle, and industrious nature of the era's social interactions. So Woodville again plays the role of the shill: he paints inviting, real-seeming pictures that look simple enough to decipher, but once he pulls us in, he abandons us, leaving us feeling a little like a blind man trying to read a newspaper. Little wonder, then, that a lithographic copy of the painting made by Goupil and Company in 1851 appeared with the alternate title *Cornered*, which refers as much to our situation in front of the painting as it does to that of the figures who inhabit the waiting room.[22]

The perplexities of Woodville's painting and Melville's novel are all the more puzzling when one considers that they were influenced by actual events that received a fair amount of attention in the media. Both men proved time and again that they were, at the very least, intrigued by popular culture, whether events, places, or characters—real and imagined—that teemed in the public's mind. The penny press documented accounts of traveling confidence men and professional swindlers, and pamphlets and advice manuals breathed additional life into the popular figures. Hans Bergmann has performed the valuable service of sorting through the historiography of this elusive antebellum figure. Bergmann explains how the term *confidence man* did not exist before the summer of 1849, "when it was applied to a particular swindler."[23]

On 8 July 1849 the *New York Herald* ran a story about the arrest of William Thompson on the previous day. "For the last few months a man has been traveling about the city, known as the 'Confidence Man,'" the paper reported. "That is, he would go up to a perfect stranger in the street, and being a man of genteel appearance, would easily command an interview. Upon this interview he would say, after some little conversation, 'have you confidence in me to trust me with your watch until to-morrow;' the stranger, at this novel request, supposing him to be some old acquaintance, not at the moment recollected, allows him to take the watch, thus placing 'confidence' in the honesty of the stranger, who walks off laughing, and the other, supposing it to be a joke, allows him so to do."[24]

The painting places itself within popular debates regarding gambling and confidence games. Though too much of a cavalier to be a true modernist like some of his contemporaries in Europe, Woodville does pull off a fine maneuver here, treating painting as its own kind of swindle. And he did this several years before Melville's chicanery with language in *The Confidence-Man*, which is worth pointing out not because anyone is keeping score but because genre painting usually falls short when measured against the novel. Woodville treated gambling as a subject, but he also employed its techniques to undermine the legibility of his preferred pictorial mode, which, to put it crudely, was painting's equivalent of the novel. Though the space the figures inhabit is identified as a waiting room, which is safe enough on the surface, it turns out to be a "meanly furnished resort of smalltime thieves."[25] Rather than read the paper or engage in productive conversation, the men in the waiting room idle away the hours playing cards and deceiving one another. All their efforts are geared toward corrupt gain; they work only at pretending to be someone else, whether a blind man or a green traveler. Though the men in the painting are fairly well dressed, their appearance tells us nothing about their respectability, decent fashion being a favorite contrivance of the confidence man.

As with the "skinning houses" along Broadway, which appeared "first-class," Woodville transforms a seemingly stable interior into a slippery space.[26] As Wolf puts it, Woodville "sets three figures into a shared space, fills that space with familiar objects, places two men in a relation that assumes, despite its competitive edge, equality and direct dealing, and then withholds the egalitarian reassurance his painting promises. What happens in the painting instead

is that the markers of stability and comfort are made ironic: The standing man functions as a 'spy,' intruding himself on the world of the card players without acknowledging his dissemblance."[27]

Cardsharps were much more than thieves; they were, as the historian Karen Halttunen demonstrates, a type of confidence man. Along with money, they stole goodwill, made a joke of good character, and pocketed the legibility of the social world. "The hypocrisy of the confidence man," she writes, "did not lie simply in a discrepancy between what they practiced and what they preached. . . . The fear of hypocrisy expressed in mid-nineteenth-century conduct manuals ran deep: these archetypal hypocrites threatened ultimately, by undermining social confidence . . . to reduce the American republic to social chaos."[28] Proper conduct in antebellum society, in other words, demonstrated above all a perfect sincerity and transparency of character, an ideal the confidence man undermined.

In writing about professional gamblers, as opposed to stationary taverngoers who bet on the throw of dice and the turn of a card, Ann Fabian argues that "gambling transactions . . . were dangerous to a republic of rational profit seekers because they encouraged false hopes for quick profits. False hopes fostered destabilizing passions, and wild passions distorted the careful political and economic deliberations necessary for an honest electorate." Gambling took on added urgency during the antebellum period because "its dangers increased as individuals moved from intimate and reciprocal economies to economies governed by relations between strangers and designed to end in asymmetrical accumulations."[29] Money gambled in a small agrarian community at least stayed within that community, whereas in the urban commercial economy of the mid-nineteenth century, money gambled was usually lost to a transient stranger, like the man in *Waiting for the Stage*, whose face we cannot see but whose carpetbag rests at his side. Those who condemned gambling, Fabian maintains, engaged in a "negative analogue"; that is, to single out gambling as degenerate was to condone "normal" capitalist pursuits, such as speculation in stocks and commodities and dependence on contracts. A fine line existed in the antebellum period's liberal economy between the ethical transfer of funds and gambling, and to attack gambling was one way to maintain a tolerable position of that line.

About the time of Thompson's arrest a dozen or so advice manuals warned young men about him and his ilk. Manuals such as William A. Alcott's *Young Man's Guide* (1833) and Daniel Eddy's *Young Man's Friend* (1855) offered advice on every aspect of life, including "morals, manners, appearance, what to eat, and whom to marry."[30] These manuals, Halttunen says, identified three types of confidence men who posed a particular threat to young people: the urban companion, who guided young men through the city's underworld; the demagogue, who was particularly wicked because of his ability to shape the minds of youths; and the gambler, who was repugnant because he fleeced young men and subverted normal capitalist pursuits.[31]

"In gambling," Alcott cautioned his readers, "it is true, property is shifted from one

individual to another, and here and there one probably gains more than he loses; but nothing is actually *made*, or *produced*."[32] One of the great fears of gambling was that it undermined the spirit of obedient productivity and thrift necessary for a healthy capitalist economy. Papers like the *New York Mirror* reported frequently on the arrest of gamblers, particularly in New Orleans and on steamships such as the fictional *Fidèle*.[33] John Harrington Green was one of the more popular and more vocal crusaders against gamblers in the 1840s. Born in Lawrenceburg, Indiana, in 1814, Green gambled for about twelve years before becoming a reformer. His books, which addressed the prevalent fondness for gambling and the growth of antigambling reformism, warned that sharps masqueraded as clergymen and respectable merchants and often operated in teams. He marketed himself and his books through his Association for the Suppression of Gambling, on whose behalf he spoke throughout the Northeast and the Midwest.[34] Reformers like Green spoke of cardsharps in terms of class, referring to them as "idlers, lackeys, servants, lazy sons of the rich" who compared unfavorably with "industrious producers."[35]

Though these indictments of gambling worked on the public—in Vicksburg, Mississippi, in 1835, citizens lynched five gamblers—gambling reform largely failed.[36] According to Fabian, reformers like Green lost their middle-class audience by "exposing the endless greed behind their search for gain" and lost their working-class audience by setting themselves up as "would-be informer[s] on gambling houses and gambling habits."[37] Gambling, despite the sanctimonious warnings of reformers, continued to thrive during the antebellum years. The problem was that so many Americans understood the confidence game as the standard strategy of the normal capitalist.

New York newspapers wasted no time in capitalizing on Thompson's arrest. From the moment his swindle was revealed, the *Herald*, the *National Police Gazette*, and the *Literary World*, among many other periodicals and papers, published reports and editorials on the confidence man. On 11 July the *Herald* ran George Houston's "'The Confidence Man' on a Large Scale," which retells the story of the arrest and then goes on to draw parallels between confidence games and the practices of Wall Street. "Let him rot in 'the Tombs,'" Houston proclaimed, "while the genuine 'Confidence Man' stands on one of the Corinthian columns of society—heads the lists of benevolent institutions—sits in the grandest pew of the grandest temple—spreads the new snares for new victims. . . . Success, then, to the real 'Confidence Man.' Long life to the real 'Confidence Man!'—the 'Confidence Man' of Wall Street—the 'Confidence Man' of the palace uptown—the 'Confidence Man' who battens and fattens on the plunder coming from the poor man and the man of moderate means!"[38]

From the moment he emerged, the confidence man was an elusive yet ubiquitous figure. He was the swindler on the street and the fat cat in the office building. Poe also drew parallels between the common sharp and the traders downtown. In an essay titled "Gambling," published in the *Broadway Journal* in 1845, Poe wrote: "There are other gamblers than those who shuffle cards and rattle dice. Nine tenths of our leading politicians are gamblers. . . .

Wall Street operators are nearly all gamblers. . . . Merchants are generally strongly imbued with gambling propensities."[39] Though the confidence man's tricks were hard to identify and define, he was omnipresent. Anyone, really, could be a confidence man—a notion that may be the true subject of Melville's novel.

On 28 August 1846 the *American Republican and Baltimore Daily Clipper*, a Baltimore daily similar in format to the *Herald*, ran a piece under the headline "Cheating the Law" that put the matter succinctly: "No matter how carefully a law may be framed, men will always find a way to cheat it." Men cheated liquor laws, lottery laws, and on Wall Street; they duped innocent citizens on the street and underpaid laborers. In the North, for instance, "urban artisans and mechanics gambled in grog shops, groceries, and taverns. They played cards, billiards, shuffleboard, and dice, bought chances and fractions of chances in lotteries, and bet on contests between bulls, bears, cocks, badgers, horses, men, and dogs."[40] The cardsharp, because he engaged in the most obvious game of deceit, came to stand for cheating in general.

In this context, the word *sharp* took on more than one meaning. The sharp was at once a craftsman who possessed the "wit of an actor, minister, or speculator" and the elusive loner, the well-dressed stranger in the corner who read the paper and got by on his wits rather than by participating in programmed pursuits. This latter type of sharp populated a good number of pamphlets and novels, and he was the one who ruined the green young man, or "flat." One such pamphlet, *Sharps and Flats; Or the Perils of City Life. Being the Adventures of One Who Lived by His Wits*, published in 1850, was written by an author with the mysterious name Asmodeus.[41] *Sharps and Flats* tells a typically cautionary tale: a young man, James Buck, arrives in Boston with dreams of making money but is quickly caught in a web of tricksters and shady deals. At one point the narrator muses, "I was a Flat, green at such business, with the stories of fortunes made by lotteries, ringing in my ears, and impressed upon my memory." Later, a man identified as a "Sharp" is described as "a flashily dressed person who sat in the corner, smoking a cigar, and to all appearance deeply interested in the perusal of a paper, which dated back some months from the time of the occurrence of which I speak. Instead of taking any interest however in the contents, he had devoured with avidity the conversation, and determined to turn it to his pecuniary advantage."[42] This sharp conforms to the type presented in Woodville's painting, the expired newspaper serving a similar function to that of the spy's dark glasses.

Asmodeus himself was a kind of confidence man, the "devil on two sticks," Bergmann explains, who appeared in Alain René Lesage's *Le Diable Boiteux* (1707). He "limped on his crutches across the roofs of Madrid to uncover the secrets of society dinner parties, sexual dalliance, betrayals, people starving in the gutter. Asmodeus had the panoramic knowledge of the whole that allowed him to show the hidden truths; he was the panoramic devil who showed people what they should not have longed so much to know. Lesage's book and character were revived in France in the nineteenth century, and American journalism and popular fiction imitate the revival."[43] Authors like Walt Whitman, whose "New York

Dissected" appeared in *Life Illustrated* in 1855 and 1856, and George G. Foster, whose "New York in Slices" ran in the *Tribune* in 1848, played the role of Asmodeus by offering fanciful tours of the city. Their satirical excursions were not unrelated to the observations of the flaneur, embodied, for instance, in the narrator of Poe's "The Man of the Crowd." Woodville, for one, had assumed this personality as early as his student days at the University of Maryland, when he earned a reputation as a probing observer; like the author of *Sharps and Flats* and like Melville, Woodville imitated the conventional Asmodeus by describing the unconventional habits of gamblers and confidence men. The point being that just as the figures in Woodville's painting cannot trust each other, so we cannot take the painting itself at face value.

"There is good reason," David S. Reynolds explains, "that critics cannot decide whether the Confidence Man is Satan, Christ, or some middling figure. It is perhaps best not to call him a *person* at all but rather a *text* or a *mode*. . . . In *The Confidence-Man* [Melville] created a new kind of literariness by exploring the activity of moral manipulation."[44] By treating subterfuge as a subject pertinent to antebellum social and economic life, not just to myth, and by breaking down the barriers between content and form, Melville created a relevant, modern text. We can say that Woodville's *Waiting for the Stage* prefigures Melville's novel, but we still have to ask what, in fact, Woodville's subject was. What, for example, distinguishes *Waiting for the Stage* from *The Card Players*?

Posing is such a central theme in *Waiting for the Stage* that it becomes difficult to determine who dupes whom in the painting. The figures in the painting bring to mind Robert Bailey, a Virginian who gave up gambling to caution against it in *The Life and Adventures of Robert Bailey*, published in 1821. Bailey spent his gambling career searching for wealthy bettors in taverns and boardinghouses, mostly in rural Virginia and in Washington, D.C. (where *Waiting for the Stage* currently hangs in the Corcoran Gallery of Art). For Bailey, fashion was a key component of gambling: "[H]e dressed like a gentleman and bragged that he danced and carried himself with more grace than his social superiors. . . . He was a poor boy who became a gambler because he wanted to be a gentleman."[45] Bailey achieved such status through gambling both because it gave him money and because, in the South especially, gentlemen gambled. Fine fashion helped sharps achieve their ends; it was virtually impossible to determine to which class a successful sharp belonged. The figures in *Waiting for the Stage*, who are well dressed, pose in this way, and their masquerades not only serve the purposes of their game but manage to confuse the viewer as well. With whom, we wonder, is the spy sided? With the bearded man facing us, or the hatted man facing away?

Starting with the obvious, the painting shows three figures playing a game of cards. As in *The Card Players*, two of the figures conspire to cheat the third. Wolf says that the spy "disrupts the gemeinschaft quality of their world by adding a note of surveillance and hinting, by his conspiratorial stance, that he may well be in cahoots with the hatted player whose face remains hidden from the viewer."[46] But perhaps it is the other way around. The hatted

player is on the go, the one waiting for the stage. His carpetbag sits at his feet, and he seems to have pulled up a chair. The bearded figure, however, looks quite at home, settled on his bench against the wall. The spy also has no carpetbag, suggesting that he too is a regular habitué of the room. If so, then the spy and the bearded man are the locals who wait here to cheat travelers. It would be wise, however, not to underestimate the hatted man, who may be the real sharp here, not likely fooled by a couple of loafers hanging around a stagecoach waiting room. He conforms to the stereotype of the transient professional gambler, whose tricks work only because he moves on after he wins his money. Advice manuals and newspaper accounts, we have seen, presented the professional gambler and the confidence man as a man without a home—a wanderer from the frontier, a steamboat traveler, a forty-niner, a nonconformist who undermined the prescribed and fixed practices of normal capitalist pursuits.

Most likely all three figures are cheats, and this is what separates *Waiting for the Stage* from *The Card Players*. In the earlier painting, Woodville so overstates the stratagems of the two younger figures who cheat the old man that viewers can rest assured that they know who is who, whereas in the later painting, Woodville avoids altogether the question of moral superiority. He even goes so far as to grant us a glimpse of the hatted man's cards, thus implicating us in the conspiracy. Other details give this picture an air of intrigue more pervasive than the one in *The Card Players*. The latticework on the bar, the birdcage on the wall in the background, and the keys dangling from the locked carpetbag add some exigencies to the painting's conspiracies.

Though so much is closed and interiorized here, the painting is a comment on broad aspects of antebellum social life. The actions of these figures reverberate in the outside world. Bergmann writes about Melville's book that even though it "takes place entirely aboard a Mississippi steamboat," it "is a New York story." Bergmann's thesis, to put it simply, is that Melville's novel attempts to make a microcosm of New York urban life, to "describe one-on-one encounters between a middle-class observer and an extraordinary individual (like Melville's man in cream colors) who belongs to the uncustomary city. All the discourse's narratives recount discoveries of the astonishing quotidian life of New York, and all are the ways the contemporary urban culture had of trying to describe itself" in the penny press and a large set of popular texts published between 1833 and 1857.[47] Early in the novel, Melville describes the *Fidèle* as a floating city: "Though her voyage of twelve hundred miles extends from apple to orange, from clime to clime, yet, like any small ferryboat, to right and left, at every landing, the huge Fidèle still receives additional passengers in exchange for those that disembark; so that, though always full of strangers, she continually, in some degree, adds to, or replaces them with strangers still more strange; like Rio Janeiro fountain, fed from the Cocovarde mountains, which is ever overflowing with strange waters, but never with the same strange particles in every part."[48]

That Woodville's painting is set in a waiting room hints at the transient nature of both its figures and its story. Just as the men in the painting travel, so does the work's actual

milieu, a phenomenon typical of texts by Melville and, again, of Poe's story "The Man of the Crowd." The economic narrative that Woodville describes, with its underhanded dealing and trickery, may resonate on antebellum Wall Street, but its figures carry with them traces of the antebellum South as well. The sharp and the confidence man, several scholars have pointed out, posed a particular threat to unwary citizens of northern cities because, like Robert Bailey, they played the role of a bewitching southern gentleman. Just as the presence of Wall Street complicated moral criticisms of gambling in the North, so slavery problema-tized the arguments of southern reformists. "The best way to begin to appreciate the connec-tions between gambling and honor," one author writes, "is to examine closely the sharp contrast between a Southern gentleman's powerful love of gambling and his equally power-ful hatred of professional gamblers," who threatened the carefully constructed social hierar-chies that made slavery possible.[49]

Woodville may never tip his hand as to his personal convictions regarding politics and commerce, but he wears the rhetoric of the modern man on his sleeve. Unlike Melville, he was not a man concerned with the "moral emergency," but he was a clever student of hypocrisy, one of the time's major philosophical dilemmas. Curiously, then, race plays an intangible and sometimes downright incorporeal role in Woodville's stories. The black figure in *The Card Players*, for example, foils the behavior of the gamblers. Their callous greed only emphasizes his disenfranchisement. Whether in paintings about the accumulation of money, reactions to news about the Mexican War, or debates about the moral implications of expansion, Woodville makes the conduct of whites in his paintings ironic by the presence of blacks, even when that presence is merely schematic. If images of gambling are appropriate to explicit dis-courses about the double-dealing aspects of American republicanism, then they must be rele-vant to implicit but ubiquitous questions about race during the 1840s and 1850s. Though Woodville painted no black figure into *Waiting for the Stage*, at least one observer saw an African American man in the picture, a peculiar but revealing testimony to the spectral pres-ence of race in the painting.

In an appendix to his 1966 dissertation on Woodville, Grubar describes the back room in *Waiting for the Stage*. "Through the open door can be seen the closed window at the far side of the next room," he writes. "A bottle and bowl are on the window sill, below which is a coffee pot. The head of a negro is faintly seen outside the window."[50] What Grubar saw is a mystery since there is no figure, black or white, standing outside the window. No record exists of a variant painting or suggests that this faintly painted man either faded or was acci-dentally rubbed from the canvas. More likely, Grubar mistook the oval belly of the coffee pot—or a shadow?—for a face, and once he saw it never looked closely at that portion of the painting again. In Grubar's mind at least, a ghostly black figure, peripheral and barely per-ceptible, stood outside the window of the stage room. Grubar's mistake prompts some provocative questions.

Even when black figures do appear in Woodville's paintings, they are unseen by the

white actors. Antebellum audiences, and some modern spectators as well, also overlooked the specter of race in many of their national stories. Woodville places blacks on the peripheries of his paintings to suggest, rather obviously, their place in society. His cardsharps take no notice of blackness, which sits outside their schemes for gain, unsavory as they are. But even for an artist as intrigued by physiognomy as Woodville was, corporeal absence does not signify disinterest. Not surprisingly, a minor black character in *The Confidence-Man* plays a role of some major, if metaphorical, importance. Melville describes this figure at the opening of the novel's third chapter: "In the forward part of the boat, not the least attractive object, for a time, was a grotesque negro cripple, in tow-cloth attire and an old coal-sifter of a tambourine in his hand, who, owing to something wrong about his legs, was, in effect, cut down to the stature of a Newfoundland dog; his knotted black fleece and good natured, honest black face rubbing against the upper part of people's thighs as he made shift to shuffle about, making music, such as it was, and raising a smile even from the gravest."[51]

The *Fidèle*'s black cripple is more than a crude representation of the most unfortunate members of Melville's shrunken city. As the story progresses, some characters turn on the cripple, accusing him of faking his deformity. The cripple mounts a defense by naming all the gentlemen on the boat who can vouch for his integrity. "Oh yes, oh yes, dar is aboard here a werry nice, good ge'mman wid a weed," he explains in Melville's version of a black dialect, "and a ge'mman in a gray coat and white tie, what knows all about me; and a ge'mman wid a big book, too; and a yarbdoctor; and a ge'mman in a yaller west; and a ge'mman wid a brass plate; and a ge'mman in a wiolet robe; and a ge'mman as is a sodjer; and ever so many good, kind honest ge'mman more aboard what know me as well as dis poor old darkie knows hisself, God bress him! . . . let 'em come quick, and show you all, ge'mmen, dat dis poor ole darkie is werry well wordy of all you kind ge'mmen's kind confidence."[52] All of these men, of course, are the confidence man who stalks the *Fidèle*'s passengers. He can work his frauds because the black cripple acts as an unwilling shill who, by describing so many different men, helps perpetrate the masquerade. But the cripple is an innocent, merely a helpless pawn in the mercenary schemes of the confidence man.

During the two decades before the Civil War, in the North as well as the South, white enterprise depended largely on blacks. Even confidence men and professional gamblers, who so often assumed the persona of the white southern gentleman, profited from slavery and black noncitizenship. The vocal antebellum reformist Henry Ward Beecher addressed the connections between gambling and confidence games, what he called "sensual habits," and slavery. "Men there are, who, without a pang or gleam of remorse, will coolly wait for character to rot, and health to sink, and means to melt, that they may suck up the last drop of the victim's blood," Beecher sermonized. "The agony of midnight massacre, the phrenzy of the ship's dungeon, the living death of the middle passage, the wails of separation, and the dismal torpor of hopeless servitude—are these found only in the piracy of the slave-trade? They are all among US! worse assassinations! worse dragging to a prison-ship! worse groans

ringing from the fetid hold! worse separations of families! worse bondage of intemperate men, enslaved by that most inexorable of all taskmasters—sensual habit!"[53]

Though the black figures in Woodville's painting possess little personality, much less a voice, they function in his pictures much like Melville's cripple. Whether as a foil to white enterprise, as an ironic symbol, or as a witness to sad stories, African Americans in Woodville's paintings serve what has to be called a humanitarian purpose: the exposure of hypocrisies, the smallest of which, a card game, reminded many outraged antebellum citizens of racism's (and some of capitalism's) absurdities.

◇

While certain details in *Waiting for the Stage* puncture the scene's stuffy interiority and let in the air—sometimes fresh, sometimes fetid—of the outside world, the painting itself was cut loose from the convenient exhibition and review system that the American Art-Union had set up for Woodville beginning in 1846. Woodville normally sent his paintings from Europe to the Art-Union, which would then exhibit them in its Broadway gallery, review them in its bulletin, engrave them for its members, and distribute them through sale or its annual December lottery. Woodville earned a reputation and some livelihood through this association with the organization. But by 1851, when he finished *Waiting for the Stage*, the Art-Union was embroiled in the legal skirmish that ultimately led to its demise in 1852, when it was closed under New York's antilottery laws. Woodville was thus deprived of his patron, and very few people saw *Waiting for the Stage*. In fact, the painting received no critical attention.

It remained hidden in the collection of the Woodville family in Baltimore until 1867, when the family sold it at the Samuel P. Avery auction in New York to Lucius Tuckerman.[54] That year, an author for the *New-York Daily Tribune* made the following small remark about the circumstances under which the painting was made: "Woodville . . . went back to Paris [from Baltimore] in September [1851], and for the next eighteen months remained in that city, painting, among other pictures, *Waiting for the Stage*." Also in 1867, Henry T. Tuckerman noted that those "previously unacquainted with [Woodville's] remarkable promise and successful performance, and who have been accustomed to look for high finish and effective expression in this species of genre painting, almost exclusive to foreign artists, were surprised to see such power of execution and effectiveness of details as are evident in *Waiting for the Stage*."[55]

Since Woodville visited the United States in 1851, it is fair to assume that he had heard about the Art-Union's legal difficulties before returning to Paris and beginning work on the painting. Perhaps the knowledge that he would not enjoy the easy patronage of the Art-Union allowed Woodville to make such a muddled, unresolved picture. Had the painting

been exhibited at the Art-Union, it would have met with the same questions that we ask of it today, such as who is in cahoots with whom? Does the reading man pretend to be blind? It is also conceivable that the very problems that mired the Art-Union in 1851 and 1852 informed this painting, for the legal charges brought against the Art-Union had to do with its lottery, which critics believed to be a form of gambling.

The managers of the organization, one historian explains, "employed commercial strategies, but their goal was influence, not profit. Their design for a shared national culture rested on their presumption of stewardship, and it sparked opposition on disparate fronts."[56] The first assault came from the genteel press, which challenged and ridiculed the Art-Union's popularizing mission. The penny press, meanwhile, portrayed the managers of the Art-Union as "privileged manipulators of the marketplace whose corrupt activities debased art and artists."[57] While artists and critics banded together on these platforms to impugn the Art-Union, lawyers were looking at the lottery, which was an easy target because lotteries had been under the intense scrutiny of reformers since the previous decade.

Each December the American Art-Union held a lottery to distribute paintings, engravings, medals, and other prizes to members (fig. 72). Not surprisingly, the organization's membership swelled each fall as the lottery approached. As a result, the Art-Union found it difficult to predict its annual budget and often paid its artists late. Frustration over the organization's finances and the lottery came to a head in late 1851 and early 1852, when the *Herald* accused the Art-Union of subverting state power. Noting that New York had in recent years pressed for the dissolution of lotteries, the *Herald* wondered if the Art-Union enjoyed "an especial immunity." Did the managers, one author asked, "rely on their high positions and influence to shield them from the penalties the law awards?" "Is a Lottery a Lottery," wondered another *Herald* author, "or is a lottery not a lottery?"[58] After various suits and countersuits, the state district attorney brought two actions against the Art-Union in the New York Supreme Court. In June 1852 the court ruled that the organization operated an illegal lottery. The New York Court of Appeals upheld the decision, and the American Art-Union closed.

Fig. 72]
Francis D'Avignon, after T. H. Matteson, *Distribution of the American Art-Union Prizes at the Tabernacle, Broadway, New York, December 24, 1846*, 1847. Lithograph printed by Sarony and Major and published by John P. Ridner. The Metropolitan Museum of Art, New York. The Edward C. Arnold Collection of New York Prints, Maps, and Pictures, Bequest of Edward C. Arnold, 1954. (54.90.1056)

During the antebellum period, lotteries were one more activity that bridged the gap between games of chance and high finance. We have seen that the penny papers, as well as Melville and Woodville, capitalized on the popular belief that Wall Street was merely a high-class gambling den. The story of the Cohen brothers of Baltimore brings the comparison into even sharper relief. In a speech at the Maryland Historical Society in 1875 Henry Stockbridge remembered the numerous lotteries operating in Baltimore during the 1840s. "But the traffic most obtrusively and flauntingly carried on, in the highways and byways and thrust upon the attention by all the schemes for attracting notice that ingenuity or greed could devise, was the traffic in lottery tickets," he recalled. "Advertisements in the papers, small

circulars setting forth the peculiarities of this particular scheme—the vast number of prizes—the absolute certainty of drawing a prize which prize should be a fortune or two—and big posters in colored letters making proclamation of the same rare chances met the traveler through our streets in every square and at every corner."[59]

The Cohens' Lottery and Exchange Office emerged as a leading vender during the most competitive years of lottery fever in Baltimore. When the Cohens' office opened in 1813 lotteries were common in Maryland. Local citizens used these early lotteries to collect capital for schools, roads, or churches without raising taxes. Run by Jacob I. Cohen Jr. and five of his brothers, the office served Baltimore for almost twenty years before becoming the Jacob I. Cohen, Jr., and Brothers, Banking House in 1831. Between 1819 and 1826 branch offices of the Cohens' lottery office opened in Norfolk, Richmond, Philadelphia, Charleston, and New York City. That the office sold lottery tickets to the public and ran a variety of financial services, such as banknote brokering and exchange services, is evidence enough of the cozy relationship between gambling and banking.[60]

Even Baltimore's most prized piece of public art, the George Washington Monument, was funded by a public lottery sponsored by the Cohens between 1810 and 1824. Lotteries like this one were aggressively advertised in papers and posters, and the drawings were exciting public spectacles. "Two large wheels were generally employed," one author explains. "Into one of the wheels went all ticket stubs. The other wheel was filled with slips of paper, most blank, but a few designating a specific prize. A ticket stub was drawn from the first wheel and then a slip from the second to see what prize, if any, the ticket had won."[61] The Cohens went so far as to publish their own newspaper from 1814 to 1830, the weekly *Cohen's Gazette and Lottery Register*, which advertised lotteries and included the addresses and profiles of past winners. The virtues of the lottery and its winners were always stressed; thus it was reported that Mr. Elisha Tarver, a $50,000 winner from Crawford County, Georgia, had been born into poverty "without a murmur." Mr. Tarver possessed "those desirable qualities which make him a firm friend, good neighbor, and estimable citizen."[62]

But financial success during this time rarely went unchallenged, and soon moral opposition to the lotteries grew under the auspices of gambling reform. Fabian explains how organized opposition to lotteries appeared in New York in the 1820s. "While lotteries funded laudable projects," she writes, "they allegedly destroyed the individuals who ventured in them, and critics beseeched the public to consider the means they used to raise revenue as well as the ends. Lotteries raised money for good causes, but they violated an equally important public interest in making people into good citizens mindful of small accumulations and small expenditures."[63] While the Society for the Prevention of Pauperism struggled to close gambling houses, it had greater success against the lottery: by 1840 lotteries had been explicitly prohibited in twelve states and were under pressure in the other fourteen. In 1841 one reformer wrote, "If it is the duty of the government to encourage idleness, that duty may be accomplished through the instrumentality of the *lottery*."[64]

The Cohens eventually became bankers, and two of the brothers, David and Benjamin, helped form the Baltimore stock exchange. But because lotteries had become associated with gambling, entrepreneurs who, like the Cohens, moved from the lottery into banking carried with them traces of corruption and helped bolster the popular opinion that even legitimate financiers were corrupt. So those reports in the New York press that accused Art-Union managers of using art as currency in a game of chance resonated with the public.

Whether from accounts gathered from newspapers sent to him in Europe, from correspondence with friends and family, from his time in Baltimore, or from his association with the American Art-Union, Woodville would have been keenly aware of nuances in the debates surrounding gambling and confidence games. *Waiting for the Stage* captures the kind of posing and posturing necessary for success in any number of economic pursuits, whether selling stocks or playing poker. Woodville again performs the role of a shill here. By painting in his usual descriptive and anecdotal manner, he leads us to believe that we are looking at a simple painting. But after peering into the picture's dark recesses, we begin to sense that we have been blinded and duped by our expectations of genre painting. Prepared only for a quick read, for instance, many viewers miss the faintly drawn sketch on the chalkboard that hangs from the latticework in the background.

The sketch is a crude caricature of a man's face with devilish features. He has a sharp chin, pointy ears, and wears a sinister grin. Though not quite hell, this waiting room, with its fiery-hot woodstove and corrupt gamblers, is certainly the devil's workshop. Woodville's penchant for overstatement may explain his gag of including a sketch of an impish face in the painting. We have seen how his exaggerations can mask subtle but pertinent social meanings. But what no one, to my knowledge, has noticed before is the resemblance between the man in the chalk sketch and Woodville himself. Woodville, we know from portraits, wore a sharp beard and had pointy ears and an angular face. The chalk sketch bears more than a passing resemblance to the artist.

By picturing himself in the waiting room, like a fly on the wall, Woodville draws attention yet again to the act of observation. Even without this little gambit, he is present in the painting as an observer. The spy stands as a sort of privileged viewer, or surrogate artist, surveying what is around him without arousing suspicion. Woodville, like the spy, was capable of thoroughly modern strokes, or so-called crooked-fingerisms—while living across the Atlantic, he placed himself in an American waiting room. "The spectator," Baudelaire said of his era's voyeurs, "is a *prince* who everywhere rejoices in his incognito."[65]

The modern man also feigned disinterest. Convincing people to believe that society was simpler than it really was, that things were as they appeared when in fact they were not, were not uncommon strategies of the modern artist and the confidence man. In order to survive in a world where gamblers were on the make, where professionals needed only appear professional, and where arts organizations were deemed criminal, Woodville had no choice but to be a man of the moment, to be confident.

Woodville's confident self-image did not change much between the early 1840s and the early 1850s, when he painted two self-portraits (figs. 73 and 74). By all reasonable standards, Woodville had had a successful career: he had studied at the esteemed Düsseldorf Academy and exhibited at the American Art-Union, whose bulletin invariably praised his paintings. Woodville did not make a fortune as an artist, but he made enough to remain in Europe and to travel between Baltimore, Düsseldorf, London, and Paris. Works such as *Waiting for the Stage* exhibit a keen knowledge of the American scene—of its costumes, customs, spaces, and characters.

Because he died in 1855, we can only speculate on how the fall of the American Art-Union would have affected Woodville's art. Certainly the loss of patronage and financial security rattled many artists who depended on the institution, but there is no telling whether Woodville would have abandoned genre painting, for example, to make a living as a portrait painter. Between 1851 and his death four years later Woodville painted one genre picture, *The Sailor's Wedding* (fig. 75), and several portraits, including two pictures of Mrs. William Fridge Murdoch (private collections), the wife of a prominent Baltimore merchant, and one of his brother William Woodville VI (private collection).

About 1853 Woodville also painted two self-portraits, both of which exhibit his poise and self-assurance. The two self-portraits function as pendants, each describing distinct sides of the artist's character. The half-length *Self-Portrait in a Black Coat* (fig. 73) shows Woodville standing against a grayish green background. The artist wears a formal black coat, a white shirt, a bow tie, and a wing collar. This self-portrait describes the same visage—the piercing eyes, angular facial features, and pointy beard—as that in the chalk sketch in the background of *Waiting for the Stage*. Here Woodville finds in himself some vestiges of a scion, of a privileged city aristocrat. He pictures himself with seriousness and formality, as well-to-do and in possession of a profound intellect. Another attitude shows itself in *Self-Portrait in a Tan Coat* (fig. 74). Dressed less primly, in a casual coat and checked pants, holding a brownish black top hat, Woodville slouches in a chair and turns slightly away from the viewer. He sits in front of a wall covered with tan wallpaper decorated with red and white roses with green leaves. With one hand raised to his face and his top hat resting on his knee, Woodville's posture here appears far more contrived; his splayed legs exaggerate his aloofness and disclose a cool detachment typical of the Parisian dandy. We know that Woodville was not an interlocutor or a zealot, but this self-portrait presents a man familiar at least with the bohemian and avant-garde posturings of Baudelaire and Courbet in the late 1840s and early 1850s. Woodville spent some time in Paris while Courbet stirred up controversy there, and it is easy to believe that a young American painter living in Europe in 1853 would have wanted to see some affinity between his work and trends in Paris. Assuming self-satisfied airs was one way Woodville might do this.

Fig. 73] Richard Caton Woodville, *Self-Portrait in a Black Coat*, c. 1853.
Oil on canvas, 9 x 7 in. (22.9 x 17.8 cm). The Walters Art Museum, Baltimore

Fig. 74] Richard Caton Woodville, *Self-Portrait in a Tan Coat*, c. 1853.
Oil on canvas, 9 x 7 in. (22.9 x 17.8 cm). The Walters Art Museum, Baltimore

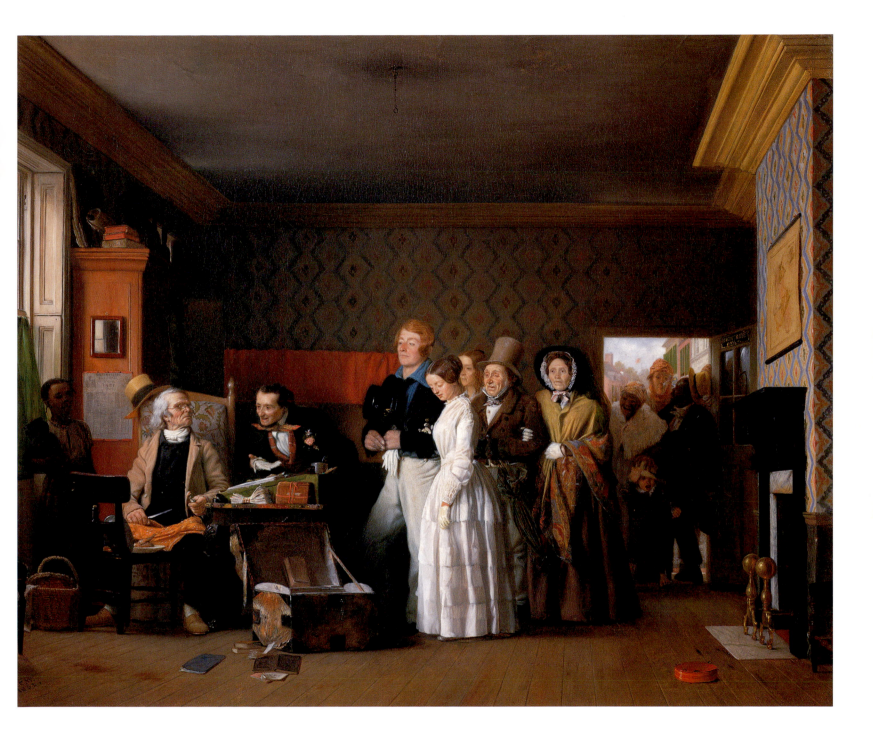

Fig. 75] Richard Caton Woodville, *The Sailor's Wedding*, 1853.
Oil on canvas, 18 ⅛ x 22 in. (46 x 55.9 cm). The Walters Art Museum, Baltimore

Perhaps the least mysterious aspect of Woodville's biography is his romantic life. He married Mary Theresa Buckler, of Baltimore, on 3 January 1845, just months before the couple departed for Düsseldorf in May 1845. According to their son, Henry "Harry" James Woodville, born on 14 September 1845, "Both were very young & hot headed."[66] After the birth of their second child, Elizabeth "Bessie" Woodville, in 1849, the couple's marriage dissolved, and Mary returned to Baltimore with the two children. One source says that Woodville "divorced [Mary Buckler] for infidelity."[67] However, Woodville was likely the adulterer: his relationship with Antoinette Schnitzler, a student at the Düsseldorf Academy who was "far older" than Woodville and "notorious in her intrigues," began as early as May 1849.[68] The couple were married in 1854.[69] A baptismal certificate for Alice Woodville, the couple's first child, documents her birth in England on 12 March 1853. Antoinette Woodville gave birth to the couple's second child, Richard Caton Woodville Jr., on 7 January 1856, after the artist's death. (Richard Caton Woodville Jr., who became a well-known artist, particularly for his battle pictures and work for the *London Illustrated News*, committed suicide on 17 August 1927.)[70] Even Woodville's family knew very little about his activities during the final years of his life. His brother William wrote to William Pennington in 1879 that "Caton was exceedingly reticent and never wrote about his affairs, projects, occupations or mode of life" and that "none of us ever knew of his second marriage until after his death, when wife No. 2, much to our surprise, turned up."[71]

It is surely nothing more than a coincidence, but Woodville's physical appearance prefigures that of an infamously bad husband from American fiction. In the 1908 edition of Henry James's *Portrait of a Lady* the author gives Woodvillean features to Isabel Archer's husband, Gilbert Osmond, whom Harold Bloom has called "very bad news."[72] James writes, "He had a fine, narrow, extremely modeled and composed face, of which the only fault was just this effect of its running a trifle too much to points; an appearance to which the shape of the beard contributed not little." James adds, "This beard, cut in the manner of the portraits of the sixteenth century and surmounted by a fair mustache, of which the ends had a romantic upward flourish, gave its wearer a foreign, traditionary look and suggested that he was a gentleman who studied style."[73]

Though it is steeped in the seventeenth century, we have seen how *The Cavalier's Return* (fig. 47) also relates to Woodville's own cavalier attitude regarding his duties as a husband and a father. The painting, remember, testifies to war's disruption of the "fireside" in the context of both the English Civil War and the Mexican War. In the painting, a mother urges her shy young son toward his itinerant father. Before his death Woodville returned one more time to the theme of marriage. Though it touches on troubling aspects of the artist's personal life, Woodville's final genre painting, *The Sailor's Wedding*, marks a departure from his usually incisive conversations with antebellum capitalism and imperialism. If not the first step in a major shift, and we cannot say for sure, *The Sailor's Wedding* at least suggests a turn toward the kind of caricature and comedy typical of Woodville's peers.

Courtship was a popular theme with antebellum genre painters. Artists like William Sidney Mount and Francis William Edmonds treated courtship as "both potentially traumatic and comic," though usually the latter. In *Rustic Dance after a Sleigh Ride* (1830; Museum of Fine Arts, Boston) and *The Sportsman's Last Visit* (fig. 76), for instance, Mount shows the pressures placed on young women by male advances. Family members, clergy, and social reformers never let unmarried women forget that choosing whom to marry was the most important decision of their lives. Courtship scenes—Edmonds's *The City and the Country Beaux* (fig. 77) is another example—rarely focused on the specific conundrums faced by middle-class women, however, capitalizing instead on the humorous aspects of love-making, mainly the meeting of the city man and the country bumpkin in the lady's house. Both *The Sportsman's Last Visit* and *The City and the Country Beaux* interpret courtship, in Johns's words, "as a proving ground of the middle-class male." Though the meeting of the city and the country had serious implications during the antebellum years—they showed the "bump-kinish, inexperienced, but ambitious sovereign, making his way in a strange world of social (and thus economic and political) exchange"—the paintings by Mount and Edmonds relied more heavily on slapstick comedy than on incisive social criticism for their success.[74]

Though Mount's painting is more understated than Edmonds's, both pictures poke

Fig. 76 *above, left*]
William Sidney Mount,
The Sportsman's Last Visit, 1835.
Oil on canvas, 21 ½ x 17 ½ in.
(54.6 x 44.5 cm).
The Long Island Museum of
American Art, History &
Carriages

Fig. 77 *above, right*]
Francis William Edmonds
(AMERICAN, 1806–1863),
The City and the Country Beaux,
1838–40. Oil on canvas,
20 ⅛ x 24 ¼ in. (51.1 x 61.6 cm).
Sterling and Francine Clark Art
Institute, Williamstown,
Massachusetts, 1955.915

fun at the suitors, whom the artists depict as well-dressed sophisticates, or confidence men, and head-scratching rubes, or bumpkins, respectively. Each painting, according to Johns, is a comedy of manners. Writing about *The City and the Country Beaux*, Johns asserts, "Both male visitors are ludicrous in their attempts to assume sophisticated manners and dress. Each is overdressed: the one in black carries his city elegance too far; the one in striped pants is clearly a newcomer to fashion *and* a new aspirant to middle-class status. Not only has he chosen the wrong style, he has not yet learned drawing-room manners."[75]

In trying to categorize these courtship scenes by Mount and Edmonds, Johns contrasts them with later genre paintings. "What," she asks, "was responsible for the shift in emphasis from courtship in the 1830s and early 1840s, images that probed male initiative, to . . . representations by young artists in the later 1840s and 1850s of a subtle 'atmosphere' under the agency of women?" Johns points to cultural productions—such as *Godey's Lady's Book*, gift book annuals, illustrations, and prints—that catered to an increasingly large female audience to explain the shift. Though by no means radical, these cultural products empowered the middle-class woman by showing her exerting some control over the home and, according to Johns, over "manners, beauty, and peace."[76] In thinking about this "subtle 'atmosphere' under the agency of women," one is reminded of Woodville's *Old '76 and Young '48*, specifically of the mother in the painting, who quietly encourages her son to carry on with his soliloquy. And Woodville, as I have been arguing, consistently used crafty atmospheres and indirect narratives to make and mask his statements. His nuanced interiors, however, were the product not of any special awareness of an increasing female audience—his primary subject was always male socialization—but of an apartness, of a willful dislocation in Europe and of a probably subconscious treatment of the alienation and disarray wrought by antebellum economics. So it comes as little surprise that when Woodville turned to marriage as the subject of his final genre painting, he broke away from customary treatments of the family interior. Not only does *The Sailor's Wedding* transform the romantic narratives told by other genre painters but in it Woodville abandons his usual bite and opts instead for a touch of burlesque, a tone that ridicules a low subject by cloaking it with mock dignity.

Grubar writes that "Woodville's *The Sailor's Wedding* was perhaps his most ambitious effort in organizing a larger group of figures within a controlled space."[77] Grubar makes a good point, for no other Woodville painting has so many figures—twelve in all—crowded into a room. It is ironic that for a supposedly intimate subject, a wedding, Woodville abandons his usual spatial constriction and the spirit of alliance typically displayed by his figures. Whether bonding over a game of chess, counting on one another to pull off a scam, or holding forth in a family drawing room or an oyster cellar, Woodville's figures always look at either the same thing or one another. Despite coming together to witness the marriage of the proud sailor and his demure bride, the figures in *The Sailor's Wedding* relate to one another more theatrically than confidentially; that is, they are arranged in the room artificially, more for the viewer's entertainment than for the purposes of an intricate narrative. Grubar

describes Woodville's arrangement this way: "Although he maintained the symmetrical stage-box design of his earlier paintings of interior scenes, the smaller group of the magistrate, negro servant and best man, and the assemblage of bystanders crowding into the open door at the right rear, act as a subordinate oblique pivot which supplements the major rapport provided between the bridal pair and the magistrate, whose placement is parallel with the picture plane."[78] In other words, Woodville prioritizes composition in this painting, and never before, except perhaps in *War News from Mexico*, had he subordinated his figures to style. Though most of Woodville's totems—clutter; a red cuspidor; a mirror; broad, stained floorboards—are in place in *The Sailor's Wedding* this is not a typical, pressure-cooked Woodville interior. *The Sailor's Wedding* marks the first time he ventilated a room with a little air and illuminated a scene with sunlight. Perhaps because of the disruptions that marriage had caused in his personal life, Woodville chose not to scrutinize his subject here too closely. Or perhaps, knowing that *The Sailor's Wedding* would not be exhibited at the American Art-Union for his usual audience, he chose to back off and air it out, so to speak.

The Sailor's Wedding is dated 1852 but was most likely begun the preceding year. In 1851 the *Bulletin of the American Art-Union* wrote, "Woodville has been engaged at Paris upon a new work, *The Wedding before the Squire*, which we understand has been purchased in advance by Goupil & Co. It is a subject well adapted to the artist's peculiar powers."[79] Although Woodville completed the painting too late for inclusion in the final exhibitions of the perishing American Art-Union, it did appear in the New York Crystal Palace Exhibition in 1853, an event of some significance since only seventeen of the nearly seven hundred paintings exhibited were by American artists. Despite its being shown at the Crystal Palace, no critical reviews of the painting appeared in the contemporary press. The most lively description of *The Sailor's Wedding*, which did not appear until 1867, was written by an anonymous author who was mysteriously well-informed on matters pertaining to Woodville:

> *The Sailor's Wedding* represents the office of a Justice-of-the-Peace in Baltimore who is interrupted, just as he is being served with his luncheon, by a party consisting of a stalwart sailor and his modest little rose-bud of a sweetheart, with the groom's next man, his old father and mother, and a single bridesmaid. The groomsman, with an overpowering politeness, points with his gloved hand to the couple, and informs the judge that they are in immediate need of his services to splice them and be done with it, or make them wait until he has finished his luncheon. Meanwhile, the old black servant continues her preparations for the Squire's meal, kneeling on the floor, and taking the good things out of the ample basket, while the little daughter who was just setting a jar of pickles on the broad window-sill, stands with it in her hands forgetful, absorbed in delighted wonder at the smart appearance of the bride. That pretty creature is dressed in a white muslin gown of a rather scrimped pattern, with deep tucks in the skirt, a waist of preternatural length, and long sleeves, with white cotton gloves.

Her hair is neatly arranged, with a rose among the braids, and she is delightfully sheep-faced, and prettily modest, and would tremble if she did not have hold of that mighty Jack's arm, who looks as scrubbed, and brushed, and proud, and good-natured, as an American sailor should, especially when he is going to be married. . . . To go over the whole catalogue of details would be wearisome—from the Franklin Almanac pasted on the side of the book-case—too much paste having been used, the superfluity was smeared over the wood, to the old hair-trunk filled with bundles of papers which the judge has been examining; from the pattern on the old negro woman's gown or that on her child's apron—at her hair, to the embossed ornament on the spittoon, or the figure on the oilcloth; everything is painted with an absolute perfection, true to nature at once in its delicacy and effect. The study of such a picture makes one deeply regret that the artist found no theme worthy of his high talent, a talent as high as that of Meissonier who also is without a subject, and great must also be our regret that such a master should have been without a pupil, and should have died without leaving more than an individual trace upon Art in America.[80]

Despite the large number of figures in the painting and the disarray of the magistrate's chamber, *The Sailor's Wedding* is Woodville's most contrived painting. None of the characters in this scene relates to the central action with the same casual demeanor typical of the figures in Woodville's other paintings. Woodville carefully tunes all the manners and postures in *The Sailor's Wedding* to the rapport between the grumpy magistrate and the bride and groom. Depicted at the exact center of the composition, the sailor is the tallest figure in the group, and his erect posture contrasts perfectly with his bride's unassuming nature and down-turned head. However, considering some of the stereotypes that were available to Woodville, we can say that he treats his "stalwart" sailor with some dignity. For instance, while the sailor's physical attributes—his red hair, fair skin, and ruddy cheeks—suggest that he is Irish, Woodville forgoes all the cruel tropes of antebellum caricatures of this immigrant group. In the popular theater and press the Irish were subjected to some of the harshest censures in antebellum society—besides those reserved for blacks. Actors and journalists portrayed the Irish as intemperate, bumbling rascals. Verbal and theatrical imagery during the 1840s and 1850s often directed attention to the Irishman's propensities for conflict and unrestrained emotionality. One study shows how the Irish were usually associated with adjectives like "frisky, enthusiastic, temperamental" and "idle, improvident, reckless." The public connected Irish immigrants to "decadence, license, and democratic radicalism" and assumed they would bring with them to America "libertinism and excess."[81] By contrast, Woodville's sailor, even if he is fickle in love, is an upstanding citizen.

Woodville might also have associated the groom with some of the stereotypes his public leveled against sailors. Antebellum maritime narratives, including William McNally's *Evils and Abuses* (1836), Richard Henry Dana Jr.'s *Two Years before the Mast* (1840), Samuel

Leech's *Thirty Years from Home* (1843), and J. Ross Browne's *Etchings of a Whaling Cruise* (1846), depicted sailors as uncivilized and antisocial brutes. These books and Melville's own maritime stories—*Typee* (1846), *Omoo* (1847), *Redburn* (1859), *Moby-Dick* (1850), *White-Jacket* (1850), and "Benito Cereno" (1856)—showed some sympathy for mariners. Rules onboard were so rigid and capricious that one scholar has drawn comparisons between the sailor's life and the slave's life. Samuel Otter describes "two related genres of antebellum anatomy, the seaman's narrative and the slave's narrative."[82] But life aboard a ship did not breed a class of abolition-minded citizens; rather, it reared mean and bitter men and then turned them loose on the terrestrial world. Melville ends *White-Jacket* with the devastating conclusion that the "organic evils" of naval life are "incurable, except when they dissolve with the body they live in."[83]

Woodville's public expected that once sailors were onshore and free from a terrible authoritarianism, they would carouse and terrorize more socialized citizens. John Carlin's painting *After a Long Cruise* (1857; Metropolitan Museum of Art, New York) shows just such behavior. In the painting three drunken sailors wreak havoc on a New York dock. Two of the sailors knock over the stand of an apple and peanut vendor, while the third, reacting ironically, perhaps, to being treated like "chattel" on his ship, accosts a black woman.[84] Viewers could laugh at Carlin's painting because, as David S. Reynolds writes, a "crew's bold depravity is found to be preferable to the institutionalized corruption embodied in tyrannical captains and the unfair naval laws they enforce."[85] But Woodville did not play his sailor for such laughs; his characterizations here result in a rather conventional view of antebellum marriage. Both the bride and the sailor conform to the customary gender roles of the day: the sailor appears confident and in firm control of his desires, while the bride remains subordinate to each man in the picture and relinquishes to them the particulars of her wedding day.

Marriage was a favorite theme of antebellum fiction and advice manuals. Authors prescribed two kinds of behavior to unmarried women in the 1840s and 1850s: either to be more conservative and accept the proposal of any decent, employed man or to be slightly more liberated and wary, to preserve the institution of the family by accepting only the advances of reputable men with whom they knew they could make a healthy home. Even female authors did not suggest that women should marry for love, because love was a fickle passion, whose legitimacy should not be gauged by young women alone. The bride in *The Sailor's Wedding*, it must be admitted, seems to be on the fence, unsure of her future, but she does not subvert the institution of marriage. Her behavior indicates, rather, that she is a typical middle-class antebellum woman who can be made to represent either of the two kinds of lady that antebellum literature on the subject called for.

Godey's Lady's Book was the most popular and most influential manual for female behavior during the antebellum period. As Isabelle Lehuu points out, *Godey's* may be seen as dissident only insofar as it provided a singular community for women, but it was, under the editorship of Sarah J. Hale, from 1837 to 1877, most certainly a "conformist" text. *Godey's*,

according to Lehuu, did not oppose dominant attitudes about female education, for instance, which "had long stressed intuitive and emotional qualities at the expense of mental capacities." Lehuu writes about the watercolored steel engravings that appeared in *Godey's* and that "illuminate the construction of femininity in antebellum printed material" (fig. 78). She might as well be remarking on the shy bride in Woodville's painting when she describes the women in these prints: "Whether standing or sitting, the ladies of *Godey's* engravings kept the same empty expression on their faces. The mouth was closed; the eyes looked down or at another lady. . . . *Godey's* ladies did not pay attention to the spectator; they looked at each other and were involved in their closed society or separate sphere." *Godey's* may have made antebellum women an active audience, but the women shown in its prints "embodied an ideology of domesticity, maternal instruction, and the power of sentiment."[86] Woodville's bride appears to be lifted right out of *Godey's* pages; she has nothing in common with the women of the 1848 Seneca Falls Convention on the Equality of Men and Women, who resolved "that all laws which prevent woman from occupying such a station in society as her conscience shall dictate, or which place her in a position inferior to that of man, are contrary to the great precept of nature, and therefore of no force or authority."[87]

Fig. 78]
Wedding Costumes, 1850.
Engraving, in *Godey's
Lady's Book* (Mar. 1850).
The Library Company
of Philadelphia

For the most part, antebellum marital fiction conformed to the conservative views of *Godey's* on the female role in society. Many such works were, in the words of one scholar, "romantic idealizations."[88] One antebellum female writer, Rose Terry Cooke, asserted in the 1850s that in law and in fiction marriage too often ends a woman's complex "historic" life "in all capacities of happiness and suffering."[89] It is easy to place Woodville's bride within these restrictive narratives; she displays no capacity for action and is a limpid china doll. Whether or not the magistrate decides to marry them before he finishes lunch, her fate is sealed. But is it much more difficult to translate the bride's diffidence into wariness or cogitation? The second type of antebellum lady, the one who is slightly more liberated, may not resist marriage but at least decides to marry for the right reasons. Might the sailor's bride be isolated from the men around her because she is absorbed in thought rather than resignation?

Lehuu writes in her essay on *Godey's* engravings that their "ladies held their heads quite artificially, like a sort of mask, as if heads were accessories like hats. They were not supposed to represent the source of female energy, for women's movements were directed not by intellect but by sentiment."[90] The distinction between sentiment and intellect may not be as sharp as Lehuu suggests, however. The sailor's bride holds her head just so, like a hat, but in that sentimental gesture we can read, if not intellect, at least sensibility, and in popular literature the sensible woman often compared favorably with the man of confidence.

"The central premise underlying all the sentimental fiction that poured off the American press in the nineteenth century was that private experience was morally superior to

public life," Halttunen writes. "Sentimentalists assigned value to private experience in proportion to its emotional intensity, or what they termed *sensibility*. Sensibility was the *summum bonum* of literary sentimentalism." Sentimentalists believed that though men could possess it, women were endowed with superior sensibility. Writing in *Literary Magazine*, one sentimentalist stated that women possess in abundance "all the virtues that are founded in the sensibility of the heart. . . . Pity, the attribute of angels, and friendship, the balm of life, delight to dwell in the female breast." Because she was endowed with superior sensibility, and because she was transparent—she cried, swooned, and fell ill—sentimentalists believed that woman was naturally more sincere than man. "This quality of involuntary candor," Halttunen writes, "was seen as one of woman's finest attributes."[91]

In the sentimental view, the natural sensibility of the antebellum woman empowered her to combat the pervasive deceit of society at large, especially the treacherous duplicities of the confidence man, "who was dangerous insofar as he contrived to be emotionally opaque."[92] Seen in this light, the confidence of the sailor—his "fair exterior and winning manners"—at such an anxious moment in his life rings false, and the sailor's mock-heroicism is the burlesque here, while the blush and timidity of the bride restores honesty to the social relations at hand.[93] To be sure, "The special responsibility of women to counteract the hypocrisy of a deceitful world was part of the larger social role assigned them within what historians have called 'the cult of domesticity,'" but it was nevertheless a responsibility that was accompanied by a hint of authority and the promise of some consequence, especially in terms of marriage.[94] In this sense, the sailor's bride provides the sole counterpoint to the burlesque that unfolds in the painting, in which case she is a far cry from a demure young lass. Either way, Woodville's bride conforms more easily to dominant stereotypes of the period than do the figures in his earlier genre paintings, who tend to hover in the obscure shadow world that determined antebellum male character and behavior. Moreover, the sensible woman was familiar to Woodville's public because of her popularity in antebellum fiction.

Though popular works of antebellum marital fiction were "romantic idealizations," as Thomas H. Fick admits, "many authors also tried to write beyond these clichés, and to explore a woman's double life in marriage."[95] Fick argues against the dominant interpretations of sentimental marital fiction, which see the genre as unrealistic, idealized, and evasive fantasy, as having nothing to do with "the actual dealings between husbands and wives."[96] Instead, Fick maintains, antebellum marital fiction was often antiromantic: "The formulaic romance appealed as little to many nineteenth-century authors as it does to academically trained critics today; indeed, popular fiction about marriage frequently targeted rather than promoted the attitudes of romance."[97] One way these works of fiction—works like the story "First Love" (1849), by Catharine Sedgwick, and the novel *Married, Not Mated* (1856), by Alice Cary—struck antiromantic chords was by emphasizing the mental work that a marriage proposal required of a woman, work that effectively extinguished the heat of romantic

passions. "The idealized suitor of the romance, these authors suggested, could in real life inflict a lifetime of suffering on a woman who mistook the illusion for reality—who either married a romantic poseur and suffered the consequences or refused the more prosaic pleasures of common, everyday life while waiting for the knight who never appeared."[98] In other words, wariness and practical concerns often dictated female behavior in marital fiction. The perfect marriage did not come easy in antebellum popular culture.

Fick classifies such fictions as "practical realism," a category that had two subgenres: the first, antiromance, targeted illusion and promoted reason, and the second cautioned against reducing marriage to a transaction or commodity. "Both sorts of fiction propose that marriage should aspire to what Catharine Sedgwick terms the 'beau actual': a moral contract based in the possible, rather than the ideal, but which does not sacrifice the spiritual for the utilitarian."[99] In each case, however, it was the woman who did the work, who checked the contract for loopholes. "I used to be a believer in *first love*," one of Sedgwick's realist heroines puts it, "now I think second thoughts best."[100] The thought and work required of women in antebellum marital fiction is also suggested by the character Annette in Alice Cary's *Married, Not Mated*, who laments, "I have suffered, and struggled, and starved here, as long as I can, and if I can't free myself in one way I will in another: by marrying Henry Graham."[101]

The point here, to summarize again, is that in *The Sailor's Wedding* the bride's detachment and absorption may be meant to signal, not powerlessness, but a mental process central to the success of the antebellum marriage. The double meaning of her action typifies Woodville's characters, but this time that double meaning is not a hidden one. Any of the viewers of *The Sailor's Wedding* who knew fictions by popular authors like Sedgwick and Cary would have recognized this behavior. Considering that *The Sailor's Wedding* was first exhibited to the public at the New York Crystal Palace Exhibition in 1853, we can assume that many among the audience read the picture's story fairly easily. We cannot say this about most of Woodville's other genre paintings, which, as we have seen, possess slippery, if not subversive, narratives.

Though plagued by financial problems and criticism in New York's press, the 1853 Crystal Palace Exhibition, or the Exhibition of the Industry of All Nations, was a large affair that attracted a great number of visitors. The New York exhibition, America's first world's fair, was inspired by the Great Exhibition at the Crystal Palace in London in 1851. That fair, specifically the successes of American exhibitors, who won many prizes there, had impressed businessmen from the United States who attended.[102] There was never any doubt that a comparable fair in the United States would be held in New York City. As early as May 1851, Horace Greeley, a major promoter of the project, wrote in the *New York Tribune* that a structure similar to the London Crystal Palace should be erected in New York. Later, in 1853, Greeley edited a book of *Tribune* articles on the New York exhibition, in which he beseeched, "We need a broad national and cosmopolitan platform whereon genius or ingenuity may at once place its productions and obtain the highest sanctions; or where pretence may meet with

a decisive check. It is in vain to speak of the patent Office at Washington as a proper place. Washington is not a metropolis. Without disparaging its claims, suffice to say it wants the houses and the multitudes to make a metropolis."[103]

Organizers, the Massachusetts auctioneer Edward Riddle most active among them, first proposed Madison Square as the site for the exhibition. But opposition from local residents resulted in a change of venue, to Reservoir Square, bounded by Fortieth and Forty-second Streets, Sixth Avenue, and the Croton Reservoir (now the site of Bryant Park). Several plans were submitted for the structure to be built at Reservoir Square, and planners chose those of Georg J. B. Carstensen, the designer of Copenhagen's famous Tivoli amusement park, and Charles Gildemeister, a New York architect and lithographer. Emulating the building that housed the London exhibition, the New York structure was constructed of iron and glass, though its configuration was quite different. The New York Crystal Palace was built in the form of a Greek cross, with a dome one hundred feet in diameter at the intersection of its arms (figs. 79 and 80).[104] Greeley included in his book an effervescent description of the building. "This edifice starts in its delicate beauty from the earth like the imagining of a happy vision," he crowed. "Viewed at a distance, its burnished dome resembles a half-disclosed balloon, as large as a cathedral, but light, brilliant, and seemingly ready to burst its bands and soar aloft. In every sense, the Crystal Palace is admirable. To us on this side of the water, it is original. Nothing like it in shape, material, or effect, has been presented to us. If it were to contain nothing, it would alone be an absorbing attraction, and be beyond all else in New York, an architectural curiosity."[105]

The Exhibition of the Industry of All Nations opened with great ceremony, attended by President Franklin Pierce, on 14 July 1853. As described in Greeley's anthology, the opening was something of a show:

> The approaches to the Palace were very much crowded as we proceeded there about eleven o'clock. The thickly-studded drinking shops were flaunting in their intemperate seductions. The various shows of monsters, mountebanks, and animals, numerous as on the jubilee days of the Champs Elysées, opened wide their attractions to simple folk. Little speculators in meats, fruits, and drinks, had their tables and stalls *al fresco*. A rush and whirl of omnibuses, coaches, and pedestrians, encircled the place. But amid all this were plainly discernible the excellent provisions of the police to maintain order. The entrances to the Palace were kept clear, and no disturbance manifested itself through the day. Different colored tickets admitted the visitors at three different sides of the Palace, the fourth closing up against the giant Croton Water Reservoir.[106]

"Foremost among the proclaimed motives [of the fair]," one scholar writes, "was national pride. . . . A world's fair in New York was to be the country's bid for a place in the

New York Crystal Palace for the Exhibition of the Industry of all Nations.

Fig. 79]

New York Crystal Palace for the Exhibition of the Industry of All Nations, c. 1852. Lithograph by Nagel and Weingärtner, figures by Carl Emil Doepler, published by Goupil & Co. Library of Congress, Prints and Photographs Division, Washington, D.C.

sun. A display of the manufactures and raw materials of the United States would parade before Europe and the world the facts of the country's economic progress." Though "American industry had indeed won its triumphs at London with its reapers, locks and sewing machines . . . a complete exhibition of American products on this side of the ocean would do justice to American industry, labor and ingenuity. At the same time, the display of European manufactures would stimulate American industry to even greater progress."[107] Greeley, remember, spoke of a "broad national and cosmopolitan platform whereon genius or ingenuity may at once place its productions and obtain the highest sanctions."

No fewer than four thousand exhibitors displayed their wares at the New York Crystal Palace. A majority of exhibitors were from the United States, and the largest single category of American exhibits was that of machinery. As John E. Findling explains, organizers patterned the classification of goods at the New York exhibition on that of the London exhi-

AN INTERIOR VIEW OF THE CRYSTAL PALACE.

New York, Published by Geo. S. Appleton, 346 Broadway N. Y.

bition. There were four divisions, each representing a nation or group of nations. These divisions were further divided into "courts," twenty-nine for each division, each representing a category of products. In addition to the displays of products relating to industry, the Crystal Palace housed a significant collection of sculpture, probably the largest such display in the United States until then, and a picture gallery. "While the quality of the paintings exhibited in the picture gallery was questioned by many contemporaries, the inclusion of that gallery was significant: the New York Crystal Palace exhibition was the first world's fair to include an exhibit of [paintings]."[108]

 Unfortunately for Woodville, and for other American genre painters like William Sidney Mount, critics either ignored or censured the picture gallery at the New York Crystal Palace Exhibition. On first learning that *The Sailor's Wedding* would be exhibited at the Crystal Palace, Woodville should have felt pride, for it was one of only seventeen American

Fig. 80]
Charles Parsons,
An Interior View of the Crystal Palace, 1853.
The Metropolitan Museum of Art, New York. The Edward C. Arnold Collection of New York Prints, Maps, and Pictures, Bequest of Edward C. Arnold, 1954. (54.90.1047)

paintings in the exhibition. Very quickly, however, Woodville would have learned that this showing would not win him world fame. The organizers and promoters of the fair apparently lacked the confidence of the American Art-Union in matters pertaining to American art. Nor did American critics possess the conviction to praise American painting at the Crystal Palace in the presence of European visitors and artists. In his book on the Crystal Palace, Greeley includes chapters on sculpture and daguerreotypy, but he does not mention a single painting in the exhibition.

In the only thorough study of the New York Crystal Palace Exhibition, Charles Hirschfeld explains that when it came to finer products, "such as English fabrics, silverware and porcelain, French silks . . . [and] the fine arts . . . the Americans humbly deferred to European skill. . . . [T]hey forgot their own vernacular standards of utility and fell back on the European esthetic tradition, even for their own furniture."[109] One exception to this rule was the art of the daguerreotype, in which American critics, Greeley included, took great pride, though more as an accomplishment of American science than as one of American culture. According to Greeley,

> If there be any one department in the whole building which is peculiarly American, and in which the country shines preeminent, it is in that of Daguerreotypes, which are exhibited below stairs; and the collection, which is an extensive one, is made up of contributions from almost every section of the Union where the art is practiced. In contrasting the specimens of art which are taken here with those taken in European countries, the excellence of American pictures is evident, which is to be accounted for by several reasons. In the first place, American skies are freer from fogs and clouds. . . . Then the chemicals and processes are, generally speaking, of a more sensitive character, and the apparatus is more convenient and suitable than that of Europe. . . . And last, though perhaps not least, our people are readier in picking up processes and acquiring the mastery of the art than our trans-Atlantic rivals.[110]

Greeley goes on to praise at some length specific daguerreotypes, as well as specific practitioners of the art, such as Whipple of Boston; Masury and Silsbee, also of Boston; and D. Clark of New Brunswick, New Jersey.[111]

American critics also reserved some kind words for American sculpture, though in general they deferred to the Europeans. One American critic wrote, "We grow sculptors as naturally as we grow Indian corn and it is no wonder that a taste for their works should be indigenous, too."[112] Hiram Powers, the American sculptor whose international reputation depended in part on the popularity of his *Greek Slave* at the London Crystal Palace Exhibition in 1851, displayed three works in New York to great acclaim. His *Eve*, a typically classical piece, was considered by one critic to be the "art-gem of the Exhibition." Of the exhibition of sculpture in general, the same author asked: "What refining influences have

already gone out from creations of the chisel here exhibited?" In answer, he cited the delight glowing on the face of "a rough looking country party" as they viewed a piece of statuary.[113]

Where, one wonders, were the American Art-Union critics and members who only a few years earlier had preferred the parochialisms of Mount and the sharp eye of Woodville to the "self-indulgent sentimentality and now sly, now innocent prurience" of Victorian sculpture?[114] Backward though it may sound, one explanation is that the selection of paintings, the vast majority of which were European, was so unpopular that American critics could not muster the energy to defend the few American artists in the exhibition. The exhibition of American paintings at the Crystal Palace was no blockbuster. Other than paintings by Woodville, Mount, Rembrandt Peale, and a reduced copy of *Washington Crossing the Delaware* executed by Leutze himself, none of the American paintings was by an artist now fondly remembered by history. The *Official Catalogue of the Pictures Contributed to the Exhibition of the Industry of All Nations in the Picture Gallery of the Crystal Palace* lists such painters as J. B. Martin, F. Dewehert of New York, and Eliza Adams of New Haven.[115] Hirschfeld explains that a great number of the paintings shown were by members of the "romantic Düsseldorf School," that wing of the school to which Woodville did not belong. "The collection as a whole found no favor with the connoisseurs, who thought the paintings trash, 'crude abominations' and humbugs. In a burst of native pride, they resented them as an imposition by Europeans who seemed to think that Americans were 'semi-barbarian, and easily tickled with a show, no matter how crude.'"[116]

No paintings in the exhibition were by painters of America's Hudson River School or by European political or realist painters. Contributions from the Düsseldorf School included works such as *Castle of Kronenburg in Denmark, by Moonlight* by M. Larson, *A Forest Inn* by William Klein, *A Chicken Surprised by a Fitchet* by Fr. Happel, and *Diana and Her Nymphs in the Bath* by "Prof. C. Sohn," one of Woodville's teachers in Düsseldorf.[117] Though these paintings were popular in Europe and the United States, they did not elicit excited responses from the New York press. Because supporters of the New York Crystal Palace Exhibition believed that their ends—a celebration of American industry and labor—would be best served by avoiding aesthetic debates altogether, very few critics even mentioned the paintings on display at the fair. Though Woodville's paintings were popular in the United States, it would have been difficult for American authors to make a case for the superiority of American art using genre painting as an example; it was better instead just to ignore the matter. As a result, the presence of *The Sailor's Wedding* in the Crystal Palace did little for Woodville's reputation, either abroad or at home.

Woodville's reputation and those of the other artists may, in fact, have suffered by association with the Crystal Palace Exhibition. As ambitious as it was, the fair was wracked by controversy from the beginning. Rather than exhibiting all that was sophisticated and accomplished about American industry and culture, the Exhibition of the Industry of All Nations displayed for the whole world all that was corrupt and avaricious about antebellum

economics and showmanship. Much as American artists were made to pay for their dependence on the American Art-Union when it was closed under New York's antilottery laws, they suffered from the ill-repute of the Crystal Palace Exhibition.

As Hirschfeld describes it, "[T]he initial impulse [for the fair] was mercenary."[118] Edward Riddle, the Massachusetts auctioneer who masterminded the exhibition, caused a scandal early on. He wheedled a site from the New York Common Council by threatening to take his project to another city. The council responded by leasing him Reservoir Square for five years at one dollar per year. At the first opportunity, Riddle swindled the council by selling the lease to his backers for ten thousand dollars and then disassociating himself from the venture. "Riddle's Palace, it was called in scorn, after that 'conspicuous, enterprising, know-how-to-make-money' man."[119] Associated businessmen then got a charter and incorporated the Association for the Exhibition of the Industry of All Nations, for which they issued a call for stock subscriptions. A cry of speculation was raised, with one critic charging, "Our New York Exhibition managers have the glorious object of making patriotic pocket full out of their own countrymen."[120]

The embarrassing spectacle only turned worse when on 10 June 1853 the Royal Commission arrived in New York to find an unfinished building. "The commissioners were chiefly worried about getting their laundry done in New York," while the "ladies went ashore and found the Palace 'very backward,' the dust annoying and the cabmen cheats. Her Majesty's man-of-war's-men were scurrilously assailed in the city's streets, presumably by angry Irish immigrants."[121] According to Hirschfeld, the difficulties of building the Crystal Palace were "insuperable." Delays, incompetence, and cost overruns bogged down the construction, prompting the architects, Carstensen and Gildemeister, to defend themselves in an "Introductory Statement" to their 1854 *Illustrated Description of the Building*. "During the progress of the Crystal Palace, after its completion, and indeed up to a very late date, the public ear was filled with rumors—all of which tended to place us in a false light before the people," they explained. "These injurious reports had none of the characteristics of the mistakes into which the public sometimes fall, and which almost immediately rectify themselves. There was a steadiness and persistency about them; a skillful and willful misinterpretation of motives, and misstatement of facts, which rendered it evident at once that a secret and clandestine influence was being brought to bear against us."[122]

Critics amplified their complaints about the exhibition after its opening. In a chapter titled "The Opening," Greeley lamented that "of all the exhibitors, not one was allowed to be on the platform sacred to clergymen, soldiers, and politicians." He continued:

> But we do not wish to condemn the Committee of Directors for the contempt which
> they displayed for artists and working-men on the occasion. They merely chimed in
> with the filthy barbarisms of society around and about them. We may say in this
> country that we respect Art, and Work, but we do not speak the truth. We *do not*

respect them. Our measure of honor is almost exclusively political. Then, out of the piddling-peddling little wars that we have, we contrive to manufacture military heroes, and so politics and the sword carry the day. In the proceedings we see no exception to this rule. . . . No one of the twenty thousand present demanded that the men whose genius, art, industry, and courage had called the gorgeous scene into life and beauty, should present themselves and receive homage. No Artist was there. No Mechanic. No Laborer.[123]

Once under way, the exhibition continued to invite the scorn of newspapermen. Inside the Crystal Palace, Americans tried to sell their economic and industrial progress to the world; on the grounds surrounding the building, the realities of American social life were evident. "On the empty lots on the three sides of the Crystal Palace, there sprang up an array of grog shops, gambling dens, side-shows, cock-fight arenas and other 'haunts of dissipation' that perturbed respectable citizens," one newspaper reported. "Here visitors who were looking for something more entertaining than water-pumps or plows could have their fill of 'double-headed calves and harlequin performances,' five-legged cows, dancing bears, mermaids, dwarfs, giants, rattlesnakes and 'grinning darkies,' the whole array of popular attractions that have crowded the midways of international expositions ever since."[124] As early as October 1853, just four months after it opened, the Crystal Palace was engulfed by the cacophony of the crowds on its surrounding lot, which were not nearly so proper and well mannered as the one depicted in a lithograph printed by Goupil and Company in 1852 (fig. 79). The press also joined in the fray, criticizing every aspect of the exhibition. Realizing that only a ringmaster could save the escapade, in the spring of 1854 the directors and stockholders persuaded P. T. Barnum to lend his showmanship to the effort to save the exhibition for another season.

Barnum took over the presidency of the Crystal Palace from Theodore Sedgwick in 1854, about nine months before the publication of his popular autobiography, *The Life of P. T. Barnum*. In this work, which he dedicated to "The Universal Yankee Nation, of which I am proud to be one," Barnum details, without apology, his life of humbuggery. Recognizing that Americans could stomach a dose of deceit with their entertainments, Barnum held nothing back in his book and offered up a fairly candid view of his life as a mercenary entrepreneur. If Barnum offers any apologia in his autobiography, it comes in the early chapters, where he describes his youth in Bethel, Connecticut. As summarized by Neil Harris, Barnum writes of "fraudulent battles between peddlers and shopkeepers, the elaborate (and sometimes nasty) practical jokes, the teasing of children and abuse of dumb animals. . . . Compassion, affection, idealism, and relaxation rarely punctuated the stream of old memories that described his boyhood." Because Barnum's neighbors and ancestors had worshipped "sharpness" over integrity, it was easy for him to admit to his own actions of "self-interest" as he moved from boyhood to his takeover of the American Museum, Tom Thumb, the Hoboken buffalo hunt, the Fejee Mermaid, and Jenny Lind. Barnum "insisted that he was governed by

neither generosity nor justice" but by "selfish calculation."[125] One reviewer of Barnum's autobiography wrote, "He seems to fear that he shall be suspected of having sometimes acted without an eye to the main chance."[126]

In a chapter of his biography of Barnum titled "The Man of Confidence," Harris describes Barnum as a self-admitted and proud confidence man: "Barnum argued that humbug was not fraudulent if it yielded to pleasure." Some newspaper authors, as Harris points out, agreed with Barnum. A piece in the *Merchant's Ledger* that was reprinted in the *Literary World*, for example, argued that there were many confidence men in society and that their success was not altogether a dangerous sign. That swindlers could trade on the "confidence of man in man, shows that all virtue and humanity of nature is not entirely extinct in the 19th century. It is a good thing . . . [that] men *can be swindled*." But "the bitterest abuse, the angriest denunciations, and the most articulate attacks" of Barnum's book "came from across the water."[127] The English were especially outraged by Barnum's admissions. The book itself was Barnum's most daring hoax, stimulating "amazement at its audacity, loathing for its hypocrisy, abhorrence for the moral obliquity which it betrays, and sincere pity for the wretched man who compiled it. He has left nothing for his worst enemy to do."[128]

Barnum's presidency of the Crystal Palace, then, is a perfect emblem for the whole exhibition. Americans were happy to have him try to resurrect the fair, but Europeans were as skeptical of him as they were of the whole enterprise. Though Barnum promised to make the exhibition a permanent institution, even he could not rejuvenate it. On 10 July 1854 he resigned the presidency, and the Crystal Palace closed on 1 November 1854, leaving a debt of three hundred thousand dollars. After various attempts to make use of the Crystal Palace failed, a fire broke out in a storeroom on 5 October 1858, destroying the whole building in twenty minutes as firemen stood by. The New York Crystal Palace Exhibition and P. T. Barnum's presidency of it symbolize the American confidence game: a great show, supported by lots of talk and bluster, resulting in the loss of lots of money.

Though the sham that was the Crystal Palace Exhibition did not serve its small exhibitors well, Woodville at least had the last laugh. The burlesque in *The Sailor's Wedding*, which is embodied in the sailor's humorously courageous pose, reflects the exhibition's aspiration, which was to turn a provincial enterprise into an international event. This was the last display of Woodville's uncanny ability to audit antebellum economic and social practices. In his telling of it, Woodville's confident sailor becomes antebellum ambition, or Barnum, trying to sell a promise to a skeptical bride, or to both Europe and the American stockholder. All of the supporting characters are in place as well: the best man makes his pitch; the family members stand tall, wanting to believe in the promise; and the black figures wait in the wings, powerless observers with an unknown stake in the deal. Littering the stage is the debris—the messy material facts of American life—that the contract always manages to ignore. The bride may be unsure, but she will proceed if the law permits; she is not immune to the contagious confidence that permeates the room.

Though Woodville could not have known that *The Sailor's Wedding* would be his last genre painting or that it would be chosen for exhibition at the New York Crystal Palace, he managed to pull off a final piece of showmanship. Woodville's life and career belie the myth that antebellum genre painting was a nostalgic or ingenuous mode of painting. From his earliest sketches as a medical student in Baltimore to his final genre painting, Woodville engaged the most complicated characters and narratives of his time. By choosing to work in a mode that appeared explicit, Woodville became something of a confidence man and a shill himself. His descriptions appeared prosaic, but the meanings and motives that lay behind them were anything but; they revealed, rather, the gamesmanship that determined the practices of the antebellum artist and the behavior of the antebellum citizen. Living abroad in Europe, Woodville might easily have fallen asleep and dreamed mundane dreams, or worse, succumbed to trite myths about America. Instead, before overdosing on morphine and falling into a final sleep, he remained wide-awake, alert to those fringe characters—the convivial oyster-house critics; transient, top-hatted cardsharps; and wary Old '76ers—who embodied some of America's principal ironies.

INTRODUCTION
Woodville's Resemblances

1. See Francis S. Grubar, "Richard Caton Woodville: An American Artist, 1825 to 1855" (Ph.D. diss., Johns Hopkins University, 1966) and *Richard Caton Woodville: An Early American Genre Painter*, exh. cat. (Washington, D.C.: Corcoran Gallery of Art, 1967).

2. S. G. W. Benjamin, "Fifty Years of American Art," *Harper's New Monthly Magazine* 59 (Sept. 1879): 492.

3. Bryan J. Wolf, "All the World's a Code: Art and Ideology in Nineteenth-Century American Painting," *Art Journal* 44 (winter 1984): 328–37 and "History as Ideology: Or, 'What You Don't See Can't Hurt You, Mr. Bingham,'" in *Redefining American History Painting*, ed. Patricia Burnham and Lucretia Hoover Giese (Cambridge: Cambridge University Press, 1995), 259–60; Elizabeth Johns, *American Genre Painting: The Politics of Everyday Life* (New Haven, Conn., and London: Yale University Press, 1991).

4. A. S. Byatt, *The Biographer's Tale* (New York: Knopf, 2001).

5. Claude Lévi-Strauss, *The Savage Mind* (Chicago: University of Chicago Press, 1966), 16–17. Lévi-Strauss explains that the verb *bricoler* applied to the "extraneous movements" of ball games, billiards, hunting, shooting, and riding, as in a rebounding ball or stray dog. Bernard Herman uses the term in his essay "The Bricoleur Revisited," in *American Material Culture: The Shape of the Field*, ed. Ann Smart Martin and J. Ritchie Garrison (Winterthur, Del.: Henry Francis du Pont Winterthur Museum, 1997; distributed by University of Tennessee Press).

6. Harold Bloom, *How to Read and "Why"* (New York: Scribner, 2000), 19.

7. Sean Wilentz, *Chants Democratic: New York City and the Rise of the American Working Class, 1788–1850* (New York: Oxford University Press, 1984), 108.

8. Marjorie Garber, *Academic Instincts* (Princeton, N.J.: Princeton University Press, 2001), 12–16.

9. David Lubin has demonstrated that a "sky's-the-limit approach to interpretation" need not be random and pointless and that many nineteenth-century American paintings "elicited a wide, often conflicting range of significations connected to the wide, often conflicting range of social groups that constituted the society in which both the art and its artist were produced" (see Lubin, *Picturing a Nation: Art and Social Change in Nineteenth-Century America* [New Haven, Conn., and London: Yale University Press, 1994], 273–74).

10. Cynthia Ozick, "The Selfishness of Art," in *Quarrel and Quandary* (New York: Knopf, 2000), 129.

11. Walt Whitman, "Song of Myself," in *Leaves of Grass* (New York: Modern Library, 1891), 27. Bloom also cites this passage in the context of his point about Whitman's sophistry (Bloom, *How to Read and "Why,"* 19).

12. John K. Howat et al., *Nineteenth-Century America: Paintings and Sculpture, an Exhibition in Celebration of the Hundredth Anniversary of the Metropolitan Museum of Art, April 16 through September 7, 1970*, exh. cat. (New York: Metropolitan Museum of Art, 1970; distributed by New York Graphic Society).

13. For a thorough discussion of the Young America movement, see Edward L. Widmer, *Young America: The Flowering of Democracy in New York City* (New York: Oxford University Press, 1999).

14. Cornelius Mathews, "Americanism," *New York Morning News*, 11 July 1845.

15. Gulian Verplanck, *Discourses and Addresses on Subjects of American History, Arts, and Literature* (New York: J. and J. Harper, 1833), 124.

16. Ralph Waldo Emerson, "Art," in *Essays: First and Second Series* (New York: Houghton Mifflin Co., 1921), 368.

17. Ralph Waldo Emerson, "Behavior," in *The Conduct of Life* (1860), contained in *Essays and Lectures*, ed. Joel Porte (New York: Library of America, 1983), 1047.

18. *Democratic Review* 10 (Feb. 1842): 200.

19. William A. Jones, in ibid., 17 (Sept. 1845): 213–17.

20. Ibid., 211.

21. F. F. Marbury, *American Art-Union Transactions for 1845* (New York: American Art-Union, 1845), 22.

22. See M[ary] B. Cowdrey, comp., *American Academy of Fine Arts and American Art-Union* (New York: New-York Historical Society, 1953), 167.

23. *Literary World* 4 (25 Nov. 1848): 852–53.

24. Asher B. Durand, "Letters on Landscape Painting," *Crayon* 1 (6 June 1855): 354–55.

25. William Sidney Mount, quoted in Lillian B. Miller, *Patrons and Patriotism: The Encouragement of the Fine Arts in the United States, 1790–1860* (Chicago: University of Chicago Press, 1966), 222.

26. See Rachel Klein, "Art and Authority in Antebellum New York City: The Rise and Fall of the American Art Union," *Journal of American History* 81, no. 4 (Mar. 1995): 1538.

27. Wendell Phillips, quoted in Irving H. Bartlett, *Wendell Phillips, Brahmin Radical* (Boston: Beacon Press, 1961), 114.

28. *Everyday life* is a much-used phrase and so has several meanings. The study of everyday life, to begin with, has been fundamental to the development of German social theory. Jürgen Habermas, for one, suggested that the authentic "life-world" was colonized by the false world of modernization and rationalization. The French Marxist theorist Henri Lefebvre held that capitalism fractured daily life through the separation of work, household, and leisure. Postmodern studies maintain that daily life is now commodified and turned into something that can be designed for commercial viability. Everyday life becomes something elusive, more a style than a fact (see, e.g., Henri Lefebvre, *Everyday Life in the Modern World*, trans. Sacha Rabinovitch [New York: Harper and Row, 1971], and Gary Day, *Re-Reading Leavis: Culture and Literary Criticism* [New York: St. Martin's Press, 1996], 115–17).

CHAPTER ONE
"Those Scorned Facts"

1. Woodville's son, Henry "Harry" Woodville, would describe his father this way in a letter of 16 January 1880 to his mother-in-law. The letter is in the private collection of Gail Woodville Roberson, North Little Rock, Arkansas.

2. William Dunlap, *Address to the students of the National Academy of Design, at the delivery of the premiums, Monday, the 18th of April, 1831* (New York: printed by Clayton and Van Norden, 1831), 11.

3. Samuel F. B. Morse, quoted in Eliot Clark, *History of the National Academy of Design* (New York: Columbia University Press, 1954), 10.

4. Paul Staiti, "Ideology and Politics in Samuel F. B. Morse's Agenda for a National Art," in *Samuel F. B. Morse: Educator and Champion of the Arts in America* (New York: National Academy of Design, 1982), 11.

5. Morse, quoted in ibid., 17.

6. Morse, responding to a review of one of his speeches, quoted in Thomas Cummings, *Historic Annals of the National Academy of Design* (Philadelphia: G. W. Childs, 1865), 61.

7. Paul Staiti, *Samuel F. B. Morse* (Cambridge: Cambridge University Press, 1989), 209.

8. See Clark, *History of the National Academy of Design*, 17–18, 94–101.

9. Because this painting was lost when Grubar worked on his dissertation and the exhibition at the Corcoran Gallery of Art, there has been some confusion regarding its date. In his dissertation Grubar cites two sources that claim the painting was made in 1841: the *Catalogue of the Entire Collection of Paintings Belonging to the Late Mr. A. M. Cozzens*, cat. no. 5 (New York; 1868); and a letter from Woodville to William A. Hoppin, 13 June 1879, Pennington Papers, Manuscripts Department, Maryland Historical Society, Baltimore. The painting has also gone by many titles. Grubar, without ever seeing it, titles it *Scene in a Bar-room*, but it has variously been called *Bar-room Interior*, *The Smokers*, and *The Tough Story*. When it was in the collection of the Kennedy Galleries in New York the painting acquired the descriptive title *Two Figures at a Stove* and was dated to 1845, the year of its first exhibition. It does seem more likely that Woodville painted it in the mid-1840s, when he turned to genre as his preferred mode. Otherwise, he made the painting when he was seventeen and then abandoned genre painting for four years while he made the Tilghman drawings (see Francis S. Grubar,

"Richard Caton Woodville: An American Artist, 1825 to 1855" [Ph.D. diss., Johns Hopkins University, 1966]).

10. Paul E. Johnson, *A Shopkeeper's Millennium: Society and Revivals in Rochester, New York, 1815–1837* (New York: Hill and Wang, 1978), 58.

11. *New-York Daily Tribune*, 22 Jan. 1867, 2. In 1841 another publication wrote, "Our friend A. M. Cozzens, Esq., of New York" is "a most liberal patron of the Fine Arts" (see *Godey's Lady's Book* 23 [Sept. 1841]: 144).

12. *New-York Daily Tribune*, 22 Jan. 1867, 2.

13. Henry T. Tuckerman, *Book of the Artists: American Artist Life* (New York: G. P. Putnam and Sons, 1867), 408.

14. Johnson, *A Shopkeeper's Millennium*, 56.

15. Ibid., 55.

16. See Michael Kaplan, "New York City Tavern Violence and the Creation of a Working-Class Male Identity," *Journal of the Early Republic* 15, no. 4 (winter 1995): 591–618. Kaplan cites numerous incidents of gang violence, vandalism, and murder in bars and taverns during the antebellum period.

17. Lyman Beecher, *Six Sermons on the nature, occasions, signs, evils, and remedy of intemperance* (1826; reprint, New York: American Tract Society, 1843), 55.

18. See David S. Reynolds, *Walt Whitman's America: A Cultural Biography* (New York: Vintage, 1995), 92–93. On the Washingtonians, see Sean Wilentz, *Chants Democratic: New York City and the Rise of the Working Class, 1788–1850* (New York: Oxford University Press, 1984), 306–7 and Milton A. Maxwell, "The Washingtonian Movement," *Quarterly Journal of Studies on Alcohol* 11 (1950): 410–51.

19. Biographical information is taken from Grubar, "Richard Caton Woodville." Though it is a straightforward biography that offers few critical analyses of Woodville's paintings, it is the only extensive study of his life and work and has been an invaluable resource for me. William Woodville V continued to import goods, furniture, and personal items from Liverpool to Baltimore until 1819 (see Otho Holland Williams Papers, 1744–1839, MS. 908 (pt. 8/8), Maryland Historical Society).

20. Philip Hone, *The Diary of Philip Hone, 1828–51*, ed. Bayard Tuckerman (New York: Dodd, Mead and Co., 1889), 1:50.

21. Ibid., 389–95. The "outrageous revolt," recorded in Hone's *Diary* on 5 December 1839, occurred on the land of the patroon General Van Rensselaer in Albany. Hone notes five days later that the governor planned on "sending 1,500 infantrymen on two steamboats to the seat of war," but the troops were never sent.

22. Grubar, "Richard Caton Woodville," 8.

23. Richard Jackson, quoted in Robert Erskine Lewis, "Brooklandwood, Baltimore County," *Maryland Historical Magazine* 43 (1948): 282.

24. Charles Carroll of Carrollton to Daniel Carroll, 13 Mar. 1787, from Robert Goodloe Harper Papers, MS 431, Manuscripts Department, Maryland Historical Society.

25. See *Charles Carroll of Carrollton and His Family: An Exhibition of Portraits, Furniture, Silver, and Manuscripts at the Baltimore Museum of Art, September 19–October 30, 1937*, exh. cat. (Baltimore: Lord Baltimore Press, 1937). See also Ann C. Van Devanter, *"Anywhere So Long As There Be Freedom": Charles Carroll of Carrollton, His Family and His Maryland*, exh. cat. (Baltimore: Baltimore Museum of Art, 1975).

26. Documents in the Maryland State Archives indicate that William Woodville had friends and enemies among Baltimore's elite. On the one hand, he served as a trustee of Richard Caton's estate and sided with famous Baltimoreans like Charles Carroll of Carrollton and Robert Goodloe Harper in land claims (see the Chancery Papers Index, MSA S 1432, for 1820 and 1849, in the Maryland State Archives, Annapolis). On the other hand, William Woodville was petitioned by members of the Pennington and Tilghman families in chancery court for a land claim and was criticized in a printed circular letter by his former business partner, James Creighton, for financial disputes relating to their firm, Creighton and Woodville (see ibid., MSA S 1432, for 1850; and *Printed circular letter: to R. U. Douglass, 1822 Sept. 28*, in the vertical file of the Maryland Historical Society. For more information about the Woodvilles, see the Woodville-Butler Letters, MSS1465 and 1465.1, Maryland Historical Society).

27. Thomas F. O'Connor, "The Founding of Mount Saint Mary's College, 1808–1835," *Maryland Historical Society Magazine* 43 (1948): 197. See also Robert J. Brugger, *Maryland: A Middle Temperament, 1634–1980* (Baltimore: The Johns Hopkins University Press in association with the Maryland Historical Society, 1988), 175, 188, 371.

28. Grubar, "Richard Caton Woodville," 10. See also Rev. James Joseph Kortendick, "The History of St. Mary's College, Baltimore, 1799–1852" (master's thesis, Catholic University of America, 1942).

29. Woodville's father wrote: "I shall send Caton next week . . . on his way to Florence, to study the profession he is bent upon adopting" (William Woodville to his brother-in-law, the Reverend Edward Butler, Herefordshire, England,

28 Apr. 1845, Corcoran Gallery of Art, Washington, D.C.). And as the critic for the *New-York Daily Tribune* wrote, "Woodville's father did not wish him to become a painter" (*New-York Daily Tribune*, 22 Jan. 1867, 2).

30. Robley Dunglison, *The Medical Student, Aids to the Study of Medicine* (Philadelphia: Carey, Lea and Blanchard, 1837), 8.

31. J. Marion Sims, *Story of My Life* (New York: D. Appleton and Co., 1884), 23. Sims graduated from Jefferson Medical College in 1835.

32. University of Maryland, College Park, School of Medicine, "Catalogue of the Alumni of School of Medicine, 1851–52," in *Catalogue of the Alumni of the School of Medicine, 1807–1877* (Baltimore: Kelly, Piet and Col, 1877), 7.

33. Richard Harrison Shryock, *Medicine in America: Historical Essays* (Baltimore: Johns Hopkins Press, 1966), 152, 18, 126.

34. Eugene Fauntleroy Cordell, "Charles Frederick Wiesenthal, Medicinae Practicus," *Johns Hopkins Hospital Bulletin* 113 (Aug. 1900): 170–82.

35. *Federal Gazette and Baltimore Daily Advertiser*, 21 Oct. 1807.

36. For a thorough history of the College of Medicine and the University of Maryland, see George H. Callcott, *A History of the University of Maryland* (Baltimore: Maryland Historical Society, 1966).

37. Ibid., 109.

38. William E. A. Aikin, *Introductory Lecture, Delivered before the Medical Class of the University, November, 1837* (Baltimore: printed by John D. Toy, 1837), 16.

39. Benjamin Franklin to Joseph Priestley, Passy, France, 1780, in *Private Correspondence of Benjamin Franklin*, ed. W. T. Franklin (London: H. Colburn, 1817), 1:52.

40. *Philadelphia Item*, 6 Nov. 1858; *Medical and Surgical Reporter* 1 (Oct. 1858): 356.

41. *Cincinnati Medical Observer* 2 (1857): 129.

42. Samuel Clagget Chew, "Address Commemorative of Professor Nathan Ryno Smith," *Maryland Medical Journal* 3 (Sept. 1878): 407–30.

43. Eugene Fauntleroy Cordell, *University of Maryland, 1807–1907* (New York: Lewis Publishing Co., 1907), 1:99.

44. James H. Cassedy, *Medicine in America: A Short History* (Baltimore: Johns Hopkins University Press, 1991), 27.

45. Callcott, *History of the University of Maryland*, 49.

46. University of Maryland, College Park, School of Medicine, "Catalogue of the Alumni of School of Medicine, 1838–39," 4, and "Catalogue of the Alumni of School of Medicine, 1846–47," 5, in *Catalogue of the Alumni of the School of Medicine, 1807–1877*.

47. Nathan Ryno Smith to a colleague, 25 Sept. 1830, Bowdoin College Archives, Brunswick, Maine.

48. Anonymous student, quoted in Callcott, *History of the University of Maryland*, 118.

49. The drawing is in a private collection, and I have not been able to locate it. It is reproduced, however, in Grubar's 1967 exhibition catalog for the Corcoran. The handling and composition of the picture are unusually sophisticated for a child. Presumably, Woodville took the drawing and design courses at Saint Mary's. If so, then Samuel Smith was Woodville's first art instructor. Smith was born in England and was active in Baltimore from 1824 to 1851. Saint Mary's College lists Smith as the drawing instructor from 1820 to 1851 (see George C. Groce and David H. Wallace, *The New-York Historical Society's Dictionary of Artists in America, 1564–1860* [New Haven, Conn., and London: Yale University Press, 1957], 43, 590).

50. Some popular images that Woodville might have known through reproductions were Benjamin West's *Death of General Wolfe* (1770); John Singleton Copley's *Death of Major Peirson* (1782–84); and John Trumbull's *Death of General Warren at the Battle of Bunker Hill, June 17, 1775* (1786).

51. To the right of the drawings on the scrapbook page is the following inscription: "Early efforts of R C Woodville— while a student at Saint Mary's College—Baltimore— 1838—SRT [Stedman R. Tilghman]." The scrapbook is in the J. Hall Pleasants Papers, 1773–1957, MS 194, Manuscripts Department, Maryland Historical Society.

52. For Tilghman's biography, see ibid.

53. An account of Tilghman's service, illness, and death is told by a fellow officer, John R. Kenly, in *Memoirs of a Maryland Volunteer: War with Mexico in the Years 1846–7–8* (Philadelphia: J. B. Lippincott and Co., 1873), 471.

54. Notebooks from the lectures of Dr. Davidge and Dr. Nathaniel Potter, 1825–26, quoted in Callcott, *History of the University of Maryland*, 120.

55. For Aikin's biography, see J. Hall Pleasants Papers, MS 194; and Grubar, "Richard Caton Woodville," 175–77.

56. Ralph Waldo Emerson, "Education," in *Lectures and Biographical Sketches* (Boston: Houghton Mifflin Co., 1883), 132.

57. Callcott, *History of the University of Maryland*, 115.

58. Ibid. Callcott cites numerous student notebooks from the 1820s and 1830s in his summary of Potter's theories on lovesickness.

59. Eugene Fauntleroy Cordell, *Historical Sketch of the University of Maryland, School of Medicine (1807–1890)* (Baltimore: Press of I. Friedenwald, 1891), 109.

60. The inscription beneath the portrait of Cadmus reads: "'Cadmus' / Student of University of Md. / Taken while listening to a lecture / of N. R. Smith—."

61. Unidentified friend of Woodville's, quoted in a supplement to the *Baltimore Sun*, 15 Nov. 1881, 1.

62. This drawing is in a private collection, and no reproductions are currently available. However, Grubar illustrated the image in his dissertation (plate 6).

63. See James Eli Adams, *Dandies and Desert Saints: Styles of Victorian Manhood* (Ithaca, N.Y.: Cornell University Press, 1995), 23, for further definition of the Baudelarian dandy.

64. Thomas Carlyle, *Sartor Resartus: On Heroes and Hero Worship* (1840; reprint, London: J. M. Dent and Sons, 1959), 204–5, 22, 205.

65. Supplement to *Baltimore Sun*, 15 Nov. 1881, 1.

66. Beneath the drawing an inscription reads: "The group represents an operation for 'Necrosis of Radius,' at Baltimore Infirmary—by Prof N. R. Smith— / drawing by R. C. W."

67. Elizabeth Johns, *Thomas Eakins: The Heroism of Modern Life* (Princeton, N.J.: Princeton University Press, 1983), 65n. According to one author, the Baltimore Infirmary "was established with a view of affording to the students an opportunity of witnessing the practice of their future profession, and attending clinical lectures. It is a large and convenient building to the west of the Medical College, and is open every day for the reception of the sick; and, excepting Sunday, for visitors. Three physicians and four surgeons attend to the patients of the house, who are nursed in the most tender and watchful manner, by the 'sisters of Charity,' who devote themselves to the task with a piety the most devoted" (see John H. B. Latrobe, *Pictures of Baltimore* [Baltimore: F. Lucas, Jr., 1832], 169).

68. J. Hall Pleasants suggests in his papers in the Maryland Historical Society that Tilghman served the almshouse as a resident physician for two years. However, Tilghman's name does not appear on the list of attending physicians at that institution compiled by John R. Quinan in *Medical Annals of Baltimore from 1608–1880* (Baltimore: Press of I. Friedenwald, 1884), 250.

69. See the *Report of the Committee Appointed by the Board of Guardians of the Poor of the City and Districts of Philadelphia, to Visit the Cities of Baltimore, New-York, Providence, Boston, and Salem* (1827), reprinted as *The Almshouse Experience: Collected Reports* (New York: Arno Press and the *New York Times*, 1971), 26. The committee noted that "one of the greatest burthens that falls upon this corporation, is the maintenance of the host of worthless foreigners, disgorged upon our shores. The proportion is so large, and so continually increasing, that we are imperatively called upon to take some steps to arrest its progress. It is neither reasonable, nor just, nor politic, that we should incur so heavy an expense in the support of people, who never have, *nor never will* contribute one cent to the benefit of this community" (28).

70. Gary Lawson Browne, *Baltimore in the Nation, 1789–1861* (Chapel Hill: University of North Carolina Press, 1980), 49, 105.

71. Norman Dain, *Concepts of Insanity in the United States, 1789–1865* (New Brunswick, N.J.: Rutgers University Press, 1964), 127–28.

72. Dr. Stephen Collins, *Report on Pauper Insanity, presented to the city council of Baltimore on March 28, 1845* (Baltimore: printed by James Lucas, 1845), 3.

73. Dain, *Concepts of Insanity*, 63.

74. See Gerald Handel, *Social Welfare in Western Society* (New York: Random House, 1982), 122–24; and Dain, *Concepts of Insanity*, 93.

75. J. H. Miller, quoted in Cassedy, *Medicine in America*, 55.

76. *Report of the Committee Appointed by the Board of Guardians of the Poor of the City and Districts of Philadelphia*, 4.

77. Ibid., 5.

78. J. Hall Pleasants suggests in his notes accompanying the Tilghman Scrapbook that Woodville visited the almshouse because the inmates would pose for free.

79. Pignatelli advertised in the *Baltimore American*, 14 Apr. 1828, stating that he occupied "a room on the first floor opposite General Ridgley's, two doors from Mr. Finlay's in Gay Street." For a brief biography of Pignatelli, see J. Hall Pleasants Papers, MS 194.

80. Pignatelli to the Reverend W. E. Wyatt, Mar. 1844, J. Hall Pleasants Papers, MS 194.

81. Pignatelli to Dr. Stedman Tilghman, 1845, ibid.

82. Grubar, "Richard Caton Woodville," 16.

83. Supplement to the *Baltimore Sun*, 15 Nov. 1881, 1. The supplement lists the following as being students of Miller: Woodville, Andrew John Henry Way (1826–88), James Craig Jones, Mayer, William Shaw Tiffany (1824–1907), and Samuel B. Wetherald. However, the article does not cite a source for this information.

84. Included in the Tilghman Scrapbook, and further suggestive of a link between Miller and Woodville, is a drawing by Woodville of Dr. Adolphus "Dole" Hermann (c. 1822–65). Hermann, a student at Saint Mary's Seminary from 1834 to

1835 and at the University of Maryland College of Medicine from 1843 to 1846, accompanied Tilghman on Stewart's 1843 hunting expedition to the Rockies. Woodville's portrait of Hermann shows him in Rocky Mountain costume, wearing a fur cap extending to the shoulders and a coat with fur and feather ornaments. Tilghman most likely asked Woodville to draw the portrait when he returned from the expedition in 1843. At this time Miller's Western scenes were popular in Baltimore, and it is likely that Woodville viewed some of them while preparing this portrait. For more information on Hermann, see J. Hall Pleasants Papers, MS 194.

85. Marvin C. Ross, *The West of Alfred Jacob Miller* (Norman: University of Oklahoma Press, 1951), xi.

86. For an analysis of the Peale Museum in Baltimore, see Ellen Hickey Grayson, "Art, Audiences, and the Aesthetics of Social Order in Antebellum America: Rembrandt Peale's *Court of Death*" (Ph.D. diss., George Washington University, 1995), 239–54.

87. Rembrandt Peale, in his 1813 "Prospectus" for the museum, quoted in ibid., 243.

88. See Jean Jepson Page, "Notes on the Contributions of Francis Blackwell Mayer and His Family to the Cultural History of Maryland," *Maryland Historical Magazine* 76, no. 3 (1981): 219.

89. Weston Latrobe, "Art and Artists in Baltimore," ibid. 33 (Sept. 1938): 213.

90. Ibid., 228 and n. 57.

91. Frank Mayer, from his unpublished autobiography, "Bygones and Rigamaroles," 17, Manuscript Collection, Maryland Historical Society.

92. Robert Gilmor funded Miller's first trip to Europe in 1832, and Miller painted a portrait of Edmondson in Baltimore in 1842.

93. For Edmondson's biography, see Lillian B. Miller, *Patrons and Patriotism: The Encouragement of the Fine Arts in the United States, 1790–1860* (Chicago: University of Chicago Press, 1966), 131; J. Hall Pleasants Papers, MS 194; and Grubar, "Richard Caton Woodville," 34.

94. See Miller, *Patrons and Patriotism*, 131; and Neil Harris, *The Artist in American Society: The Formative Years, 1790–1860* (New York: George Braziller, 1966), 105.

95. Two sources mention that Woodville visited the Gilmor collection: the *New-York Daily Tribune*, 22 Jan. 1867, 2, and Tuckerman, *Book of the Artists*, 408.

96. Gilmor's collection was sold after his death in 1848, and it has been difficult for contemporary scholars to catalogue. My description is based on Anna Wells Rutledge, "Robert Gilmor, Jr., Baltimore Collector," *Journal of the Walters Art Gallery* 12 (1949): 19–41, and a letter to me from Lance Humphries, 15 Mar. 1997, then stating that Gilmor owned a total of about four hundred paintings, of which about forty could be called genre paintings. Of these forty, Humphries says, about twenty-one were Dutch, eight American, and three English (see also Lance Lee Humphries, "Robert Gilmor, Jr. [1774–1848]: Baltimore Collector and American Art Patron" [Ph.D. diss., University of Virginia, 1998]).

97. Harris, *Artist in American Society*, 104–5.

98. Ariel, "An Account of the Grand Musical Soirée which took place on the night of the 14th inst.," *New York Herald*, 27 Mar. 1844. See also "New Discoveries in American Art," *American Art Journal* 21, no. 4 (1989): 76–77.

99. Robert Gilmor Jr. to Jonathan Meredith, 2 Apr. 1844, MS 1367, Jonathan D. Meredith Papers, 1807–1853, MS 397, Manuscripts Department, Maryland Historical Society.

100. For more on Edmonds, see Maybelle Mann, "Francis William Edmonds: Mammon and Art," *American Art Journal* 2, no. 2 (1970): 92–106. See also *National Academy of Design Exhibition Record, 1826–1860*, 2 vols. (New York: printed for the New-York Historical Society, 1943).

101. See William H. Gerdts, *From All Walks of Life: Painting of the Figure from the National Academy of Design* (New York: National Academy of Design, 1979), 69.

102. Walt Whitman, "Letter from New York," *National Era* 4 (31 Oct. 1850): 175.

103. Karl Marx, *The Writings of the Young Marx on Philosophy and Society*, ed. Lloyd D. Easton and Kurt H. Guddat (Garden City, N.Y.: Doubleday, 1976), 222–23, 225.

104. Wilentz, *Chants Democratic*, 359. For more on urban mobs, crime, and violence, see Paul A. Gilje, *Rioting in America* (Bloomington: Indiana University Press, 1996) and *The Road to Mobocracy: Popular Disorder in New York City, 1763–1834* (Chapel Hill: University of North Carolina Press for the Institute of Early American History and Culture, 1987); Karen Halttunen, *Murder Most Foul: The Killer and the American Gothic Imagination* (Cambridge, Mass.: Harvard University Press, 1998); and Louis P. Masur, *Rites of Execution: Capital Punishment and the Transformation of American Culture, 1776–1865* (New York: Oxford University Press, 1989).

105. This account is from Ivor Guest, *Fanny Elssler* (Middletown, Conn.: Wesleyan University Press, 1970), 138–40.

106. This story is related in Hamilton Owens, *Baltimore on the Chesapeake* (Garden City, N.Y.: Doubleday, Doran and Co., 1941), 224.

107. Nativism in big cities such as Baltimore usually took the form of anti-Catholicism, although hatred was based as well on the more general categories of nationality, race, and ethnicity. Two popular anti-Catholic texts of the period were Samuel F. B. Morse's *Foreign Conspiracy against the Liberties of the United States* (New York: Leavitt, Lord, and Co., 1835) and Edward Beecher's *Papal Conspiracy Exposed* (New York: M. W. Dodd. 1855). Popular fiction also capitalized on these prejudices. Two such novels are Rebecca Reed's *Six Months in a Convent* (Boston: Russell, Odiorne, 1835) and Maria Monk's *Awful Disclosures of the Hotel Dieu Nunnery of Montreal* (New York: Howe and Bates, 1836). See also Owens, *Baltimore on the Chesapeake*, 261–70; Joseph G. Mannard, "The 1839 Baltimore Nunnery Riot: An Episode in Jacksonian Nativism and Social Violence," *Maryland Historian* 11, no. 1 (spring 1980): 13–28; and Ray A. Bellington, *The Protestant Crusade, 1800–1860: A Study of the Origins of Nativism* (New York: Macmillan, 1938).

108. See Charles G. Steffen, *The Mechanics of Baltimore: Workers and Politics in the Age of Revolution, 1763–1812* (Chicago: University of Illinois Press, 1984), xiii. See also Steffen's, "Changes in the Organization of Artisan Production in Baltimore," *William and Mary Quarterly* 36, no. 1 (1979): 101–17, and his "The Pre-Industrial Iron Worker: Northampton Iron Works, 1780–1820," *Labor History* 20, no. 1 (1979): 89–110.

109. Thomas J. Scharf, *The Chronicles of Baltimore; being a complete history of "Baltimore Town" and Baltimore City from the earliest period to the present time* (Baltimore: Turnbull Brothers, 1874), 457.

110. Browne, *Baltimore in the Nation*, 122–23.

111. The firm of Alex Brown and Sons, quoted in ibid., 123.

112. See Scharf, *Chronicles of Baltimore*, 474–79, for a detailed account of the rioting over the Bank of Maryland Affair, including a list of those arrested.

113. *Washington Native American*, quoted in Mannard, "1839 Baltimore Nunnery Riot," 22.

114. *Baltimore Register*, 5 Sept. 1835.

115. Today Baltimore actually celebrates its reputation as a dangerous, tormented city. Baltimoreans loved the television crime drama *Homicide: Life on the Streets*: the *Baltimore Sun* named the cast and crew of the program Marylanders of the Year for 1996, hailing the show as a "gloomy television drama series dwelling on human depravity that makes us proud of Baltimore." A native filmmaker, John Waters, said, "Baltimore has always celebrated the odd. That's why the city is so much fun" (see "The Pride of Baltimore," *New Yorker*, 24 Feb. and 3 Mar. 1997, 50, 52).

116. Walt Whitman, "Song of Myself," in *Leaves of Grass*, ed. Harold Blodgett and Sculley Bradley (New York: New York University Press, 1965), 84–85.

117. Reynolds, *Walt Whitman's America*, 105.

118. Ibid.

119. Whitman, in *Brooklyn Star*, 10 Oct. 1845.

120. Whitman, in *Brooklyn Daily Times*, 7 Nov. 1857, cited in Walt Whitman, *I Sit and Look Out: Editorials from the Brooklyn Daily Times*, ed. Emory Holloway and Vernolian Schwartz (New York: AMS Press, 1966), 43.

121. Daniel Walker Howe, *The Political Culture of the American Whigs* (Chicago: University of Chicago Press, 1979), 34.

122. Ralph Waldo Emerson, quoted in ibid.

123. William Woodville to the Reverend Edward Butler, 28 Apr. 1845.

124. Walter Benjamin, "On Some Motifs in Baudelaire," in Benjamin, *Illuminations*, ed. Hannah Arendt and trans. Harry Zohn (New York: Schocken, 1969), 175–76.

125. Herman Melville, *The Confidence-Man: His Masquerade*, ed. and intro. Elizabeth S. Foster (New York: Hendricks House, 1954), 270.

126. Edgar Allan Poe, "The Man of the Crowd," in *Selected Poetry and Prose of Edgar Allan Poe*, ed. T. O. Mabbott (New York: The Modern Library, 1951), 158; Albert Camus, quoted in Adams, *Dandies and Desert Saints*, 22.

127. R. H. Byer, "Mysteries of the City: A Reading of Poe's 'The Man of the Crowd,'" in *Ideology and Classic American Literature*, ed. Sacvan Bercovitch and Myra Jehlen (Cambridge: Cambridge University Press, 1986), 222.

CHAPTER TWO
Homing Devices

1. Charles Baudelaire, "The Painter of Modern Life," in *The Painter of Modern Life and Other Essays*, trans. and intro. Jonathan Mayne (Greenwich, Conn.: Phaidon, 1964; distributed by New York Graphic Society), 9.

2. Although both conservative and revolutionary ideology fermented in urban institutions such as the Düsseldorf Academy, some recent scholarship emphasizes the central role that rural communities, activists, and laborers played in the 1848 revolutions (see, e.g., Jonathan Sperber, *Rhineland Radicals: The Democratic Movement and the Revolution of 1848–1849* [Princeton, N.J.: Princeton University Press, 1991]).

3. See Wend Von Kalnein, "The Düsseldorf Academy," in *The Düsseldorf Academy and the Americans*, by Donelson F. Hoopes, exh. cat. (Atlanta: High Museum of Art, 1972), 13; and Irene Markowitz, *Die Düsseldorfer Malerschuler* (Düsseldorf: Kunstmuseum Düsseldorf, 1967).

4. "Düsseldorf and the Artists," *Literary World* 10 (1 May 1852): 333.

5. Donelson F. Hoopes, "The Düsseldorf Academy and the Americans," in Hoopes, *The Düsseldorf Academy and the Americans*, 20.

6. Peter von Cornelius and William Morris Hunt, quoted in ibid., 20, 19.

7. Friedrich Wilhelm von Schadow, quoted in Kalnein, "Düsseldorf Academy," 14.

8. J. W. E. [John Whetten Ehninger], "The School of Art at Düsseldorf," *Bulletin of the American Art-Union* 3 (Apr. 1850): 5–7. The author, probably John Whetten Ehninger (1827–89), who lived in Europe during the late 1840s and early 1850s, describes at great length the rigors of the academy's curriculum.

9. William H. Gerdts, "The Düsseldorf Connection," in *Grand Illusions: History Painting in America*, exh. cat. (Fort Worth: Amon Carter Museum, 1988), 137.

10. Henry Tuckerman, *Artist-life; or, Sketches of American Painters* (Boston: D. Appleton and Co., 1847), 23.

11. Worthington Whittredge in his autobiography, quoted in Hoopes, *The Düsseldorf Academy and the Americans*, 26.

12. *Bulletin of the American Art-Union*, 1849, quoted in ibid., 23.

13. The Düsseldorf Gallery opened on 18 April 1849 on the upper floor of the Church of the Divine Unity at 548 Broadway (see Raymond L. Stehle, "The Düsseldorf Gallery of New York," *New-York Historical Society Quarterly* 58 [Oct. 1974]: 304–14).

14. Gerdts, "Düsseldorf Connection," 139–40.

15. R. Wiegmann, *Die Königliche Kunst-Akademie zu Düsseldorf, Ihre Geschichte, Einrichtung und Wirksamkeit und die Düsseldorfer Künstler* (Düsseldorf; 1856), 339–40.

16. Benjamin Champney, *Sixty Years' Memories of Art and Artists*, ed. and intro. H. Barbara Weinberg (New York: Garland, 1977), 88. See also *Bulletin of the American Art-Union*, Apr. 1850, 7, which details Woodville's association with the Düsseldorf Academy.

17. Kalnein, "Düsseldorf Academy," 16, 21.

18. Gerdts, "Düsseldorf Connection," 140. The most comprehensive essay on Hasenclever and the revolution's impact on Düsseldorf is Albert Boime's "Social Identity and Political Authority in the Response of Two Prussian Painters to the Revolution of 1848," *Art History* 13 (Sept. 1990): 344–87. See also William Vaughan, "Cultivation and Control: The 'Masterclass' and the Düsseldorf Academy in the Nineteenth Century," in *Art and the Academy in the Nineteenth Century*, ed. Rafael Cardoso Denis and Colin Trodd (New Brunswick, N.J.: Rutgers University Press, 2000), 150–63, esp. 159–60.

19. Marx's letter is quoted in Boime, "Social Identity and Political Authority," 349. There are two other versions of Hasenclever's painting, an oil sketch (1848–49; Westfälisches Landesmuseum, Münster) and a finished oil (1848–49; Bergisches Museum, Schloss Burg).

20. Kalnein, "Düsseldorf Academy," 17.

21. Boime, "Social Identity and Political Authority," 349.

22. Boime notes, "It was the discontent of the declassed master artisans and unemployed journeymen that contributed to the successful alliance of bourgeois and proletarian forged during the March days" (ibid., 348).

23. For more on the 1848 revolutions in Germany, see Friedrich Engels and Karl Marx, *Germany: Revolution and Counterrevolution*, ed. Eleanor Marx (New York: International Publishers, 1969), originally published as a series of articles in the *New York Tribune* in 1851–52. See also Axel Korner, ed., *1848: A European Revolution? International Ideas and National Memories of 1848* (New York: St. Martin's Press, 2000); Wolfram Siemann, *The German Revolution of 1848–49*, trans. Christiane Banerji (New York: St. Martin's Press, 1998); and Sperber, *Rhineland Radicals*. For more on the Forty-eighters, see Carl Frederick Wittke, *Refugees of Revolution: The German Forty-eighters in America* (Philadelphia: University of Pennsylvania Press, 1952); and A. E. Zucker, *The Forty-eighters: Political Refugees of the German Revolution of 1848* (New York: Columbia University Press, 1950).

24. Barbara S. Groseclose, *Emanuel Leutze, 1816–1868: Freedom Is the Only King* (Washington, D.C.: Smithsonian Institution Press, 1975), 20–23, 31.

25. Gerdts, "Düsseldorf Connection," 149.

26. Groseclose, *Emanuel Leutze*, 52–53. This was especially true later on. George Caleb Bingham, for example, who was a Whig politician and popular genre painter, was in Düsseldorf from 1856 to 1858, and again for several months in 1859. He recorded the following observation of the city: "It appears to be the policy of both Church and State to encourage as much as possible whatever may be calculated to direct the

minds of the people from the serious matter of politics. But in the event these gentle and seductive appliances should not suffice, a far more effective auxiliary, in the shape of a standing army of 40,000 men, is kept ready to be called out to suppress any demonstrations threatening the established order of things" (see C. B. Rollins, "Letters of George Caleb Bingham to James S. Rollins," *Missouri Historical Review* 32 [1937–38]: 361).

27. Boime, "Social and Political Authority," 355.

28. The painting received a favorable review in Baltimore (see the unidentified Baltimore newspaper item, 23 May 1847, in the Dielman File, Maryland Historical Society, Baltimore). The Pennsylvania Academy in Philadelphia exhibited *The Card Players* (see Francis S. Grubar, "Richard Caton Woodville: An American Artist, 1825 to 1855" [Ph.D. diss., Johns Hopkins University, 1966], 52).

29. William Woodville to the Boston Athenaeum, 22 July and 3 Oct. 1847, Woodville Correspondence, Boston Athenaeum Library, Boston. Though the letters suggest that the Boston Athenaeum exhibited the picture, there is no corroborating record in the Athenaeum catalogs from 1847 or 1848.

30. William Woodville to the American Art-Union, 26 Oct. and 14 Nov. 1847, American Art-Union Papers, New-York Historical Society, New York.

31. *The Bulletin of the American Art-Union*, May 1849, 9 and Apr. 1850, 7.

32. *Literary World* 8 (30 Nov. 1850): 432.

33. Sean Wilentz, *Chants Democratic: New York City and the Rise of the American Working Class, 1788–1850* (New York: Oxford University Press, 1984), 356–58.

34. Michael T. Gilmore, *American Romanticism and the Marketplace* (Chicago: University of Chicago Press, 1985), 1, 60.

35. See Terrence H. Witkowski, "Farmers Bargaining: Buying and Selling as a Subject in American Genre Painting, 1835–1868," *Journal of Macromarketing* 16, no. 2 (fall 1996): 84–101. Witkowski uses genre painting, especially the works of William Sidney Mount and Francis W. Edmonds, as a "data source for investigating the exchange activities of buyers and sellers in nineteenth-century America" (84–85).

36. Gilmore, *American Romanticism and the Marketplace*, 60.

37. Herman Melville, "Hawthorne and His Mosses," in *Moby-Dick*, ed. Harrison Hayford and Hershel Parker, Norton Critical Edition, (New York: W. W. Norton and Co., 1967), 536, 541–42.

38. Paul Royster, "Melville's Economy of Language," in *Ideology and Classic American Literature*, ed. Sacvan Bercovitch

and Myra Jehlen (Cambridge: Cambridge University Press, 1986), 313.

39. Henry David Thoreau, journal entry for 26 Dec. 1841, in *The Selected Works of Thoreau*, rev. and intro. Walter Harding (Boston: Houghton Mifflin Co., 1975), 19.

40. American Art-Union, *Transactions of the American Art-Union* (New York, 1844), 10.

41. Neil Harris, *Cultural Excursions: Marketing Appetites and Cultural Tastes in Modern America* (Chicago: University of Chicago Press, 1990), 17–19. See also Rachel Klein, "Art and Authority in Antebellum New York City: The Rise and Fall of the American Art Union," *Journal of American History* 81, no. 4 (Mar. 1995): 1535.

42. Quoted without citation in Patricia C. Click, "The Ruling Passion: Gambling and Sport in Antebellum Baltimore, Norfolk, and Richmond," *Virginia Cavalcade* 39, no. 2 (1989): 63, 62.

43. Ibid., 66, 63; Patricia C. Click, "The Ruling Passion," *Virginia Cavalcade* 39, no. 3 (1990): 101–2.

44. Ann Fabian, *Card Sharps, Dream Books, and Bucket Shops: Gambling in Nineteenth-Century America* (Ithaca, N.Y.: Cornell University Press, 1990), 43–44.

45. Elizabeth Johns, *American Genre Painting: The Politics of Everyday Life* (New Haven, Conn., and London: Yale University Press, 1991), 179, 180.

46. Henry Brevoort to Washington Irving, in *Letters of Henry Brevoort to Washington Irving*, ed. George S. Hellman (New York: G. P. Putnam's Sons, 1916), 2:132–33, quoted in Johns, *American Genre Painting*, 181.

47. George Lippard, *The Quaker City: or, The Monks of Monk Hall. A Romance of Philadelphia Life, Mystery and Crime* (1845; reprint, New York: Odyssey, 1970), 23, 155. On Lippard, see David S. Reynolds, *Beneath the American Renaissance: The Subversive Imagination in the Age of Emerson and Melville* (Cambridge, Mass.: Harvard University Press, 1988), 300–301.

48. Herman Melville, *The Confidence-Man: His Masquerade*, ed. and intro. Elizabeth S. Foster (New York: Hendricks House, 1954), 53, 54, 55.

49. Fabian, *Card Sharps, Dream Books, and Bucket Shops*, 35.

50. See Reynolds, *Beneath the American Renaissance*, 300. There is, for example, John Neal's novel *The Down-Easters* (1833), which Reynolds describes as a source for Melville's *The Confidence-Man* (1857).

51. See Grubar, "Richard Caton Woodville," 81 n. 14.

52. Johns, *American Genre Painting*, 179.

53. George G. Foster, *Celio: or, New York Above-Ground and Under-Ground* (New York: De Witt and Davenport, 1850), 68.

54. Edgar Allan Poe, *The Complete Works of Edgar Allan Poe*, ed. James A. Harrison (New York: AMS Press, 1965).

55. *National Era* 6 (5 Aug. 1852): 126.

56. Charles Dickens, *American Notes and Pictures from Italy* (New York: Chapman and Hall, 1907), 73.

57. Francis J. Grund, *Aristocracy in America* (1839; reprint, New York: Harper, 1959), 120, 123.

58. See Kalnein, "Düsseldorf Academy," 17.

59. *Bulletin of the American Art-Union*, Apr. 1851, 12.

60. *Literary World* 9 (27 Sept. 1851): 251. In terms of the reference to the "Abyssinian priests in white robes," many waiters in the oyster houses were black. There were, however, oyster houses that were patronized mostly by blacks.

61. Johns, *American Genre Painting*, 181.

62. Francis F. Beirne, *The Amiable Baltimoreans* (New York: E. P. Dutton and Co., 1951), 302.

63. William Woodville to John Latrobe, 29 May 1848, Walters Art Museum, Baltimore.

64. The paintings were titled *Woman Preparing Vegetables* and *Peasant Regaling*. See Maryland Historical Society, *Catalogue of Paintings, Engravings, Etc., at the Picture Gallery of the Maryland Historical Society First Annual Exhibition, 1848* (Baltimore, 1848), 4, 6.

65. *Literary World* 8 (21 Dec. 1850): 515.

66. Klein, "Art and Authority in Antebellum New York City," 1535–36, 1538.

67. John Kendrick Fisher, *New York Tribune*, 13 Sept. 1850, 3.

68. Walt Whitman, *Leaves of Grass*, ed. Harold Blodgett and Sculley Bradley (New York: New York University Press, 1965), 42.

69. Klein, "Art and Authority in Antebellum New York City," 1556.

70. *Illustrated London News*, 31 July 1852, plate 78. See also Algernon Graves, *The Royal Academy of Arts* (London: H. Graves and Co., 1906), 349.

71. Grubar, "Richard Caton Woodville," 130–31.

72. George G. Foster, *New York by Gas-Light and Other Urban Sketches*, ed. and intro. Stuart M. Blumin (Berkeley, and Los Angeles: University of California Press, 1990), 73. *New York by Gas-Light* was first published in 1850.

73. Rev. Robert Turnbull, "Dangers of the Theatre," *Colored American*, 14 Mar. 1840. Some New York oyster houses enjoyed better reputations. Thomas Downing, an African American, ran Downing's Oyster House on the corner of Broad and Wall Streets, where bankers, brokers, lawyers, and merchants went "to have a good meal, leave a message, or make a deal." Leading politicians of the day were prone to "dropping in to have a chat while enjoying their half-dozen Saddle Rocks or Blue Points," one observer remarked (see John H. Hewitt, "Mr. Downing and His Oyster House," *American Visions* 9 [June–July 1994]: 22).

74. Wilentz, *Chants Democratic*, 283.

75. Alvan Stewart, *Prize Address, for the New York City Temperance Society: on the subject of licenses to retail ardent spirits* (Utica, N.Y., 1835), 7–8.

76. Walt Whitman, *The Early Poems and the Fiction*, ed. Thomas L. Brasher (New York: New York University Press, 1963), 236.

77. See David S. Reynolds, *Walt Whitman's America: A Cultural Biography* (New York: Vintage, 1995), 92–93.

78. Dickens, *American Notes and Pictures from Italy*, 95.

79. Captain Frederick Marryat, *A Diary in America, with Remarks on its Institutions* (1839; reprint, New York: Knopf, 1962), 157.

80. *New York Evening Mirror*, 26 Mar. 1852; *New York Herald*, 9 June 1852.

81. Dr. William Andrus Alcott, *The House I Live In; or, the Human Body* (Boston: Waitt, Peirce and Co., 1844), 15.

82. Samuel Otter, *Melville's Anatomies* (Berkeley and Los Angeles: University of California Press, 1999), 5. See also Joan Burbick, *Healing the Republic: The Language of Health and the Culture of Nationalism in Nineteenth-Century America* (Cambridge: Cambridge University Press, 1994).

83. Melville, "Bartleby, the Scrivener: A Story of Wall Street," in *Great Short Works of Herman Melville*, ed. and intro. Warner Berthoff (New York: Harper and Row, 1969), 56.

84. Otter, *Melville's Anatomies*, 124–26.

85. O. S. Fowler and L. N. Fowler, *Illustrated Self-Instructor in Phrenology and Physiology* (New York: Fowlers and Wells, 1852). Orson Squire and Lorenzo Niles Fowler were publishers of popular books on phrenology and health (see, e.g., Russell Thacher Trall, *The Illustrated Family Gymnasium* [New York: Fowler and Wells, 1857]).

86. Ralph Waldo Emerson, "Self-Reliance," in *Ralph Waldo Emerson: Selected Prose and Poetry*, ed. and intro. Reginald I. Cook (New York: Rinehart and Co., 1950), 189, 183, 191.

87. William Ellery Channing tried to naturalize physical labor by describing it as a virtuous activity: "Every blow on the anvil, on the earth, on whatever material [man] works upon, contributes something to the perfection of his nature" (Channing, *Self-culture. An address introductory to the*

Franklin lectures, delivered at Boston, September, 1838 [Boston: Dutton and Wentworth, printers, 1838], 47). *Physical culture* was another term used at the time (see, e.g., Rev. J. H. Eames, *Physical Culture: An Address Before the Trustees [of Norwich University, Vermont], August 1859*, John Hay Library, Brown University, Providence, R.I.).

88. Henry T. Tuckerman, *Book of the Artists: American Artist Life* (New York: G. P. Putnam and Sons, 1867), 408; *Literary World* 9 (27 Sept. 1851): 251.

89. *New York Evening Mirror*, 22 Sept. 1852.

90. Foster, *New York by Gas-Light*, 71.

91. *Yankee Doodle* 1 (17 Oct. 1846): 21.

92. Linda Patterson Miller, "Poe on the Beat: *Doings of Gotham* as Urban, Penny Press Journalism," *Journal of the Early Republic* 7, no. 2 (summer 1987): 147–65.

93. Edgar Allan Poe, *Doings of Gotham: As Described in a Series of Letters to the Editors of the Columbia Spy . . .*, ed. Jacob E. Spannuth with comments by Thomas Ollive Mabbott (Pottsville, Pa., 1929), 61, 25. See also Miller, "Poe on the Beat," 158.

94. These articles appeared in *Spy*, 23 and 30 Nov. 1844, and are quoted in Miller, "Poe on the Beat," 150.

95. *New York Herald*, 27 May 1852, 21; 18 Sept. 1854; 22 Mar. 1855; 31 Mar. 1855; 11 Apr. 1855; 3 July 1857, 27.

96. The antebellum press was a battleground of rude quips and insults that came to be called the Moral War. In the *Brooklyn Daily Eagle*, 26 Feb. 1847, Whitman wrote that, "scurrility— the truth may as well be told—is a sin of the American newspaper press." Bennett, who was the period's profane newspaperman, traded barbs with his enemies: "'Obscene vagabond,' 'mass of trash,' 'loathsome and leprous slanderer and libeler' were some of the epithets traded in the mud-fest" (see Reynolds, *Walt Whitman's America*, 100).

97. Thoreau, *Selected Works of Thoreau*, 293.

98. Reynolds, *Walt Whitman's America*, 64. The word *loafer*, what Hans Bergmann calls "another New York Americanism of the [antebellum] period," could also refer in some contexts to the elite classes. For instance, James Gordon Bennett, the editor of the *New York Herald*, called his adversary Philip Hone a "loafer" (see Hans Bergmann, *God in the Street: New York Writing from the Penny Press to Melville* [Philadelphia: Temple University Press, 1995], 28).

99. George Templeton Strong, *Diary of G. T. Strong*, ed. Allan Nevins and Milton Halsey (New York: Macmillan, 1952), 62, 94.

100. Walt Whitman, *The Uncollected Poetry and Prose of Walt Whitman*, ed. Emory Holloway (Gloucester, Mass.: Peter Smith, 1972), 1:44.

101. John H. B. Latrobe, quoted in John E. Semmes, *John H. B. Latrobe: His Life and Times* (Baltimore: Norman, Remington Co., 1917), 443.

102. Alan Heimert, "*Moby-Dick* and American Political Symbolism," *American Quarterly* 15, no. 4 (Winter 1963): 501.

103. Ibid., 504.

104. George Caleb Bingham promoted Whig agendas in his genre paintings, especially in his election series. Nancy Rash explains that though the Art-Union managed to market his works without too much political palaver, the Democratic press in Missouri reacted to his art less favorably than the Whig press (see Nancy Rash, *The Painting and Politics of George Caleb Bingham* [New Haven, Conn., and London: Yale University Press, 1991]).

105. Barbara Groseclose, "Politics and American Genre Painting of the Nineteenth Century," *Magazine Antiques*, Nov. 1981, 1215.

106. Johns, *American Genre Painting*, 179.

107. Walt Whitman, "Letter from New York," *National Era* 4 (31 Oct. 1850): 175.

108. Groseclose, "Politics and American Genre Painting of the Nineteenth Century," 1215.

109. Melville, *The Confidence-Man*, 271.

110. See Christopher Brown, *Images of the Golden Past: Dutch Genre Painting of the Seventeenth Century* (New York: Abbeville Press, 1984), 210.

111. Humphrey Repton, *Observations on the Pictures by Adriaen Van Ostade in the Marquis of Stafford's Collection*, quoted in Lindsay Errington, *Tribute to Wilkie*, exh. cat. (Edinburgh: National Galleries of Scotland, 1985), 26.

112. See Catherine Hoover, "The Influence of David Wilkie's Prints on the Genre Paintings of William Sidney Mount," *American Art Journal* 13, no. 3 (1981): 4–33.

113. Though *The Cavalier's Return* (fig. 47) was Woodville's first period painting, and the *Game of Chess* (fig. 51) his last, he did make several sketches and drawings between 1845 and his death in 1855 that fall into the same category. These include *The Fencing Lesson* (1847–49; private collection), a preparatory drawing for *The Cavalier's Return*; two 1852 sketches called *The Knight and the Scribe* (private collection; Baltimore Museum of Art); *The Magician's Apprentice* (c. 1850; private collection); *The Welcome Drink* (c. 1850; private collection), a sketch of an elderly cavalier and a young child offering him a drink; and *Young Woman Mourning a Fallen Knight* (1850; private collection).

114. See Peter C. Sutton, "Masters of Dutch Genre Painting," in *Masters of Seventeenth-Century Dutch Genre Painting*, exh. cat. (Philadelphia: Philadelphia Museum of Art, 1984), lii–lvii.

115. Kalnein, "Düsseldorf Academy," 14.

116. Karl Immermann, quoted in ibid., 16.

117. See Johns, *American Genre Painting*, 240–41 n. 6.

118. *Bulletin of the American Art-Union*, 10 Dec. 1848, 19.

119. Mary P. Ryan, *The Cradle of the Middle Class: The Family in Oneida County, New York, 1790–1865* (Cambridge: Cambridge University Press, 1981), 125.

120. David Lubin, "Lily Martin Spencer's Domestic Genre Painting in Antebellum America," in *Picturing a Nation: Art and Social Change in Nineteenth-Century America* (New Haven, Conn., and London: Yale University Press, 1994), 161, 159.

121. Henriette A. Hardy, "Mrs. Lilly M. Spencer," *Sartain's Union Magazine* 9 (Aug. 1851): 152–53.

122. Lubin, "Lily Martin Spencer's Domestic Genre Painting in Antebellum America," 162, 164.

123. Wendy Greenhouse, "Imperiled Ideals: British Historical Heroines in Antebellum American History Painting," in *Redefining American History Painting*, ed. Patricia M. Burnham and Lucretia Hoover Giese (Cambridge: Cambridge University Press, 1995), 265.

124. *Literary World* 1 (5 June 1847): 419.

125. Greenhouse, "Imperiled Ideals," 272.

126. Ibid., 274.

127. *Bulletin of the American Art-Union*, Apr. 1851, reprinted in *Harper's New Monthly Magazine* 2 (June 1851): 136. *The Game of Chess* was long lost and then discovered in the early 1960s in the private collection of Mr. John Van Buren Duer in Essex, Connecticut, where it remains today.

128. See *Bulletin of the American Art-Union*, Dec. 1851, 153.

129. Edgar Allan Poe, "The Murders in the Rue Morgue," in *Selected Poetry and Prose of Edgar Allan Poe*, ed. T. O. Mabbott (New York: Modern Library, 1951), 163. On Retzsch's engraving, see Carl Borromaeus von Miltitz, *The Game of Life, or, The Chess-Players: A Drawing by Moritz Retzch* (Boston: Weeks, Jordan and Co., 1837); and *Knickerbocker* 17 (Apr. 1841): 344.

CHAPTER THREE
Here and There: The Mexican War

1. See John Schroeder, *Mr. Polk's War: American Opposition and Dissent, 1846–1848* (Madison: University of Wisconsin Press, 1973), esp. 20, 23, 91. Added to this chaos was the position of the "reluctant imperialist," Senator John C. Calhoun of South Carolina, who broke ranks with fellow southern Democrats and opposed the war. Calhoun's objections to the war came from his advocacy of states' rights and rested on constitutional grounds: "'Hostilities' had occurred, he argued, but 'war' did not and could not exist until formally declared by Congress" (see Ernest McPherson Lander Jr., *Reluctant Imperialists: Calhoun, the South Carolinians, and the Mexican War* [Baton Rouge: Louisiana State University Press, 1980]; see also Walt Whitman, *The Gathering of the Forces*, ed. Cleveland Rodgers and John Black, 2 vols. [New York: G. P. Putnam's Sons, 1920], 1:240).

2. *New York Mirror*, 10 May 1845, 72.

3. *Yankee Doodle* 1 (12 Dec. 1846): 114.

4. *New York Herald*, 28 May 1847; *Daily National Intelligencer*, 31 Mar. 1847.

5. William Jay, *A Review of the Causes and Consequences of the Mexican War* (Boston: B. B. Massey and Co., 1849), 178–82, 257, 248–52.

6. William Bement, *The Mexican War and War in General, Considered in Two Sermons, Preached at East-Hampton, October 17, 1847* (Northampton, Mass.: printed by John Metcalf, 1847), 6.

7. Abiel Abbot Livermore, *The War with Mexico Reviewed* (Boston: American Peace Society, 1850), 14, 233, 239.

8. Charles T. Porter, *Review of the Mexican War, embracing the causes of the war, the responsibility of its commencement, the purposes of the American government in its prosecution, its benefits and its evils* (Auburn, N.Y.: Alden and Parsons, 1849), iv, 161, 162, 164.

9. For an account of Morse's invention and demonstration before Congress, see Paul Staiti, *Samuel F. B. Morse* (Cambridge: Cambridge University Press, 1989), 207–32, and Lewis Coe, *The Telegraph: A History of Morse's Invention and Its Predecessors in the United States* (Jefferson, N.C.: McFarland, 1993). See also *Yankee Doodle* 1 (10 Oct. 1846): 5. *Yankee Doodle* was published by Cornelius Mathews, a co-founder of the Young America movement, in 1846–47 and 1854–56.

10. Oscar Handlin, "Man and Magic: First Encounters with the Machine," *American Scholar* 33 (summer 1964): 415.

11. Menahem Blondheim, *News over the Wires: The Telegraph and the Flow of Public Information in America, 1844–1897* (Cambridge, Mass.: Harvard University Press, 1994), 31. See also James W. Carey, "Technology and Ideology: The Case of the Telegraph," in *Prospects: The Annual of American Cultural Studies* (Cambridge: Cambridge University Press, 1983), 8: 305.

12. Ezra S. Gannett, quoted in Daniel Joseph Czitrom, *Media and the American Mind: From Morse to McLuhan* (Chapel Hill: University of North Carolina Press, 1982), 9. See also Ezra S. Gannett, *The Atlantic Telegraph: A Discourse Delivered in the First Church, August 8, 1858* (Boston: Crosby, Nichols, 1858), 7. For more on responses to the telegraph and electricity see Handlin, "Man and Magic," 408–19; and Carey, "Technology and Ideology," 302–25.

13. Staiti discusses Morse's fears regarding the telegraph and espionage in Staiti, *Samuel F. B. Morse*, 211, 223.

14. *Home Journal*, 14 Feb., 16 May 1846.

15. See Gene M. Brack, *Mexico Views Manifest Destiny, 1821–1846: An Essay on the Origin of the Mexican War* (Albuquerque: University of New Mexico Press, 1975), 79. See also Ron Tyler, "Historic Reportage and Artistic License: Prints and Paintings of the Mexican War," in *Picturing History: American Painting, 1770–1930*, ed. William Ayres (New York: Rizzoli, 1993), 101–15.

16. Margaret C. S. Christman, *1846: Portrait of the Nation* (Washington, D.C.: Smithsonian Institution Press, 1996), 121.

17. Philip Hone, *The Diary of Philip Hone, 1828–51*, ed. Bayard Tuckerman (New York: Dodd, Mead and Co., 1889), 2:765.

18. Painted in Düsseldorf in 1848, *War News from Mexico* was purchased by George W. Austen, an American Art-Union Management Committee member. Austen exhibited the painting in the Art-Union galleries the following year.

19. Francis Grubar, "Richard Caton Woodville: An American Painter, 1825 to 1855" (Ph.D. diss., Johns Hopkins University, 1966), 113.

20. *Morning Courier and New-York Enquirer*, 28 Mar. 1849.

21. *Bulletin of the American Art-Union*, May 1849, 9, and 31 Dec. 1850, 189. Alfred Jones, born in Liverpool in 1819, studied at the National Academy of Design and became an Academician in 1851. He was a noted engraver and made reproductions for the Art-Union of works by Mount and Francis William Edmonds, among others (see New York Public Library, *One Hundred Notable American Engravers* [New York, 1928], 29). Jones's small engraving appeared as the front plate of *Bulletin of the American Art-Union* for 1 April 1851, and his larger folio engraving was the major gift print distributed to subscribers in 1851. During the legal investigation of the Art-Union in 1853, the treasurer's report estimated that fourteen thousand impressions had been made of the engraving (see Grubar, "Richard Caton Woodville," 111–12). Another engraving appeared later in the gift album *Ornaments of Memory* (New York: D. Appleton and Co., 1857).

22. *Art Journal* 3 (1 Oct. 1851): 259.

23. *Putnam's Monthly Magazine* 16 (Oct. 1870): 379.

24. Bryan J. Wolf, "All the World's a Code: Art and Ideology in Nineteenth-Century American Painting." *Art Journal* 44 (winter 1984): 328–37. The following quotations are from this essay.

25. Hans Bergmann, *God in the Street: New York Writing from the Penny Press to Melville* (Philadelphia: Temple University Press, 1995), 28.

26. Hone, quoted in ibid.

27. James Gordon Bennett, in *New York Herald*, 19 Aug. 1836.

28. Bergmann, *God in the Street*, 33.

29. Horace Greeley, quoted in Robert Taft, *Photography and the American Scene: A Social History, 1839–1889* (New York: Macmillan, 1938), 69.

30. Blondheim, *News over the Wires*, 20.

31. Ibid., 24.

32. Ibid., 4.

33. Melville's letter and a commentary by Jay Leyda are in *The Portable Melville*, ed. Jay Leyda (New York: Viking Press, 1952), 339–41.

34. Morse, quoted in Carey, "Technology and Ideology," 308; Czitrom, *Media and the American Mind*, 17.

35. Wolfgang Schivelbusch, "Railroad Space and Railroad Time," *New German Critique* 14 (spring 1978): 40.

36. See James W. Carey, "The Communications Revolution and the Professional Communicator," *Sociological Review Monograph* 13 (Jan. 1969): 23–38.

37. Ernest Hemingway, quoted in Lincoln Steffens, *The Autobiography of Lincoln Steffens* (New York: Harcourt, Brace and World, 1958), 834.

38. Carey, "Technology and Ideology," 311.

39. Henry David Thoreau, "Life without Principle," in *Walden and Other Writings by Henry David Thoreau*, ed. and intro. Joseph Wood Krutch (New York: Bantam Books, 1962), 366. Thoreau delivered this essay as a lecture as early as 1854, though the core of it appeared in various passages in his *Journal* during the first half of the 1850s.

40. Elizabeth Johns, *American Genre Painting: The Politics of Everyday Life* (New Haven, Conn., and London: Yale University Press, 1991), 122.

41. *Bulletin of the American Art-Union*, May 1849, 9.

42. Thoreau, "Life without Principle," 366.

43. Luman Reed, a New Yorker who made a fortune in the wholesale grocery business, owned at least two pictures by Mount, *Bargaining for a Horse* and *The Truant Gamblers*

(see Ella M. Foshay, *Mr. Luman Reed's Picture Gallery* [New York: Harry N. Abrams, 1990]).

44. This aspect of Mount's popularity is expertly analyzed by Johns in *American Genre Painting*.

45. William Sidney Mount to Robert Gilmor, 5 Dec. 1837, Archives of American Art, Washington, D.C. This correspondence is documented in Alfred Frankenstein, *William Sidney Mount* (New York: Harry N. Abrams, 1975), 74–78.

46. W. Alfred Jones, in *American Whig Review* 14 (Aug. 1851): 122.

47. David S. Reynolds, *Walt Whitman's America: A Cultural Biography* (New York: Vintage, 1995), 279.

48. Grubar, "Richard Caton Woodville," 25.

49. I summarize from John K. Mahon, *History of the Second Seminole War, 1835–1842* (Gainesville: University of Florida Press, 1967).

50. Woodburne Potter, *The War in Florida: Being an Exposition of its Causes and an Accurate History of the Campaigns of Generals Clinch, Gaines, and Scott* (Baltimore: Lewis and Coleman, 1836). A portion of the Camp Moultrie Treaty reads: "The United States will take the Florida Indians under their care and patronage, and will afford them protection against all persons whatsoever" (ibid., 65).

51. Ibid., 14–19, 16, 17–18.

52. See Mahon, *History of the Second Seminole War*, 324, for a description of fighting conditions.

53. Potter cites these reports but questions their veracity (see Potter, *The War in Florida*, 106).

54. Ibid., 110–11.

55. A 1955 letter from William Woodville, of Washington, D.C. (the great-nephew of the artist), to Edward S. King (then director of the Walters Art Gallery in Baltimore) also suggests that *Soldier's Experience* addresses the Seminole War. The letter is in the J. Hall Pleasants Papers, 1773–1957, MS 194, Manuscripts Department, Maryland Historical Society, Baltimore.

56. Potter, *War in Florida*, 65.

57. Ibid., 23.

58. Jacob K. Neff, *The Army and Navy of America* (Philadelphia: J. H. Pearsol and Co., 1845), 32.

59. See John T. Sprague, *The Origin, Progress, and Conclusions of the Florida War . . .* (New York: D. Appleton and Co., 1848), 288–92.

60. Livermore, *War with Mexico Reviewed*, 233.

61. Wolf uses the word *mythopoetic* to describe how ideology avoids the facts of social history (see Wolf, "All the World's a Code," 333).

62. *New York Herald*, 27 Sept. 1850; Walt Whitman, "Letter from New York" in *National Era* 4 (31 Oct. 1850): 175 and in Rollo G. Silver, "Whitman in 1850: Three Uncollected Articles," *American Literature* 13 (Jan. 1948): 305; *Literary World* 8 (30 November 1850): 432; *Bulletin of the American Art-Union*, Nov. 1850, 135.

63. *Bulletin of the American Art-Union*, June 1850, 46.

64. Walt Whitman, *The Early Poems and the Fiction*, ed. Thomas L. Brasher (New York: New York University Press, 1963), 95.

65. Reynolds, *Walt Whitman's America*, 91.

66. Gail E. Husch, "'Freedom's Holy Cause': History, Religious, and Genre Painting in America, 1840–1860," in *Picturing History: American Painting, 1770–1930*, ed. William Ayres (New York: Rizzoli, 1993), 82.

67. Emanuel Leutze, quoted in *The West as America: Reinterpreting Images of the Frontier, 1820–1920*, ed. William H. Truettner (Washington D.C.: Smithsonian Institution Press for the National Museum of American Art, 1991), 62.

68. *Bulletin of the American Art-Union*, July 1849, 8. For more on Leutze, see Barbara Gaehtgens, "Fictions of Nationhood: Leutze's Pursuit of an American History Painting in Düsseldorf," *American Icons: Transatlantic Perspectives on Eighteenth- and Nineteenth-Century American Art*, ed. Thomas Gaehtgens and Heinz Ickstadt (Chicago: Getty Center for the History of Art and the Humanities, 1992; distributed by University of Chicago Press), 147–84. See also Patricia Hills, "The American Art-Union as Patron for Expansionist Ideology in the 1840s," in *Art in Bourgeois Society*, ed. Andrew Hemingway and William Vaughn (Cambridge: Cambridge University Press, 1998), 314–39.

69. James Thomas Flexner, *That Wilder Image: The Painting of America's Native School from Thomas Cole to Winslow Homer* (Boston: Little, Brown, 1962), 141.

70. Wolf, by contrast, has written that Woodville was concerned with "the theme of generational conflict and reconciliation" (see Wolf, "All the World's a Code," 332). This was not the first time Woodville treated the clash of youth with the elderly. In the drawing *Soldier's Experience* (1844), in *The Card Players* (1846), and in *Politics in an Oyster House* (1848) Woodville depicted tense moments between young and old characters. It is worth remembering here that Woodville clashed with his own father over personal matters (see Glenn Wallach, *Obedient Sons: The Discourse of Youth and Generations in American Culture, 1630–1860* [Amherst: University of Massachusetts Press, 1997]).

71. Joseph J. Ellis, *Founding Brothers: The Revolutionary Generation* (New York: Knopf, 2001), 9.

72. Husch, "Freedom's Holy Cause," 86.

73. See Jonathan Weinberg, "The Artist and the Politician: George Caleb Bingham," *Art in America* 10, no. 88 (Oct. 2000): 138. For the quotation see Nathaniel Hawthorne, *The House of the Seven Gables* (1850; reprint, Charlottesville: University of Virginia Library, 1995), 133.

74. Husch, "Freedom's Holy Cause," 88–93.

75. Richard Haywarde, "The Veteran of Seventy-Six," *Knickerbocker* 30 (Jan. 1854): 40–41.

76. Johns, *American Genre Painting*, 142.

77. Mrs. A. J. Graves, *Woman in America: Being an Examination into the Moral and Intellectual Condition of American Female Society* (New York: Harper and Brothers, 1843), 63. See also Ellen Carol Dubois, "Women's Rights and Abolition: The Nature of the Connection," in *Antislavery Reconsidered: New Perspectives on the Abolitionists*, ed. Lewis Perry and Michael Fellman (Baton Rouge: Louisiana State University Press, 1979), 238–47. Dubois discusses the New York Female Moral Reform Society in contrast to a more political, "Garrisonian abolitionism."

78. Lynn Pioneer, *The Lily* (Seneca Falls, N.Y.) 1 (Feb. 1849): 10.

79. Wolf, "All the World's a Code," 332.

80. Alan Heimert, "*Moby-Dick* and American Political Symbolism," *American Quarterly* 15, no. 4 (winter 1963): 505. In this passage Heimert quotes from the *Congressional Globe, Appendix*, 28th Cong., 2nd sess., pages 273, 55.

81. It is worth noting here that Woodville's old friend Stedman Tilghman enlisted in the Mexican War as a surgeon in the District of Columbia and Maryland Regiment of Volunteers. Broken down from the strain of the war, Tilghman died at the age of twenty-six in New Orleans in 1848. An account of Tilghman's service, illness, and death is told by a fellow officer, John R. Kenly, in *Memoirs of a Maryland Volunteer: War with Mexico in the Years 1846–7–8* (Philadelphia: J. B. Lippincott and Co., 1873), 471. Woodville had one more definite connection with the Mexican War. His brother, William Woodville, married a "Miss Schley of Maryland, a niece of Major [Samuel] Ringold of Mexican War fame." Major Ringold died on 8 May 1846 at the Battle of Palo Alto, which General Zachary Taylor's army won. This information is related in a letter of 16 January 1880 from Woodville's son, Henry James Woodville, to his mother-in-law. The letter is in the private collection of Gail Woodville Roberson, the artist's great-great-granddaughter, of North Little Rock, Arkansas.

82. See Eric Robert Papenfuse, "The Evils of Necessity: Robert Goodloe Harper and the Moral Dilemma of Slavery," afterword to *Transactions of the American Philosophical Society* 87, no. 1 (1997): 73. Papenfuse also points out that William Pennington, a companion of Woodville's, married the daughter of Harper's son, Charles Carroll Harper.

83. Ibid., 10.

84. Robert Goodloe Harper, quoted in ibid., 9, 69, and 55–57. For a thoughtful discussion of colonization as the result of white prejudice, see Benjamin Schwarz, "What Jefferson Helps to Explain," *Atlantic Monthly*, Mar. 1997, 60–72.

85. "Old Moses" (Moses Johns, 1790–1842) was a well-known Baltimore street vendor also known as "Poor Old Moses," "Oyster Moses," and "Ice Cream Moses." His cries for oysters, crabs, and ice cream were inimitable: "My oysters are fresh, / An 'jis from de shell; / I can't tell de reason / My oysters won't sell" (quoted by Col. J. Thomas Scharf in *The Chronicles of Baltimore; being a complete history of "Baltimore Town" and Baltimore City from the earliest period to the present time* [Baltimore: Turnbull Bros., 1874], 523. A full account of "Old Moses" is related by John Williamson Palmer, *Lippincott's Magazine* 8 [Oct. 1871]: 370–72; Scharf reprints much of Palmer's article, 521–23. For a discussion of black servitude in Baltimore, see Frank Towers, "Serena Johnson and Slave Domestic Servants in Antebellum Baltimore," *Maryland Historical Magazine* 89, no. 3 [1994]: 334–37). Richard Jackson's letter is quoted in Robert Erskine Lewis, "Brooklandwood, Baltimore County," *Maryland Historical Magazine* 43 (1948): 282.

86. William Wirt to his daughter, Jan. 1825, quoted in John P. Kennedy, *Memoirs of the Life of William Wirt*, 2 vols. (Philadelphia: Blanchard and Lea, 1852), 2:169.

87. Papenfuse points out the similarity between the scene set by Wirt in his letter and that illustrated by Woodville more than twenty years later (see Papenfuse, "Evils of Necessity," 72). Papenfuse also quotes Charles Carroll's request that Harper stop buying furniture.

88. See Frederick Douglass, *The Oxford Frederick Douglass Reader*, ed. and intro. William L. Andrews (New York: Oxford University Press, 1996).

89. For studies of slave life and free-black life in Baltimore, see Christopher Phillips, *Freedom's Port: The African-American Community of Baltimore, 1790–1860* (Urbana: University of Illinois Press, 1997); and T. Stephen Whitman, *The Price of Freedom: Slavery and Manumission in Baltimore and Early*

National Maryland (Lexington: University Press of Kentucky, 1997).

90. Douglass, *Oxford Frederick Douglass Reader*, 31–33.

91. Eclectic interiors were popular at the time. In the April issue of the *North American Review*, the architect Arthur Gilman urged such eclecticism and "universal borrowing" (quoted in *Early American Rooms*, ed. Russell Hawes Kettell [New York: Dover, 1967], 173. For more, see Katherine C. Grier, *Culture and Comfort: Parlor Making and Middle-Class Identity, 1850–1930* [Washington, D.C.: Smithsonian Institution Press, 1997]).

92. Flexner, *That Wilder Image*, 141.

93. Ancestors of Woodville's are quoted as saying that the Old '76er is a portrait of Richard Caton, that the parents in the painting are really the artist's parents, and that the children are his siblings. It is possible that Woodville tried to remember their faces from Düsseldorf, but there is no direct evidence that the claim is true (see Edward S. King and Marvin C. Ross, *Catalogue of the American Works of Art* [Baltimore: Walters Art Gallery, 1956], 13).

94. Friedrich Nietzsche, "On Truth and Falsity in Their Ultramoral Sense," in *The Complete Works of Friedrich Nietzsche*, ed. Oscar Levy, 18 vols. (Edinburgh: Foulis, 1911), 2:180.

CHAPTER FOUR
Cornered

1. In addition to the article in the *New-York Daily Tribune*, the best source for Woodville's whereabouts during these years is the *Bulletin of the American Art-Union*, which tracked Woodville's movement in Europe (see, e.g., *Bulletin of the American Art-Union*, July 1851, 63; September 1851, 98; and December 1851, n.p.).

2. Francis S. Grubar, "Richard Caton Woodville: An American Painter, 1825 to 1855" (Ph.D. diss., Johns Hopkins University, 1966), 145.

3. Wolf, "History as Ideology: Or, 'What You Don't See Can't Hurt You, Mr. Bingham,'" in *Redefining American History Painting*, ed. Patricia Burnham and Lucretia Hoover Giese (Cambridge: Cambridge University Press, 1995), 259–60.

4. I owe thanks to Professor Peter C. Bunnell, at Princeton University, for bringing to my attention the striking similarity between the glasses worn by the spy and those worn by the blind man in the daguerreotype.

5. Wolf, "History as Ideology," 261.

6. Ibid., 260.

7. Herman Melville, *The Confidence-Man: His Masquerade*, ed. and intro. Elizabeth S. Foster (New York: Hendricks House, 1954), 286.

8. Elizabeth S. Foster, introduction to ibid., xx.

9. Herman Melville to Nathaniel Hawthorne, 1851, quoted in ibid. The letter is printed in full in Willard Thorp, *Herman Melville: Representative Selections, with Introduction, Bibliography, and Notes* (New York: American Book Company, 1938), 389–93.

10. Foster, introduction, xx.

11. *Athenaeum* 30 (11 Apr. 1857): 462-63; *Literary Gazette*, 11 Apr. 1857, 348–49.

12. *Mrs. Stephen's New Monthly* 2 (June 1857): 288.

13. Melville, *The Confidence-Man*, 2.

14. See Tom Quirk, *Melville's Confidence Man: From Knave to Knight* (Columbia: University of Missouri Press, 1982), 37.

15. Melville, *The Confidence-Man*, 14.

16. Foster, introduction, xiv; Elizabeth Johns, *American Genre Painting: The Politics of Everyday Life* (New Haven, Conn., and London: Yale University Press, 1991), 179, 180.

17. Michael T. Gilmore, *American Romanticism and the Marketplace* (Chicago: University of Chicago Press, 1985), 52.

18. Foster, introduction, xvi–xvii.

19. Melville, *The Confidence-Man*, 1–5; see also ibid., l–lii.

20. Quirk, *Melville's Confidence Man*, 3.

21. Ibid., 1, 3.

22. I have been unable to locate a copy of this lithograph. Grubar says that Goupil and Company published a lithograph by C. Schultz that had been printed by Lemercier (probably the French lithographer Joseph Lemercier). According to Grubar, the copyright for this lithograph was entered in New York by William Schaus (see Grubar, "Richard Caton Woodville," 148 and 167 n. 37).

23. See Hans Bergmann, "The Original Confidence Man," *American Quarterly* 21 (fall 1969): 560–77, and *God in the Street: New York Writing from the Penny Press to Melville* (Philadelphia: Temple University Press, 1995), 194–98. See also David S. Reynolds, *Beneath the American Renaissance: The Subversive Imagination in the Age of Emerson and Melville* (Cambridge, Mass.: Harvard University Press, 1988), 163.

24. *New York Herald*, 8 July 1849, quoted in Bergmann, *God in the Street*, 194–95.

25. Ann Fabian, *Card Sharps, Dream Books, and Bucket Shops: Gambling in Nineteenth-Century America* (Ithaca, N.Y.: Cornell University Press, 1990), 43–44.

26. Ibid.

27. Wolf, "History as Ideology," 260–61.

28. Karen Halttunen, *Confidence Men and Painted Women: A Study of Middle-Class Culture in America, 1830–1870* (New Haven, Conn., and London: Yale University Press, 1982), xv–xvi.

29. Fabian, *Card Sharps, Dream Books, and Bucket Shops*, 2.

30. Halttunen, *Confidence Men and Painted Women*, 1.

31. Ibid., 11–18.

32. William A. Alcott, *Young Man's Guide* (Boston: Lilly, Wait, Colman, and Holden, 1834), 158, quoted in Halttunen, *Confidence Men and Painted Women*, 17.

33. See, e.g., *New York Mirror*, 3 May 1845, 64.

34. For a thorough biography of Green, see Fabian, *Card Sharps, Dream Books, and Bucket Shops*, 70–82.

35. See John M. Findlay, *People of Chance: Gambling in American Society from Jamestown to Las Vegas* (New York: Oxford University Press, 1986), 49.

36. For an account of this lynching, see Kenneth S. Greenberg, *Honor and Slavery* (Princeton, N.J.: Princeton University Press, 1996), 136.

37. Fabian, *Card Sharps, Dream Books, and Bucket Shops*, 95.

38. George Houston, "'The Confidence Man' on a Large Scale," *New York Herald*, 11 July 1849, quoted in Bergmann, *God in the Street*, 195.

39. Edgar Allan Poe, "Gambling," *Broadway Journal* 1 (1 Mar. 1845): 133–34. Poe goes on to describe the gambling "hells" of New York (see also Bergmann, *God in the Street*, 246 n.13).

40. "Cheating the Law," *American Republican and Baltimore Daily Clipper*, 28 Aug. 1846, quoted in Fabian, *Card Sharps, Dream Books, and Bucket Shops*, 41.

41. Asmodeus, *Sharps and Flats; Or the Perils of City Life. Being the Adventures of One Who Lived by His Wits* (Boston: William Berry and Co., [1850]).

42. Ibid., 15, 16.

43. Bergmann, *God in the Street*, 27.

44. Reynolds, *Beneath the American Renaissance*, 164–65.

45. Fabian, *Card Sharps, Dream Books, and Bucket Shops*, 17.

46. Wolf, "History as Ideology," 261.

47. Bergmann, *God in the Street*, 1, 3.

48. Melville, *The Confidence-Man*, 7.

49. Greenberg, *Honor and Slavery*, 136. On gambling in the South, see also Bertram Wyatt-Brown, *Honor and Violence in the Old South* (New York: Oxford University Press, 1986).

50. Grubar, "Richard Caton Woodville," 259.

51. Melville, *The Confidence-Man*, 9.

52. Ibid., 12–13.

53. Henry Ward Beecher, preface to *Seven Lectures to Young Men, on Various Important Subjects: Delivered Before the Young Men Indianapolis, Indiana, during the Winter of 1843–4*, quoted in Halttunen, *Confidence Men and Painted Women*, 6.

54. See Grubar, "Richard Caton Woodville," 147. See also *Catalogue of the Private Collection of Oil Paintings by American Artists, made by Samuel P. Avery during the past 15 Years and now to be sold on account of his going to Europe, by Henry H. Leeds & Miner's . . .* (New York, 4 Feb. 1867), no. 68. The painting remained in the possession of the Tuckerman family until the early 1950s, when Marvin C. Ross brought it to light and the Corcoran Gallery of Art acquired the work.

55. *New-York Daily Tribune*, 22 Jan. 1867; Henry T. Tuckerman, *Book of the Artists: American Artist Life* (New York: G. P. Putnam and Sons, 1867), 408–11.

56. Rachel Klein, "Art and Authority in Antebellum New York City: The Rise and Fall of the American Art Union," *Journal of American History* 81, no. 4 (Mar. 1995): 1535.

57. Ibid., 1535–36.

58. Ibid., 1558; *Herald*, 14 Feb. 1852, 6; 28 Mar. 1852, 2; 17 Mar. 1852, 4.

59. Henry Stockbridge Sr., "Baltimore in 1846," *Maryland Historical Magazine* 6 (Mar. 1911): 25, quoted in W. Ray Luce, "The Cohen Brothers of Baltimore: From Lotteries to Banking," *Maryland Historical Magazine* 68, no. 2 (summer 1973): 288.

60. Fabian, *Card Sharps, Dream Books, and Bucket Shops*, 113–14; Luce, "Cohen Brothers of Baltimore," 289.

61. Luce, "Cohen Brothers of Baltimore," 291.

62. *Cohen's Gazette and Lottery Register*, 12 Aug. 1824, quoted in ibid., 294.

63. Fabian, *Card Sharps, Dream Books, and Bucket Shops*, 114–15.

64. Thomas Doyle, *Five Years in a Lottery Office; or, An Exposition of the Lottery System in the United States* (Boston: S. N. Dickinson, 1841), 12, quoted in ibid., 121.

65. Charles Baudelaire, "The Painter of Modern Life," in *The Painter of Modern Life and Other Essays*, trans. and intro. Jonathan Mayne (Greenwich, Conn.: Phaidon, 1964; distributed by New York Graphic Society), 9.

66. Henry James Woodville to his mother-in-law, 16 Jan. 1880. Though Henry speculates about the reasons for the divorce and complains that his father's "vanity" had damaged the Woodville name, he is careful to point out that "I come from

a family of gentlemen" and "shall instill into my son the same creed I have always held, that of 'Noblesse Oblige.'" The letter is in the private collection of Gail Woodville Roberson, Woodville's great-great-granddaughter, of North Little Rock, Arkansas.

67. William Woodville VII to Dr. J. Hall Pleasants, 12 Oct. 1940, J. Hall Pleasants Papers, 1773–1957, MS 194, Manuscripts Department, Maryland Historical Society, Baltimore.

68. Antoinette Schnitzler was so described by Woodville's son Henry in the letter to his mother-in-law of 16 Jan. 1880.

69. Grubar, "Richard Caton Woodville," 158, 168 n. 45.

70. Ibid., 168–69 n. 50. In the 1890s Woodville's children from his first marriage, Henry James and Elizabeth, feuded with Richard Caton Woodville Jr. over his small inheritance from Woodville. This feud is documented in a letter from Elizabeth "Bessie" Woodville to her brother Henry James Woodville, 16 Feb. 1893, in the private collection of Gail Woodville Roberson, North Little Rock, Arkansas. In the letter, Bessie refers to her "poor" father's "unfortunate story" and the way her mother, Buckler, had been "mistreated and ill used" by the Woodvilles after the divorce.

71. William Woodville's letter, once owned by William A. Hoppin of Providence, Rhode Island, is now in the Pennington Papers, Manuscripts Department, Maryland Historical Society.

72. Harold Bloom, *How to Read and "Why"* (New York: Scribner, 2000), 177.

73. Henry James, *The Portrait of a Lady* (New York: Modern Library, 1909), 78.

74. Johns, *American Genre Painting*, 143–44.

75. Ibid., 146–47.

76. Ibid., 149.

77. Grubar, "Richard Caton Woodville," 148.

78. Ibid.

79. *Bulletin of the American Art-Union*, July 1851, 63. Grubar notes, "Goupil & Co. apparently retained the painting long enough to publish a lithograph after it, executed by Thielly. Only one copy of the color print has been discovered to date, in the collection of Mrs. Sumner Parker of Baltimore. . . . The letter press denotes the title, *A Civil Marriage in the United States*, in French and German as well as English. M. Knoedler copyrighted the work in the United States in 1855, where it was advertised [in the *New-York Daily Tribune*, 14 June 1855] by the Fine Arts Gallery, 366 Broadway, as '*The Sailor's Wedding*, after the well-known painting by Woodville'" (Grubar, "Richard Caton Woodville," 150–51).

80. *New-York Daily Tribune*, 22 Jan. 1867. This author's lengthy description of *The Sailor's Wedding* is interesting not only because it classifies genre themes as lowly but also for its mention of the "old black servant" wearing a patterned gown who prepares the squire's lunch. No such figure appears in the only known version of the painting, that in the Walters Art Museum. This servant's daughter does appear in the painting, on the extreme left, but the composition ends at her shoulder. On page 154 of his dissertation, Grubar makes note of this discrepancy. He proposes, correctly I believe, that the author of the *Tribune* article was looking at a different version of the painting. We know that Woodville made at least two versions of *Politics in an Oyster House*, the other appearing with the title *A New York Communist Advancing an Argument* (see chapter 2), so it is certainly possible that Woodville made more than one version of *The Sailor's Wedding*. Grubar believes the author saw a later version of the painting, made between 1853 and 1855, though it is not possible to determine whether a different version was made earlier or later than the one in the Walters. It is also possible that at some point the known version of *The Sailor's Wedding* was amended, the left side of the painting being removed, which might explain its abrupt framing.

81. See Dale T. Knobel, *Paddy and the Republic: Ethnicity and Nationality in Antebellum America* (Middletown, Conn.: Wesleyan University Press, 1986), 27, 53.

82. Samuel Otter, *Melville's Anatomies* (Berkeley and Los Angeles: University of California Press, 1999), 58.

83. Herman Melville, *White-Jacket; or The World in a Man-of-War*, in vol. 5 of *The Writings of Herman Melville*, ed. Harrison Hayford, Hershel Parker, and G. Thomas Tanselle (Evanston: Northwestern University Press; Chicago: Newberry Library, 1968), 375.

84. For more on Carlin's painting see *American Paintings in the Metropolitan Museum of Art*, ed. Kathleen Luhrs (New York: Metropolitan Museum of Art in association with Princeton University Press, 1994), 1:566–68. Samuel Otter uses the term *chattel* in his discussion of sea and slave narratives (see Otter, *Melville's Anatomies*, 57). For an analysis of how certain immigrants, the Irish especially, "became white" by harassing black Americans, see Noel Ignatiev, *How the Irish Became White* (New York: Routledge, 1995).

85. Reynolds, *Beneath the American Renaissance*, 286.

86. Isabelle Lehuu, "Sentimental Figures: Reading *Godey's Lady's Book* in Antebellum America," in *The Culture of Sentiment: Race, Gender, and Sentimentality in*

Nineteenth-Century America, ed. Shirley Samuels (New York: Oxford University Press 1992), 89, 78, 73, 79, 89.

87. From the "Declaration of Sentiments" issued by the Seneca Falls Convention on the Equality of Men and Women in 1848, in *Major Problems in the Early Republic, 1787–1848: Documents and Essays*, ed. Sean Wilentz (Lexington, Mass.: D. C. Heath and Co., 1992), 436.

88. Thomas H. Fick, "Real Lives: Didactic Realism in Antebellum Marital Fiction," in *Joinings and Disjoinings: The Significance of Marital Status in Literature*, ed. JoAnna Stephens Mink and Janet Doubler Ward (Bowling Green, Ohio: Bowling Green State University Press, 1991), 52.

89. Rose Terry Cooke, *"How Celia Changed Her Mind" and Selected Stories*, ed. and intro. Elizabeth Ammon (New Brunswick, N.J.: Rutgers University Press, 1986), 42.

90. Lehuu, "Sentimental Figures," 79.

91. Halttunen, *Confidence Men and Painted Women*, 56–57; "The Female Sex," *Literary Magazine* 15 (1805), quoted in Halttunen, *Confidence Men and Painted Women*, 57.

92. Halttunen, *Confidence Men and Painted Women*, 57, 58.

93. Reverend Rufus Clark, *Lectures on the Formation of Character, Temptations and Mission of Young Men* (Boston: John P. Jewett and Co., 1853), 133.

94. Halttunen, *Confidence Men and Painted Women*, 58.

95. Fick, "Real Lives," 52.

96. Allen Stein, *After the Vows Were Spoken: Marriage in American Literary Realism* (Columbus: Ohio State University Press, 1984), 5.

97. Fick, "Real Lives," 53.

98. Ibid.

99. Ibid., 54–55.

100. Catharine Sedgwick, "Second Thoughts Best," in *The Token and Atlantic Souvenir: A Christmas and New Year's Present*, ed. S[amuel] G. Goodrich (Boston: Otis, Broaders, 1840), 378.

101. Alice Cary, *Married, Not Mated; or, How They Lived at Woodside and Throckmorton Hall* (New York: Derby and Jackson, 1856), 41.

102. John E. Findling, ed., *Historical Dictionary of World's Fairs and Expositions, 1851–1988* (Westport, Conn.: Greenwood Press, 1990), 12.

103. Horace Greeley, ed., *Art and Industry as Represented in the Exhibition at the Crystal Palace, New York 1853–4; Showing the Progress and State of the Various Useful and Esthetic Pursuits* (New York: Redfield, 1853), xix.

104. See Findling, *Historical Dictionary of World's Fairs and Expositions*, 12. For a detailed description of the building and for an account of its construction, also see Georg J. B. Carstensen and Charles Gildemeister, *New York Crystal Palace. Illustrated Description of the Building* (New York: Riker, Thorne, and Co., 1854).

105. Greeley, *Art and Industry*, 13.

106. Ibid., 17.

107. Charles Hirschfeld, "America on Exhibition: The New York Crystal Palace," *American Quarterly* 9 (summer 1957): 101–16.

108. Findling, *Historical Dictionary of World's Fairs and Expositions*, 13.

109. Hirschfeld, "America on Exhibition," 110.

110. Greeley, *Art and Industry*, 171.

111. Ibid., 173–77.

112. American critic, quoted without citation in Hirschfeld, "America on Exhibition," 111.

113. "The Great Exhibition and Its Visitors," *Putnam's Monthly Magazine* 2 (1853): 580.

114. Hirschfeld, "America on Exhibition," 111.

115. *Official Catalogue of the Pictures Contributed to the Exhibition of the Industry of All Nations in the Picture Gallery of the Crystal Palace* (New York: G. P. Putnam and Co., 1853).

116. Hirschfeld, "America on Exhibition," 112.

117. *Official Catalogue of the Pictures Contributed to the Exhibition of the Industry of All Nations*, cat. nos. 15, 41, and 51.

118. Hirschfeld, "America on Exhibition," 102.

119. *Albany Evening Atlas*, 9 Dec. 1852, quoted in ibid.

120. Richard O. Cummings, "The Growth of Technical Cooperation with Governments Abroad, 1849–1853," *Pacific Historical Review* 18 (1949): 205, quoted in Hirschfeld, "America on Exhibition," 102–3.

121. Hirschfeld, "America on Exhibition," 107.

122. Carstensen and Gildemeister, *New York Crystal Palace*, 2.

123. Greeley, *Art and Industry*, 28.

124. In "America on Exhibition," 112, Hirschfeld summarizes reports from the *New York Times*, 25 Mar., 7 May, 16 June, 13, 14 July, and 9 Aug. 1853.

125. Neil Harris, *Humbug: The Art of P. T. Barnum* (Boston: Little, Brown and Brown, 1973), 209, 213.

126. "The Lesson of Barnum's Life," *Littell's Living Age* 44 (Jan. 1855): 150.

127. Harris, *Humbug*, 224, 225, 227.

128. "Revelations of a Showman," *Blackwood's Edinburgh Magazine*, American ed., 40 (Feb. 1855): 187–201.

CHRONOLOGY

◈

30 APRIL 1825
Richard Caton Woodville is born in Baltimore.

1836–41
Woodville studies at Saint Mary's College in Baltimore; makes first sketches.

1842–43
Attends the University of Maryland College of Medicine in Baltimore; sketches friends and professors.

1844–45
Sketches inmates at the Baltimore City and County Almshouse.

3 JANUARY 1845
Marries Mary Theresa Buckler of Baltimore.

SPRING 1845
Exhibits *Two Figures at a Stove* (fig. 1) at the National Academy of Design in New York City.

MAY 1845
Sails from New York to France, then settles in Düsseldorf, Germany, to study at the Düsseldorf Academy.

14 SEPTEMBER 1845
Henry "Harry" James Woodville born to Woodville and Mary Theresa Buckler.

1845–46
Studies at the Düsseldorf Academy for one year, then drops out.

1846–SPRING 1851
Lives in Düsseldorf and paints the majority of his pictures.

FALL 1847
Woodville's father, William Woodville V, brokers a relationship between his son and the American Art-Union.

SPRING 1849
Elizabeth "Bessie" Woodville born to Woodville and Mary Theresa Buckler.

1849
Woodville separates from his wife and begins a romantic relationship with the artist Antoinette Schnitzler of Düsseldorf.

SPRING 1851
Moves to Paris.

SUMMER 1851
Visits New York and Baltimore.

SEPTEMBER 1851
Sails for Liverpool.

FALL 1851
Stays briefly in London.

DECEMBER 1851–MARCH 1853
Settles in Paris and paints.

12 MARCH 1853
Alice Woodville born to Woodville and Antoinette Schnitzler.

MARCH 1853–APRIL 1855
Lives in London; makes one brief visit to the United States.

1854
Marries Antoinette Schnitzler.

13 AUGUST 1855
Dies in London.

7 JANUARY 1856
Richard Caton Woodville Jr. born to Woodville and Antoinette Schnitzler.

BIBLIOGRAPHY

◇

MANUSCRIPT SOURCES

American Art-Union Papers. Letters from artists, letters received, and letterpress book. New-York Historical Society, New York.

Estate of William Woodville VIII. Managed by the Trust Administrative Officer of Riggs National Bank, Washington, D.C.

J. Hall Pleasants Papers, 1773–1957. Manuscripts Department. Maryland Historical Society, Baltimore, Maryland.

Otho Holland Williams Papers, 1744–1839. Manuscripts Department. Maryland Historical Society, Baltimore, Maryland.

Pennington Papers. Manuscripts Department. Maryland Historical Society, Baltimore, Maryland.

Gail Woodville Roberson, private collection. North Little Rock, Arkansas.

Robert Goodloe Harper Papers. Manuscripts Department. Maryland Historical Society, Baltimore, Maryland.

Woodville-Butler Letters. Manuscripts Department. Maryland Historical Society, Baltimore, Maryland.

Woodville Correspondence. Boston Athenaeum Library, Boston, Massachusetts.

Woodville Manuscripts. Historical Society of Washington, D.C.

SELECTED WORKS

Adams, James Eli. *Dandies and Desert Saints: Styles of Victorian Manhood*. Ithaca, N.Y.: Cornell University Press, 1995.

Alcott, William A. *Young Man's Guide*. Boston: Lilly, Wait, Colman, and Holden, 1834.

Ashworth, John. *Slavery, Capitalism, and Politics in the Antebellum Republic*. Cambridge: Cambridge University Press, 1995.

Asmodeus. *Sharps and Flats; Or the Perils of City Life. Being the Adventures of One Who Lived by His Wits*. Boston: William Berry and Co., [1850].

Bartlett, Dr. Elisha. *An Essay on the Philosophy of Medical Science*. Philadelphia: Lea and Blanchard, 1844.

Baym, Nina. *Novels, Readers, and Reviewers: Responses to Fiction in Antebellum America*. Ithaca, N.Y.: Cornell University Press, 1984.

Beirne, Francis F. *The Amiable Baltimoreans*. New York: E. P. Dutton and Co., 1951.

Bellington, Ray A. *The Protestant Crusade, 1800–1860: A Study of the Origins of Nativism*. New York: Macmillan, 1938.

Bement, William. *The Mexican War and War in General, Considered in Two Sermons, Preached at East-Hampton, October 17, 1847*. Northampton, Mass.: printed by John Metcalf, 1847.

Bergmann, Hans. *God in the Street: New York Writing from the Penny Press to Melville*. Philadelphia: Temple University Press, 1995.

———. "The Original Confidence Man." *American Quarterly* 21 (fall 1969): 560–77.

Berlin, Ira. *Slaves without Masters: The Free Negro in the Antebellum South*. New York: Pantheon Books, 1974.

Bethel, Elizabeth Rauh. *The Roots of African-American Identity: Memory and History in Free Antebellum Communities*. New York: St. Martin's Press, 1997.

Bloch, Maurice E. "The American Art-Union's Downfall." *New-York Historical Society Quarterly* 37 (1953): 331–59.

Blondheim, Menahem. *News over the Wires: The Telegraph and the Flow of Public Information in America, 1844–1897.* Cambridge, Mass.: Harvard University Press, 1994.

Blumin, Stuart. *The Emergence of the Middle Class: Social Experience in the American City, 1760–1900.* Cambridge: Cambridge University Press, 1989.

———. "The Hypothesis of Middle-Class Formation in Nineteenth-Century America: A Critique and Some Proposals." *American Historical Review* 90 (Apr. 1985): 299–339.

Boime, Albert. "Social Identity and Political Authority in the Response of Two Prussian Painters to the Revolution of 1848." *Art History* 13 (Sept. 1990): 344–87.

Brack, Gene M. *Mexico Views Manifest Destiny, 1821–1846: An Essay on the Origin of the Mexican War.* Albuquerque: University of New Mexico Press, 1975.

Brock, Peter. *Radical Pacifists in Antebellum America.* Princeton, N.J.: Princeton University Press, 1968.

Brown, Christopher. *Images of the Golden Past: Dutch Genre Painting of the Seventeenth Century.* New York: Abbeville Press, 1984.

Browne, Gary Lawson. *Baltimore in the Nation, 1789–1861.* Chapel Hill: University of North Carolina Press, 1980.

Bruce, Dickson D. *Violence and Culture in the Antebellum South.* Austin: University of Texas Press, 1979.

Brugger, Robert J. *Maryland: A Middle Temperament, 1634–1980.* Baltimore: Johns Hopkins University Press in association with the Maryland Historical Society, 1988.

Bulletin of the American Art-Union. 1844–52.

Byer, R. H. "Mysteries of the City: A Reading of Poe's 'The Man of the Crowd.'" In *Ideology and Classic American Literature*, ed. Sacvan Bercovitch and Myra Jehlen. Cambridge: Cambridge University Press, 1986.

Callcott, George H. *A History of the University of Maryland.* Baltimore: Maryland Historical Society, 1966.

Carey, James W. "The Communications Revolution and the Professional Communicator." *Sociological Review Monograph* 13 (Jan. 1969): 23–38.

———. "Technology and Ideology: The Case of the Telegraph." In *Prospects: The Annual of American Cultural Studies*, 8:303–25. Cambridge: Cambridge University Press, 1983.

Carstensen, Georg J. B., and Charles Gildemeister. *New York Crystal Palace: Illustrated Description of the Building.* New York: Riker, Thorne, and Co., 1854.

Carwardine, Richard. *Evangelicals and Politics in Antebellum America.* New Haven, Conn., and London: Yale University Press, 1993.

Cassedy, James H. *Medicine in America: A Short History.* Baltimore: Johns Hopkins University Press, 1991.

Champney, Benjamin. *Sixty Years' Memories of Art and Artists.* Ed. and intro. H. Barbara Weinberg. New York: Garland, 1977.

Christman, Margaret C. S. *1846: Portrait of the Nation.* Washington, D.C.: Smithsonian Institution Press, 1996.

Click, Patricia. *Spirit of the Times: Amusements in Nineteenth-Century Baltimore, Norfolk, and Richmond.* Charlottesville: University Press of Virginia, 1989.

Coe, Lewis. *The Telegraph: A History of Morse's Invention and Its Predecessors in the United States.* Jefferson, N.C.: McFarland, 1993.

Cordell, Eugene Fauntleroy. *University of Maryland, 1807–1907.* New York: Lewis Publishing Co., 1907.

Cowdrey, M[ary] B., comp. *American Academy of Fine Arts and American Art-Union.* New York: New-York Historical Society, 1953.

Cowling, Mary. *The Artist as Anthropologist: The Representation of Type and Character in Victorian Art.* Cambridge: Cambridge University Press, 1989.

Cox, Richard J., and Patricia M. Vanorny. "The Records of a City: Baltimore and Its Historical Sources." *Maryland Historical Magazine* 70 (fall 1975): 286–310.

Czitrom, Daniel Joseph. "Media and the American Mind: The Intellectual and Cultural Reception of Modern Communication, 1838–1965." Ph.D. diss., University of Wisconsin, 1979.

Dain, Norman. *Concepts of Insanity in the United States, 1789–1865.* New Brunswick, N.J.: Rutgers University Press, 1964.

Danbom, David B. "The Young America Movement." *Journal of the Illinois State Historical Society* 67 (1974): 294–306.

De Grave, Kathleen. *Swindler, Spy, Rebel: The Confidence Man in Nineteenth-Century America*. Columbia: University of Missouri Press, 1995.

Della, M. Ray, Jr. "An Analysis of Baltimore's Population in the 1850s." *Maryland Historical Magazine* 68 (1973): 20–35.

Dickens, Charles. *American Notes and Pictures from Italy*. New York: Chapman and Hall, 1907.

Douglass, Frederick. *The Oxford Frederick Douglass Reader*. Ed. and intro. William L. Andrews. New York: Oxford University Press, 1996.

Doyle, Thomas. *Five Years in a Lottery Office; or, An Exposition of the Lottery System in the United States*. Boston: S. N. Dickinson, 1841.

Dunlap, William. *History of the Rise and Progress of the Arts of Design in the United States*. Ed. Alexander Wyckoff. New York: B. Blom, 1965.

Emerson, Ralph Waldo. *Essays: First and Second Series*. New York: Houghton Mifflin Co., 1921.

Engels, Friedrich, and Karl Marx. *Germany: Revolution and Counter-revolution*. Ed. Eleanor Marx. New York: International Publishers, 1969.

Errington, Lindsay. *Tribute to Wilkie*. Exh. cat. Edinburgh: National Galleries of Scotland, 1985.

Fabian, Ann. *Card Sharps, Dream Books, and Bucket Shops: Gambling in Nineteenth-Century America*. Ithaca, N.Y.: Cornell University Press, 1990.

Fick, Thomas H. "Real Lives: Didactic Realism in Antebellum Marital Fiction." In *Joinings and Disjoinings: The Significance of Marital Status in Literature*, ed. JoAnna Stephens Mink and Janet Doubler Ward. Bowling Green, Ohio: Bowling Green State University Press, 1991.

Findlay, John M. *People of Chance: Gambling in American Society from Jamestown to Las Vegas*. New York: Oxford University Press, 1986.

Findling, John E., ed. *Historical Dictionary of World's Fairs and Expositions, 1851–1988*. Westport, Conn: Greenwood Press, 1990.

Foster, George G. *New York by Gas-Light and Other Urban Sketches*. Ed. and intro. Stuart M. Blumin. Berkeley and Los Angeles: University of California Press, 1990.

Frankenstein, Alfred. *William Sidney Mount*. New York: Harry N. Abrams, 1975.

Frey, Jacob. *Reminiscences of Baltimore*. Baltimore: Maryland Book Concern, 1893.

Gardner, Bettye. "Ante-bellum Black Education in Baltimore." *Maryland Historical Magazine* 71 (fall 1976): 360–66.

Gerdts, William H. "The Düsseldorf Connection." In *Grand Illusions: History Painting in America*. Exh. cat. Fort Worth: Amon Carter Museum, 1988.

Gilmore, Michael T. *American Romanticism and the Marketplace*. Chicago: University of Chicago Press, 1985.

Graves, Mrs. A. J. *Woman in America: Being an Examination into the Moral and Intellectual Condition of American Female Society*. New York: Harper and Brothers, 1843.

Grayson, Ellen Hickey. "Art, Audiences, and the Aesthetics of Social Order in Antebellum America: Rembrandt Peale's *Court of Death*." Ph.D. diss., George Washington University, 1995.

Greeley, Horace, ed. *Art and Industry as Represented in the Exhibition at the Crystal Palace, New York 1853–4; Showing the Progress and State of the Various Useful and Esthetic Pursuits*. New York: Redfield, 1853.

Greenberg, Kenneth S. *Honor and Slavery*. Princeton, N.J.: Princeton University Press, 1996.

Greenhouse, Wendy. "Imperiled Ideals: British Historical Heroines in Antebellum American History Painting." In *Redefining American History Painting*, ed. Patricia M. Burnham and Lucretia Hoover Giese. Cambridge: Cambridge University Press, 1995.

Grier, Katherine C. *Culture and Comfort: Parlor Making and Middle-Class Identity, 1850–1930*. Washington, D.C.: Smithsonian Institution Press, 1997.

Groseclose, Barbara S. *Emanuel Leutze, 1816–1868: Freedom Is the Only King*. Washington, D.C.: Smithsonian Institution Press, 1975.

Grubar, Francis S. "Richard Caton Woodville: An American Artist, 1825 to 1855." Ph.D. diss., Johns Hopkins University, 1966.

———. *Richard Caton Woodville: An Early American Genre Painter*. Exh. cat. Washington, D.C.: Corcoran Gallery of Art, 1967.

Grund, Francis J. *Aristocracy in America*. 1839. Reprint, New York: Harper, 1959.

Halttunen, Karen. *Confidence Men and Painted Women: A Study of Middle-Class Culture in America, 1830–1870*. New Haven, Conn., and London: Yale University Press, 1982.

Hardy, Henriette A. "Mrs. Lilly M. Spencer." *Sartain's Union Magazine* 9 (Aug. 1851): 152–53.

Harris, Neil. *The Artist in American Society: The Formative Years, 1790–1860*. New York: George Braziller, 1966.

———. *Cultural Excursions: Marketing Appetites and Cultural Tastes in Modern America*. Chicago: University of Chicago Press, 1990.

———. *Humbug: The Art of P. T. Barnum*. Boston: Little, Brown and Brown, 1973.

Heimert, Alan. "*Moby-Dick* and American Political Symbolism." *American Quarterly* 15, no. 4 (winter 1963): 498–534.

Hills, Patricia. *The Painter's America: Rural and Urban Life, 1810–1910*. Exh. cat. New York: Praeger Publishers in association with the Whitney Museum of American Art, 1974.

———. "The Politics of Interpretation." *Oxford Art Journal* 17 (1994): 115–21.

Hirschfeld, Charles. "America on Exhibition: The New York Crystal Palace." *American Quarterly* 9 (summer 1957): 101–16.

Hoffert, Sylvia D. *When Hens Crow: The Women's Rights Movement in Antebellum America*. Bloomington: Indiana University Press, 1995.

Hone, Philip. *The Diary of Philip Hone, 1828–51*. Ed. Bayard Tuckerman. 2 vols. New York: Dodd, Mead and Co., 1889.

Hoopes, Donelson F. *The Düsseldorf Academy and the Americans*. Exh. cat. Atlanta: High Museum of Art, 1972.

Hoover, Catherine. "The Influence of David Wilkie's Prints on the Genre Paintings of William Sidney Mount." *American Art Journal* 13, no. 3 (1981): 4–33.

Houston, George. "'The Confidence Man' on a Large Scale." *New York Herald*, 11 July 1849.

The Hudson and the Rhine. Exh. cat. Düsseldorf: Kunstmuseum Düsseldorf, 1976.

Husch, Gail E. "'Freedom's Holy Cause': History, Religious, and Genre Painting in America, 1840–1860." In *Picturing History: American Painting, 1770–1930*, ed. William Ayres. New York: Rizzoli, 1993.

J.W.E. [John Whetten Ehninger]. "The School of Art at Düsseldorf." *Bulletin of the American Art-Union* 3 (Apr. 1850): 5–7.

Jay, William. *A Review of the Causes and Consequences of the Mexican War*. Boston: B. B. Massey and Co., 1849.

Johns, Elizabeth. *American Genre Painting: The Politics of Everyday Life*. New Haven, Conn., and London: Yale University Press, 1991.

Johnson, Hon. H. V. *The Republic of the United States of America: Its Duties to Itself, and its Responsible Relations to Other Countries. Embracing also a Review of the Late War Between the United States and Mexico*. New York: D. Appleton and Co., 1848.

Johnson, Paul E. *A Shopkeeper's Millennium: Society and Revivals in Rochester, New York, 1815–1837*. New York: Hill and Wang, 1978.

Johnston, William R. "The Early Years in Baltimore and Abroad." In *Alfred Jacob Miller: Artist on the Oregon Trail*, ed. Ron Tyler. Exh. cat. Fort Worth: Amon Carter Museum, 1982.

Kaplan, Michael. "New York City Tavern Violence and the Creation of a Working-Class Male Identity." *Journal of the Early Republic* 15, no. 4 (winter 1995): 591–618.

Kenly, John R. *Memoirs of a Maryland Volunteer: War with Mexico in the Years 1846–7–8*. Philadelphia: J. B. Lippincott & Co., 1873.

Kiesling, Lynne L. *Explaining the Rise in Antebellum Pauperism: New Evidence*. Cambridge, Mass.: National Bureau of Economic Research, 1996.

Klein, Rachel. "Art and Authority in Antebellum New York City: The Rise and Fall of the American Art Union." *Journal of American History* 81, no. 4 (Mar. 1995): 1534–61.

Koch, Cynthia M. "Teaching Patriotism: Private Virtue for the Public Good in the Early Republic." In *Bonds of Affection: Americans Define Their Patriotism*, ed. John Bodnar. Princeton, N.J.: Princeton University Press, 1996.

Kortendick, Rev. James Joseph. "The History of St. Mary's College, Baltimore, 1799–1852." Master's thesis, Catholic University of America, 1942.

Latrobe, John H. B. *Pictures of Baltimore*. Baltimore: F. Lucas, Jr., 1832.

Lee, James M. *History of American Journalism*. Cambridge: Houghton Mifflin Co., 1917.

Lefebvre, Henri. *Everyday Life in the Modern World*. Trans. Sacha Rabinovitch. New York: Harper and Row, 1971.

Lehuu, Isabelle. "Sentimental Figures: Reading *Godey's Lady's Book* in Antebellum America." In *The Culture of Sentiment: Race, Gender, and Sentimentality in Nineteenth-Century America*, ed. Shirley Samuels. New York: Oxford University Press, 1992.

"The Lesson of Barnum's Life." *Littell's Living Age* 44 (Jan. 1855).

Lindbergh, Gary H. *The Confidence Man in American Literature*. New York: Oxford University Press, 1982.

Livermore, Abiel Abbot. *The War with Mexico Reviewed*. Boston: American Peace Society, 1850.

Lubin, David. "Lily Martin Spencer's Domestic Genre Painting in Antebellum America." In *Picturing a Nation: Art and Social Change in Nineteenth-Century America*. New Haven, Conn., and London: Yale University Press, 1994.

Mahon, John K. *History of the Second Seminole War, 1835–1842*. Gainesville: University of Florida Press, 1967.

Maizlish, Stephen E., and John J. Kushma, eds. *Essays on American Antebellum Politics, 1840–1860*. College Station: Published for the University of Texas at Arlington by Texas A&M University Press, 1982.

Mannard, Joseph G. "The 1839 Baltimore Nunnery Riot: An Episode in Jacksonian Nativism and Social Violence." *Maryland Historian* 11, no. 1 (spring 1980): 13–28.

Marbury, F. F. *American Art-Union Transactions for 1845*. New York: The American Art-Union, 1845.

Markowitz, Irene. *Die Düsseldorfer Malerschuler*. Düsseldorf: Kunstmuseum Düsseldorf, 1967.

Mathews, Cornelius. "Americanism." *New York Morning News*, 11 July 1845.

McClane, Louis. *The Private Journal of Louis McClane, U.S.N., 1844–1848*. Ed. Jay Monaghan. Los Angeles: Published for the Santa Barbara Historical Society by Dawson's Book Shop, 1971.

Melville, Herman. *The Confidence-Man: His Masquerade*. Ed. and intro. Elizabeth S. Foster. New York: Hendricks House, 1954.

———. "Hawthorne and His Mosses." In *Moby-Dick*, ed. Harrison Hayford and Hershel Parker. Norton Critical Edition. New York: W.W. Norton and Co., 1967.

Miller, Angela. "The Mechanisms of the Market and the Invention of Western Regionalism: The Example of George Caleb Bingham." In *American Iconology: New Approaches to Nineteenth-Century Art and Literature*, ed. David Miller. New Haven, Conn., and London: Yale University Press, 1993.

Miller, Lillian B. *Patrons and Patriotism: The Encouragement of the Fine Arts in the United States, 1790–1860*. Chicago: University of Chicago Press, 1966.

Miller, Linda Patterson. "Poe on the Beat: *Doings of Gotham* as Urban, Penny Press Journalism." *Journal of the Early Republic* 7, no. 2 (summer 1987): 147–65.

Monk, Maria. *Awful Disclosures of the Hotel Dieu Nunnery of Montreal*. New York: Howe & Bates, 1836.

Nash, Jay Robert. *Hustlers and Con Men: An Anecdotal History of the Confidence Man and His Games*. New York: M. Evans, 1976.

Norton, Anne. *Alternative Americas: A Reading of Antebellum Political Culture*. Chicago: University of Chicago Press, 1986.

———. *Republic of Signs: Liberal Theory and American Popular Culture*. Chicago: University of Chicago Press, 1993.

O'Connor, Thomas F. "The Founding of Mount Saint Mary's College, 1808–1835." *Maryland Historical Society Magazine* 43 (1948).

Official Catalogue of the Pictures Contributed to the Exhibition of the Industry of All Nations in the Picture Gallery of the Crystal Palace. New York: G. P. Putnam and Co., 1853.

Otter, Samuel. *Melville's Anatomies*. Berkeley and Los Angeles: University of California Press, 1999.

Owens, Hamilton. *Baltimore on the Chesapeake*. Garden City, N.Y.: Doubleday, Doran and Co., 1941.

Papenfuse, Eric Robert. Afterword to "The Evils of Necessity: Robert Goodloe Harper and the Moral Dilemma of Slavery." *Transactions of the American Philosophical Society* 87, no. 1 (1997): 71–77.

Phillips, Christopher. *Freedom's Port: The African-American Community of Baltimore, 1790–1860*. Urbana: University of Illinois Press, 1997.

Poe, Edgar Allan. *Doings of Gotham: As Described in a Series of Letters to the Editors of the Columbia Spy. . . .* Ed. Jacob E. Spannuth with comments by Thomas Ollive Mabbott. Pottsville, Pa., 1929.

———. "Gambling." *Broadway Journal* 1 (1 Mar. 1845): 133–34.

———. "The Man of the Crowd." In *Selected Poetry and Prose of Edgar Allan Poe*, ed. T. O. Mabbott. New York: Modern Library, 1951.

Porter, Carolyn. "Reification and American Literature." In *Ideology and Classic American Literature*, ed. Sacvan Bercovitch and Myra Jehlen. Cambridge: Cambridge University Press, 1986.

Porter, Charles T. *Review of the Mexican War, embracing the causes of the war, the responsibility of its commencement, the purposes of the American government in its prosecution, its benefits and its evils*. Auburn, N.Y.: Alden and Parsons, 1849.

Potter, Woodburne. *The War in Florida: Being an Exposition of its Causes and an Accurate History of the Campaigns of Generals Clinch, Gaines, and Scott*. Baltimore: Lewis and Coleman, 1836.

[Pray, Isaac C.]. *Memoirs of James Gordon Bennett and His Times*. New York: Stringer and Townsend, 1855.

Quinan, John R. *Medical Annals of Baltimore from 1608–1880*. Baltimore: Press of I. Friedenwald, 1884.

Quirk, Tom. *Melville's Confidence Man: From Knave to Knight*. Columbia: University of Missouri Press, 1982.

Rash, Nancy. *The Painting and Politics of George Caleb Bingham*. New Haven, Conn., and London: Yale University Press, 1991.

"Revelations of a Showman." *Blackwood's Edinburgh Magazine*, American ed. 40 (Feb. 1855): 187–201.

Reynolds, David S. *Beneath the American Renaissance: The Subversive Imagination in the Age of Emerson and Melville*. Cambridge, Mass.: Harvard University Press, 1988.

———. *Walt Whitman's America: A Cultural Biography*. New York: Vintage, 1995.

Rogin, Michael Paul. "Revolutionary Fathers and Confidence Men." In *Herman Melville: A Collection of Critical Essays*, ed. Myra Jehlen. Englewood Cliffs, N.J.: Prentice Hall, 1994.

Romero, Lora. *Home Fronts: Domesticity and Its Critics in the Antebellum United States*. Durham, N.C.: Duke University Press, 1997.

Rutledge, Anna Wells. "Robert Gilmor, Jr., Baltimore Collector." *Journal of the Walters Art Gallery* 12 (1949): 19–41.

Samuels, Shirley, ed. *The Culture of Sentiment: Race, Gender, and Sentimentality in Nineteenth-Century America*. New York: Oxford University Press, 1992.

Scharf, Col. J. Thomas. *The Chronicles of Baltimore; being a complete history of "Baltimore Town" and Baltimore City from the earliest period to the present time*. Baltimore: Turnbull Brothers, 1874.

———. *History of Baltimore City and County, from the Earliest Period to the Present Day*. Philadelphia: Louis Everts, 1881.

Schroeder, John H. *Mr. Polk's War: American Opposition and Dissent, 1846–1848*. Madison: University of Wisconsin Press, 1973.

Shryock, Richard Harrison. *Medicine in America: Historical Essays*. Baltimore: Johns Hopkins Press, 1966.

Siemann, Wolfram. *The German Revolution of 1848–49*. Trans. Christiane Banerji. New York: St. Martin's Press, 1998.

Silver, Rollo G. "Whitman in 1850: Three Uncollected Articles." *American Literature* 13 (Jan. 1948): 301–17.

Singletary, Otis. *The Mexican War*. Chicago: University of Chicago Press, 1960.

Sperber, Jonathan. *The European Revolutions, 1848–1851*. Cambridge: Cambridge University Press, 1994.

———. *Rhineland Radicals: The Democratic Movement and the Revolution of 1848–1849*. Princeton, N.J.: Princeton University Press, 1991.

Staiti, Paul. "Ideology and Politics in Samuel F. B. Morse's Agenda for a National Art." In *Samuel F. B. Morse: Educator and Champion of the Arts in America*. New York: National Academy of Design, 1982.

———. *Samuel F. B. Morse*. Cambridge: Cambridge University Press, 1989.

Steffen, Charles G. *The Mechanics of Baltimore: Workers and Politics in the Age of Revolution, 1763–1812*. Chicago: University of Illinois Press, 1984.

Stehle, Raymond L. "The Düsseldorf Gallery of New York." *New-York Historical Society Quarterly* 58 (Oct. 1974): 304–14.

Stein, Allen. *After the Vows Were Spoken: Marriage in American Literary Realism*. Columbus: Ohio State University Press, 1984.

Stockbridge, Henry Sr. "Baltimore in 1846." *Maryland Historical Magazine* 6 (Mar. 1911): 18–25.

Stott, Richard Briggs. *Workers in the Metropolis: Class, Ethnicity, and Youth in Antebellum New York City*. Ithaca, N.Y.: Cornell University Press, 1990.

Sullivan, David K. "William Lloyd Garrison in Baltimore, 1829–30." *Maryland Historical Magazine* 68 (spring 1973): 64–79.

Sutton, Peter C. "Masters of Dutch Genre Painting." In *Masters of Seventeenth-Century Dutch Genre Painting*. Exh. cat. Philadelphia: Philadelphia Museum of Art, 1984.

Sweeney, John A. H. *The Treasure House of Early American Rooms*. New York: Viking Press, 1963.

Thoreau, Henry David. *Walden and Other Writings by Henry David Thoreau*. Ed. and intro. Joseph Wood Krutch. New York: Bantam Books, 1962.

Tuckerman, Henry T. *Artist-life; or, Sketches of American Painters*. Boston: D. Appleton and Co., 1847.

———. *Book of the Artists: American Artist Life*. New York: G. P. Putnam and Sons, 1867.

Tyler, Ron, ed. *Alfred Jacob Miller: Artist on the Oregon Trail*. Exh. cat. Fort Worth: Amon Carter Museum, 1982.

———. "Historic Reportage and Artistic License: Prints and Paintings of the Mexican War." In *Picturing History: American Painting, 1770–1930*, ed. William Ayres. New York: Rizzoli, 1993.

Van Devanter, Ann C. *"Anywhere So Long As There Be Freedom": Charles Carroll of Carrollton, His Family and His Maryland*. Exh. cat. Baltimore: Baltimore Museum of Art, 1975.

Verplanck, Gulian. *Discourses and Addresses on Subjects of American History, Arts, and Literature*. New York: J. and J. Harper, 1833.

Whitman, T. Stephen. *The Price of Freedom: Slavery and Manumission in Baltimore and Early National Maryland*. Lexington: University Press of Kentucky, 1997.

Whitman, Walt. *I Sit and Look Out: Editorials from the Brooklyn Daily Times*. Ed. Emory Holloway and Vernolian Schwartz. New York: AMS Press, 1966.

———. "Song of Myself." In *Leaves of Grass*, ed. Harold Blodgett and Sculley Bradley. New York: New York University Press, 1965.

———. *The Uncollected Poetry and Prose of Walt Whitman*. Ed. Emory Holloway. Vol. 1. Gloucester, Mass.: Peter Smith, 1972.

Widmer, Edward L. *Young America: The Flowering of Democracy in New York City*. New York: Oxford University Press, 1999.

Wilentz, Sean. *Chants Democratic: New York City and the Rise of the American Working Class, 1788–1850*. New York: Oxford University Press, 1984.

Williams, Hermann Warner, Jr. *Mirror to the American Past: A Survey of American Genre Painting, 1750–1900*. Greenwich, Conn.: New York Graphic Society, 1973.

Williams, Raymond. *Culture and Society, 1780–1950*. New York: Columbia University Press, 1983.

Wittke, Carl Frederick. *Refugees of Revolution: The German Forty-eighters in America*. Philadelphia: University of Pennsylvania Press, 1952.

Wolf, Bryan J. "All the World's a Code: Art and Ideology in Nineteenth-Century American Painting." *Art Journal* 44 (winter 1984): 328–37.

———. "History as Ideology: Or, 'What You Don't See Can't Hurt You, Mr. Bingham.'" In *Redefining American History Painting*, ed. Patricia Burnham and Lucretia Hoover Giese. Cambridge: Cambridge University Press, 1995.

Wolff, Janet, and John Seed, eds. *The Culture of Capital: Art, Power, and the Nineteenth-Century Middle Class*. Manchester: Manchester University Press, 1988.

Wyatt-Brown, Bertram. *Honor and Violence in the Old South*. New York: Oxford University Press, 1986.

Zboray, Ronald J. *A Fictive People: Antebellum Economic Development and the American Reading Public*. New York: Oxford University Press, 1993.

Ziegler, Valarie H. *The Advocates of Peace in Antebellum America*. Bloomington: Indiana University Press, 1992.

Zucker, A. E. *The Forty-eighters: Political Refugees of the German Revolution of 1848*. New York: Columbia University Press, 1950.

ACKNOWLEDGMENTS

◇

I want to thank my advisor at Princeton University, John Wilmerding, for his guidance and friendship during my time as his graduate student and while I was writing this book. I owe a special debt as well to Linda Docherty, who first encouraged my interest in American art. For their comments on various stages of the manuscript that became this book I wish to thank Peter C. Bunnell, Elizabeth Johns, Paul Johnson, Sean Wilentz, and Bryan Jay Wolf. A fellowship from the John Nicholas Brown Center for the Study of American Civilization in Providence, Rhode Island, allowed me to finish work on this book and begin research on a new one. I am indebted as well to the Department of Art and Archaeology at Princeton University for generous financial assistance to cover some of the book's research and printing costs. I am also grateful to Nancy Grubb, my sensible editor at Princeton University Press, as well as her entire editorial team: Sarah Henry, Devra K. Nelson, Ken Wong, and Kate Zanzucchi. My thanks also go to Patricia Fidler, who took on this book while she was still at Princeton University Press; Joanne Allen, my copyeditor; Laurie Burton, my proofreader; and Kathleen Friello, who prepared the useful index. I wish to thank my father, who read the first drafts of this book and encouraged me to keep going. Finally, thank you to my wife, Megan, for her patience and compassion—and for saying yes.

INDEX

◈

Note: Pages on which figures appear are indicated with italics. Works by Woodville are alphabetized according to the sitter's surname.

Click, Patricia, 67
Clonney, James Goodwyn: *Mexican News*, fig. 60, *108*, *109*; *Politicians in a Country Bar*, fig. 42, 83, *84*
Coacoochee (Miccosukee Indian), 116
Cohen brothers, 151–53
Cole, Thomas, 19, 42
College of Medicine, University of Maryland, 17, 27–32, 36, 42, 180n.67, 181n.84; Woodville at, 17, 27–35, 37–39, 44, 51, 111, 195
confidence men, 66, 68, 78, 140–49, 160, 165, 174; William Thompson, 142–44; and Woodville works, 10, 45, 81, 142, 146, 153, 175. *See also* card sharps; gambling; Melville, Herman, *The Confidence-Man*
Cooke, Rose Terry, 164
Copley, John Singleton, *Death of Major Peirson*, 179n.50
Cornelius, Peter von, 56
Cortez, Hernán, 119
Courbet, Gustave, 154
Couture, Thomas, 56
Cozzens, Abraham, 21
Creighton, James, 178n.26
Cromwell, Oliver, 90
Crystal Palace Exhibition, New York, 60, 161, 166–74; art exhibited at, 169–72; *New York Crystal Palace for the Exhibition of the Industry of All Nations*, fig. 79, *168*, 173; Woodville exhibited at, 161, 166, 169–71

Dain, Norman, 36
Dana, Richard Henry Jr., 162
D'Avignon, Francis, after Matteson, *Distribution of the Prizes at the American Art-Union*, fig. 72, *151*
Deas, Charles, 67
Democrats, 13, 20, 25, 50, 60, 78, 80–82, 186n.104; and Mexican War, 95, 121, 128, 187n.1
Dickens, Charles, 71, 75–76
Doughty, Thomas, 74
Douglass, Frederick, 130–31
Downing, Thomas, 185n.73
drinking and drunkards, 21–22, 36, 75, 78; in genre painting, 38–39, 75; and temperance movement, 22, 45, 75; and Washingtonians, 22, 75; in Woodville works, 19–22, 44, 75, 77–78
Duer, John Van Buren, 187n.127
Dunlap, William, 19
Durand, Asher B., 13, 19; *Kindred Spirits*, 104
Düsseldorf, 55–56, 183–84n.26; Woodville's residence in, 9, 55, 73, 154, 158, 191n.93, 195
Düsseldorf Academy, 54–61, 86, 132, 158, 171, 182n.2, 183n.8; American artists at, 57–61, 82, 90, 119; Düsseldorf style, 57–58; and Malkasten, 60; Woodville at, 9, 17, 50, 53–58, 61, 63–64, 135, 137, 154, 195

Düsseldorf Gallery, New York, 57–58, 183n.13
Duyckinck, Evert, 11

Eakins, Thomas, *The Gross Clinic*, fig. 16., *35*
Eddy, Daniel, 143
Edmonds, Francis William, 21, 45, 67, 184n.35; *The City and the Country Beaux*, fig. 77, *159*, 160; engravings of paintings, 188n.21; *Facing the Enemy*, 45; after Woodville, *Mexican News*, fig. 57, 91, *94*, 102, *103*, 188n.21; *Strolling Musician*, 13
Edmondson, Thomas, 42, 44
Ehninger, John Whetten, 183n.8
Ellis, Joseph J., 122
Elssler, Fanny, 45–47
Emerson, Ralph Waldo, 12, 32, 50, 77

Fabian, Ann, 67, 143–44, 152
family, 88–89, 163; in genre painting, 88–89; in Woodville works, 85, 89–91, 99, 124–26, 132, 158, 160–61, 165
Fick, Thomas H., 165–66
Field, David Dudley, 11
Findling, John E., 168
Finney, Charles Grandison, 88
Fisher, John Kendrick, 74
Flexner, James Thomas, 132
Florida, Seminole Wars in, 114–16, 189n.55
Foster, Elizabeth, 139–41
Foster, George G., 68, 75, 78, 146
Foster, Thomas, 66
Fowler, Lorenzo Niles, 77, 185n.85
Fowler, Orson Squire, 77, 185n.85
Franklin, Benjamin, 28
Frick, Charles, 37

gambling, 49, 67–69, 105, 143–49, 151–53, 173, 192n.39; in genre paintings, 66–67, 83; reformers, 144, 152; in Woodville works, 10, 45, 61, 68, 83, 93, 137, 139, 142, 146–48, 153. *See also* card sharps; confidence men
Gannett, Rev. Ezra S., 98
Garber, Marjorie, 10
genre painting, 8–14, 21, 39, 42, 45, 71–72, 83, 175, 184n.35; and American Art-Union, 11–13, 64, 72, 74, 82; Dutch, 42, 44, 85–86, 102; English, 42, 44, 85; European, 83–85; Flemish, 42, 85; French, 85; German, 42, 58–60; and politics, 61, 82, 126; types in, 8, 67, 83, 85, 112–13, 159–61; and Woodville, 8–9, 14, 44, 51, 64, 111, 114, 142, 154, 166, 175. *See also* subjects listed *individually*
Gildemeister, Charles, 167, 172
Gilman, Arthur, 191n.91

Gilmor, Robert Jr., 21, 42–44, 181n.92; collection of, 22, 42–44, 111–14, 181n.96
Gilmore, Michael T., 140
Godey's Lady's Book, 89, 160, 163–64
Goupil and Company, 73, 173; prints after Woodville, 73, 141, 161, 191n.22, 193n.79
Graves, A. J., 125
Great Exhibition, London, 166, 168, 170
Greeley, Horace, 105–6, 166–68, 170, 172–73
Green, John Harrington, 144
Greenhouse, Wendy, 90–91
Gross, Samuel, 35
Grubar, Francis, 7–8, 38, 74, 101–2, 104, 114, 137, 148, 160–61, 177n.9, 178n.19, 180n.62, 191n.22, 193nn. 79 and 80
Grund, Francis J., 71, 75

Hale, Sarah J., 163
Hall, Richard Wilmot, 29
Halttunen, Karen, 143, 165
Happel, Fr., *A Chicken Surprised by a Fitchet*, 171
Harper, Charles Carroll, 190n.82
Harper, Robert Goodloe, 72, 81, 129–30, 178n.26, 190nn. 82 and 87
Harper, Mrs. Robert (née Catherine Carroll), 129
Harris, Neil, 42, 66, 173–74
Harrison, Gabriel, *California News*, fig. 59, *105*; Hollyer after, *Walt Whitman*, fig. 29, 49
Hasenclever, Johann Peter, 58–61; *Scene in the Atelier*, fig. 33, 58, *59*, 60; *Workers Confronting the Magistrature*, 60, 183n.19
Hawthorne, Nathaniel, 11, 77, 122, 139
Haywarde, Richard, 124
Heimert, Alan, 81–82, 128
Henry, Joseph, 40
Hermann, Dr. Adolphus, 180n.84
Hildebrandt, Ferdinand Theodor, 58
Hirschfeld, Charles, 170–72
historical romance: British subjects in genre painting, 86, 90; and Woodville works, 85, 88–91, 186n.113
Hobbema, Meindert, 42
Hollyer, Samuel, after Harrison, *Walt Whitman*, fig. 29, 49
Homer, Winslow, *Prisoners from the Front*, 102
Hone, Philip, 50, 105, 178n.21, 186n.98; on Catons, 25–26; on Mexican War, 101; as patron, 42; on rowdyism, 25; on social breakdown, 36
Hooch, Pieter de, 86
Hoppin, William J., 66
Houston, George, 144
Hübner, Karl Wilhelm, 60
Hunt, William Morris, 56
Husch, Gail E., 122–23

PHOTOGRAPHY CREDITS

❖